baac

The Library Book

The Library Book
 Photographs and afterword
 by Thomas R. Schiff
Introduction by Alberto Manguel
First edition, 2017
Library of Congress Control Number:
 2016957042
ISBN 978-1-59711-374-8

aperture

The Libraries

Introduction
Alberto Manguel

In the New-York Historical Society there is, among its many exhibits, one that to me is particularly moving. It is a copy of the *Iliad*, translated by Alexander Pope (J. Whiston, 1771), which Lafayette brought with him from his own library in the Château de Chavaniac when he sailed to America in 1777. As is well-known, Lafayette came from a wealthy aristocratic French family and, following the martial tradition of his ancestors, became a commissioned officer at the age of thirteen. Convinced that the American Revolutionary War was a noble cause, he traveled to America, became friends with Washington, Hamilton, and Jefferson, and, at the age of nineteen, he was made a major general in the revolutionary army. In bringing his *Iliad* with him from France, Lafayette followed another, more ancient martial tradition: that of Alexander the Great, who, the legend goes, also carried with him into battle a copy of the *Iliad*.

If readers' private libraries are symbols of their private identities, the public libraries of the society in which they live symbolize the communal one. A public library is the memory, the voice, and the face of the society that houses it. It is therefore not surprising that the first public library in the United States was created around a core collection, gifted by Benjamin Franklin, in 1790, when a town in Massachusetts honored the enlightened reader by changing the town's name to his. In gratitude, Franklin donated over a hundred of his own books and the town decided to lend these books to all citizens free of charge. Thomas R. Schiff's sweeping vistas of American libraries have this same all-encompassing, essentially democratic sense about them. "In the past, I've always looked for a photograph and tried to isolate a tiny area that would make a good print," Schiff writes. "With panoramic photography, you approach it a different way. Instead of trying to isolate a photograph, you look for an entire area where there is a good view in all directions." "A good view in all directions": this is an excellent definition of a public library.

My own relationship to public libraries has always been an odd one. On the one hand, I love the space of a public library. I love these monuments that stand like emblems of the identity that a society chooses for itself, imposing or unobtrusive, intimidating or familiar. I love the endless rows of books whose titles I try to make out in their vertical script that has to be read (I've never discovered why) from top to bottom in English and Italian, and from bottom to top in French and Spanish. I love the muffled sounds, the pensive silence, the subdued glow of the lamps (especially if they are made of green glass), the desks polished by the elbows of generations of readers. I love the ancient smells of dust and paper and leather, and the newer ones of plastified desktops and caramel-scented cleaning sprays. I love the all-seeing eye of the information desk and the sibylline solicitude of the librarians. I love the catalogues, especially the old card drawers (wherever they survive) with their inexhaustible typed or scribbled offerings.

And yet, on the other hand, I don't feel at ease in a public library. I'm impatient. I don't like to wait for the books I want (unless the library is blessed with the generosity of open stacks). I don't like being forbidden to write on the margins of the books I choose. I don't like having to give the books back if I discover something that interests me. Like a greedy looter, I want the books I read to be mine.

I would argue that public libraries are an essential, a vital need. I would defend to my last breath their place as the holder of society's memory and experience. I would say that without public libraries, and without a conscious understanding of their role, a society of the written word is doomed to oblivion. I realize how petty, how egotistical it may seem, this longing to own the books I borrow. I believe that theft is reprehensible, and yet countless times I've had to dredge up all the moral stamina I could find in myself in order not to pocket a desired volume. Polonius echoed in *Hamlet* my thoughts precisely when he told his son, "Neither a borrower nor a lender be." My own personal library carries this reminder clearly posted.

I love public libraries, and they are the first places I visit whenever I'm in a city I don't know. But I can only work happily in my own private library, with my own books, or rather, with the books I know to be

mine. Maybe there's a certain ancient faithfulness in this, a sort of monogamous domesticity, a more conservative trait in my nature than my anarchic youth would have ever admitted. My library, as Lafayette's was for him, is my exoskeleton, as if I were a turtle or a lobster. Perhaps because of this, every library is autobiographical, and its loss seems to have something of a self-obituary about it.

The most famous and dearest of readers who are condemned to lose their libraries is perhaps Alonso Quijano, the old man who becomes Don Quixote through his reading. The village priest and the barber, to cure him from what they perceive as madness, throw most of the old man's books into the fire and wall up the survivors to make it appear as if the library had never existed. When, after two days of convalescing, Don Quixote leaves his bed and goes to seek the comfort of his books, he doesn't find them. He is told that a wizard arrived one night on a cloud and made his library vanish in a puff of smoke. Cervantes doesn't tell us what Don Quixote feels when he hears this; he simply says that the knight remained for a full fortnight at home, without saying a word about pursuing his knightly quests. The reader understands that, without his library, Don Quixote is no longer who he was. But a few pages later, as he reflects on his reading and remembers the books that had taught him of the world's need for the ethics of chivalry, his imaginative strength comes back to him. He leaves his house, recruits a neighboring peasant, Sancho Panza, as his squire, and sets off on new adventures. Don Quixote will continue to see the world through the printed words of stories, but he will no longer have need of them in a material sense. Having lost his books as tangible objects, Don Quixote rebuilds his library in his mind and finds in the remembered pages a source for renewed comfort. Don Quixote will no longer read a book, any book, even that which tells of his own life when he and Sancho discover the chronicle of their adventures printed by a press in Barcelona, because now Don Quixote has attained the state of perfect readership. He now knows his books by heart, in the strictest sense of the word. Loss, as Don Quixote learns, helps you remember, and loss of a library helps you remember who you truly are.

Plato, in the *Timaeus*, says that when one of the wisest men of Greece, the statesman Solon, visited Egypt, he was told by an old priest that the Greeks were like mere children because they possessed no truly ancient traditions or notions "gray with time." In Egypt, the priest continued proudly, "there is nothing great or beautiful or remarkable that is done here, or in your country, or in any other land that has not been long since put into writing and preserved in our temples." In the third century BCE, about the same time that Plato was writing his dialogues, the Egyptian kings coalesced this colossal ambition and ordered that every book in the known world be collected and placed in the great library they had founded in Alexandria. Hardly anything is known of the Library of Alexandria except its fame: neither its exact site nor how it was used, not even how it came about its end. And yet, as one of history's most distinguished ghosts, the Library of Alexandria became the archetype of all libraries, even of the Bibliothèque et Archives nationales du Québec, standing on a land that the librarians of Alexandria never knew existed.

Since the time of Alexandria, libraries have held a symbolic function. For the Ptolemaic kings, the library was a symbol of their power; eventually it became the encompassing symbol of an entire society, a numinous place where readers could learn the art of attention, which, Hannah Arendt argued, is a definition of culture. But since the mid-twentieth century, libraries no longer seem to carry this symbolic meaning and, as mere storage rooms of a technology deemed defunct, are not considered worthy of proper preservation and funding.

In our beleaguered century, in most of the world, the number of public libraries has been decreasing, perhaps because some politicians believe that it is easier to impose their will on a population prevented from reading. But libraries are resilient. Intent on surviving in an age where the intellectual act has lost almost all prestige,

libraries have become, almost wherever they still persist, mainly social centers. Most public libraries today are used less to borrow books than to seek protection from harsh weather, keep kids entertained, and find jobs online, all very necessary services, and it is admirable that librarians have lent themselves to these tasks that don't traditionally belong to their job description. A new definition of the role of librarians in today's society could be drafted by diversifying their mandate. But such restructuring must ensure that the librarians' primary purpose is not forgotten: to guide readers to their books.

Under the present conditions, the use of the libraries' scant resources to fulfill these essential social obligations diminishes the funds for buying new books and other materials. Of course, libraries have always been more than a place where readers come to read. The librarians of Alexandria no doubt collected things other than books: maps, art, and instruments, and the ancient readers probably came there not only to consult books but also to research, attend public lectures, converse with one another, teach, and learn. And yet the library remained principally a place where books, in all their various forms, were stored, as Plato reminded us, for consultation and preservation of ancient traditions or notions "gray with time." Other institutions fulfilled other complementary tasks necessary in a civilized society: hospitals, philanthropic associations, guilds.

If libraries are to be not only repositories of society's memory and emblems of its identity but also larger social centers where citizens are taught how to find their way in the mazes of bureaucracy and given temporary care and instruction and shelter, then changes must be made consciously by an intellectually strong institution that recognizes its exemplary role, and teaches us what books can do: they can show us our responsibilities toward one another, they can help us question our values and undermine our prejudices, they can lend us courage and ingenuity to continue to live together, and they can give us illuminating words that might allow us to imagine better times.

Unfortunately, time and time again, such wishful imaginings of what libraries should be, of powerfully envisioned places that offer us the possibility of becoming better and wiser, are ignored, ridiculed, or violently rejected even by those who should know better. In the past one hundred years, the ruins of the libraries of Warsaw, Nankai, Leuven, Dresden, Belgrade, Baghdad, Sarajevo, and hundreds of others stand as shameful examples of our refusal to embrace the notion of the library as a place of learning to be wiser and better human beings. A lesser-known example of our infamy is emblematic of our madness: when Israeli troops began occupying Palestinian territories in the forties, the soldiers looted private houses and public libraries, and requisitioned many of the books. Attempts by the exiled owners to recover their books from the Israeli authorities were met with silence or refusal, but functionaries at the National Library in Jerusalem acknowledged that many of the looted volumes can be found today on the National Library's shelves.

And yet, these qualities of a library, however wishful, however impossible to achieve, are necessary, even vital, and justify or demand that libraries should be preserved, multiplied, respected, and helped to grow. The universe is chaotic, the injustice and misery of this world are almost impossible at times to bear, and no amount of books will remedy a single instant of deliberately inflicted suffering. However, libraries—these assemblies of books that since the days of Alexandria we house against the dilapidations of time—may help us remember who we are, and where we are, and the many things we did wrong, and the few things we got right. "Collecting: to assert control over what's unbearable," wrote the English poet Ruth Padel. Perhaps this is the ultimate meaning of a library, and also its modest justification.

Buenos Aires, September 24, 2016

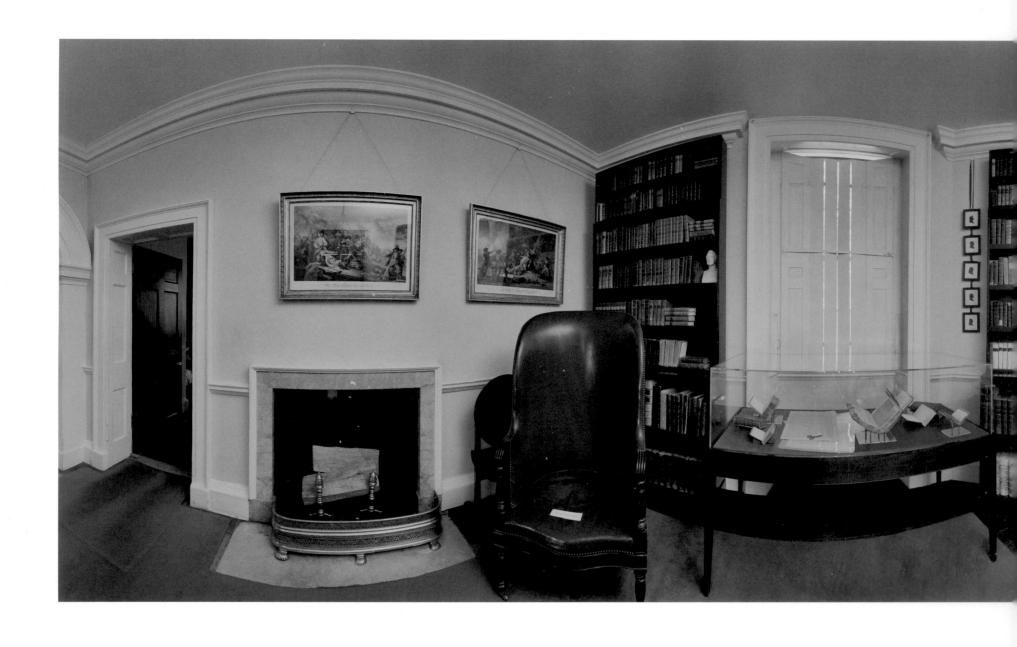

Monticello, Charlottesville, Virginia
Thomas Jefferson's library is housed at Monticello, his architectural "autobiographical masterpiece," which he spent forty years redesigning and renovating. The library held Jefferson's personal collection of more than six thousand volumes. While the originals were sold to Congress in 1815, the shelves still offer most of the same titles. The tall red easy chair is one of the unique pieces of furniture in the library; legend has it that Jefferson used it while he was vice president.

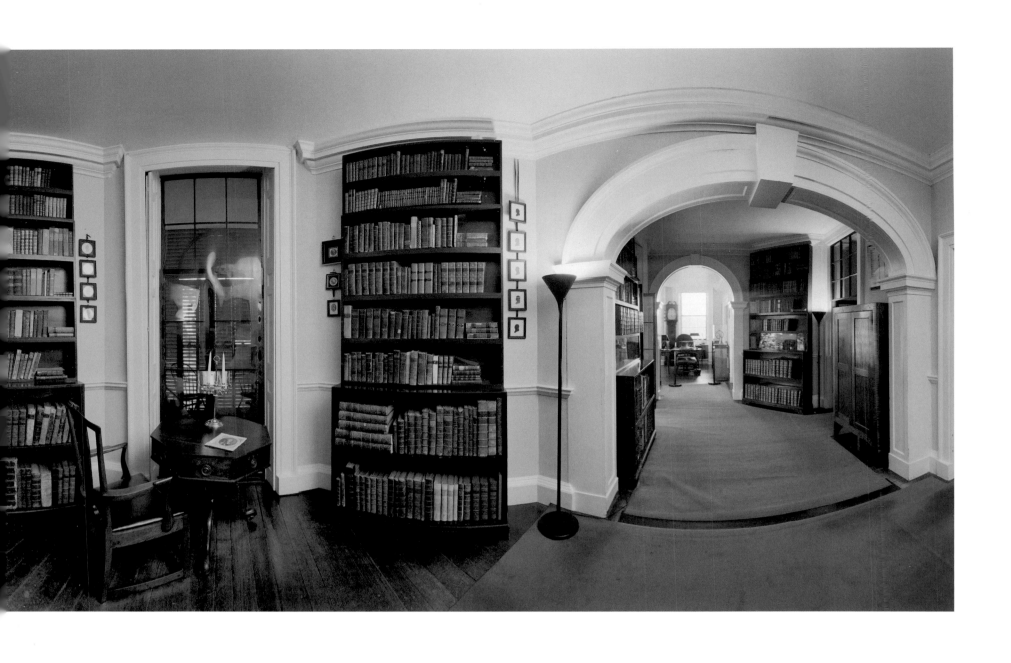

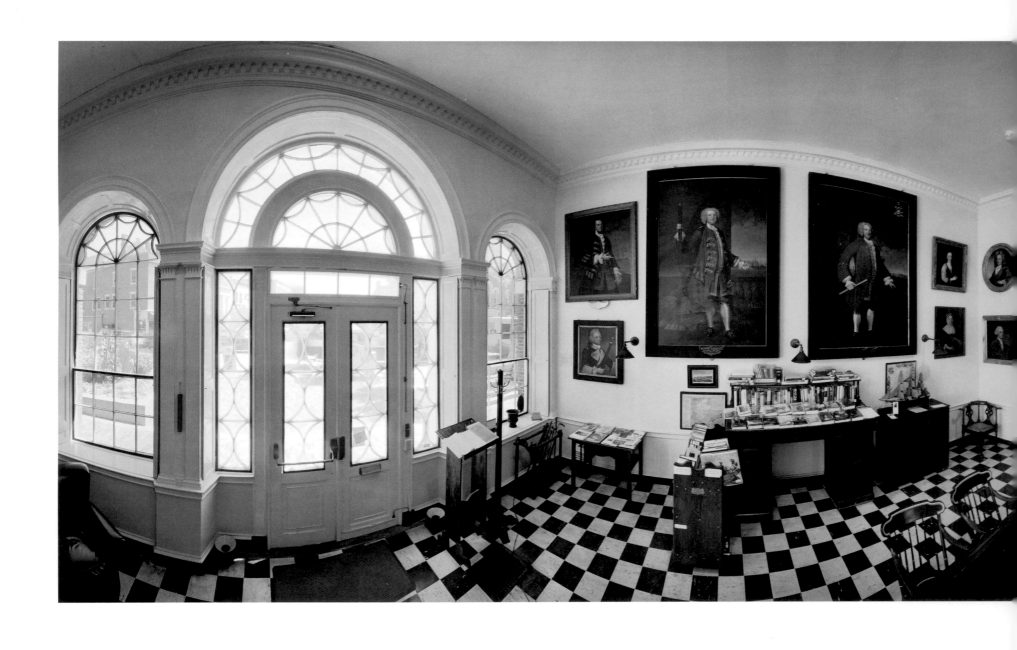

Portsmouth Athenaeum, New Hampshire
The Portsmouth Athenaeum is a nonprofit membership library and museum, one of the few membership libraries left in the United States. Its building first housed an insurance company as well as St. John's No. 1 Masonic Lodge. In its early years, the Athenaeum also included a botanical and mineral museum, boasting curiosities from around the world, though the contemporary museum features art and nautical artifacts such as portraits of ship captains and naval officers, model ships, and the gilt figurehead from the schooner *Alcea*.

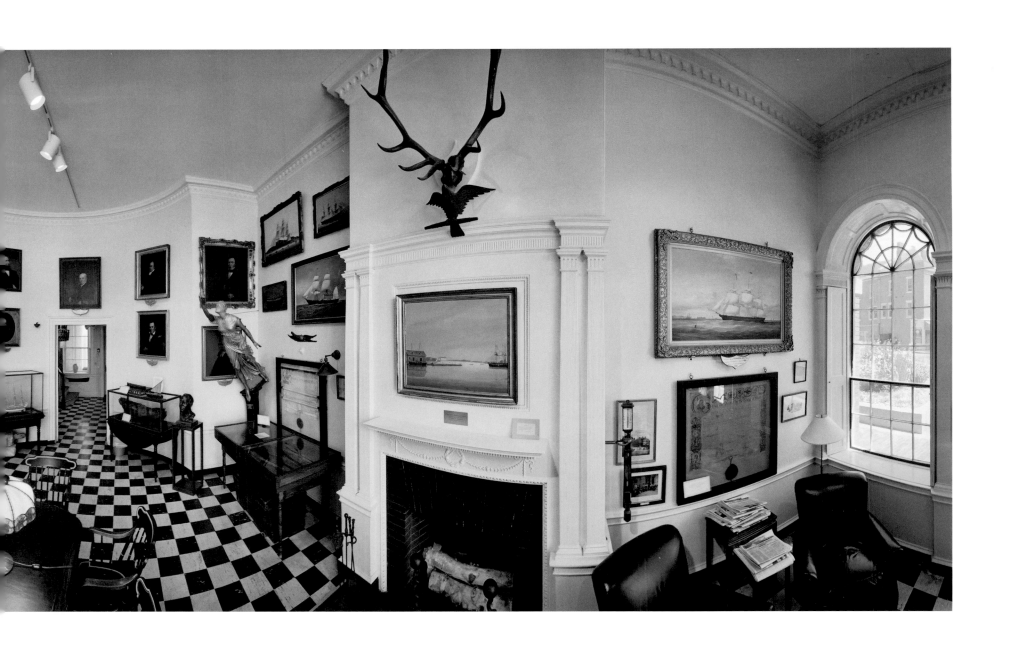

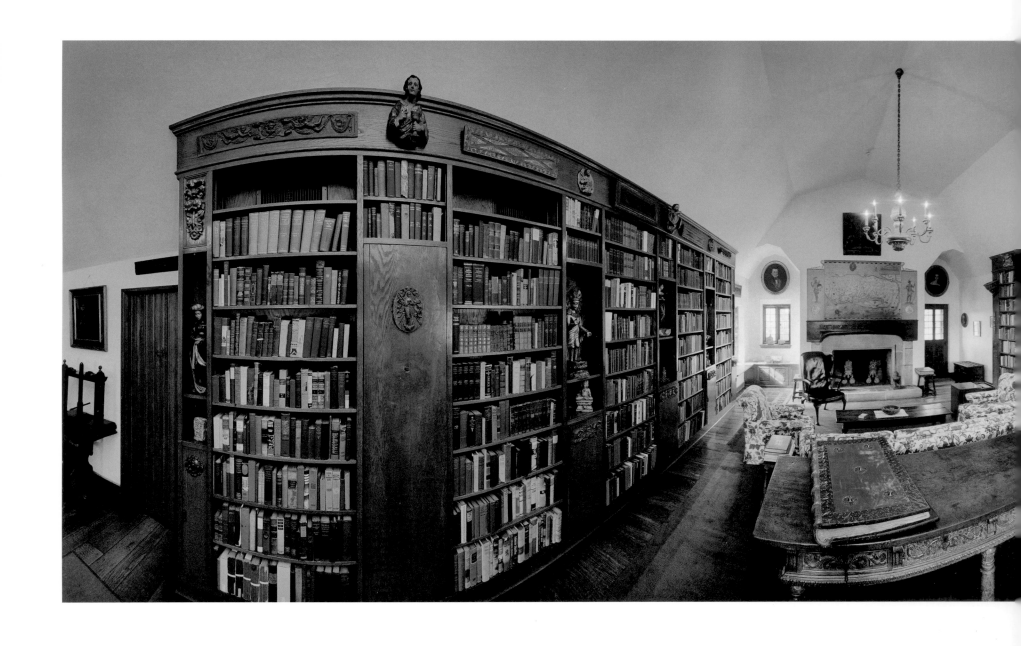

Virginia House Library, Richmond
The library at the Virginia Historical Society is open to members and offers a broad noncirculating collection of books and documents related to Virginia's history and culture, including county, military service, church, and tax records, as well as maps, rare books, Confederate imprints, and sheet music. The library and the historical society are situated within the Virginia House, a former English manor completed in 1929, whose display of antiques, draperies, Oriental rugs, and fine china bear witness to its original owners' taste.

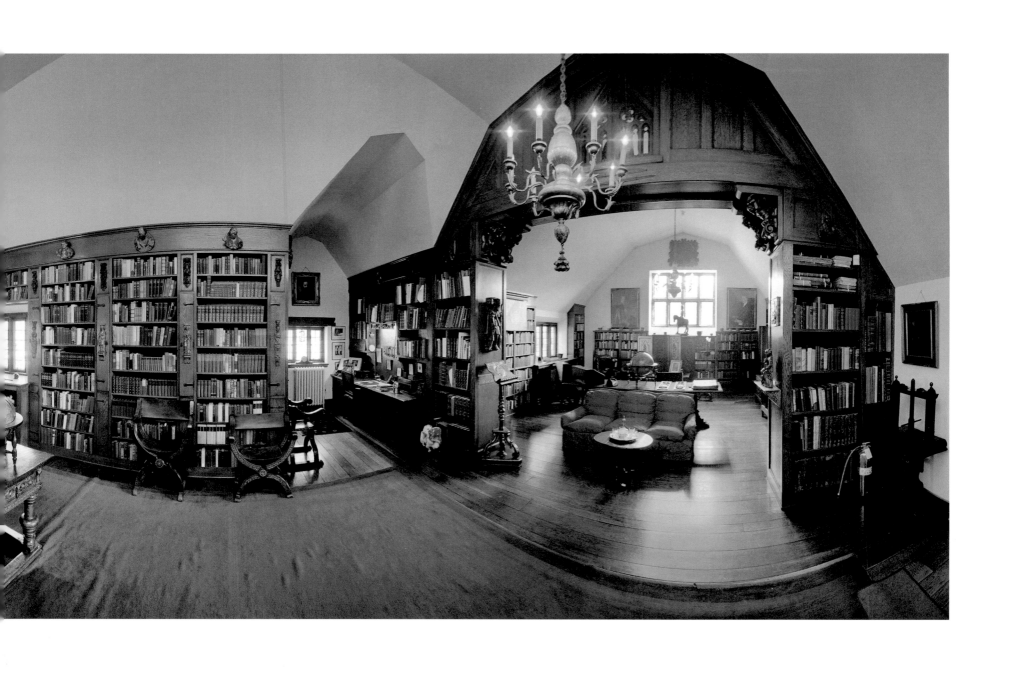

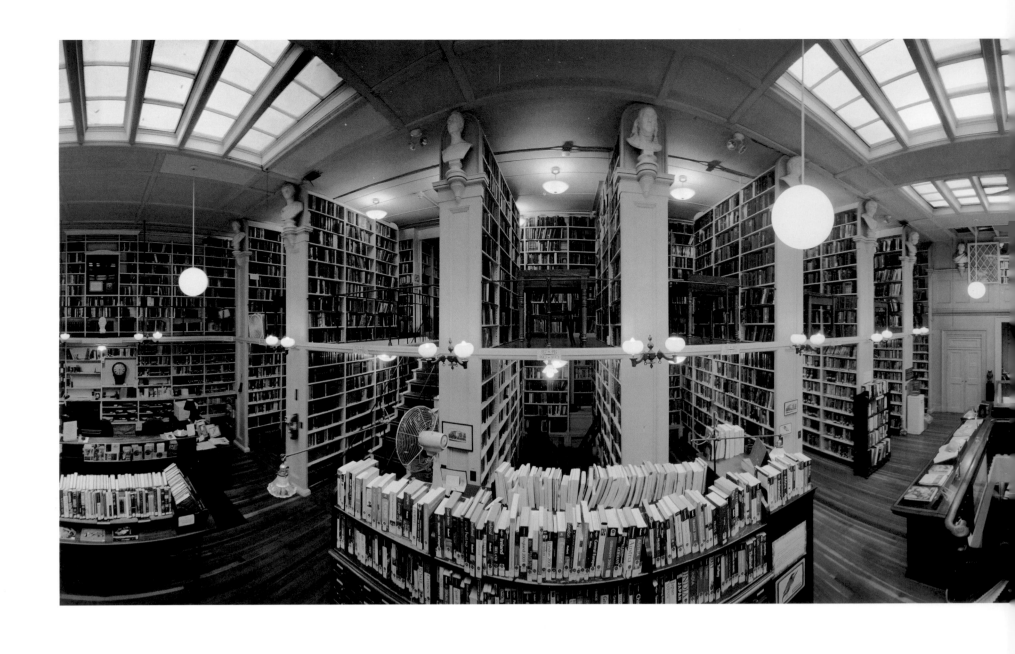

Providence Athenaeum, Rhode Island
The independent, member-supported Providence Athenaeum is a library and cultural center founded in 1836. Whereas only members benefit from borrowing privileges, the library buildings and most programs are free and open to the public. During its almost two-hundred-year history, the Athenaeum has collected notable works such as *Description de l'Égypte,* an oversize, illustrated set of twenty-three volumes on Napoleon's journey to Egypt in the late 1790s. Among its illustrious patrons are the writer Charlotte Perkins Gilman and Secretary of State John Hay.

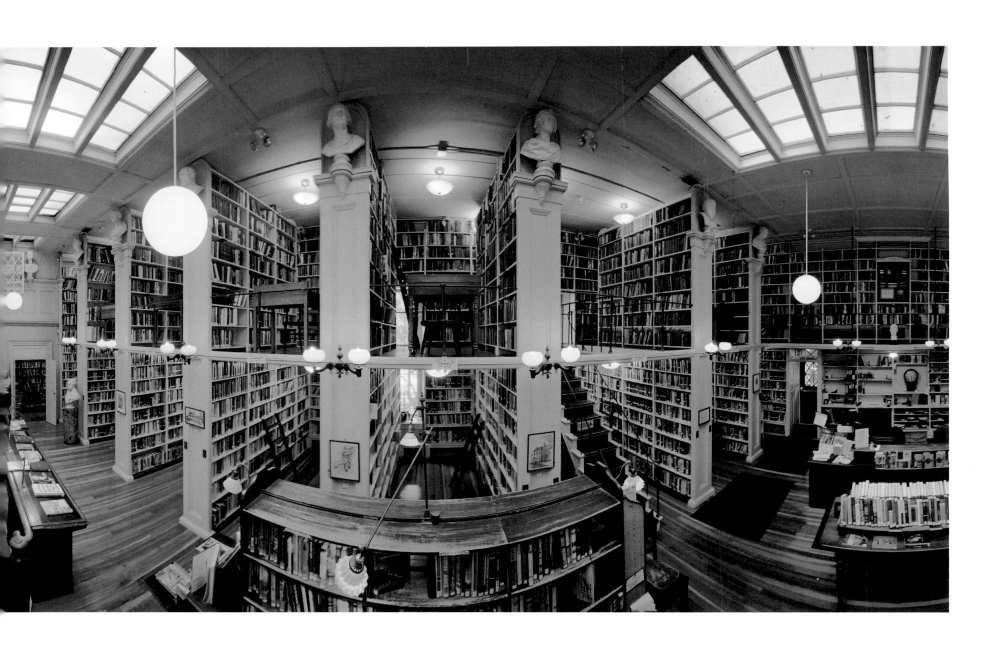

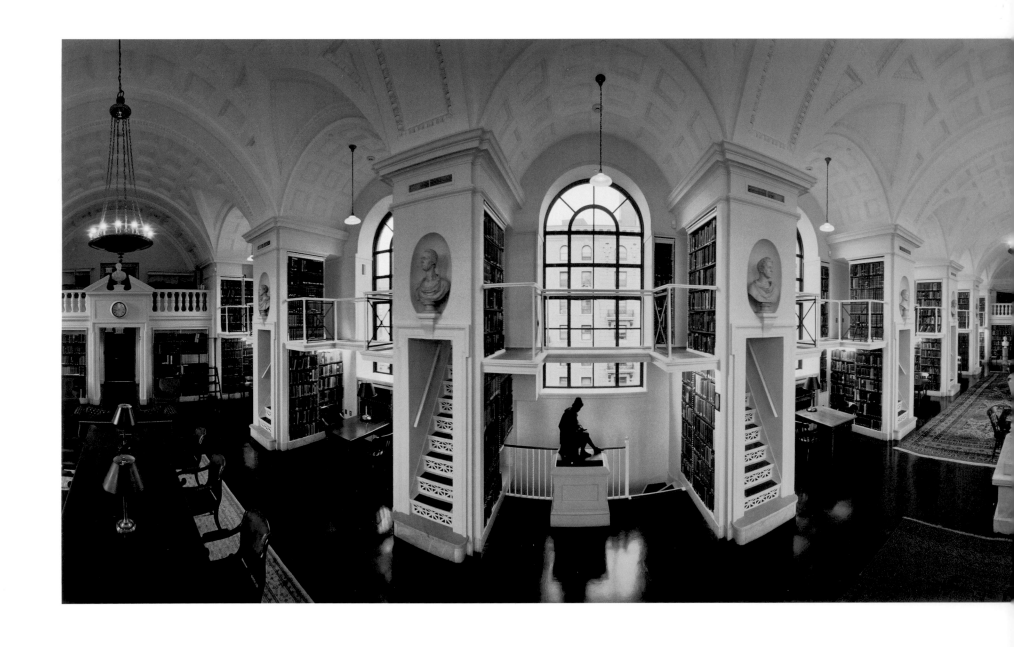

Boston Athenaeum

Before it had become one of the largest libraries in the United States in 1851, the Boston Athenaeum was founded in 1807 through the Anthology Society, which published a monthly magazine. Currently home to over half a million volumes, the Athenaeum has also served as a gallery for European and American art since 1827. After multiple relocations, the library's current home on Beacon Street, designed by Edward Clarke Cabot and renovated by Henry Forbes Bigelow, was named a National Historic Landmark in 1966.

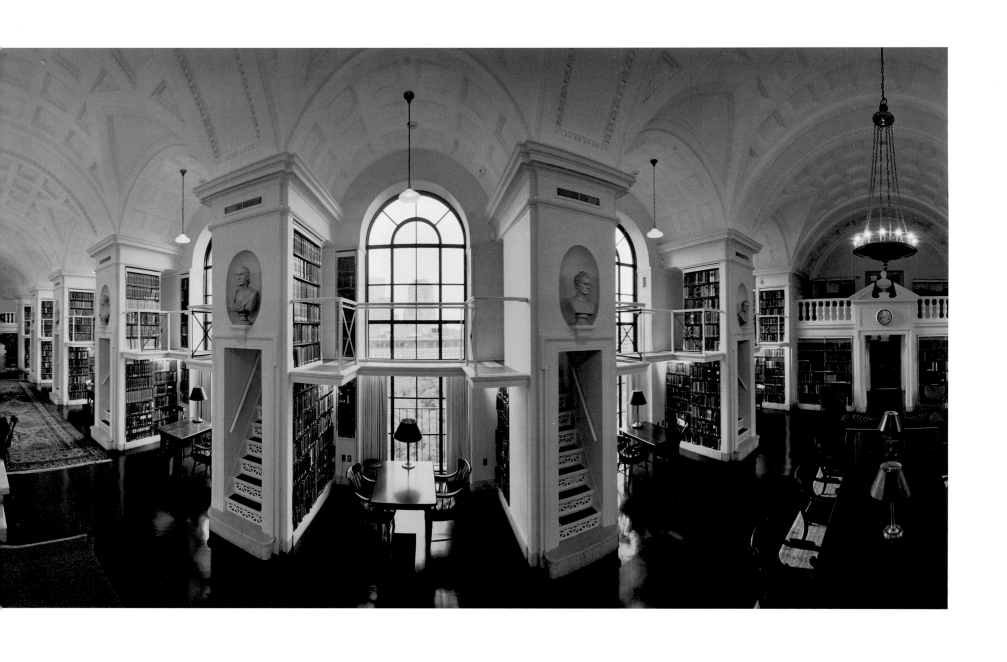

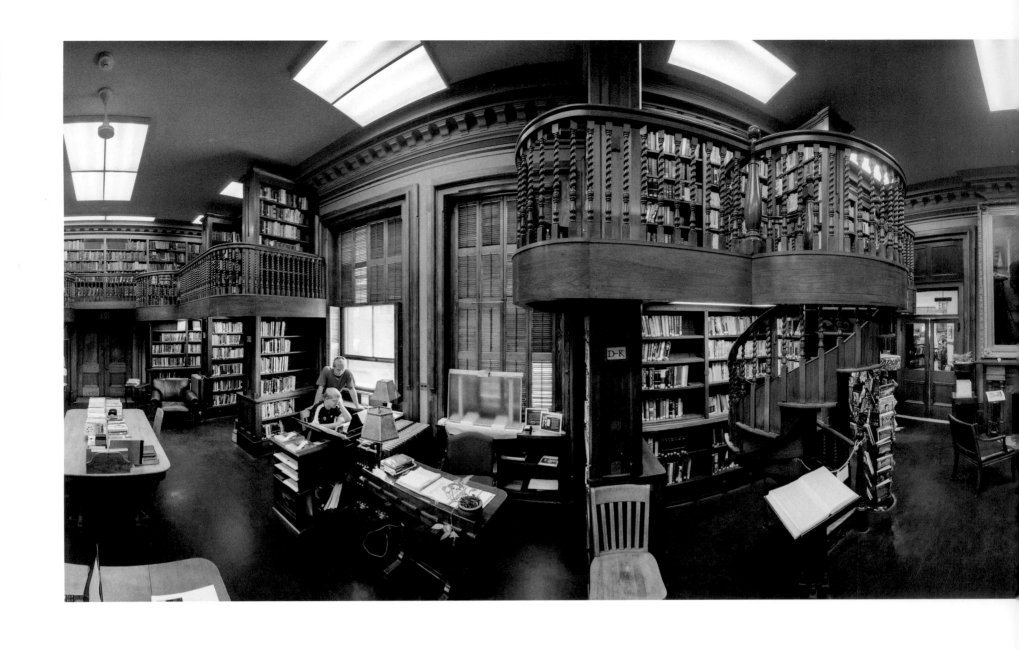

St. Johnsbury Athenaeum Fiction Room, Vermont
The Athenaeum was created in 1871 by Horace Fairbanks, an avid collector of Hudson River School paintings. His collection, particularly Alfred Bierstadt's enormous *Domes of the Yosemite* painting, determined the layout of the galleries inside the Athenaeum, whose design was conceived in the French Second Empire style by New York architect John Davis Hatch III. *Time* identified it in 1965 as the country's "oldest unaltered art gallery still standing," and the collection has continuously expanded since. While technically a private corporation, the Athenaeum serves as the town's public library.

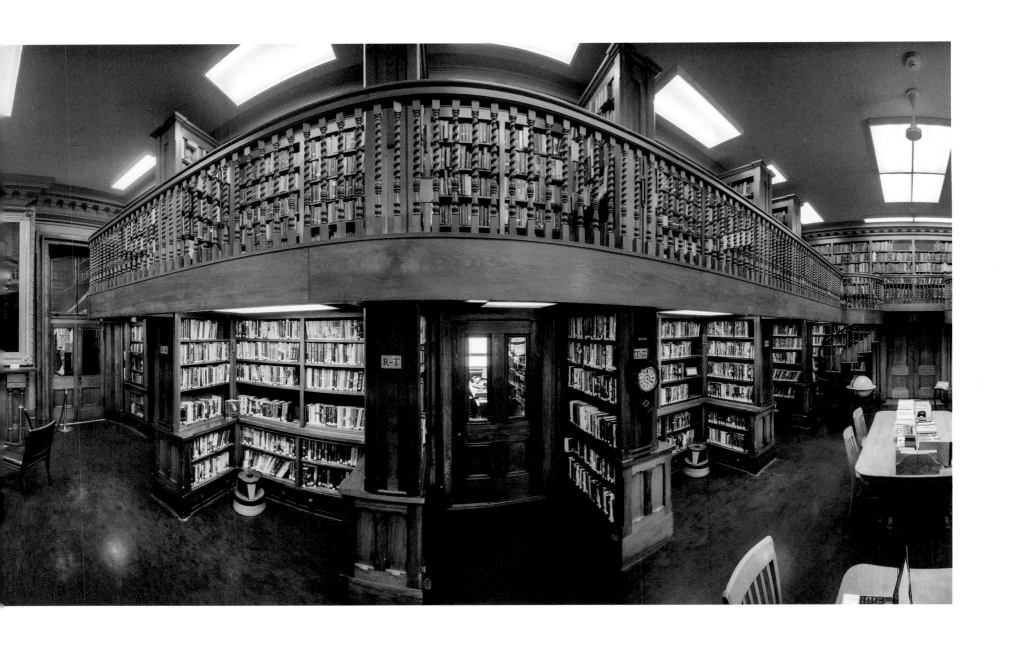

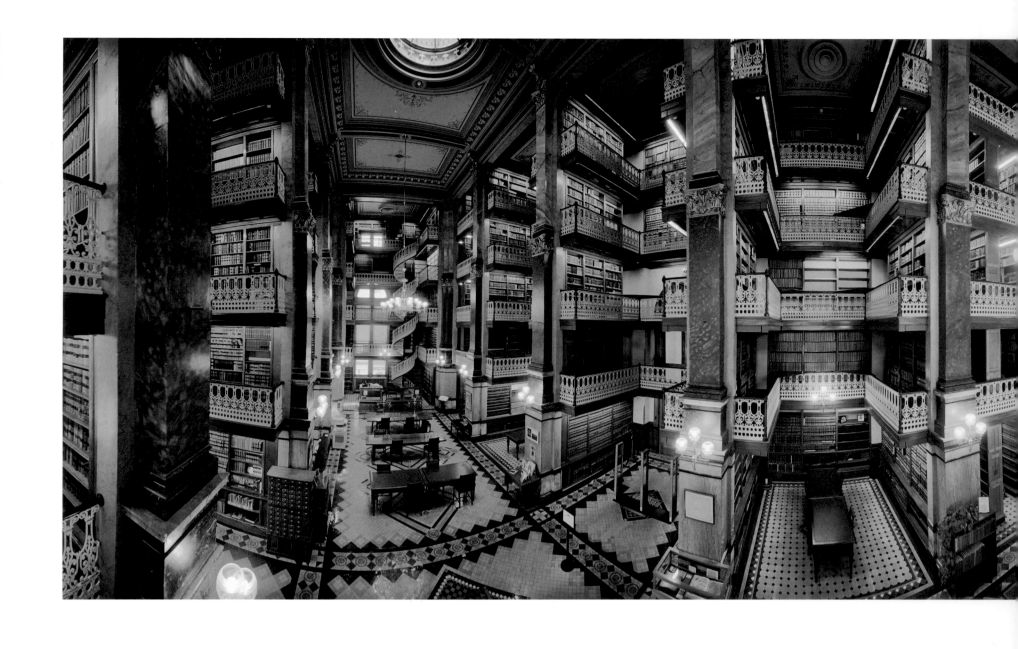

State Library of Iowa Law Library, Des Moines
Among its thousands of holdings, the State Library of Iowa's Law Library includes specialized collections of state and federal law; legal periodicals; and treatises, abstracts, and arguments related to cases tried in the Iowa Supreme Court. Housed in the Des Moines capitol building, the library is well-known for its stunning interior architecture: its two fairy-tale winding staircases on its north and south ends, beautiful ash and chestnut finishing, marble wainscoting, and encaustic tile floor draw thousands of visitors year round.

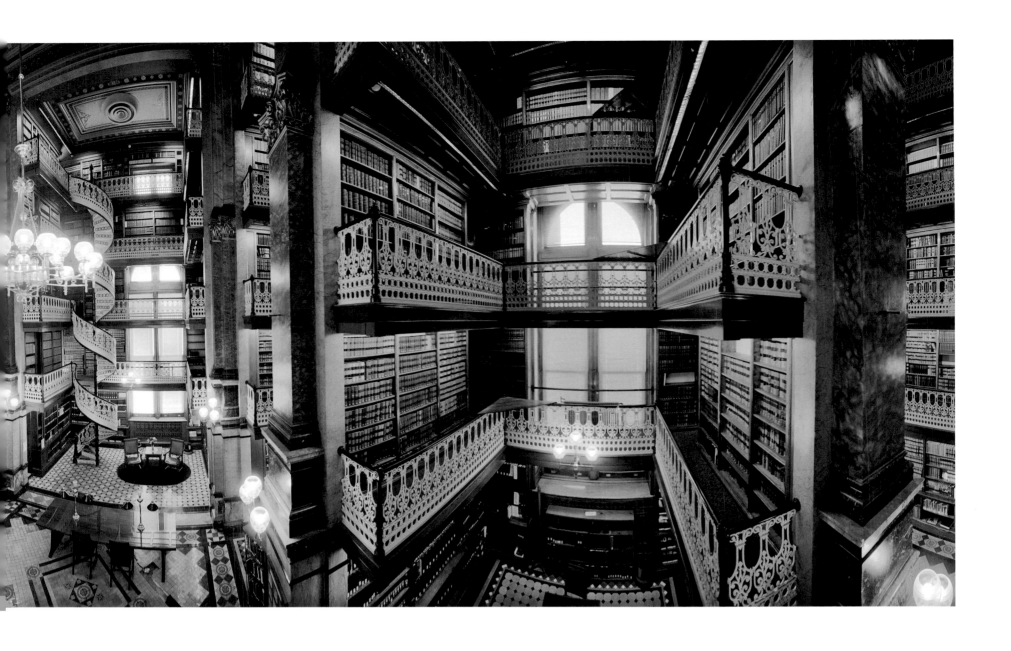

Following pages
Redwood Library and Athenaeum, Newport, Rhode Island
The Redwood Library is the oldest lending library in the United States and
the oldest library structure still in use. Since 1747, it has been a membership
library, open to the public and sustained by paying subscribers. During the
Revolutionary War, the building was occupied by British officers, and more
than half the library's books disappeared. In 1806, the library began advocating
for the return of the missing volumes, and then a concerted effort began in
1947; remarkably, nearly 90 percent of the lost tomes have been recovered.

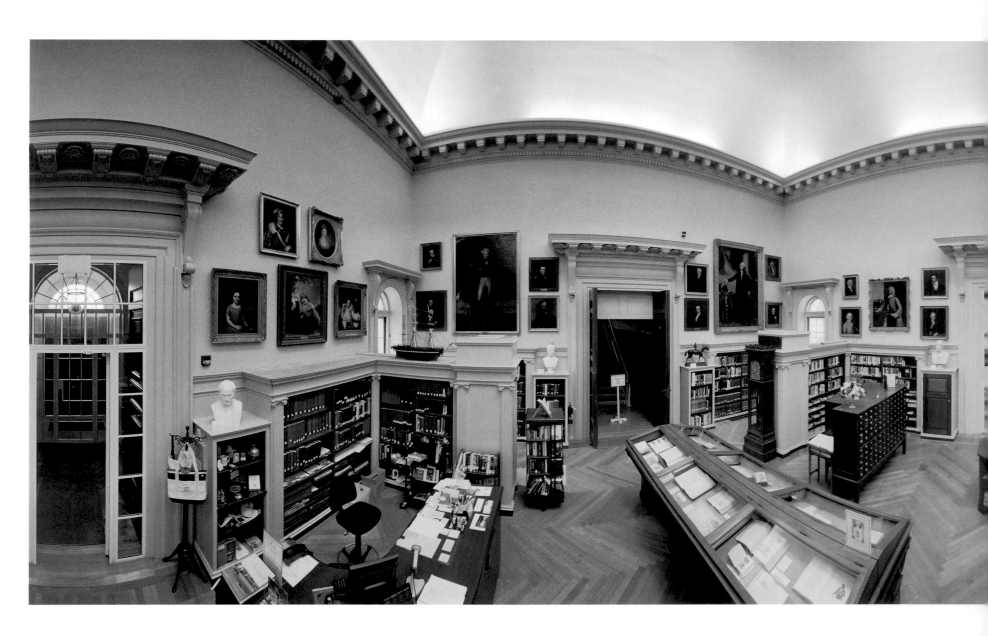

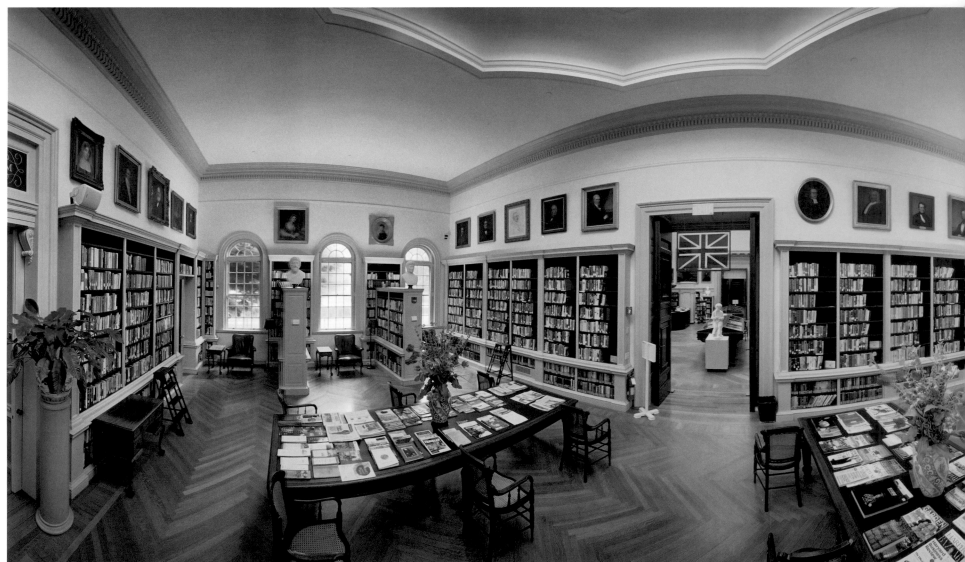

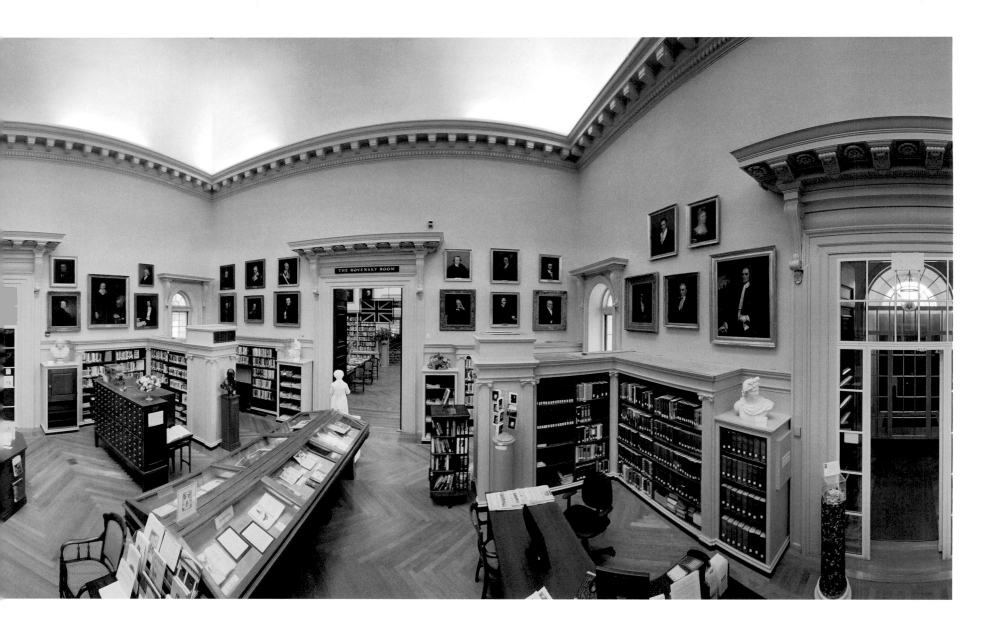

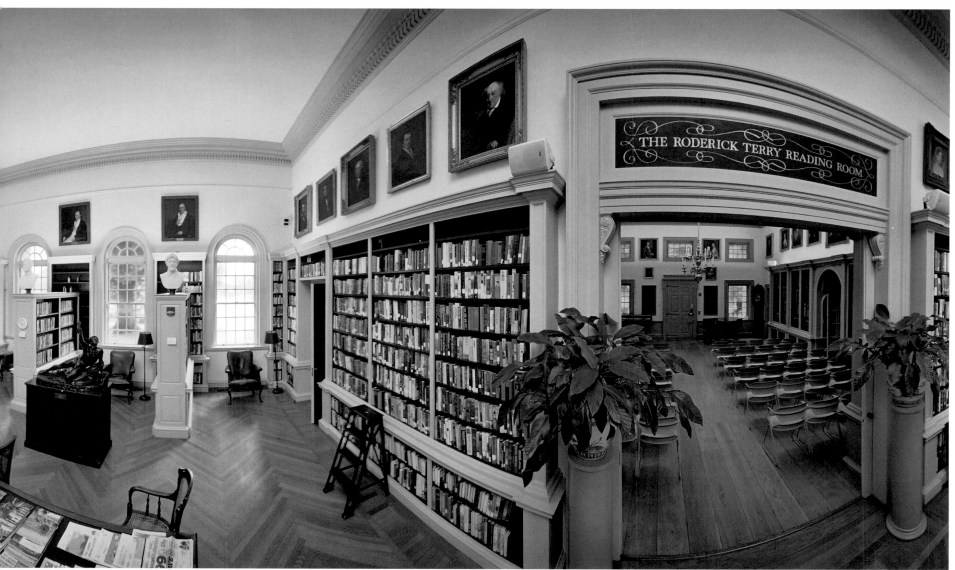

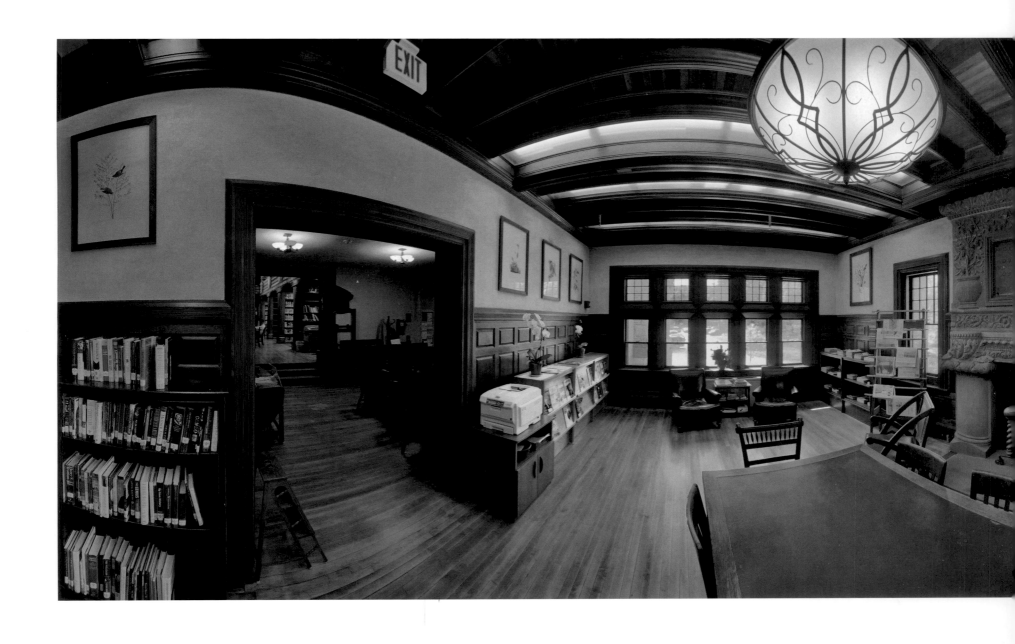

Ames Free Library, Easton, Massachusetts
The Ames Free Library was designed by prolific architect Henry Hobson
Richardson, also responsible for the library in nearby Quincy. Because of the
building's renown, the library draws not only local patrons but also students
of architecture from around the world. They come to admire Richardson's
characteristic low doorway arch, used for the first time in this building, as
well as the carvings and gargoyles on its exterior, the detailed woodwork
inside, and the unconventional barrel-vaulted ceiling above the book stacks.

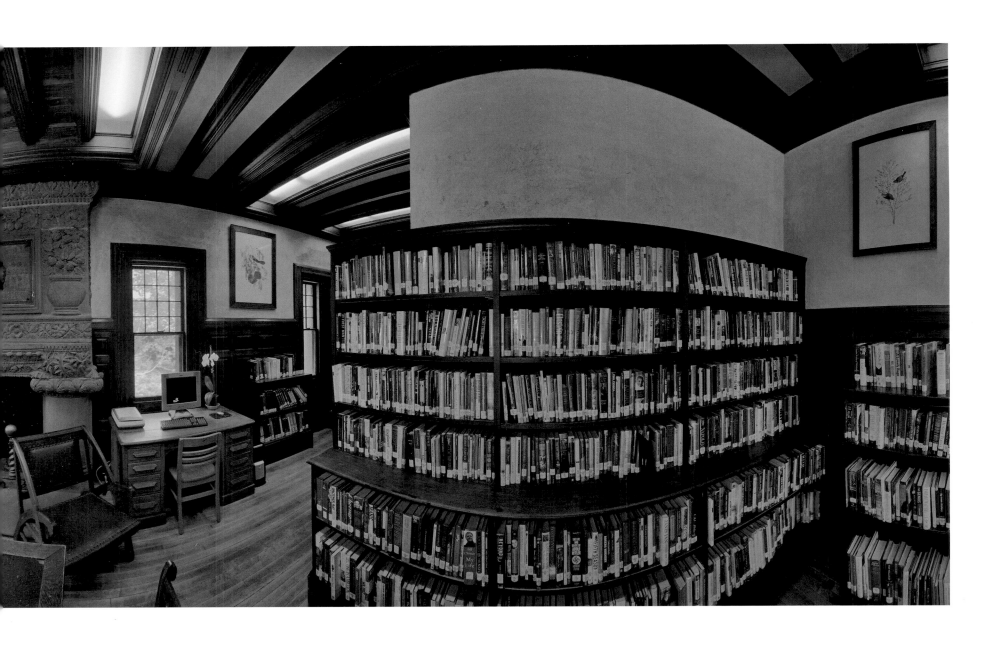

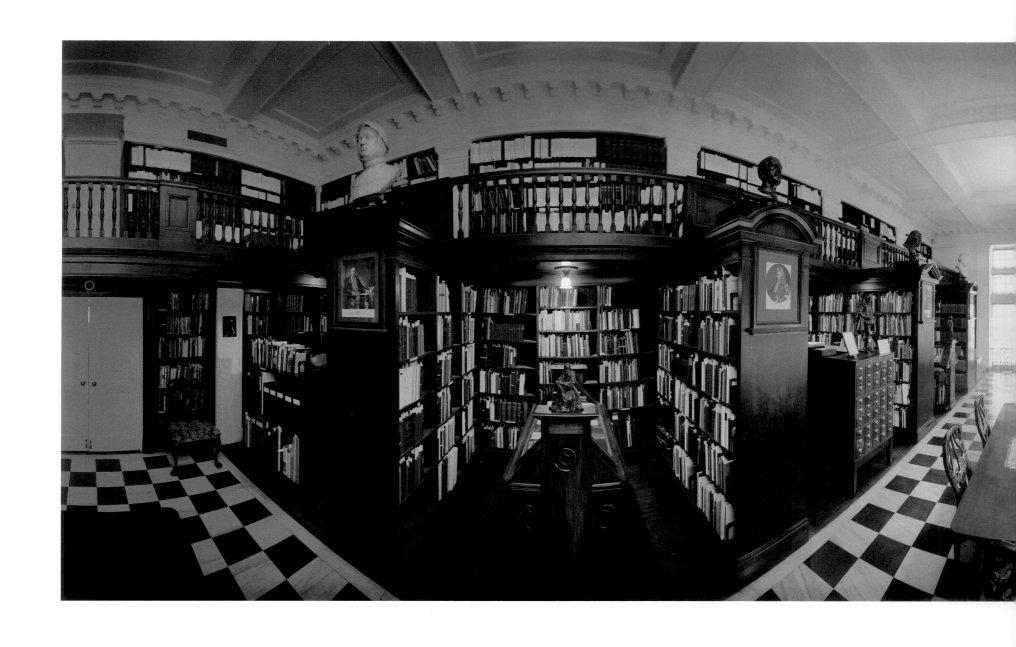

Grolier Club Library, New York
The Grolier Club Library is a cooperative reference library and an essential part of the Grolier Club, a membership organization founded in New York in 1884, dedicated to the art of books. The library's extensive collection centers on the history of book publishing, printing, and the book trade. In fact, the library's biggest draw for scholars is its sixty-thousand-volume collection of book dealer and book auction catalogues spanning "every major European and American antiquarian dealer and auction house," including rare volumes dating to the seventeenth century.

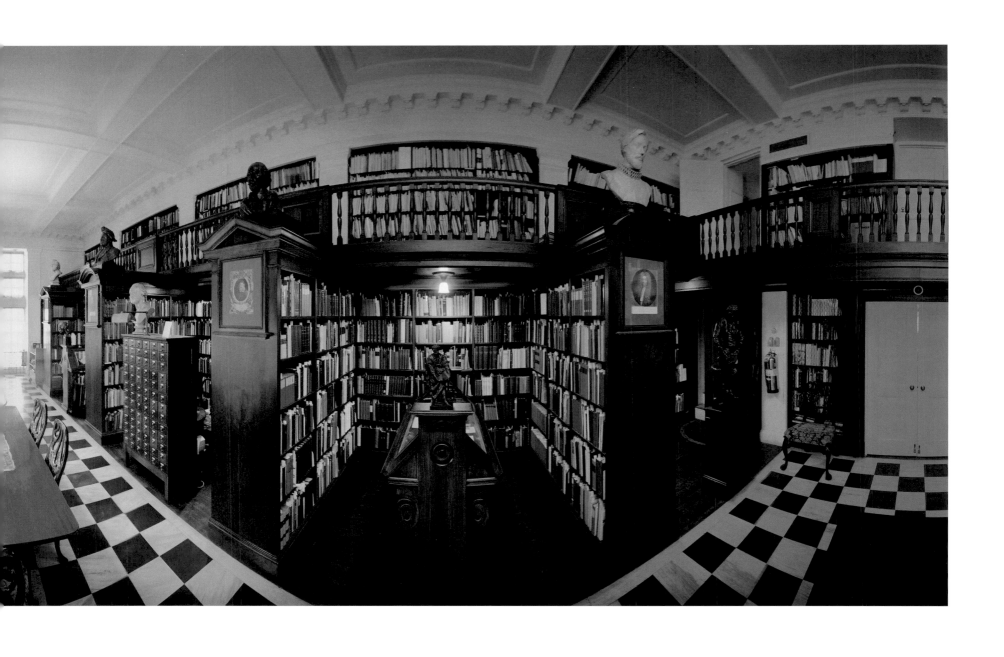

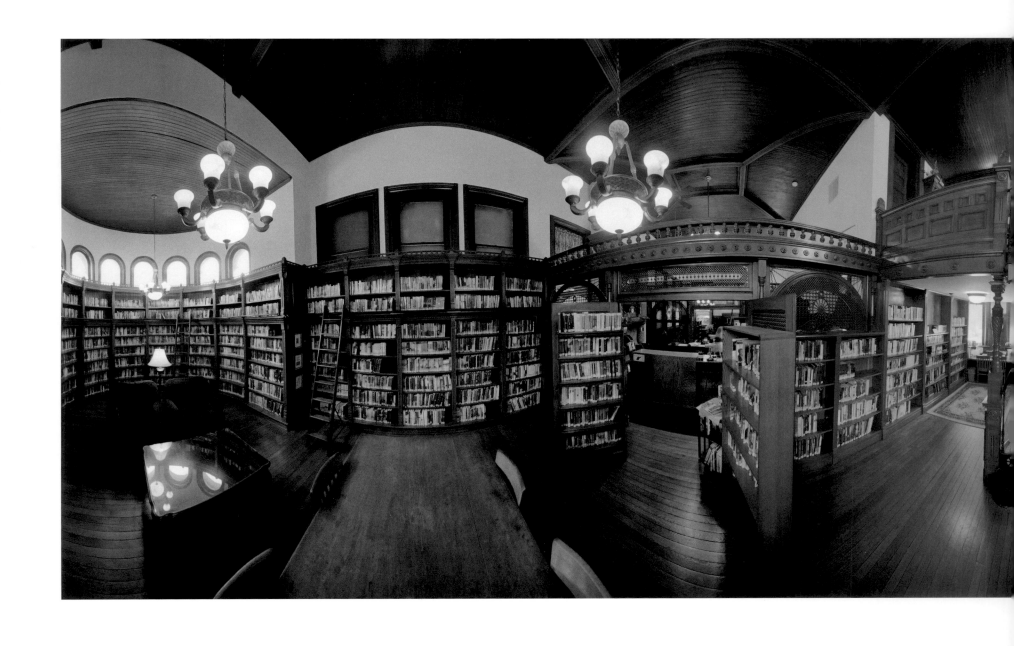

Amelia Givin Library, Mount Holly Springs, Pennsylvania
When the Amelia Givin Library was inaugurated in 1890, it was the first free library open to the public in Cumberland County, Pennsylvania. Commissioned in the Richardsonian Romanesque style by its patron Amelia Steele Givin, the eponymous library is known for its intricate interior woodwork. Known as Moorish fretwork, this style of wooden lattice screens is inspired by Victorian ornamentation and lends the library an exotic, mysterious ambience. In 2004, the National Register of Historic Places added the library to its registry.

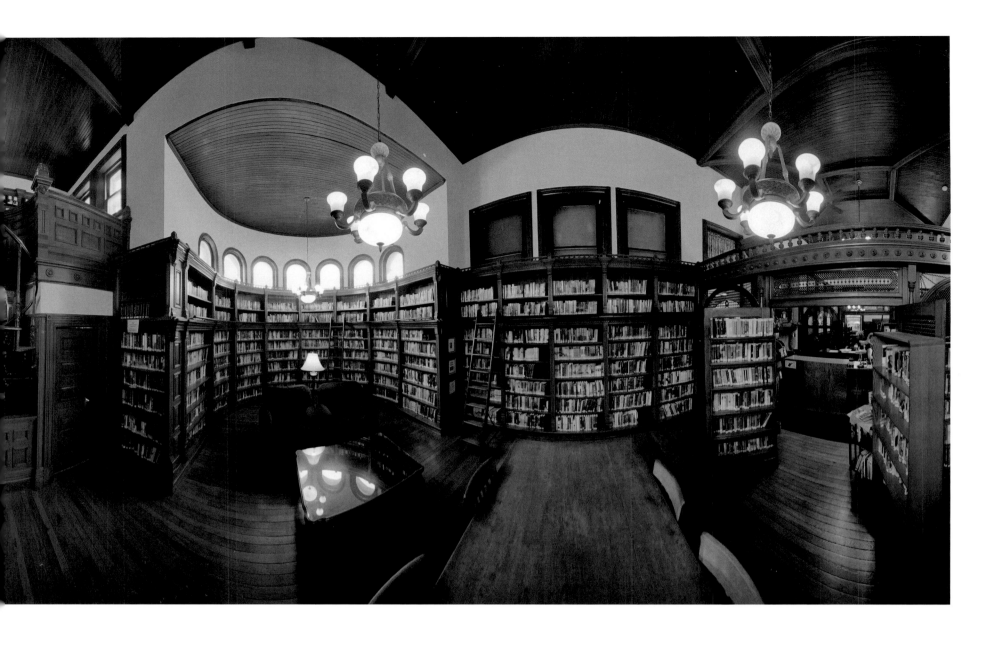

Following pages
Century Association Clubhouse, New York
The Century Association is a private club that evolved out of two private men's clubs in New York in the nineteenth century: the Sketch club, which promoted interest in the fine arts and literature, and the Column Club, a Columbia University alumni association. Its early members included Winslow Homer and Asher Durand; the club began admitting women only in 1989 following a court order. Today, its members include two thousand writers, artists, and amateurs whose "main activity is conversation."

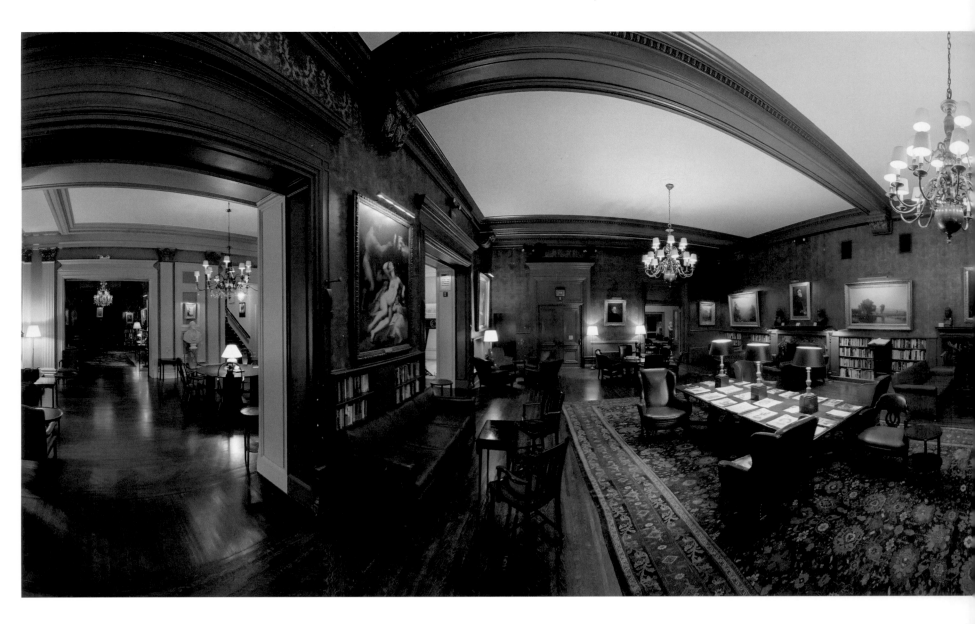

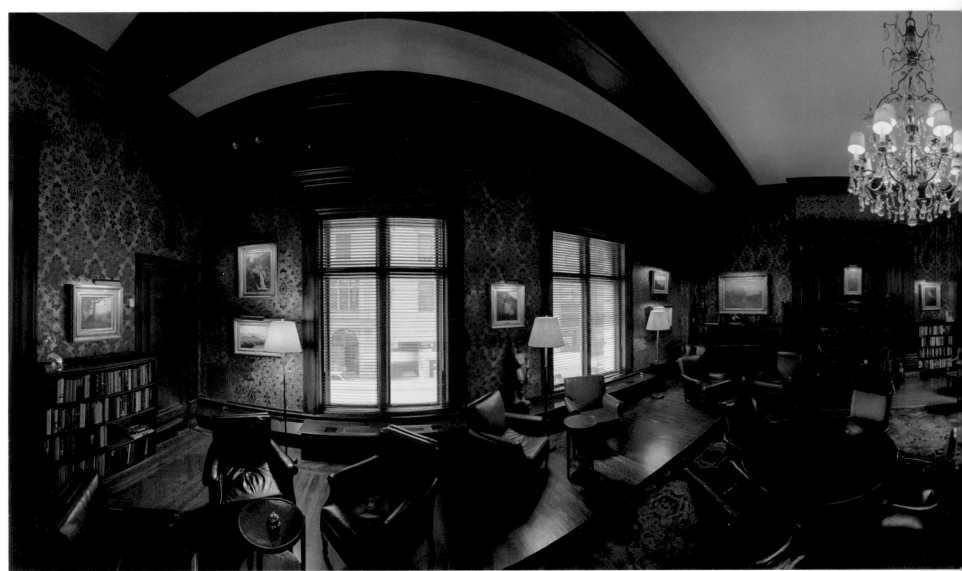

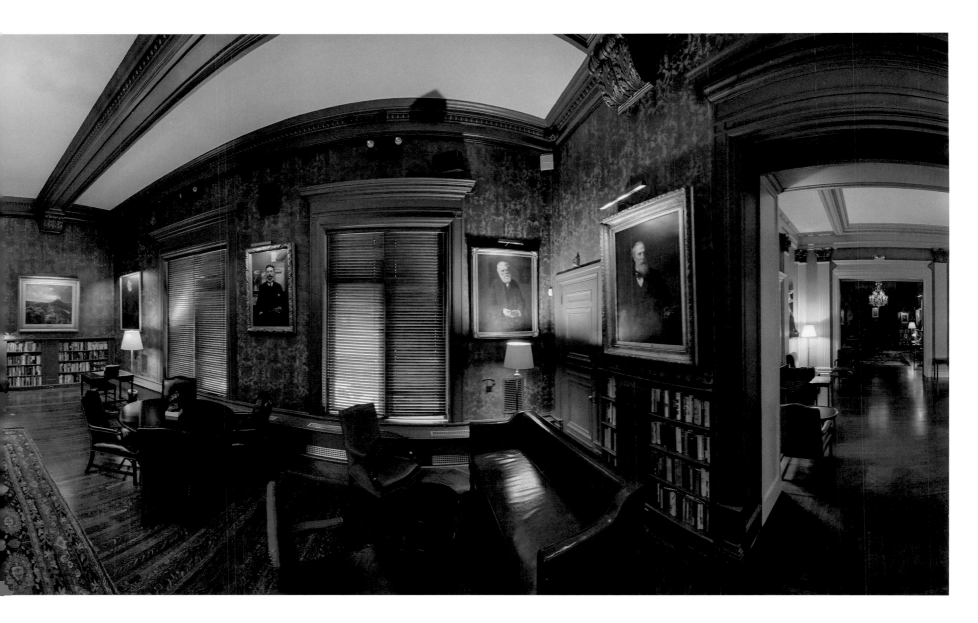

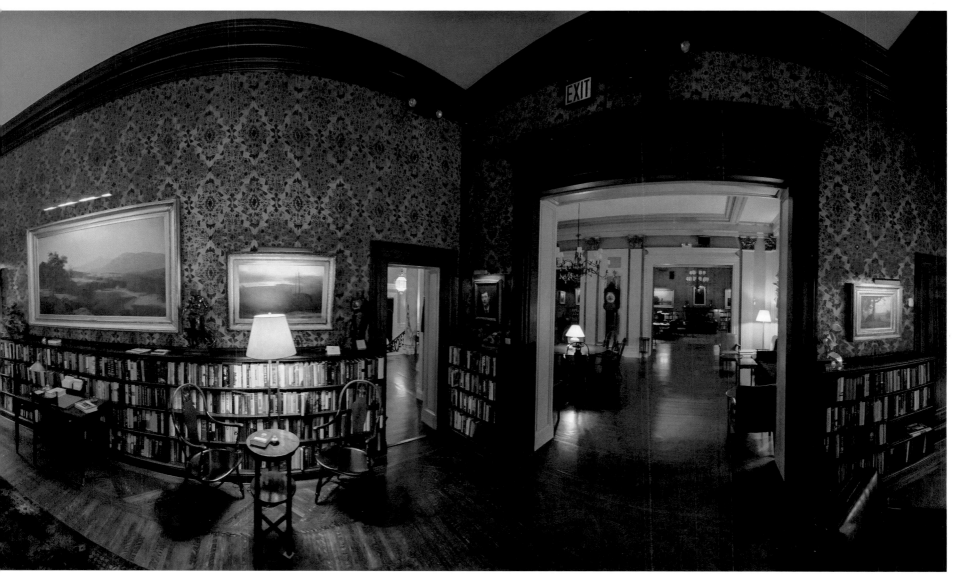

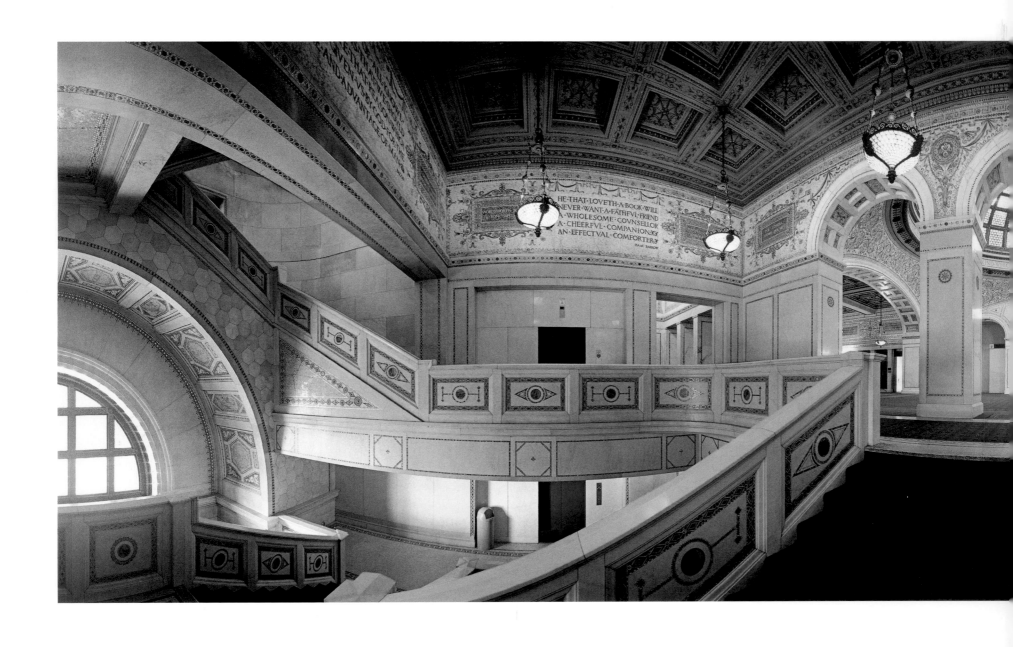

Chicago Cultural Center

The Chicago Cultural Center was built using sumptuous materials such as fine marbles, hardwoods, and mosaics. Completed in 1897, the library is famous for its two elegant stained-glass domes: one is the world's largest Tiffany dome, made of thirty thousand individual pieces of glass; the other, designed by Healy and Millet, includes fifty thousand glass pieces arranged in an intricate Renaissance pattern. In 1977, the library was converted into an arts and culture center, and remains one of Chicago's most popular attractions.

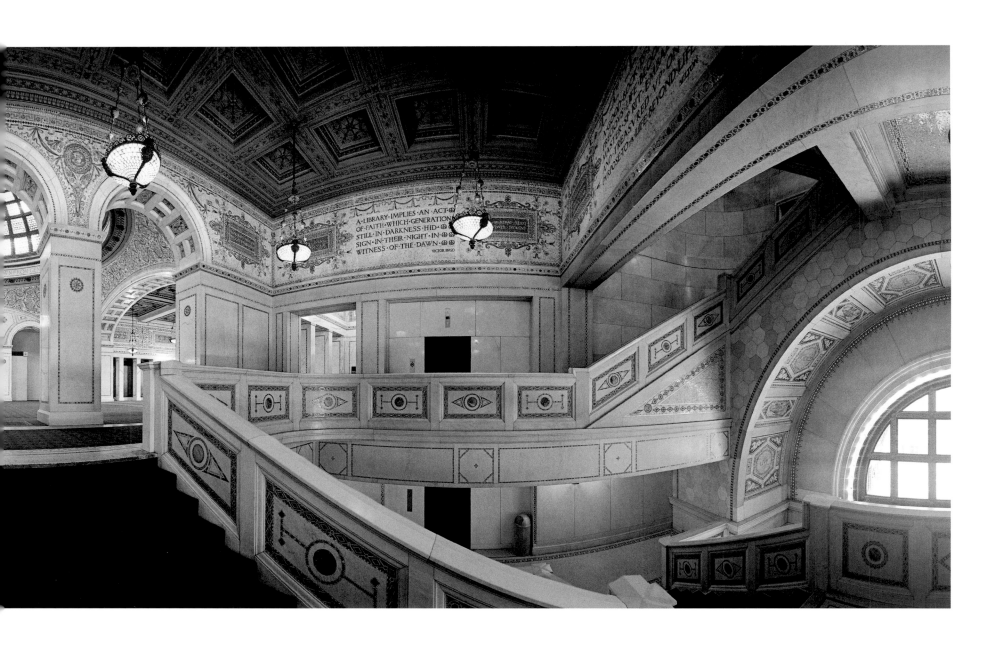

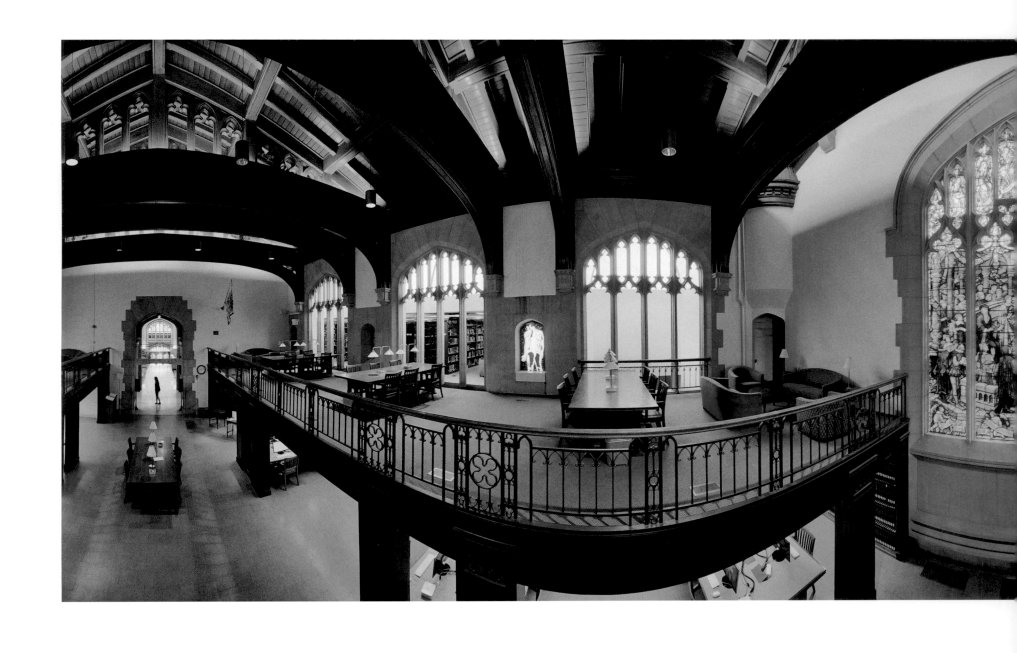

Frederick Ferris Thompson Memorial Library, Vassar College, Poughkeepsie, New York
The Thompson Memorial Library at Vassar College grew from a single room at the university's founding in 1865 to a remarkable building housing over one million volumes, plus thousands of serial, periodical, and newspaper titles. A stained-glass window in the west wing depicts Elena Lucrezia Cornaro Piscopia, a young Venetian who was denied a doctor-of-theology degree for being a woman but later obtained a doctorate in philosophy from the University of Padua in 1678—the first woman believed to have obtained a PhD in Europe.

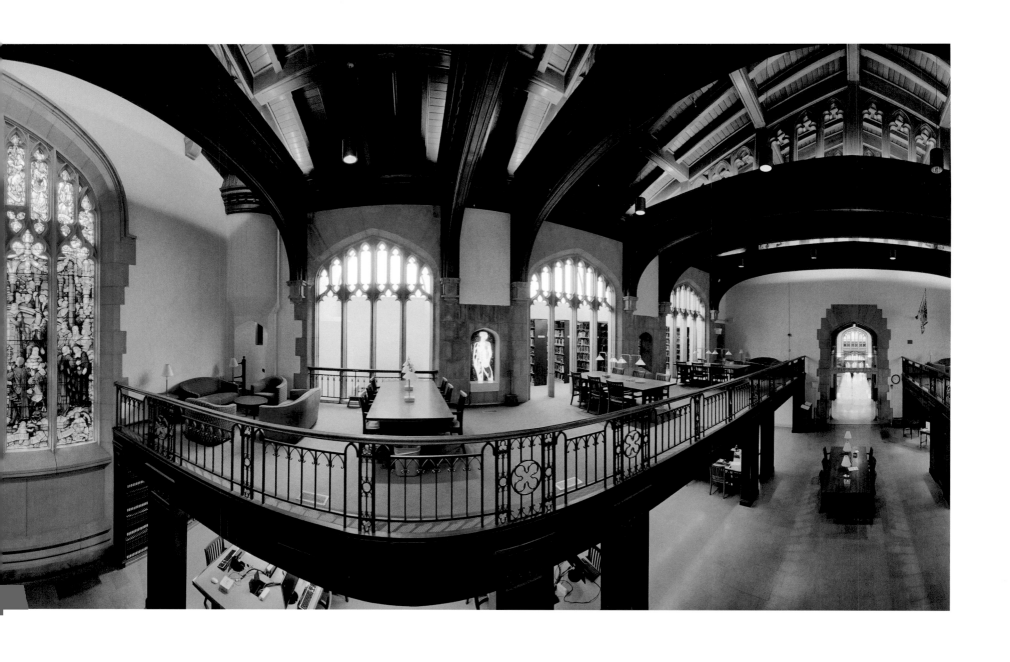

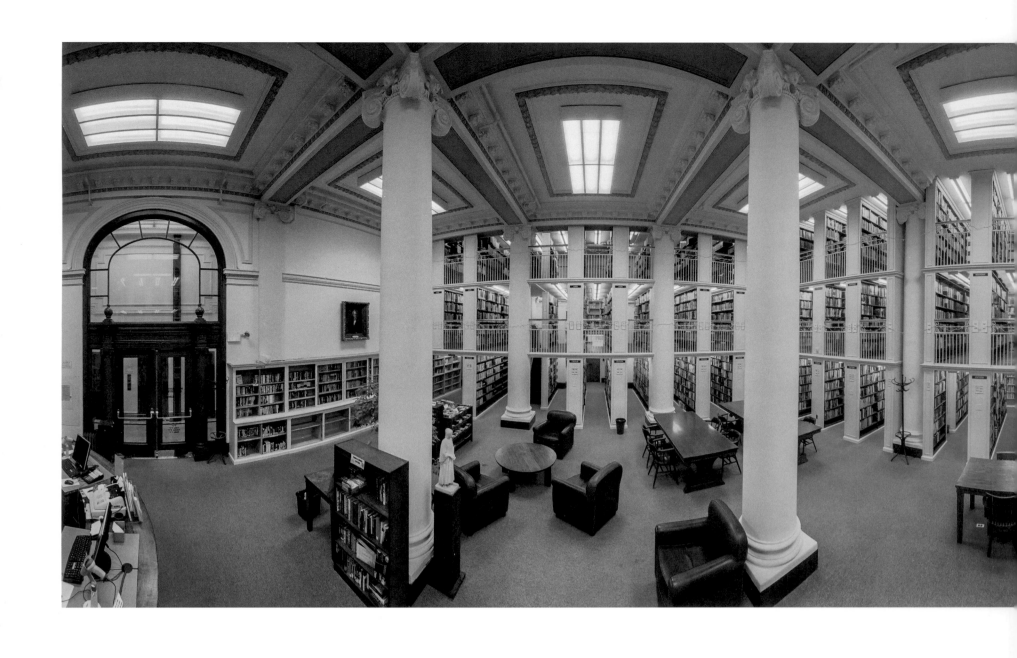

Mechanics' Institute Library and Chess Room, San Francisco
The chess room at the Mechanics' Institute, founded in 1854, is the oldest chess club in continuous operation in the United States, hosting renowned chess champion visitors and nurturing would-be titleholders, such as Sam Shankland and Daniel Naroditsky, who competed in the 2015 World Chess Team Championship. Like the Mechanics' Institute as a whole, the library is no longer focused solely on mechanical arts but supports the organization's mission of promoting the intellectual growth of its members through its general-interest book collection and discussion and writers' groups.

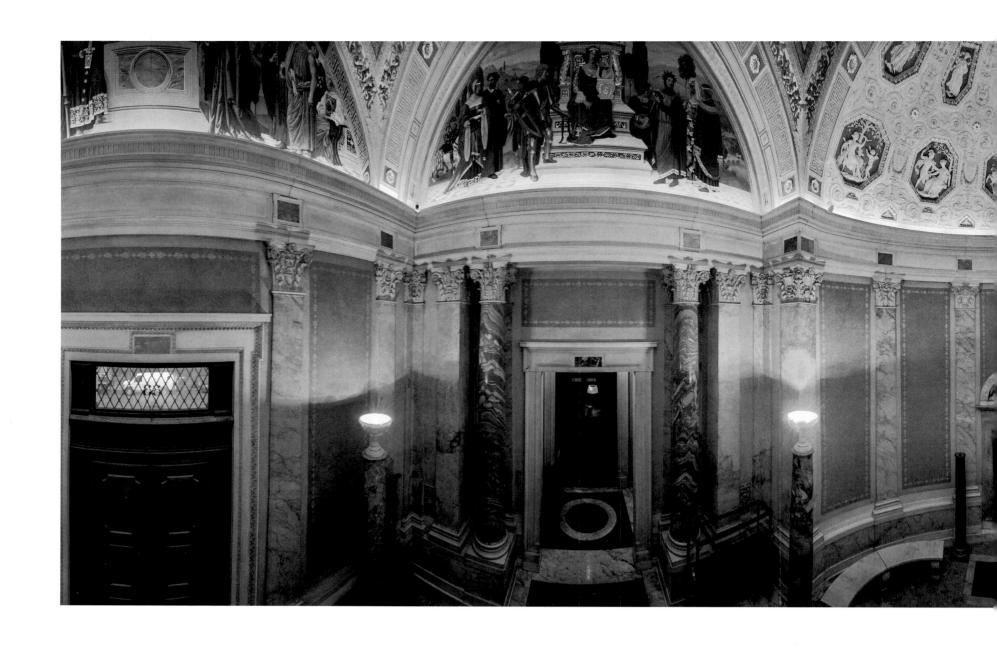

Above and gatefold
Morgan Library and Museum, New York
The Morgan Library features one of the world's most prestigious compendiums of rare books, manuscripts, music, and art, the collection of the financier—and voracious collector—Pierpont Morgan. Conceived as a majestic Renaissance-style palazzo that mirrored America's Age of Elegance, it was built between 1902 and 1906, and is considered the masterpiece of its architect, Charles McKim. More than a library, the Morgan is one of the great museums of New York City.

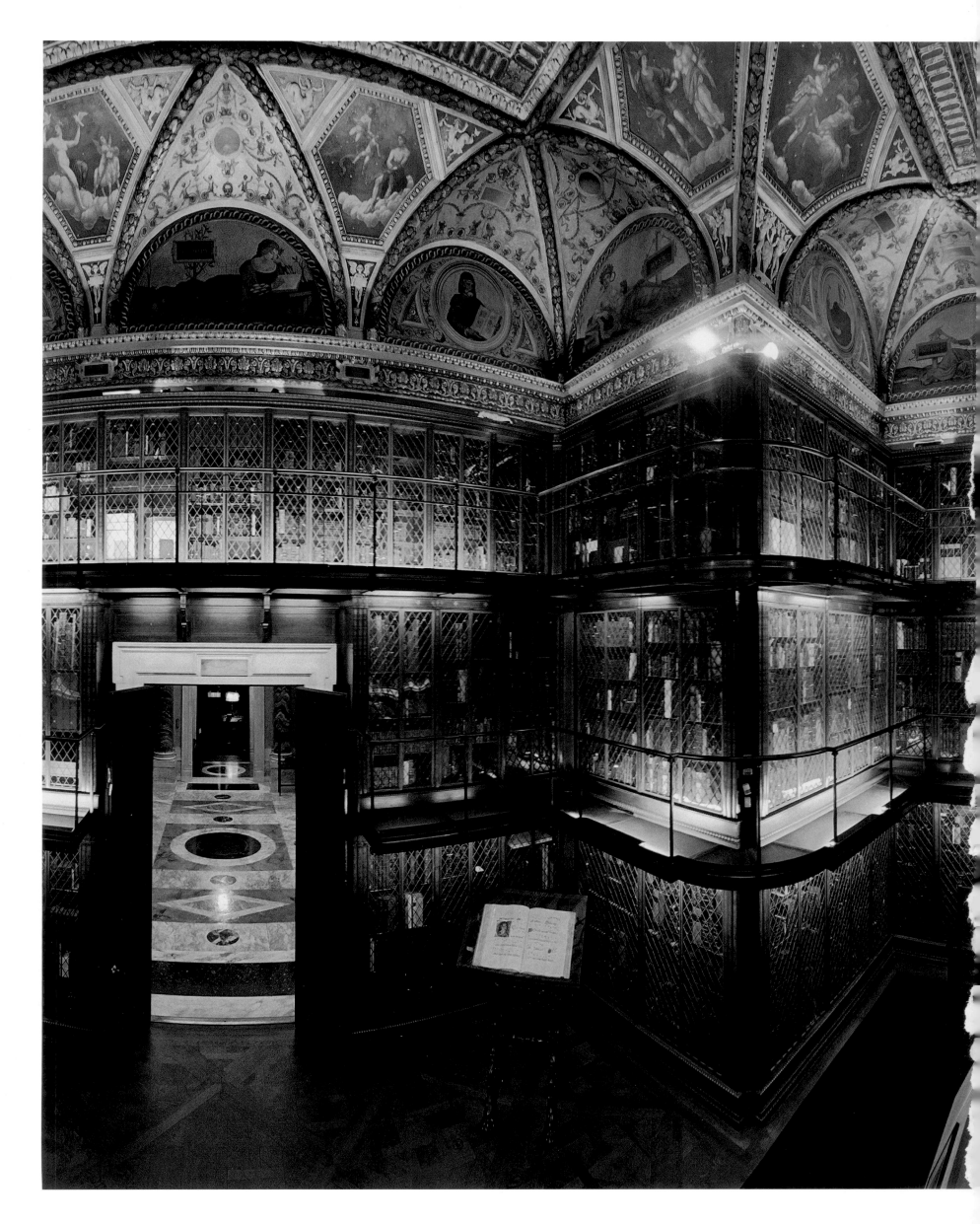

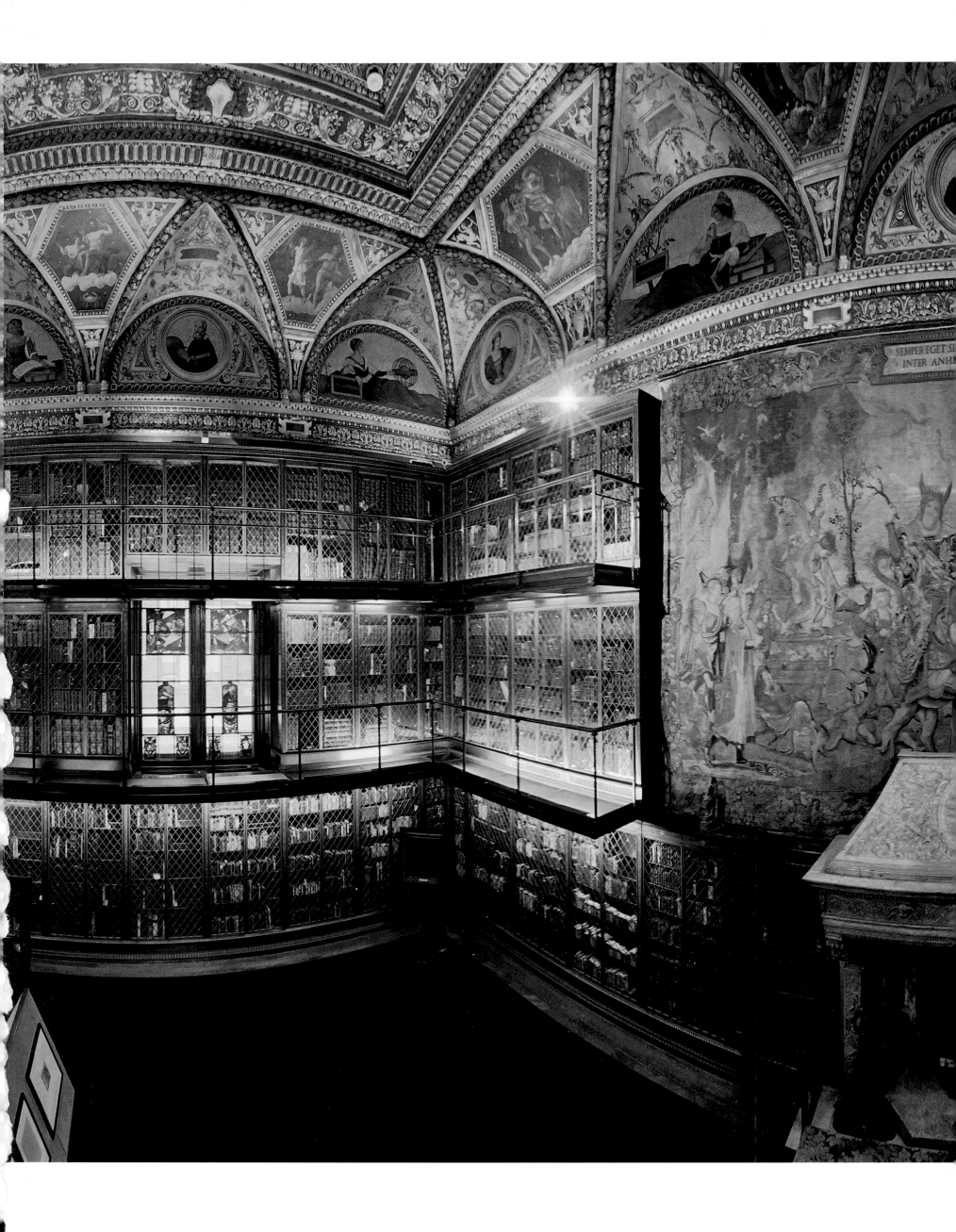

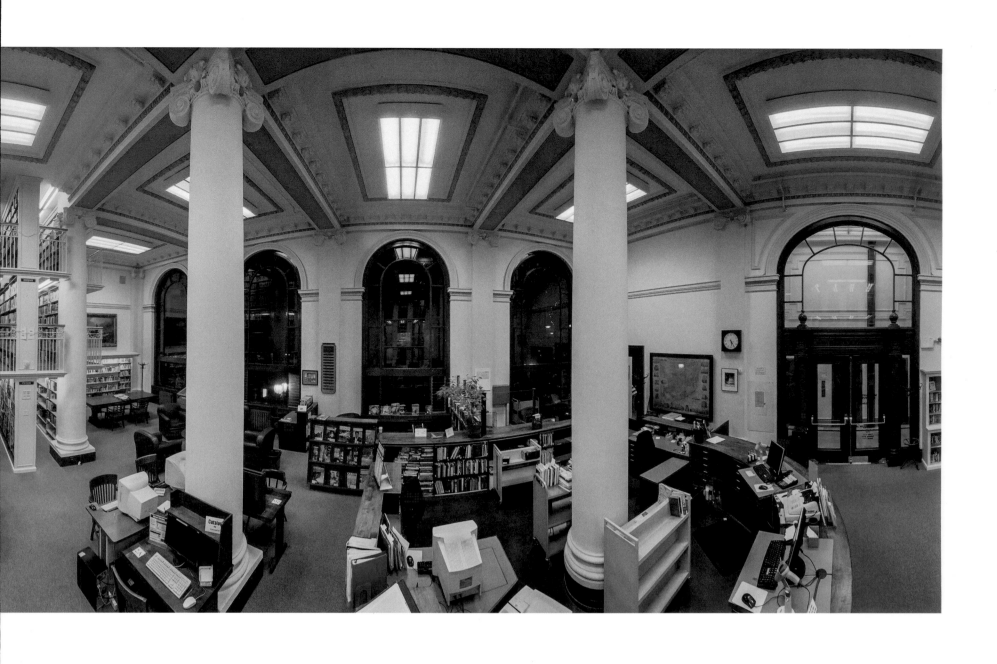

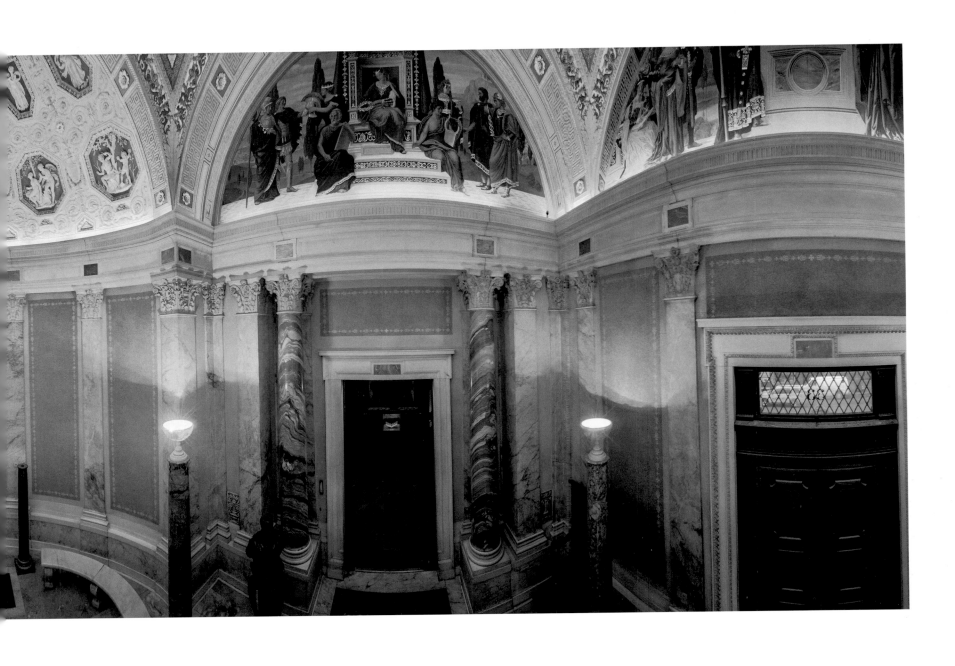

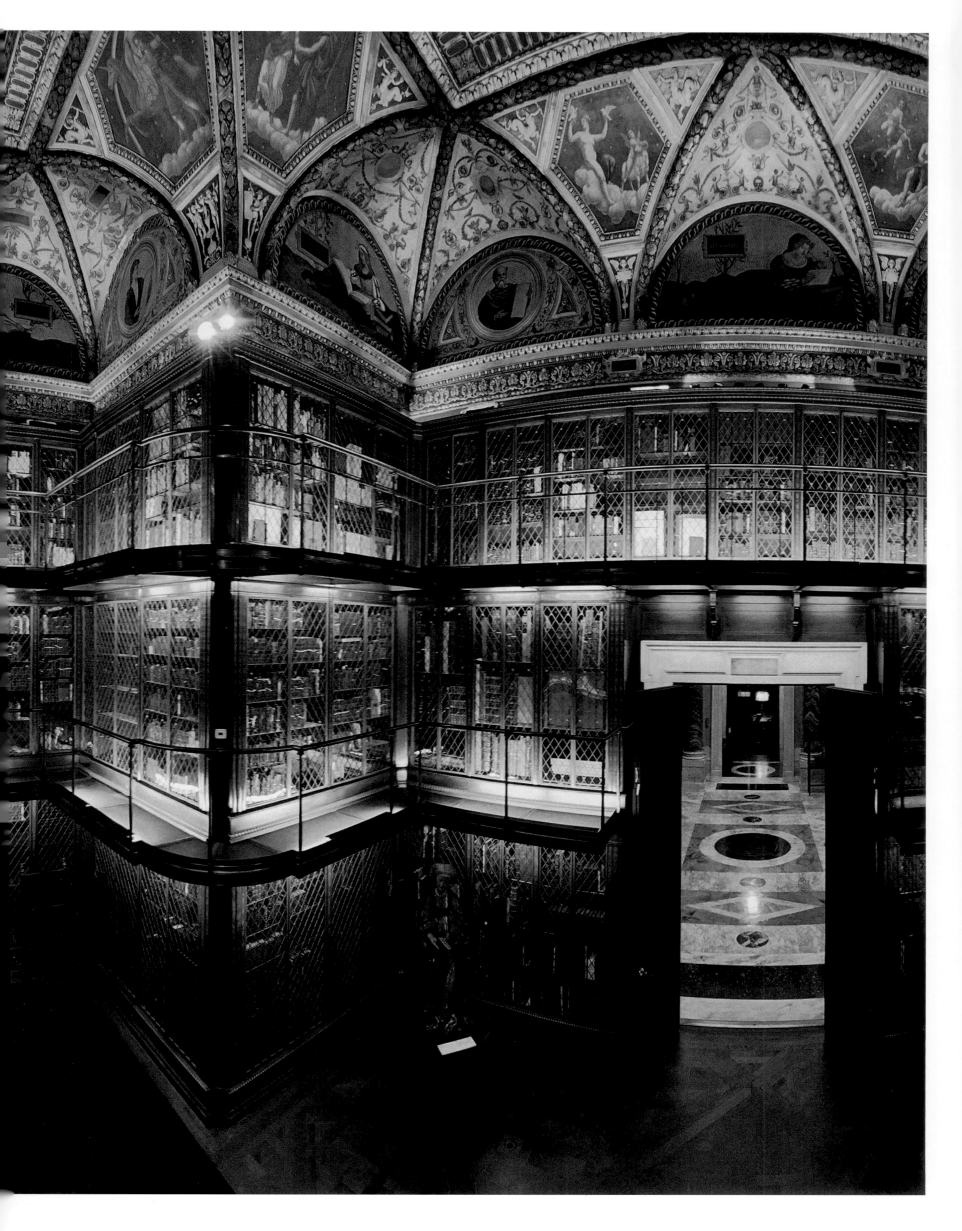

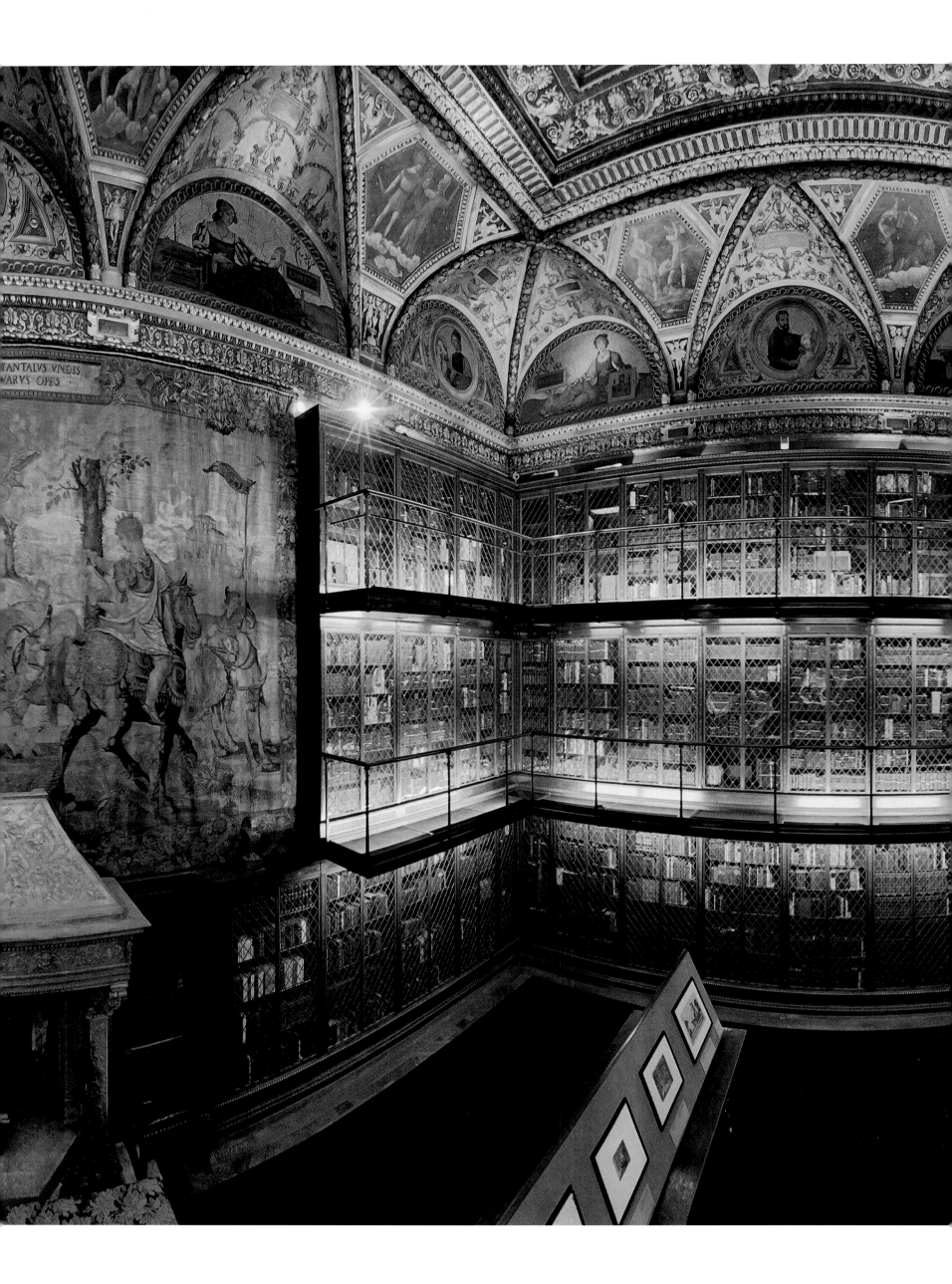

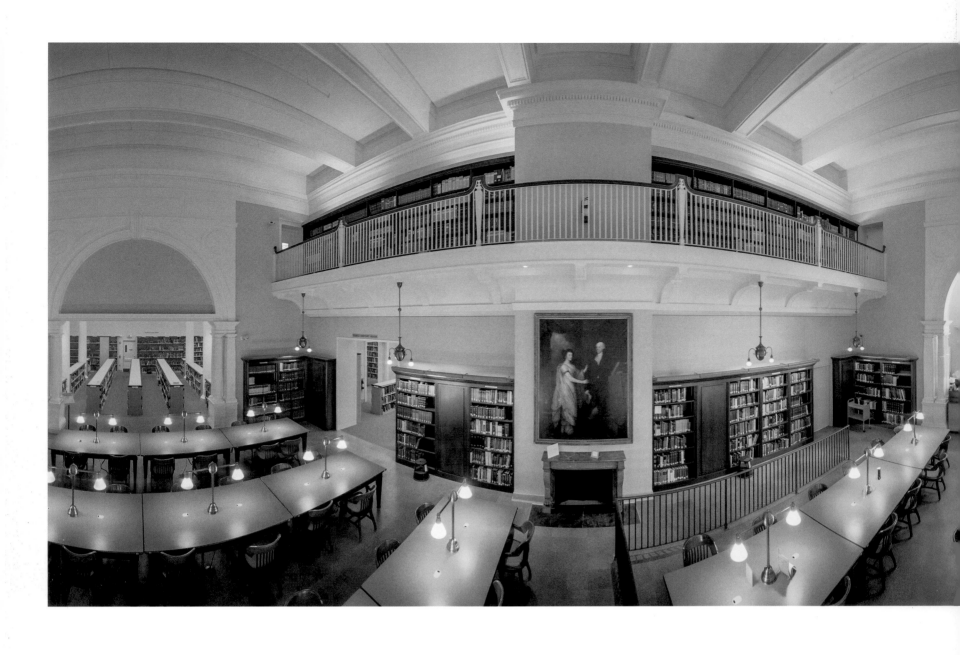

Historical Society of Pennsylvania Library, Philadelphia
Founded in 1824, the Historical Society of Pennsylvania is one of the oldest historical societies in the country, with an expansive collection that covers more than 350 years of American history, from its beginnings in the seventeenth century to the contributions of newer immigrants. Its ethnic history materials record the experiences of more than sixty ethnic groups in the United States, such as African American, Chinese, Greek, Irish, Japanese, Jewish, Native American, Polish, Puerto Rican, and Ukrainian communities.

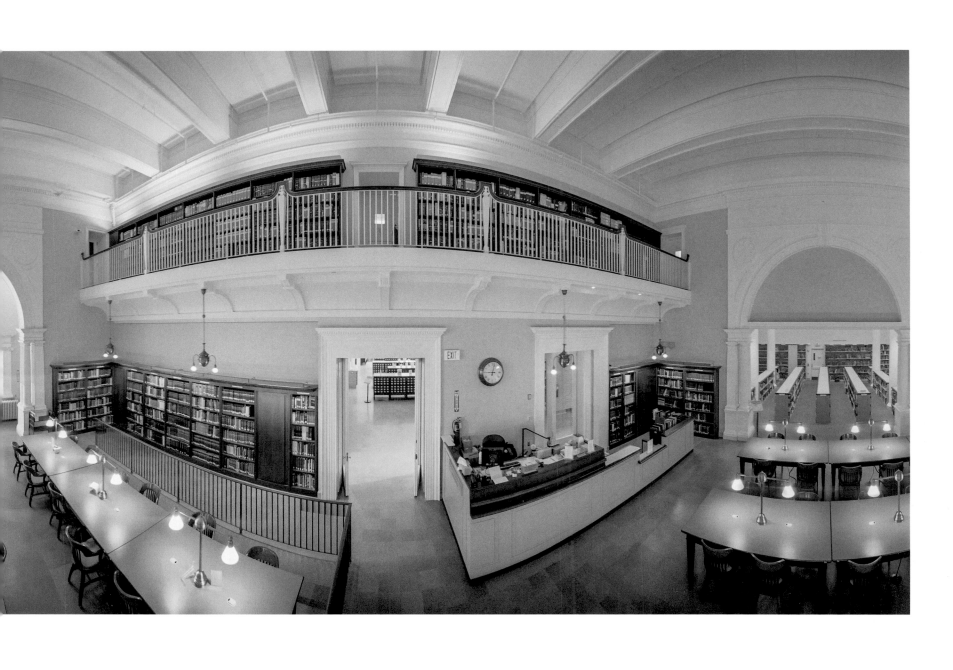

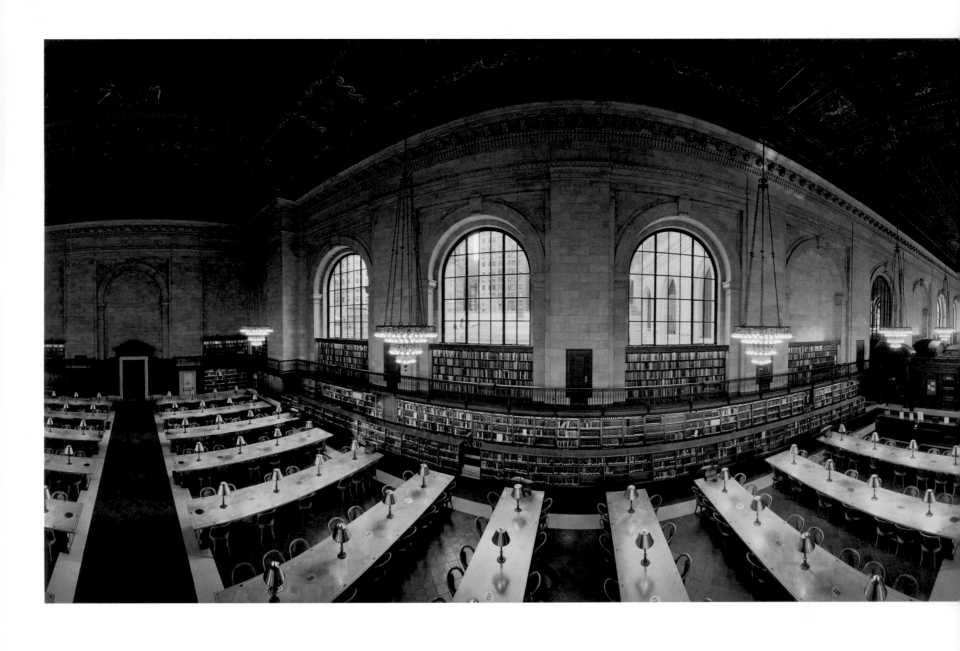

Rose Reading Room, New York Public Library
At 78 by 297 feet, the Rose Reading Room in the New York Public Library measures almost the length of two city blocks and is known for its high ceilings depicting dramatic skies. Featured in several films, including 1984's *Ghostbusters*, the room's long oak tables, furnished with bronze lamps, have harbored great literary figures such as Norman Mailer, Elizabeth Bishop, and E. L. Doctorow. After a two-year renovation, the hall reopened to the public in October 2016.

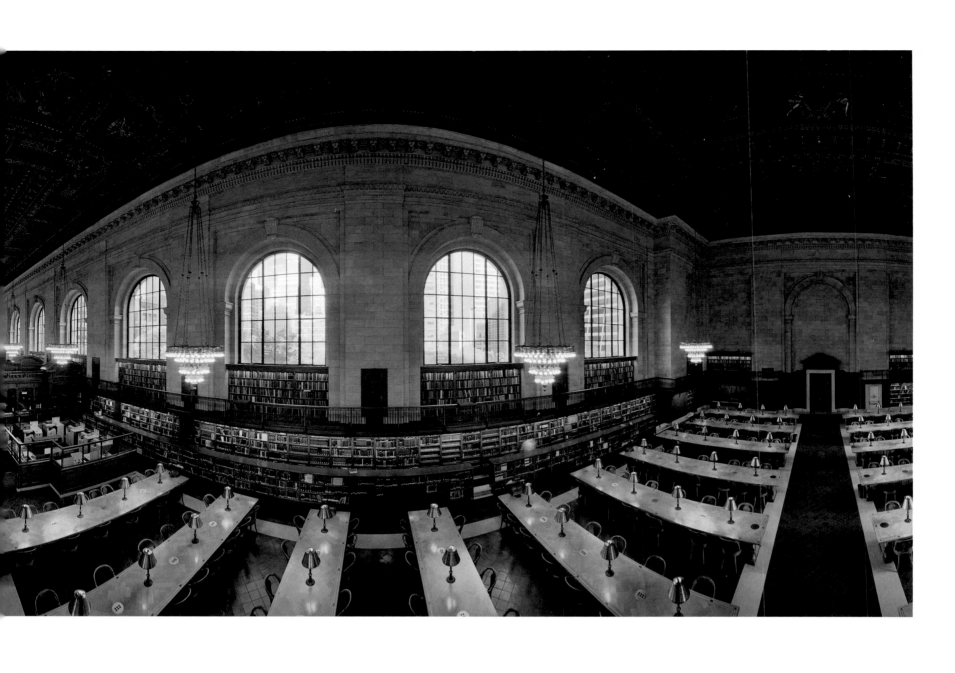

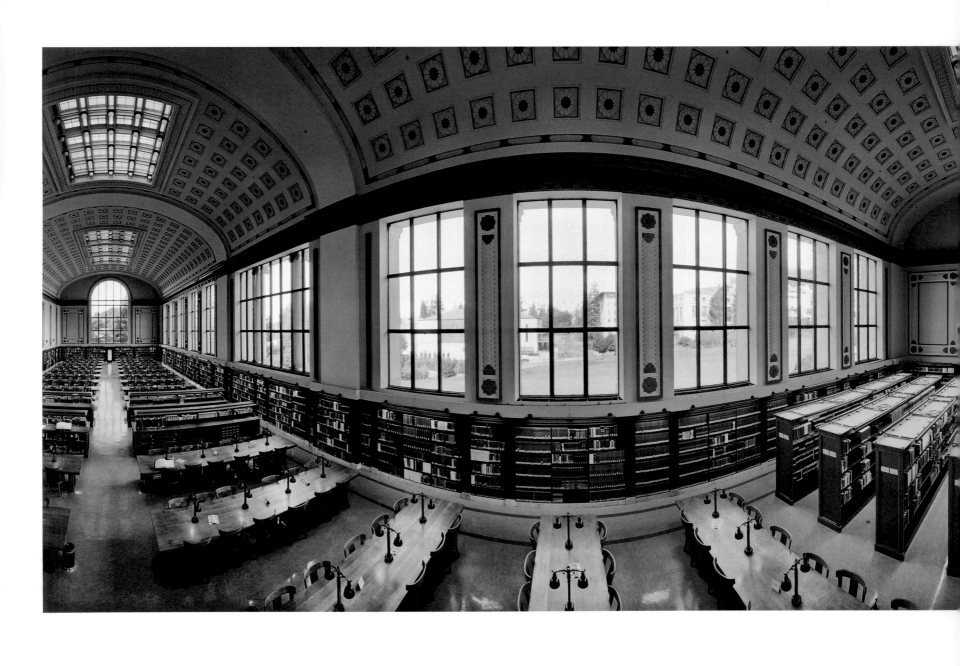

North Reading Room, Doe Library, University of California, Berkeley
The Doe Memorial Library is the main library of the UC Berkeley library system and was designed by John Galen Howard, the university's supervising architect at the time. The Greco-Roman–style building, which opened in 1912, houses the undergraduate and the Gardner main stacks collection, a four-story underground structure consisting of fifty-two miles of bookshelves. The main stacks, built in 1997, include four large skylights that provide natural lighting to the underground structure.

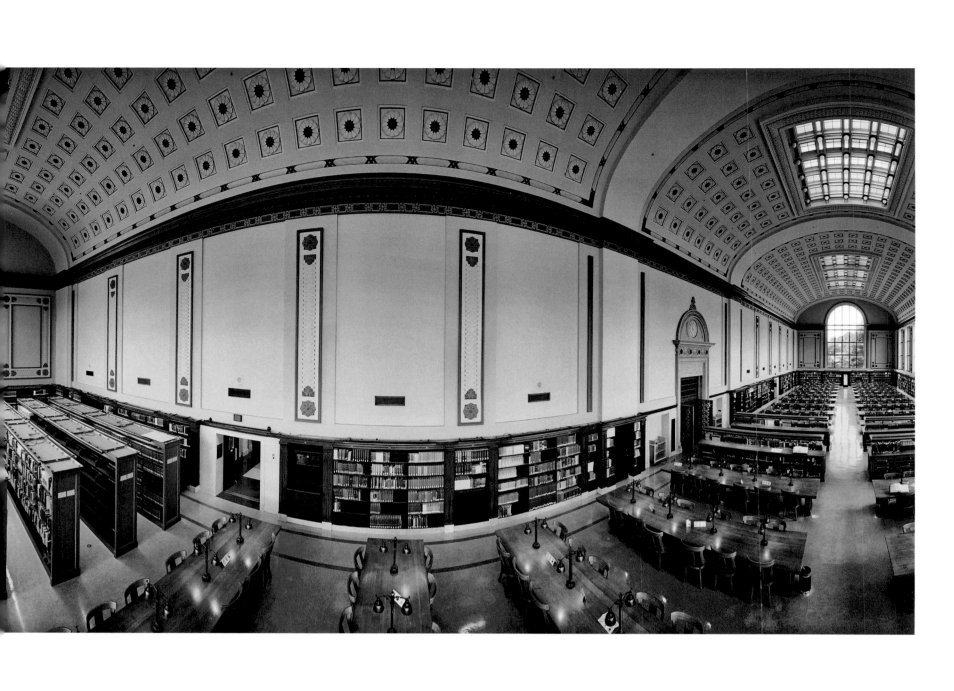

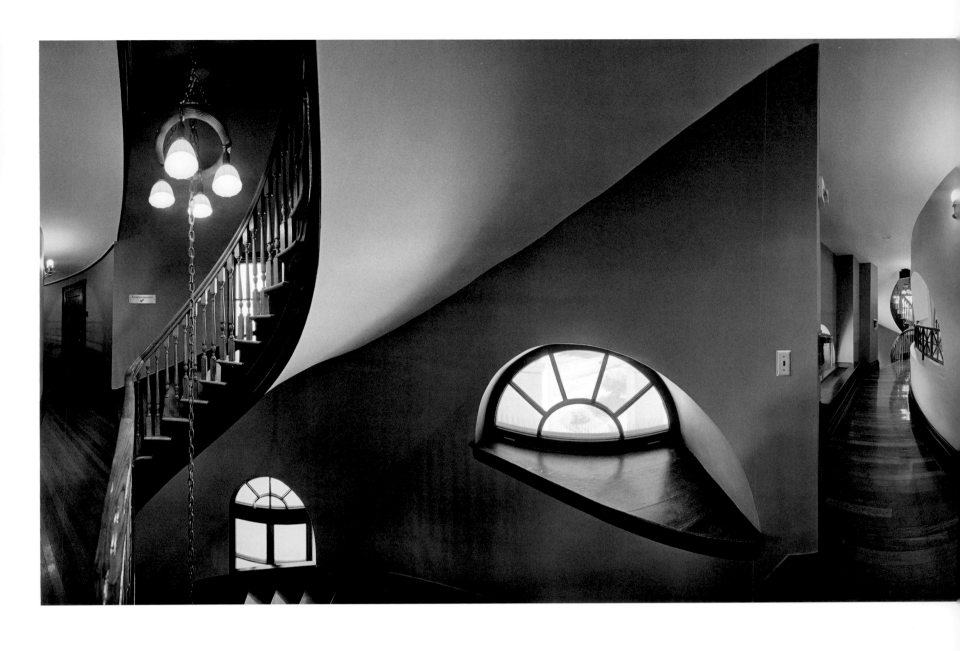

Handley Library, Winchester, Virginia
The Handley Library occupies a regal building designed by a team of New York architects in Beaux Arts style. Funded by Irish American coal magnate John Handley and completed in 1913, the building was made from Indiana limestone and includes an embellished dome, esplanades, and colonnades, and includes several reading rooms, an auditorium, and stacks five levels high. Until December 1953, the library only admitted white patrons; at that time, the city passed a resolution that made the library available to all.

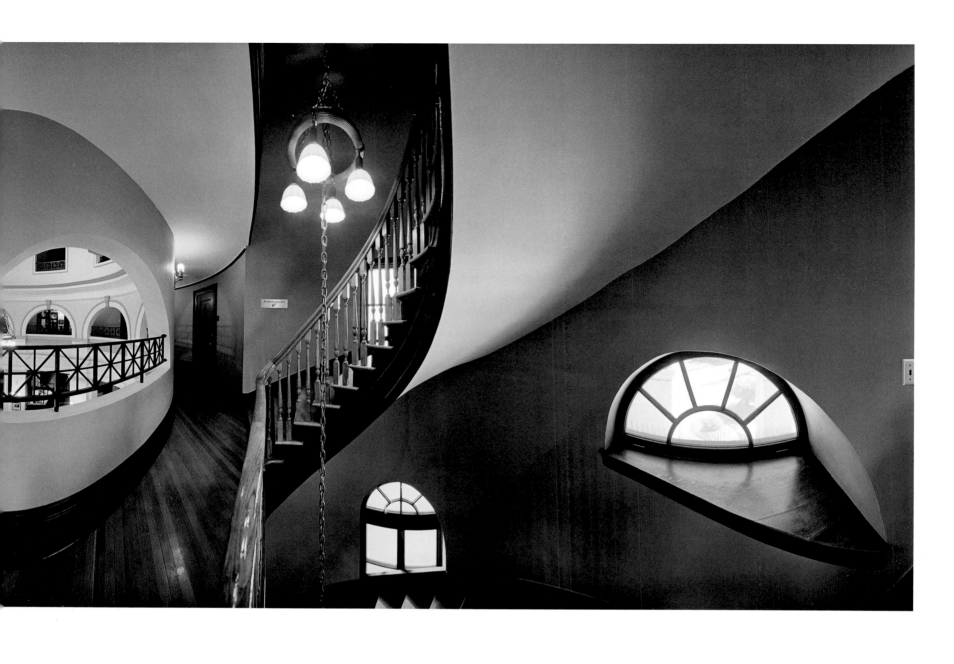

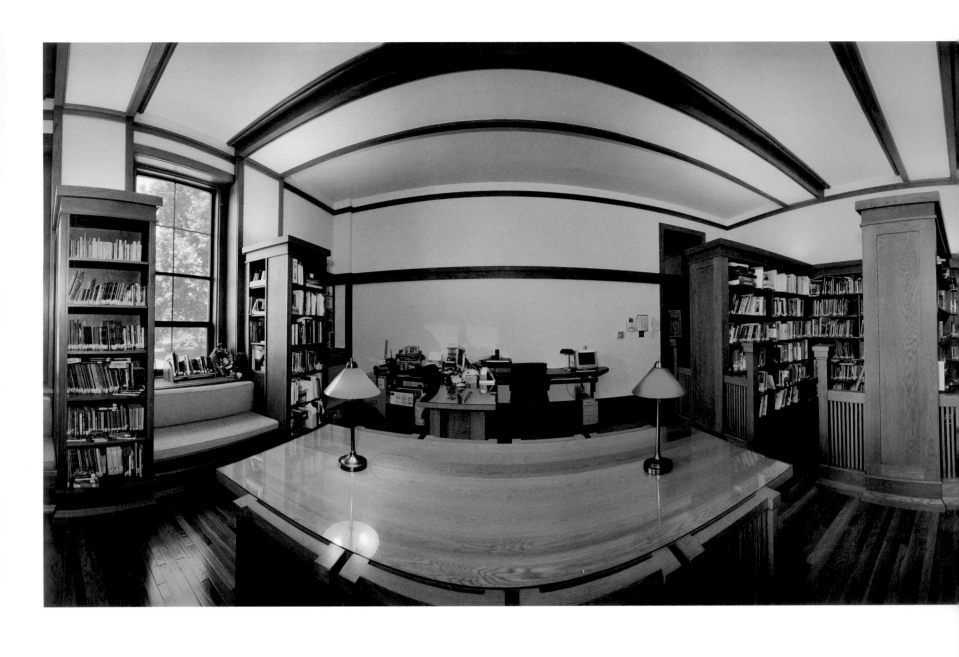

Lawrence Memorial Library, Springfield, Illinois
Commissioned by Susan Lawrence Dana, the Lawrence Memorial Library
was designed by Frank Lloyd Wright and built in 1905. It echoes Wright's
prairie-style design of Dana's private home, the Susan Dana Thomas House,
located nearby. Designed for use by children, the library room was restored
to its original purpose in the 1990s. Due to its historic design, the library
accommodates guests and offers a display of relevant books, reports,
and articles reflecting Dana's interest in children and in public education.

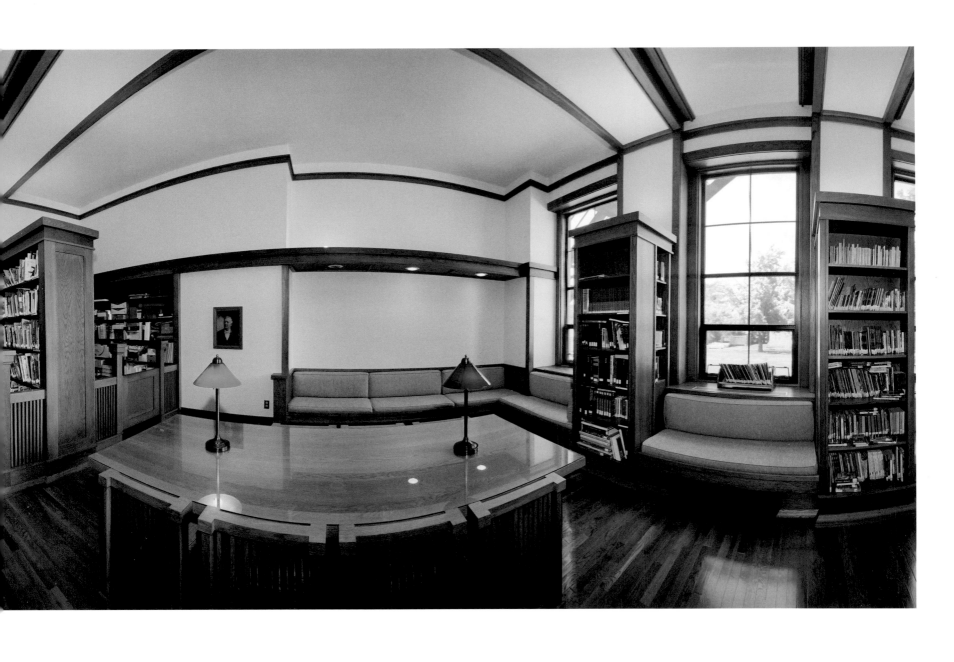

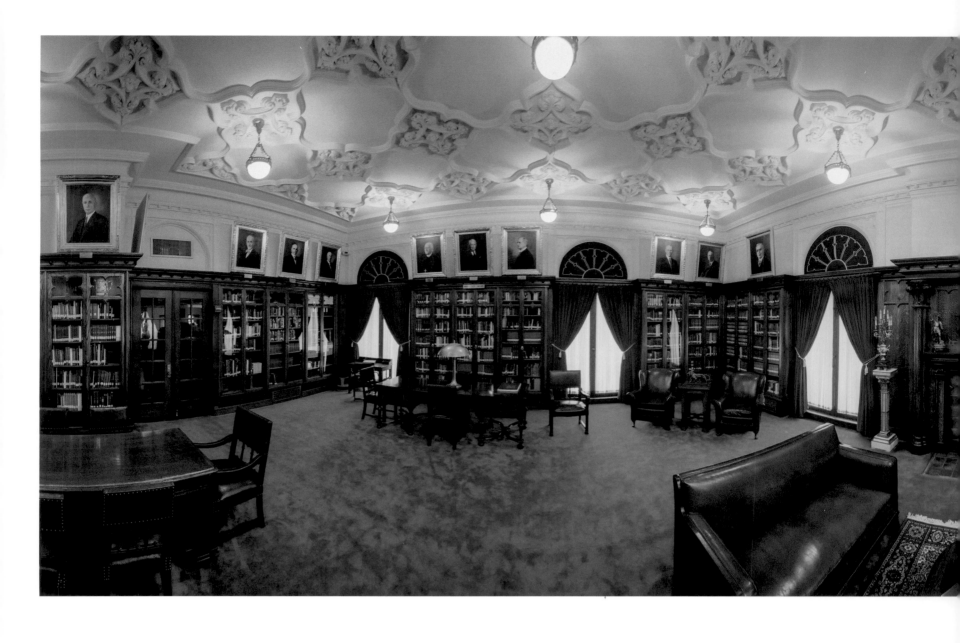

Scottish Rite of Freemasonry Library and Museum, Dallas
The library at the Dallas Scottish Rite of Freemasonry is an important feature
of the organization's cathedral. The library is based on the private collection
of Englishman Harry Carr, a scholar of the modern Freemason movement,
which was acquired by the Scottish Rite. The collection of approximately one
thousand books includes works penned by Carr, as well as historical volumes
and rarities such as a leather-bound Oxford Bible. The building was designed
in a neoclassical revival style and has been occupied by the Scottish Rite
since 1913.

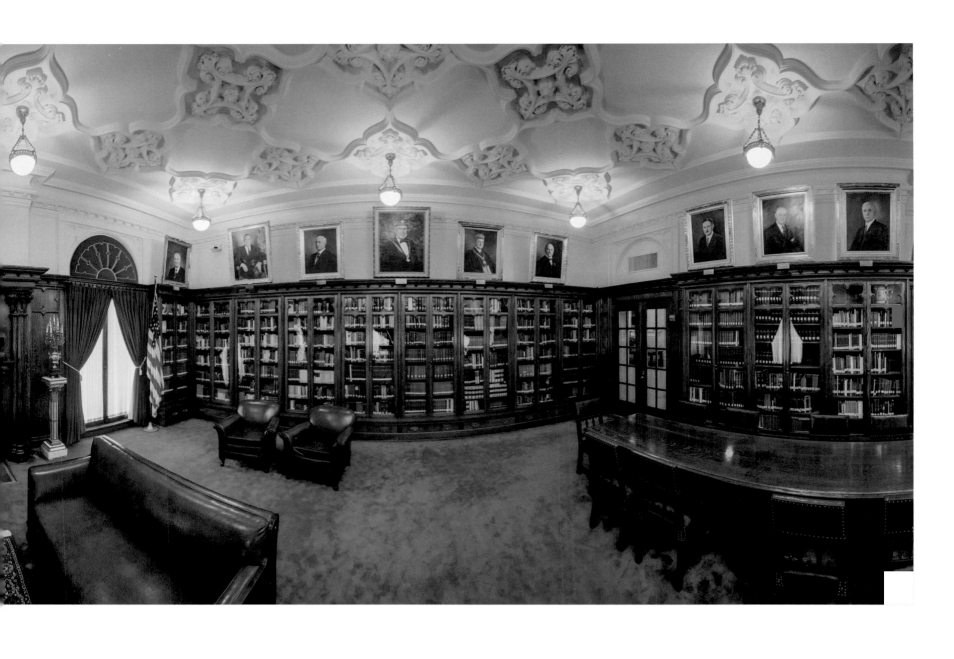

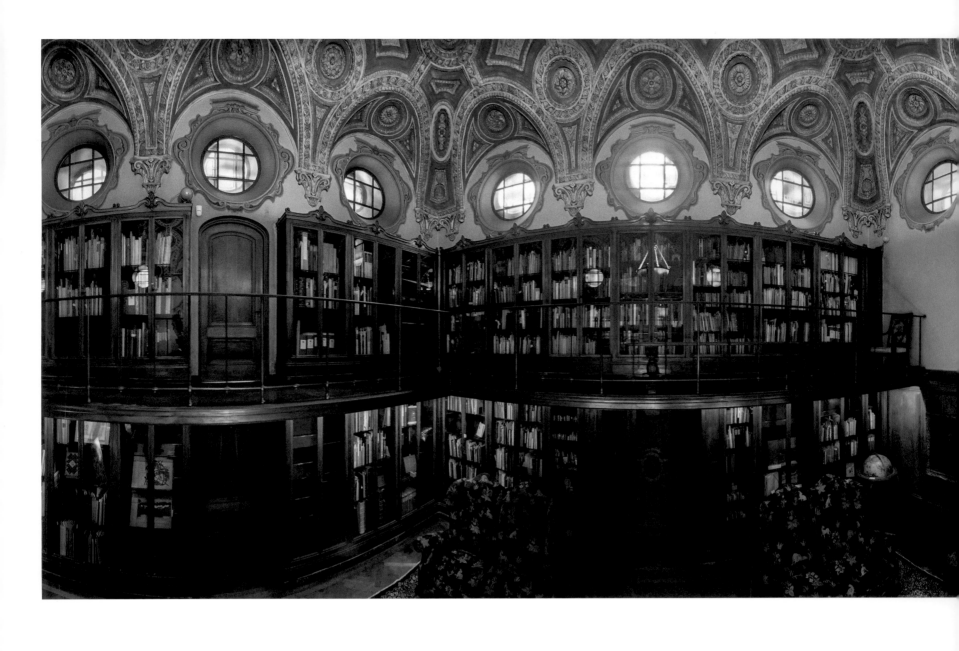

William Andrews Clark Memorial Library, University of California, Los Angeles
The William Andrews Clark Memorial Library is home to a specialized rare book and manuscript collection that includes a selection of pre-1501 printed volumes known as incunabula, books from the Tudor and early Stuart periods in England, and the world's most complete collection of Oscar Wilde's books, editions, manuscripts, and letters. Located on a historic property in West Adams, Los Angeles, the library building was completed in 1926 after its architect Robert D. Farquhar studied the designs of many libraries in the eastern United States.

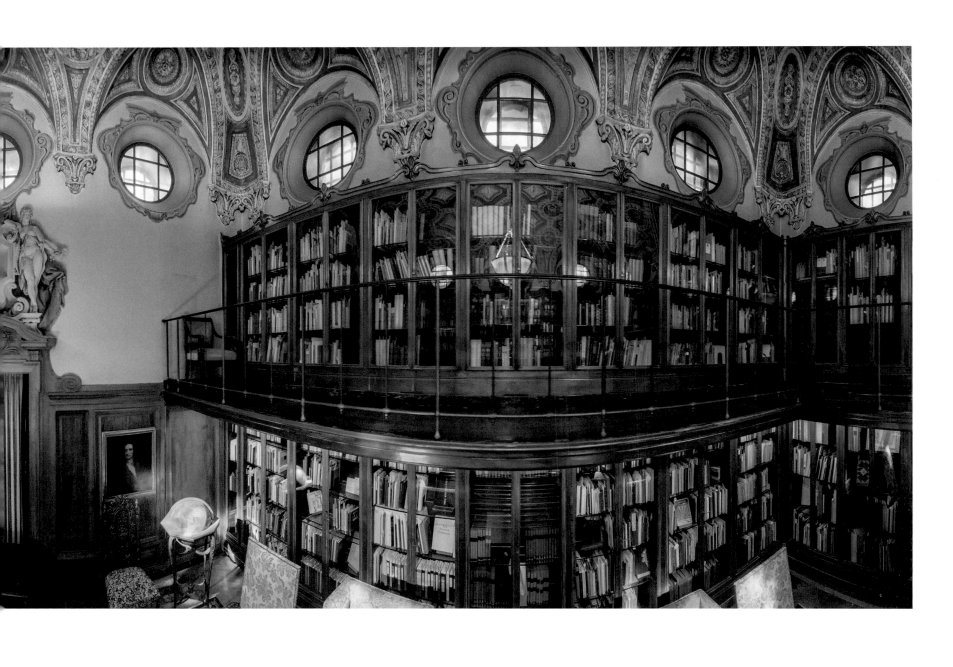

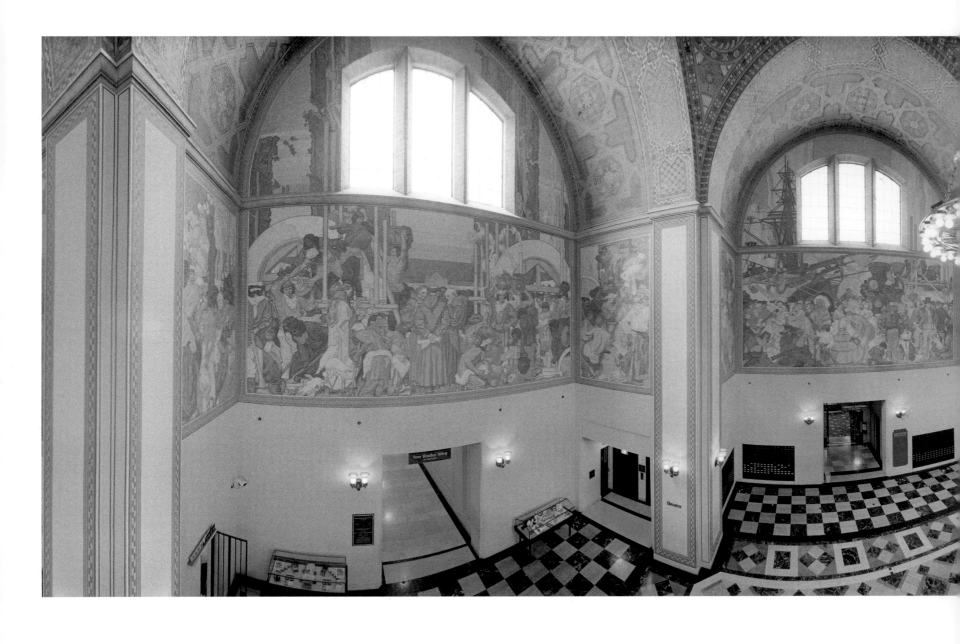

Los Angeles Public Library
The Los Angeles Public Library serves the largest population of any publicly funded library system in the United States. The library's extensive photography collection, comprising more than three million historic images, includes a collection of Ansel Adams's 1940s L.A. photographs and the "Shades of L.A." archive, which echoes city residents' diverse ethnic histories through over ten thousand donated family images. The Art Deco design of the Central Library was the last of New York architect Bertram Goodhue's career before he died suddenly during the library's construction.

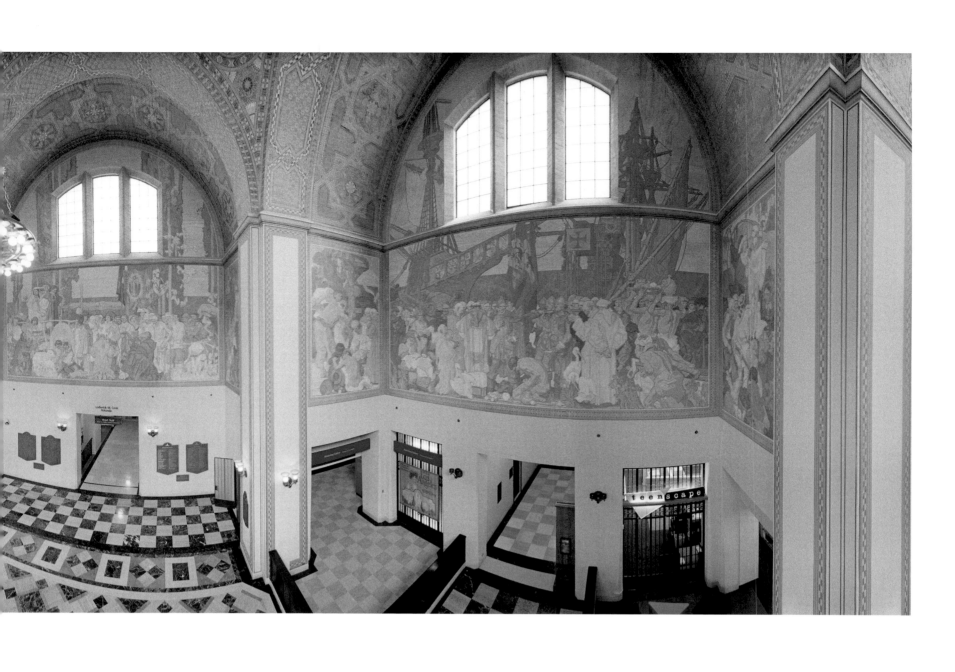

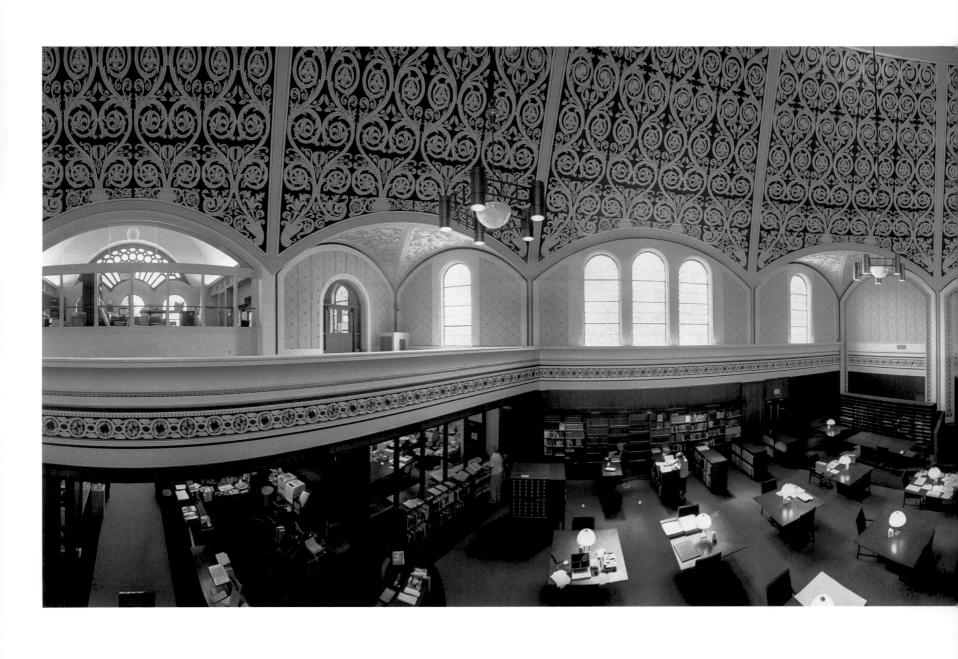

Missouri History Museum Library and Research Center, St. Louis
The Missouri History Museum Library and Research Center offers visitors a broad collection focused on the history of St. Louis and the state of Missouri, as well as archives, photographs, and prints about the American West in the nineteenth century. Occupying a former synagogue, the research center adapted the Byzantine-type architecture to suit its needs in the late 1980s, transforming its sanctuary into the library's reading room and adding stacks for its collection of books, prints, and photographs. The renovated building was dedicated in 1991.

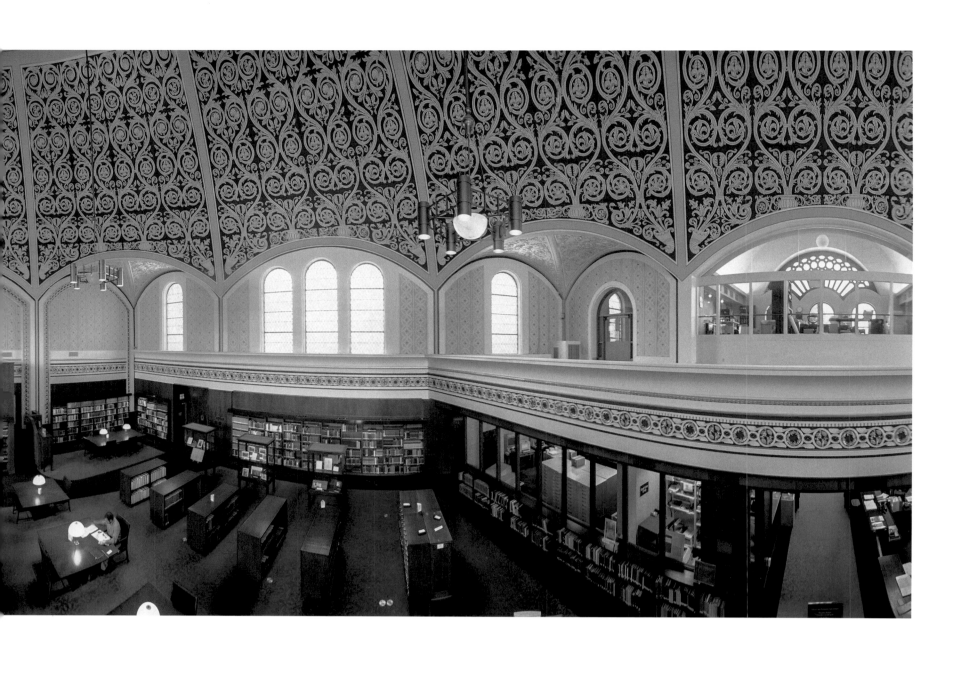

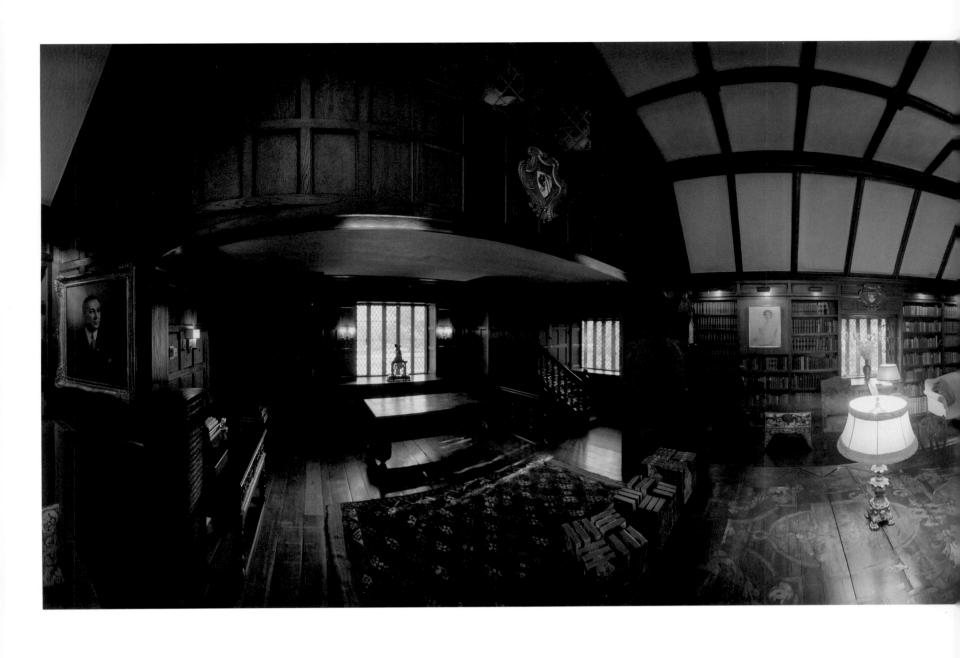

Agecroft Hall Library, Richmond, Virginia
Agecroft Hall was originally built by the Irwell river near Manchester, England, some five hundred years ago. After its last residents departed and the house was sold at auction in 1925, its new owner disassembled the structure and shipped it to the United States, where he rebuilt it with modifications in Richmond. While the house was later refurbished to reflect the English Tudor era, the library is the one room that was preserved in its original condition from the 1920s. Agecroft Hall has welcomed visitors since 1969.

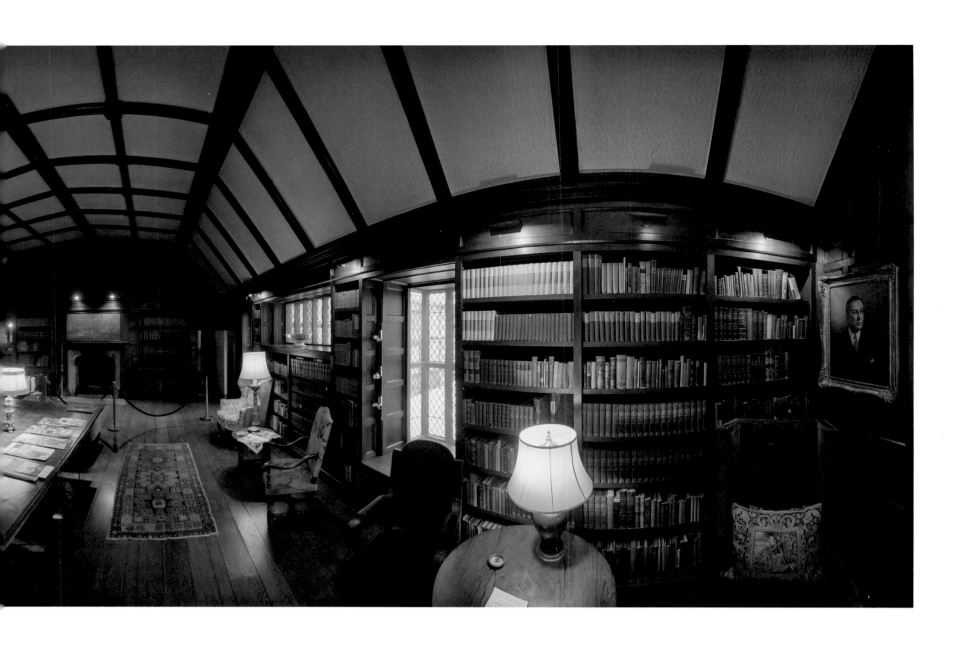

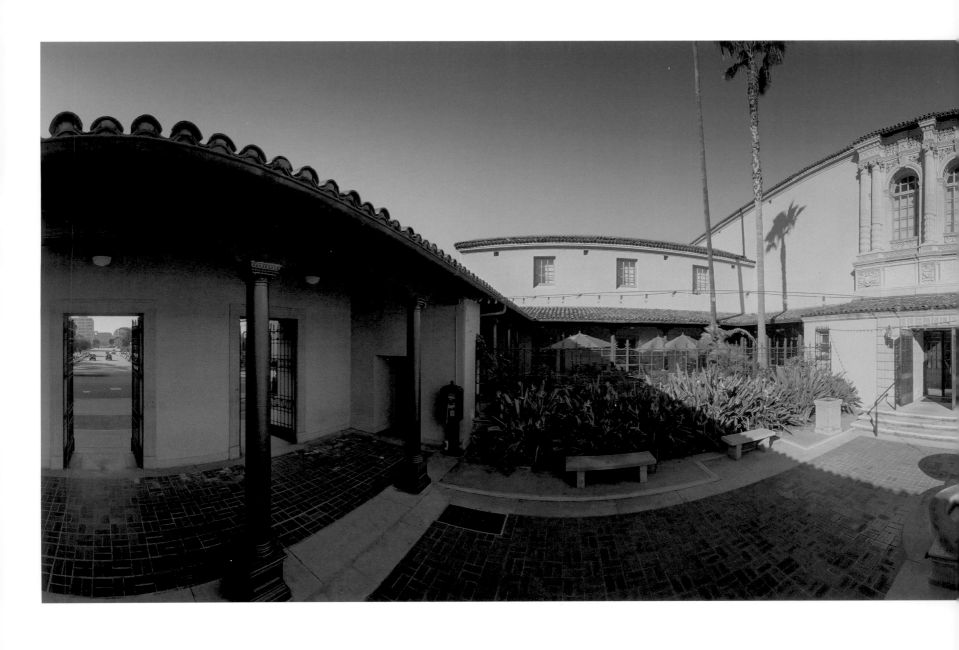

Pasadena Public Library, California
The Pasadena Public Library was founded as a private subscription library
in 1882, preceding the city's establishment by four years. A 1920s competition
called on ten California architects to propose designs for the library, city hall,
and auditorium, specifying that Renaissance style or later would be preferred.
The winning proposal included a stunning entrance and facade, a patio, and
possibilities for later expansion. The building was dedicated in 1927. The library
has served as the location for several films, including the 1996 children's
movie *Matilda*.

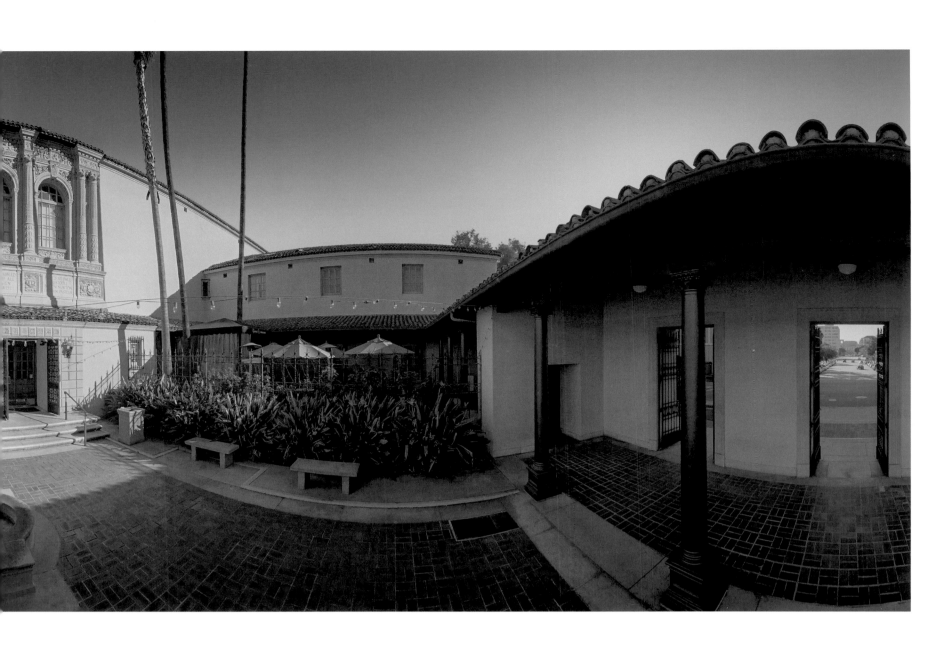

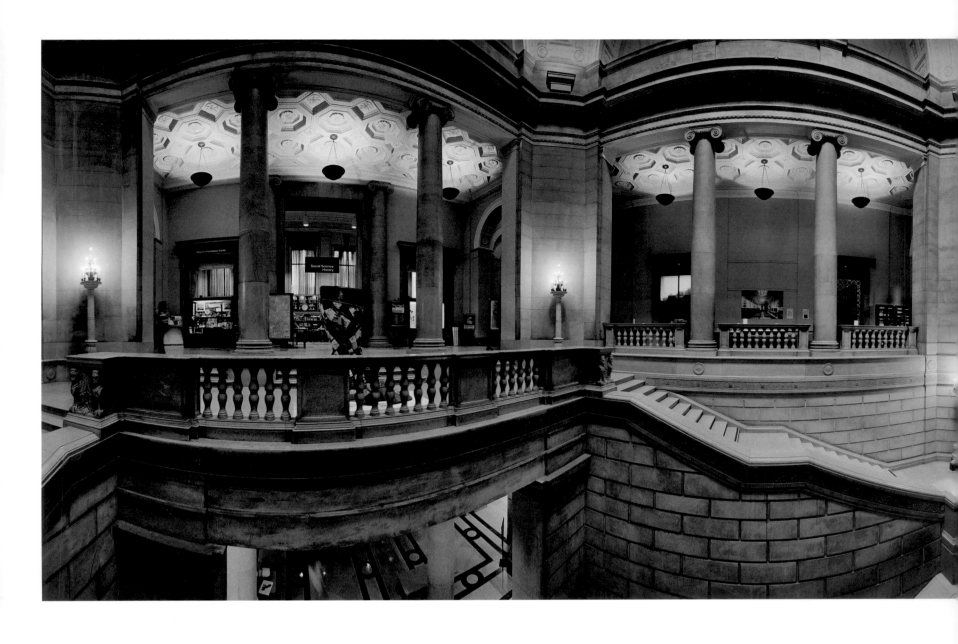

Free Library of Philadelphia
The Free Library of Philadelphia occupied many homes before its current location on Logan Square: it took up three crowded rooms in City Hall when it opened in 1894; a year later, it was moved to an old concert hall, but working conditions were deemed unsanitary and it was relocated again in 1910. The Central Library, whose design was led by Horace Trumbauer and Julian Abele, and reflects their taste in French eighteenth-century classical architecture, took seventeen years to complete and was inaugurated in 1927.

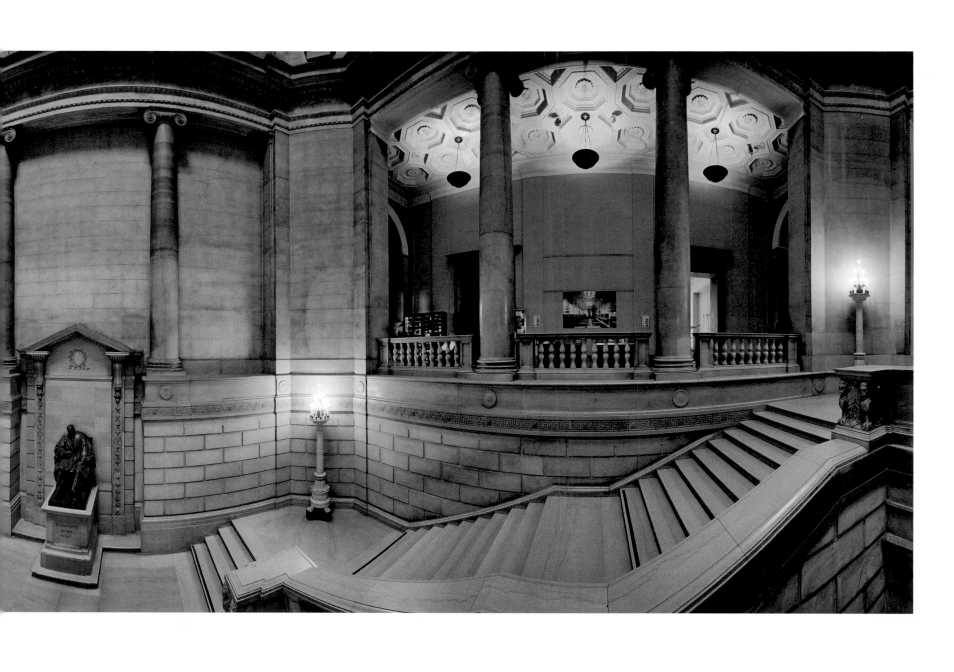

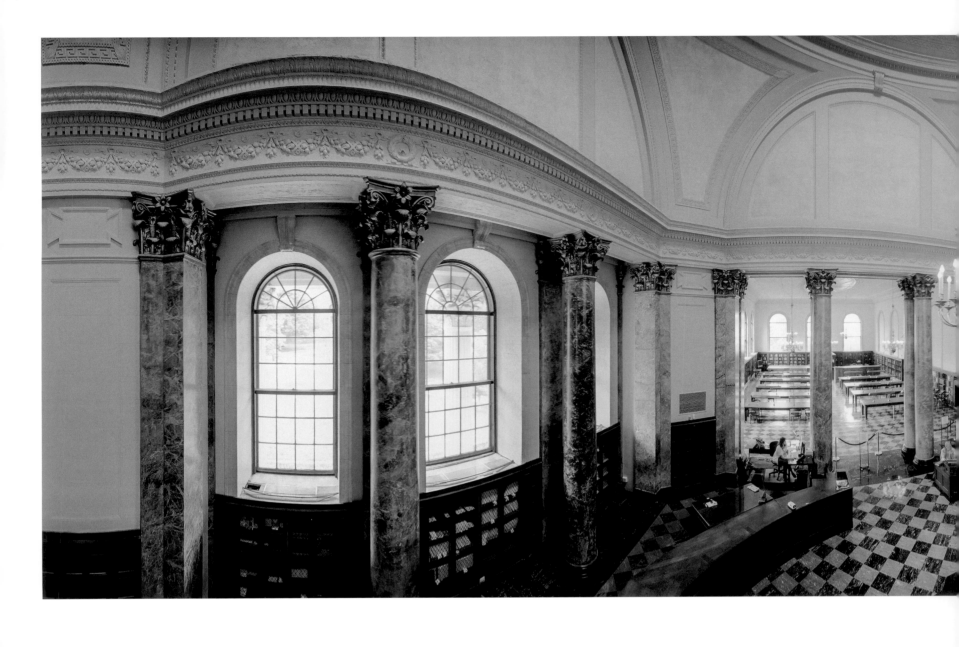

Wilson Library, University of North Carolina, Chapel Hill
The Wilson Library, completed in 1929, represented a major effort on
behalf of UNC–Chapel Hill to become a modern institution. The neoclassical
structure was conceived to blend in with the campus's overall colonial style
and follows the general plan of the Carnegie libraries in the United States.
The library was named after Louis Round Wilson in 1956; Wilson was
responsible for gifts to the library during the Great Depression that
funded some of its notable collections.

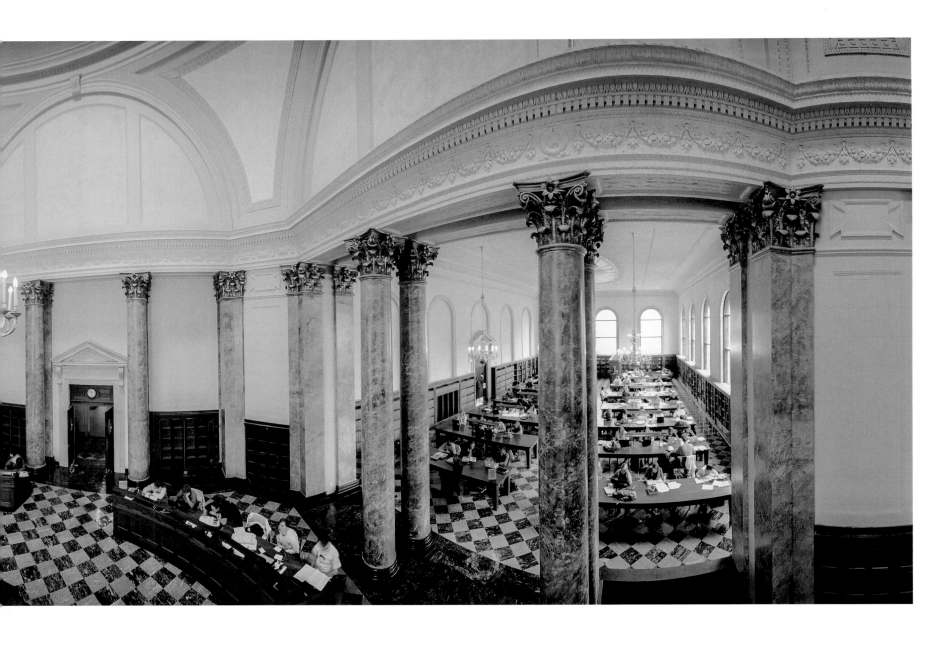

Sterling Memorial Library, Yale University, New Haven, Connecticut
The Sterling Memorial Library, completed in 1930, stands out on Yale's campus with its Gothic cathedral-style structure with sixty-foot ceilings, a circulation desk altar, cloisters, and 3,300 stained-glass windows. One of the building's principal features is its book stacks tower, a seven-story steel structure that at the time of construction represented the largest welding project of its kind; it houses sixteen levels of stacks with more than three million volumes. Inside, almost every surface, whether stone, wood, or plaster, bears a carved motif related to the theme of learning.

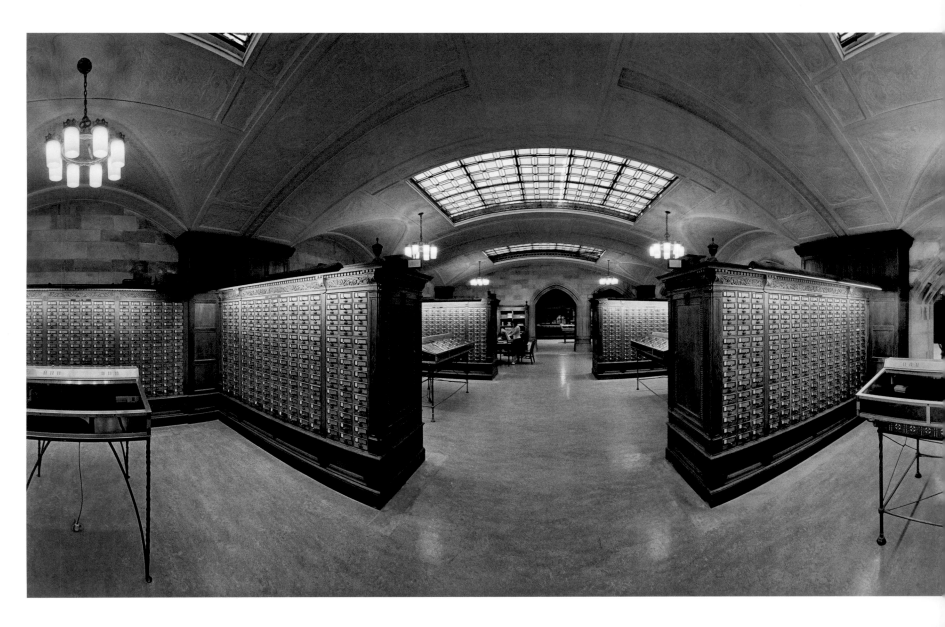

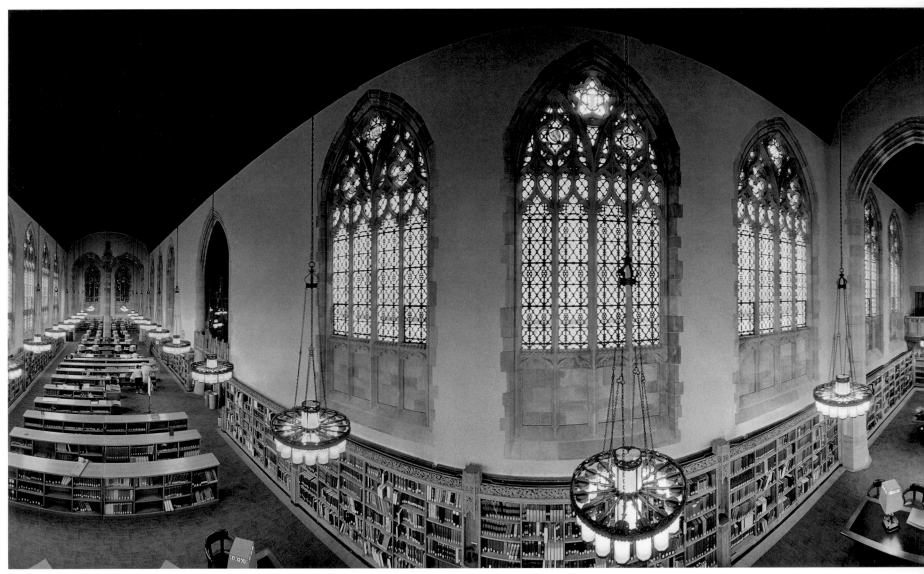

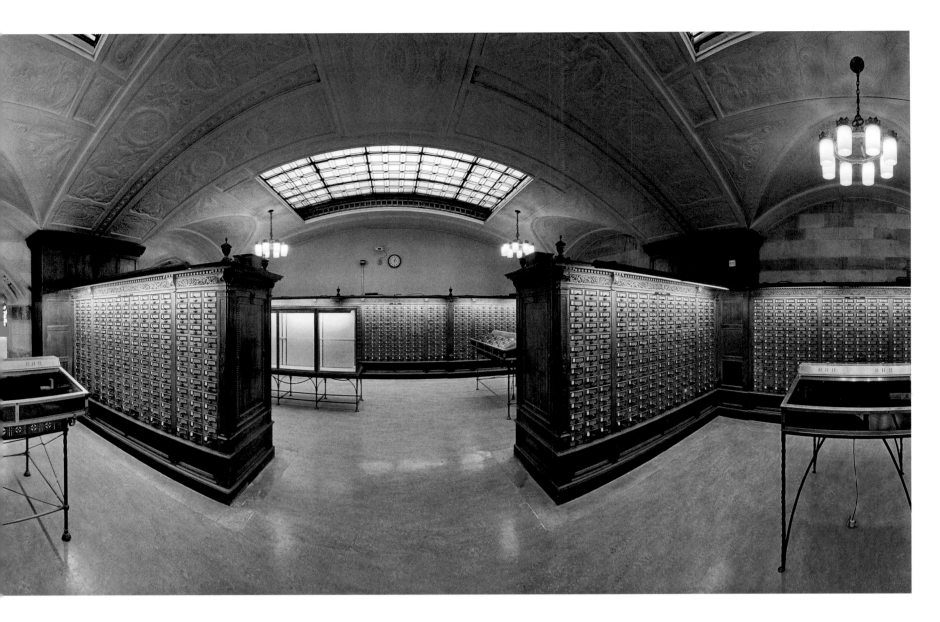

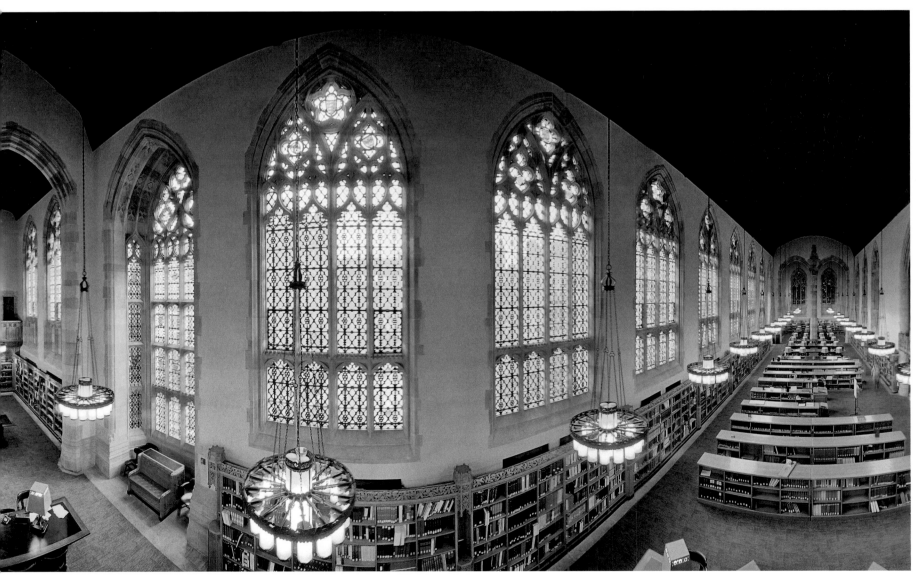

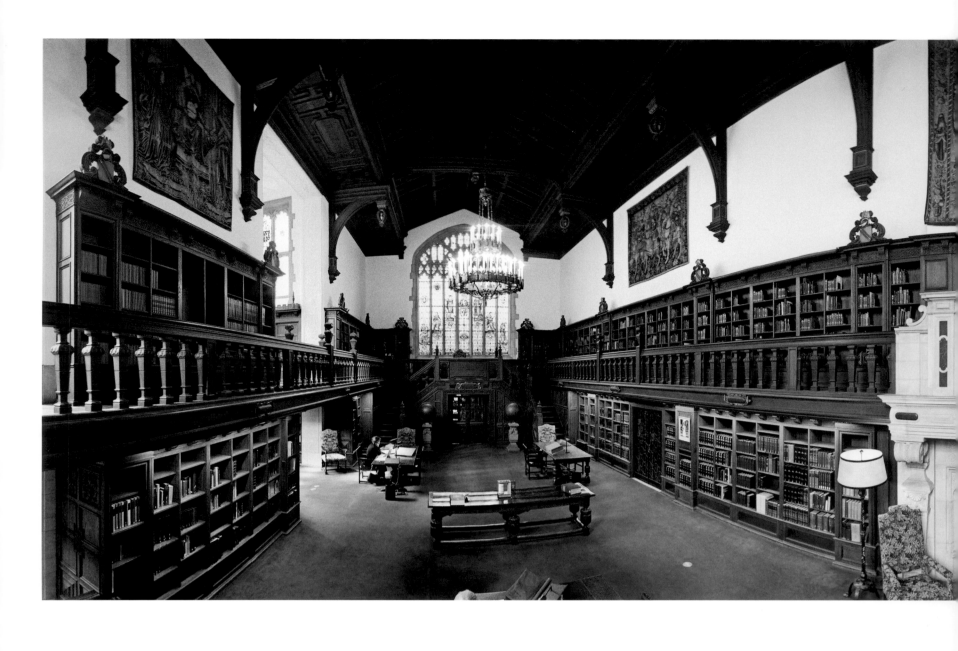

Folger Shakespeare Library, Washington, D.C.
The Folger holds the world's foremost collection of Shakespeare materials outside of England. Both the collection and the library building are the legacy of Henry Clay Folger, an oil businessman, and his wife, Emily Jordan Folger, a Shakespeare scholar. The neoclassical structure, commissioned from architect Paul Philippe Cret, is well-known for the bas-reliefs along its northern face, by New York sculptor John Gregory. The library also prides itself on its conservation laboratory, responsible for training book and paper conservators for over three decades.

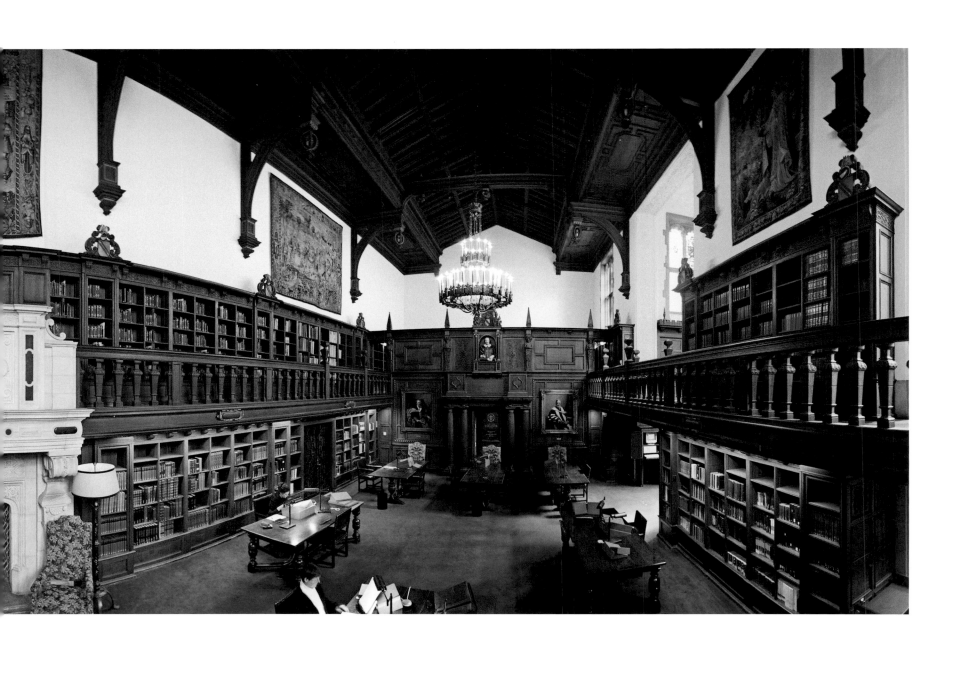

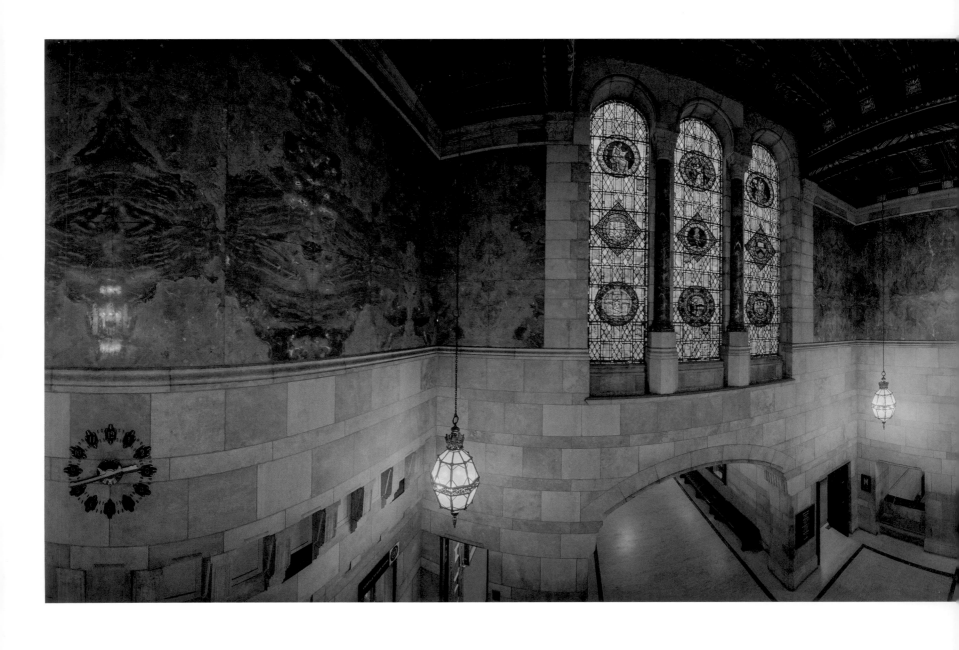

Doheny Memorial Library, University of Southern California, Los Angeles
The Doheny Memorial Library is an intellectual and cultural center that opened in 1932. Built in memory of USC trustee and alumnus Edward L. Doheny Jr., the library has earned awards for its Italian Romanesque architecture, which is embellished with native Californian woods such as sycamore, redwood, and knotty pine. In addition to a vast book and journal collection, the library offers students unique spaces like the Los Angeles Times Mirror Reference Room, an Arts Corridor, and a teahouse.

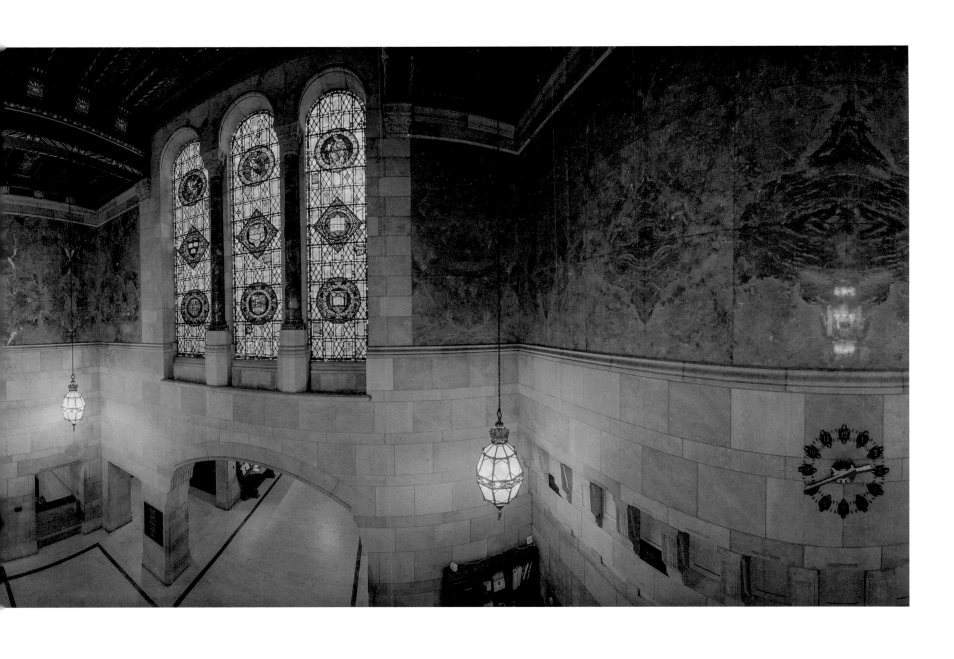

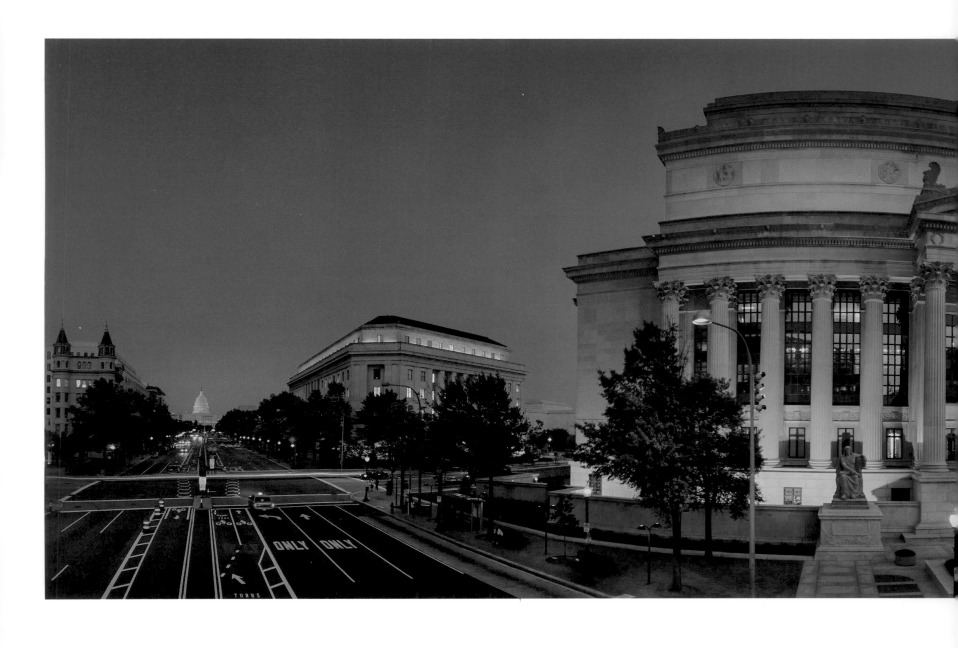

National Archives, Washington, D.C.
The National Archives were established in 1934 by Franklin Roosevelt with
the purpose of holding the country's important records dating back to 1775.
In addition to documents such as the Declaration of Independence, the U.S.
Constitution, and the Bill of Rights, the National Archives also house records
of ordinary citizens, including military records of U.S. veterans and immigrants'
naturalization documents. Other artifacts include slave-ship manifests, Japanese
and German documents from World War II, and journals from polar expeditions.

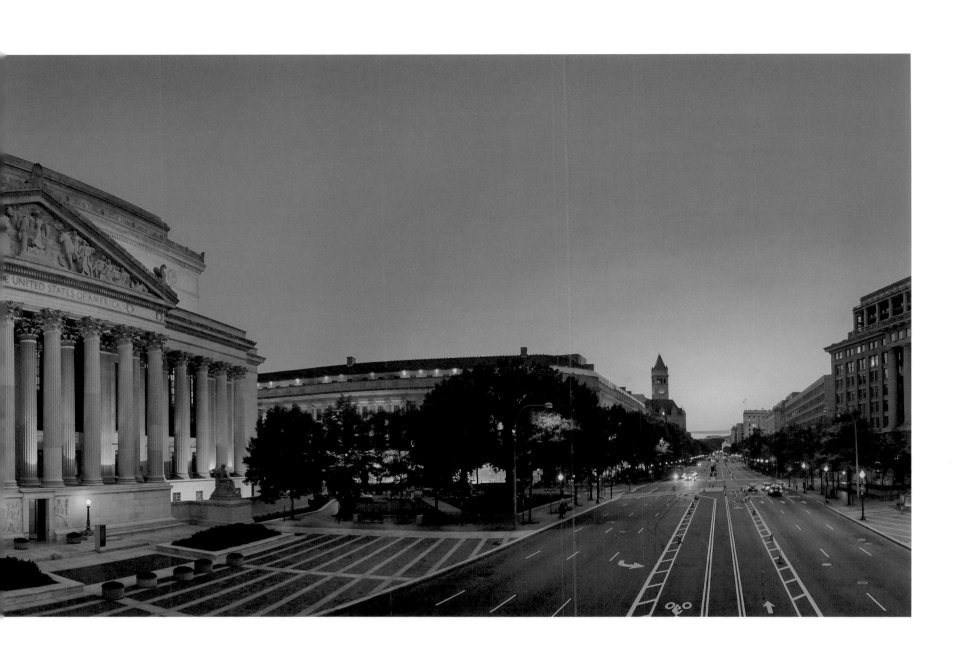

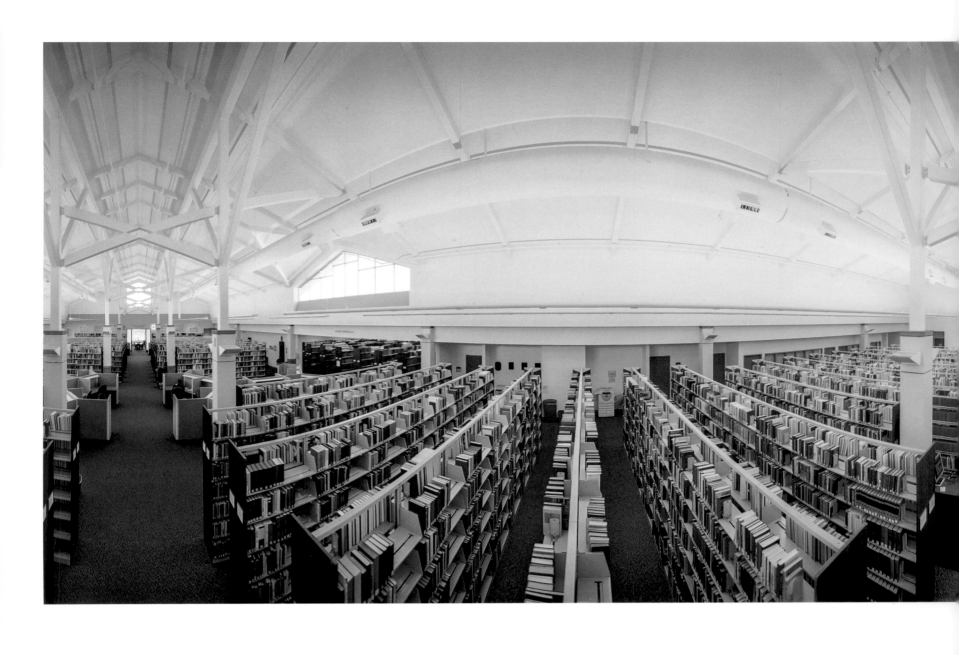

Carey S. Thomas Library, Denver Seminary, Littleton, Colorado
The Carey S. Thomas Library is part of the Denver Seminary, a graduate school of theology, and named after the seminary's first president, who served from 1951 to 1955. The library offers over 175,000 books and periodicals, carefully selected volumes of the world's theological and scholarly literature, to serve the seminary's nearly nine hundred students, who represent over fifty denominations. A part of the Lewan Learning Resource Center, the library is located near the historic South Platte River, overlooking the Rocky Mountains.

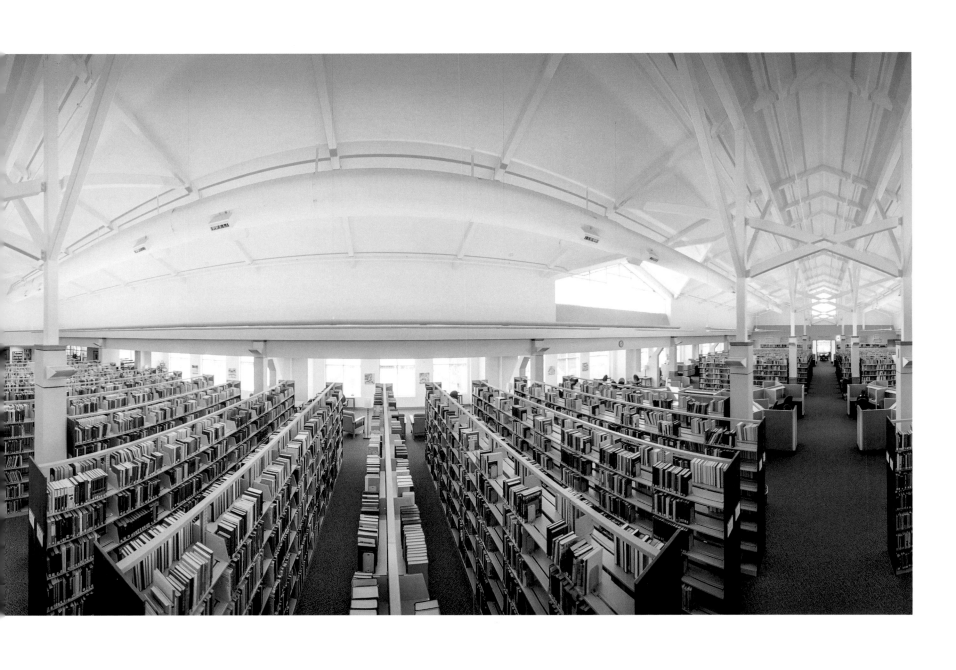

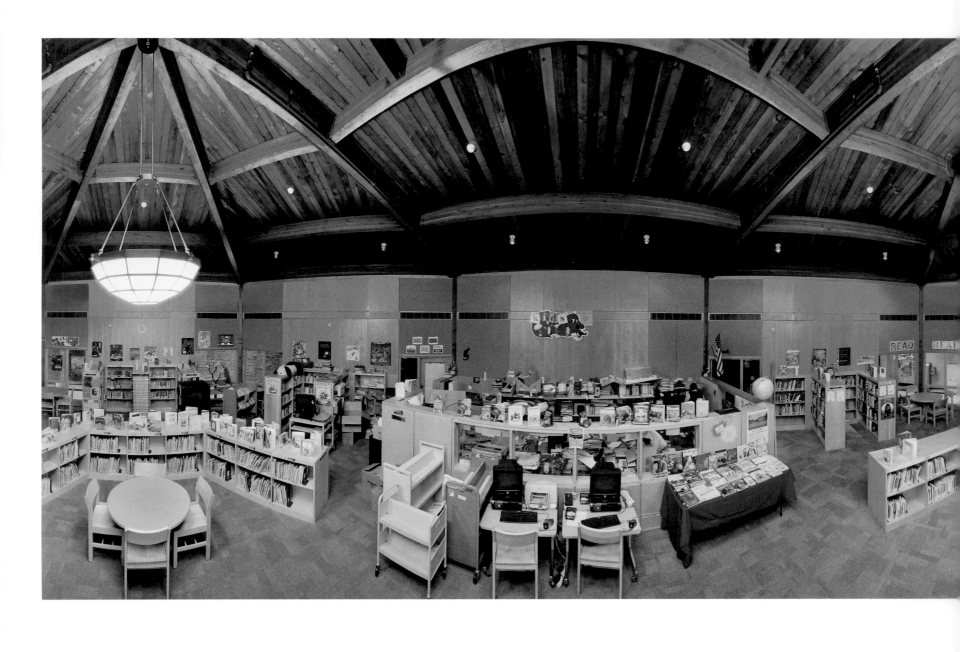

Lillian C. Schmitt Elementary School Library, Columbus, Indiana
The Lillian C. Schmitt Elementary School was constructed as part of a
post–World War II initiative to create new buildings in Columbus, Indiana.
It was funded by the Cummins Foundation and designed by Harry Weese,
a modernist architect influenced by Eliel and Eero Saarinen and responsible
for many Columbus commissions. Completed in 1957, the school shares
characteristics with the Saarinens' Crow Island School in Winnetka, Illinois,
with every room scaled for children's use and created as independent spaces,
and each outfitted with a distinctive pitched roof.

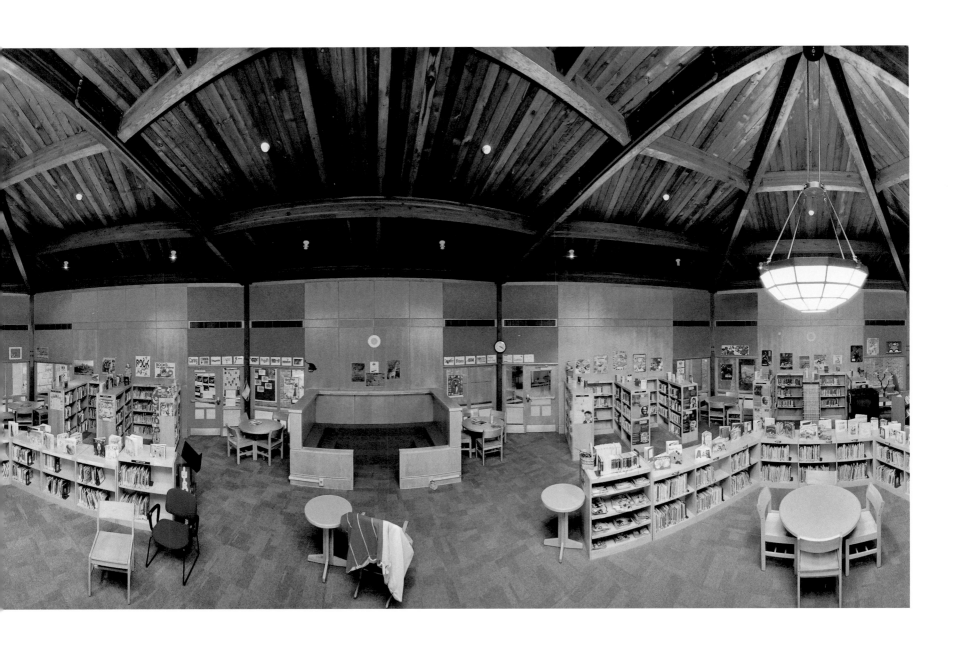

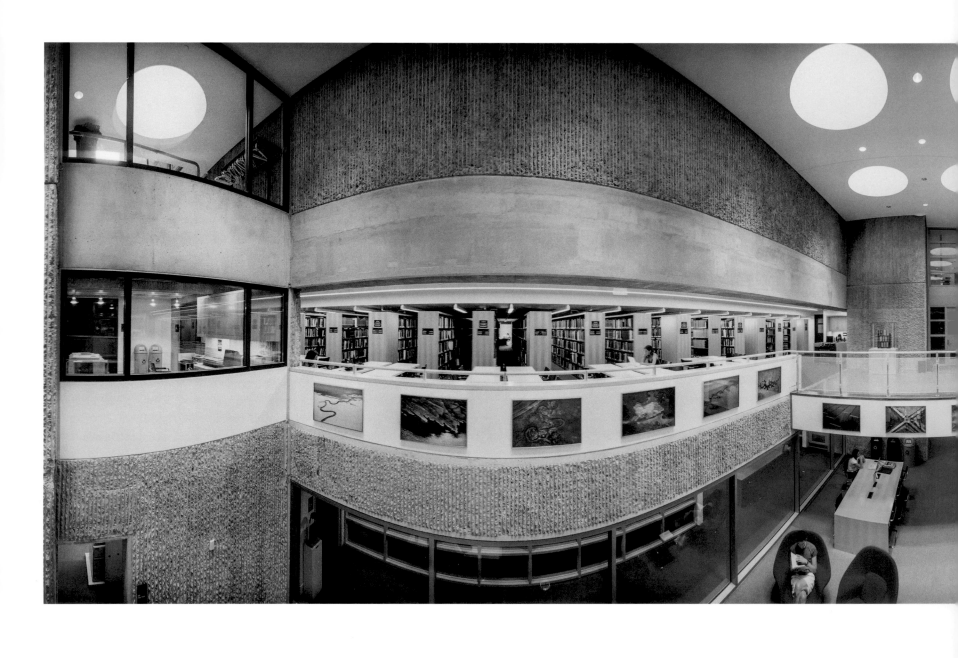

Robert B. Haas Family Arts Library, Yale University, New Haven, Connecticut

The Haas Family Arts Library grew out of a modest collection in the 1870s and later was housed in the Yale Art Gallery. A new building for the School of Art and Architecture, designed by architect and Yale faculty Paul Rudolph, opened in 1963 and was acclaimed as a landmark for his approach, blending Brutalist textures with a postmodern aesthetic. After a fire in 1969, it was restored by Rudolph's former student, architect Charles Gwathmey. The library's collections include the distinctive Faber Birren Collection of Books on Color.

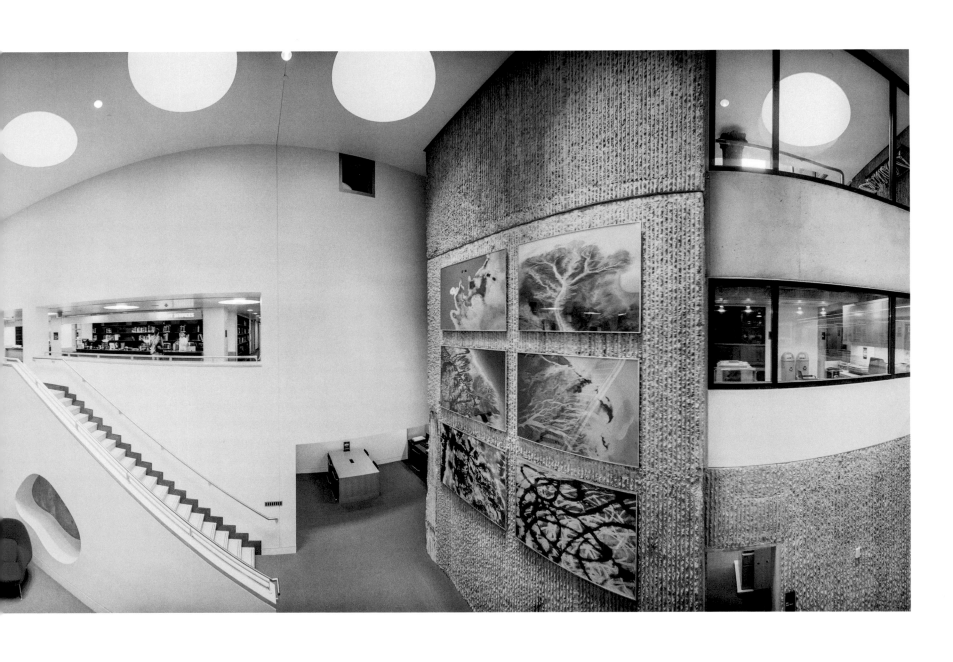

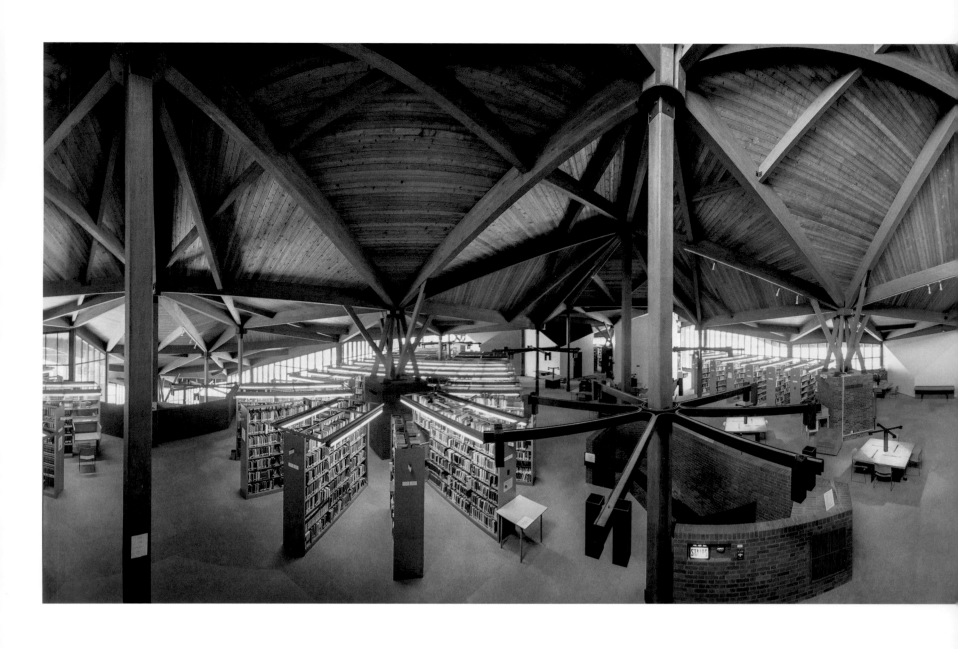

Louis Jefferson Long Library, Wells College, Aurora, New York
The Louis Jefferson Long Library was completed in 1968, marking Wells College's centennial anniversary. Its modern design, by recognized Chicago architect Walter A. Netsch Jr., embodies Netsch's distinctive approach known as "field theory," an adaptable use of geometric structures tailored to the building's surrounding environment. Its brick and timber structure overlooks nearby Cayuga Lake while its open design accommodates over 218,000 volumes and around three hundred students throughout its common areas and quiet nooks.

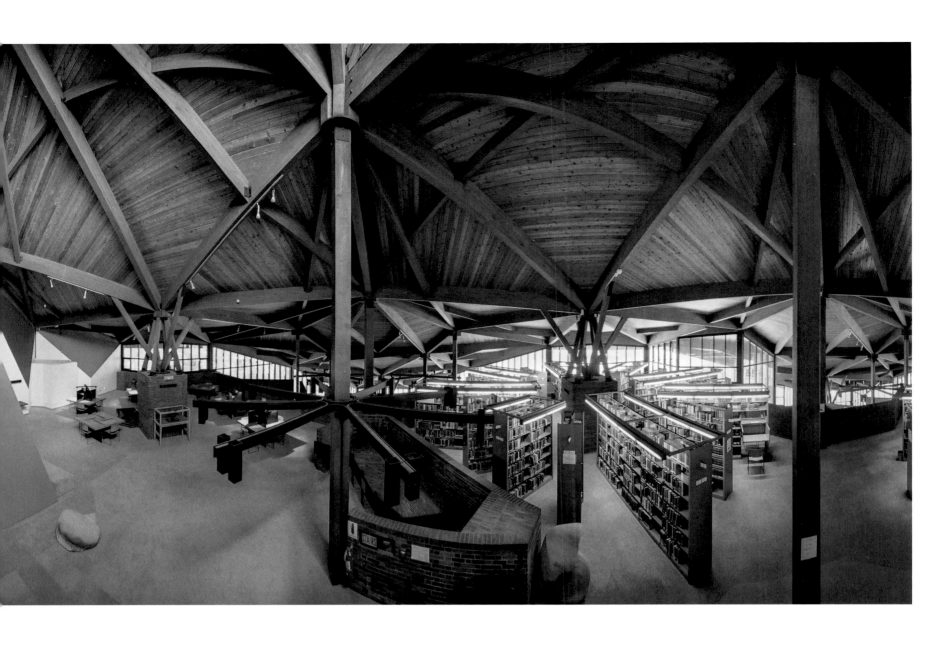

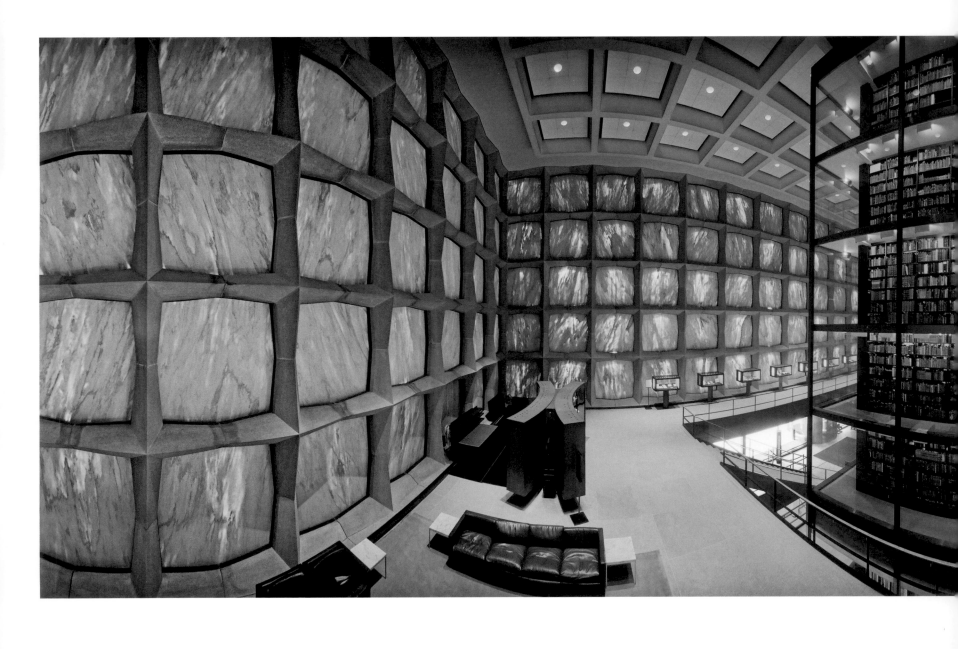

**Beinecke Rare Book and Manuscript Library, Yale University,
New Haven, Connecticut**

The Beinecke Rare Book and Manuscript Library has housed Yale University's
rare books and manuscripts since its completion in 1963. Its unique construction
and materials—an exterior grid of translucent slabs of Vermont marble framed
by granite, and a rectangular glass structure housing the books within the
building—provide the adequate light conditions to view rare materials without
damage. The library permanently exhibits a Gutenberg Bible, the first Western
book printed from movable type, and John James Audubon's *Birds of America*.

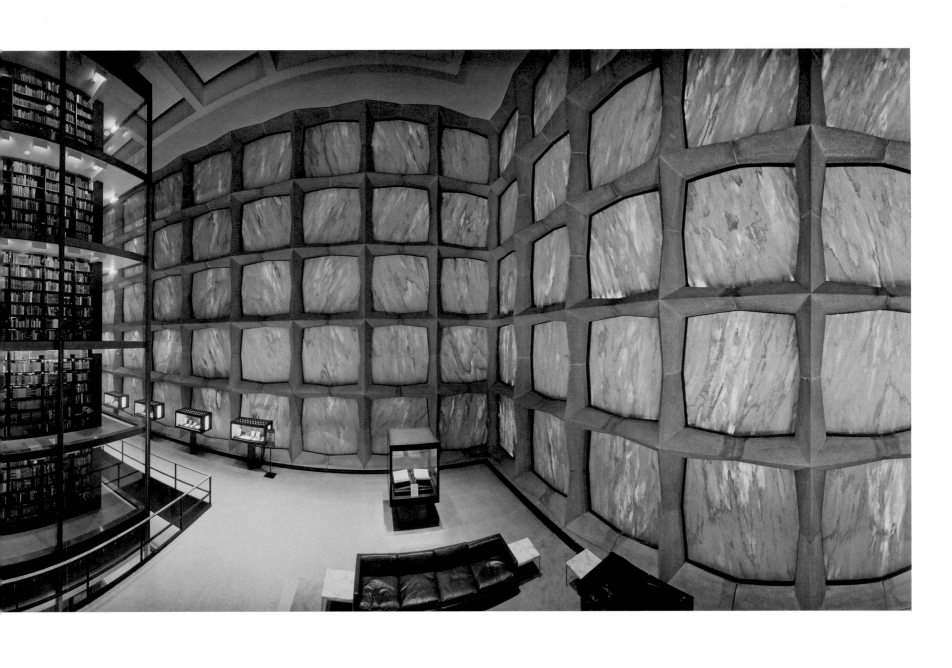

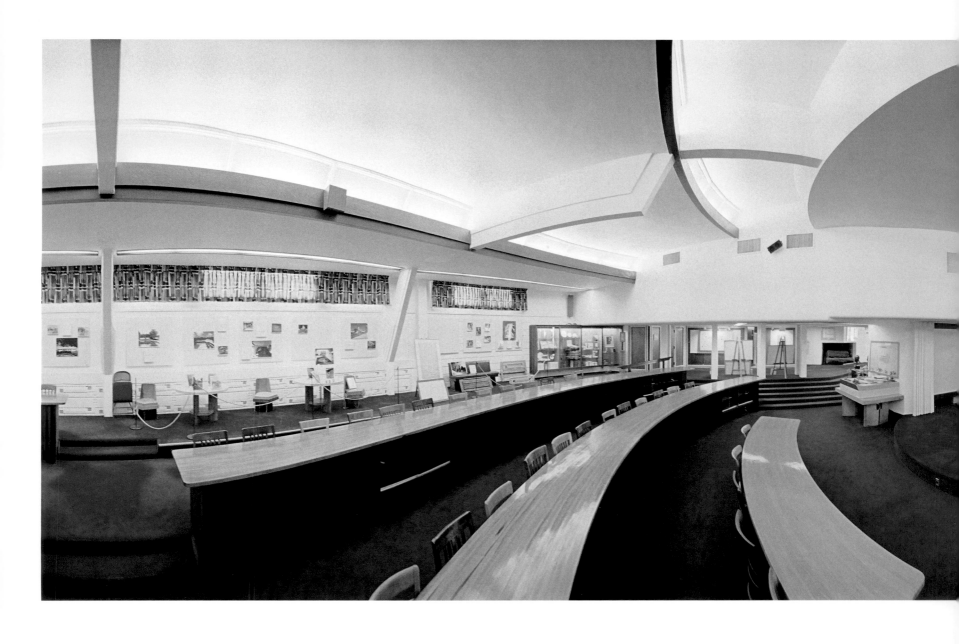

Roux Library, Florida Southern College, Lakeland
The Roux Library at Florida Southern College was designed by Nils Schweizer, an influential Florida architect and student of Frank Lloyd Wright, who had supervised some of Wright's buildings on campus. The original Roux Library, completed in 1946 from Wright's design, was repurposed and renamed when the new Roux Library was inaugurated in 1968. The new library, built near the Wright-designed water dome at the highest point of the campus, can accommodate over four hundred students between its carrel seats, study areas, and meeting rooms.

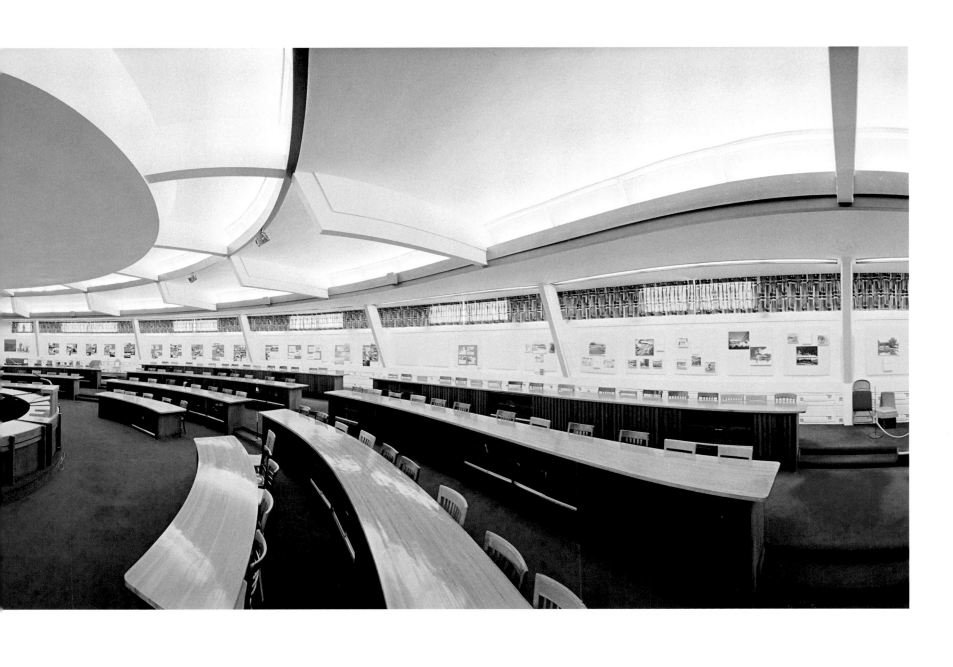

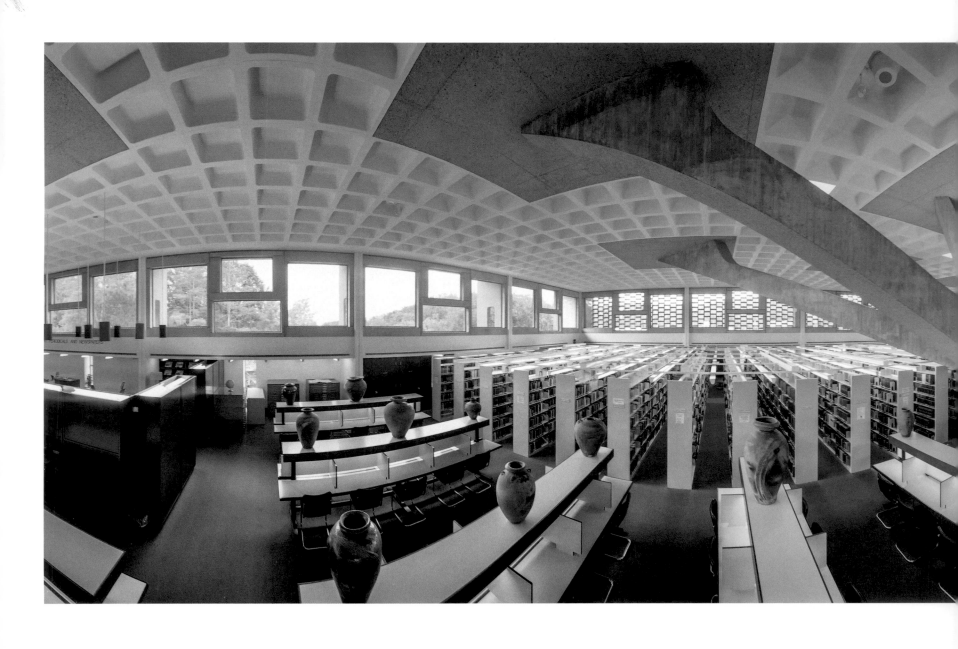

Alcuin Library, Saint John's University, Collegeville, Minnesota
The Alcuin Library at Saint John's University was designed by Bauhaus architect
Marcel Breuer and dedicated in 1966, one of several buildings on the campus
by Breuer. Its vast holdings include special collections of artists' books, the Proulx
collection of sacred music, and the historic Saint John's rare book collection.
The library underwent renovations in 2016 with the goal of producing a more
welcoming environment for students by creating more open floor space. It plans
to reopen in the spring of 2017.

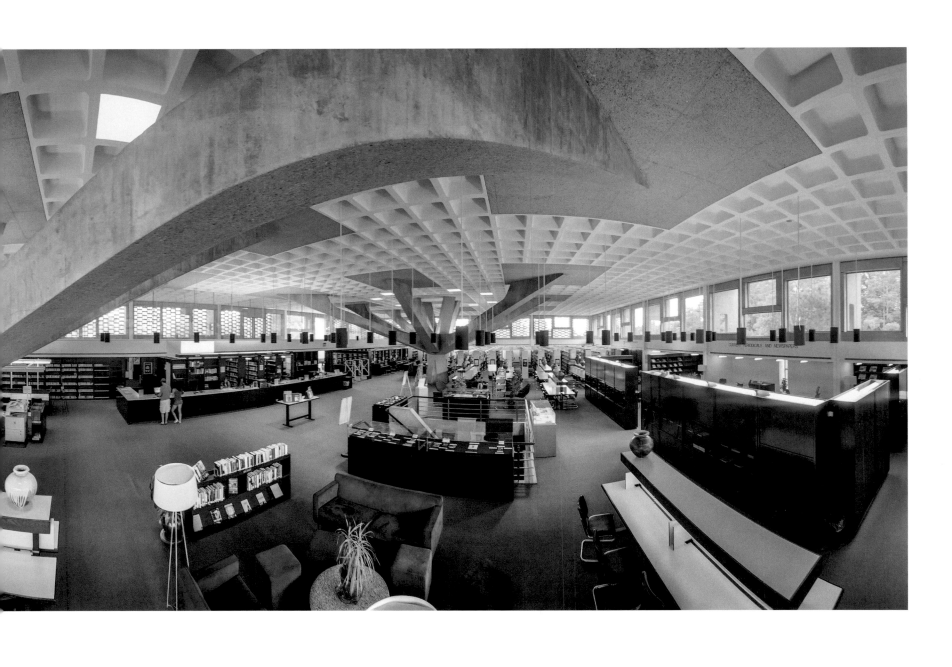

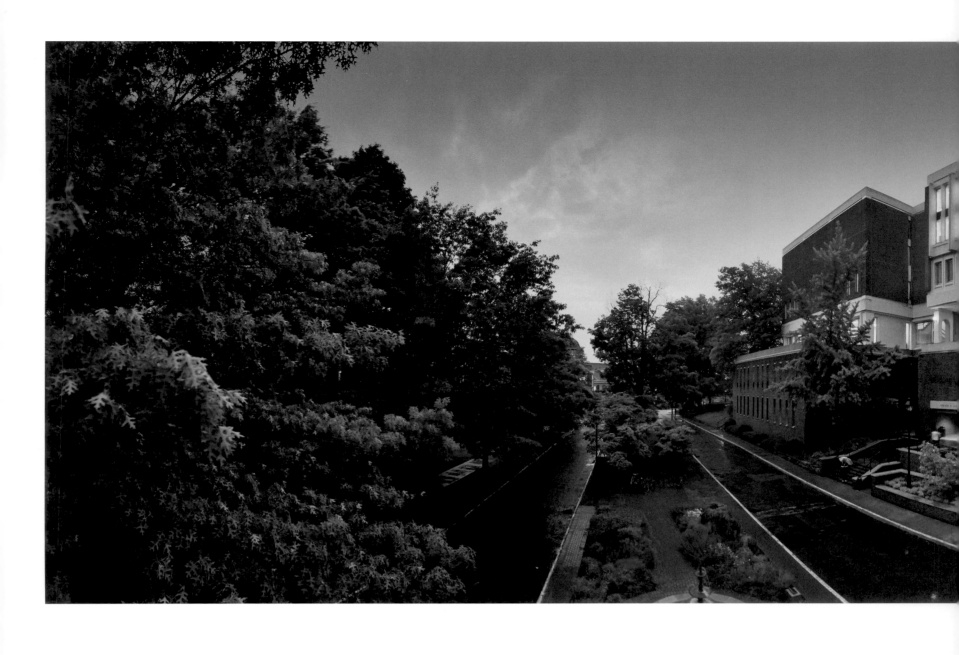

Alden Library, Ohio University, Athens
The Library of Ohio University was originally established in 1814. Today the Alden Library includes rare, early books and unique treasures such as the Coonskin Library, one of the first circulating libraries, founded in 1804 in nearby Ames, Ohio. Concerned about the education of their children, local residents accumulated animal furs to sell in order to purchase books. The sale yielded seventy-something dollars, good for fifty-one books selected by Manasseh Cutler, one of the university's founders.

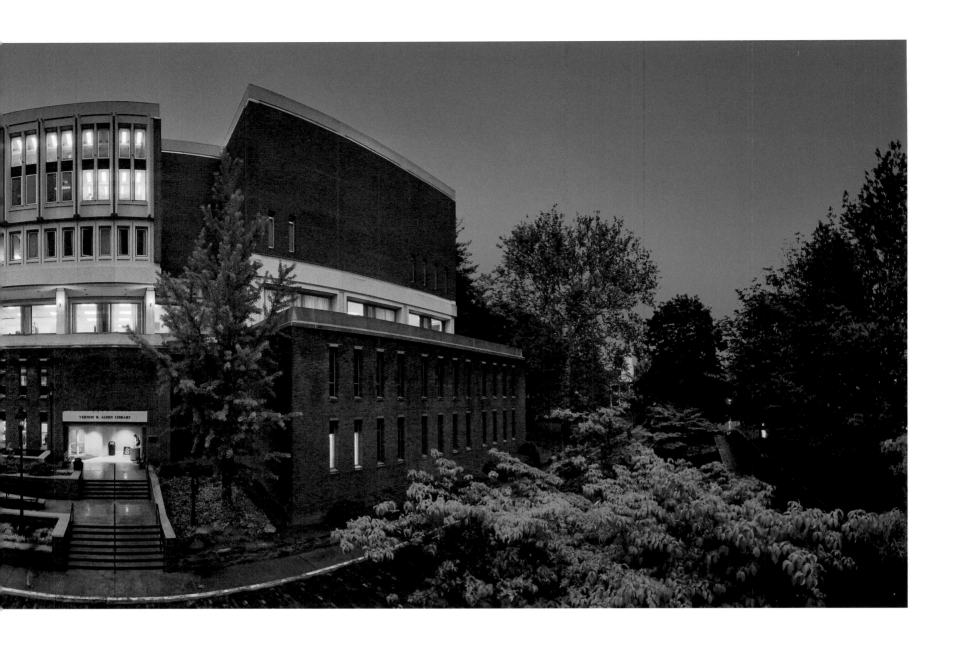

Following pages
Geisel Library, University of California, San Diego, La Jolla
Named after Audrey and Theodor "Dr. Seuss" Geisel, the library honors the popular children's book author through its Dr. Seuss Collection, which is a part of its Mandeville Special Collections, and contains original sketches, manuscripts, and memorabilia related to the La Jolla cult figure. Situated at the center of the university campus, the library occupies a distinctive building designed by American architect William Pereira, which combines aspects of Brutalism and Futurism into a structure that has been described as alien and otherworldly.

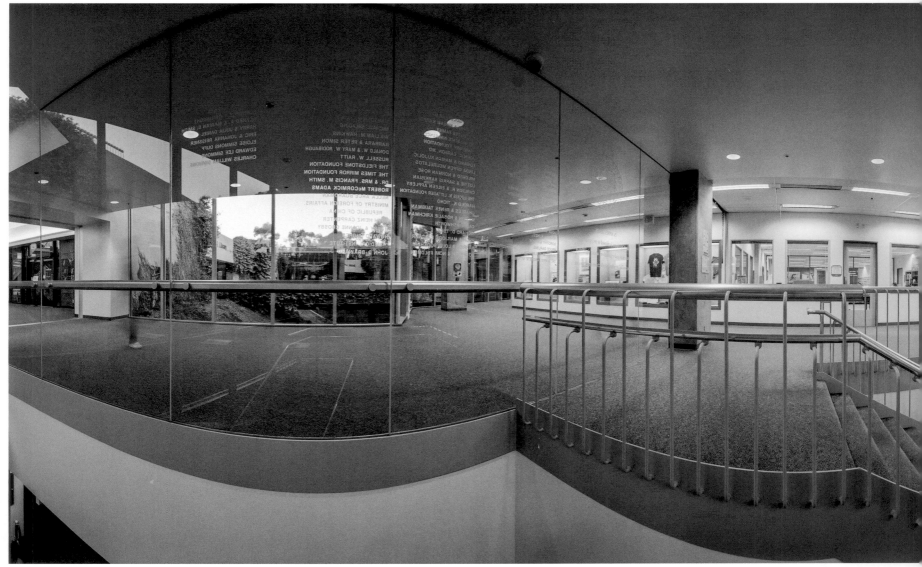

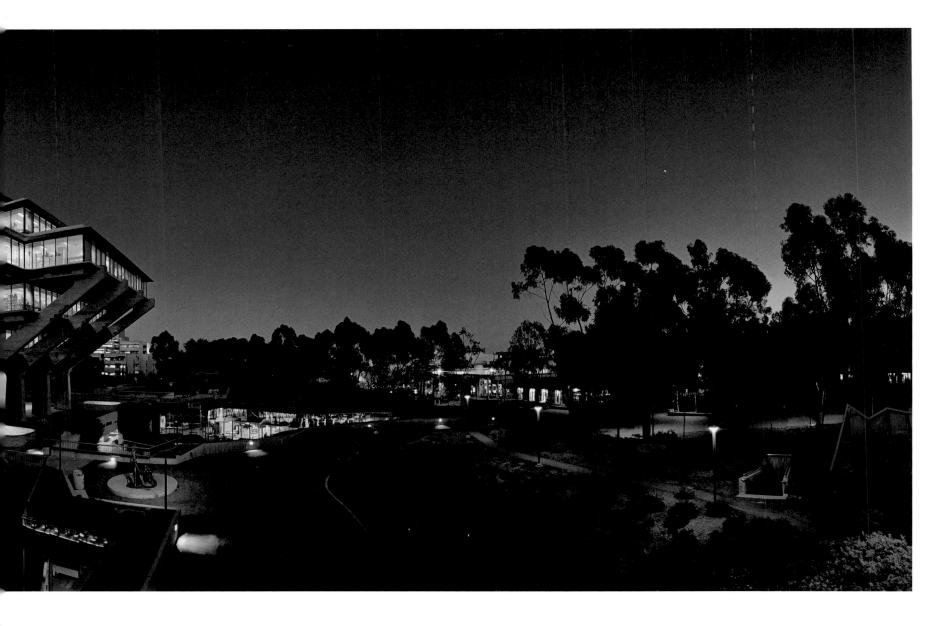

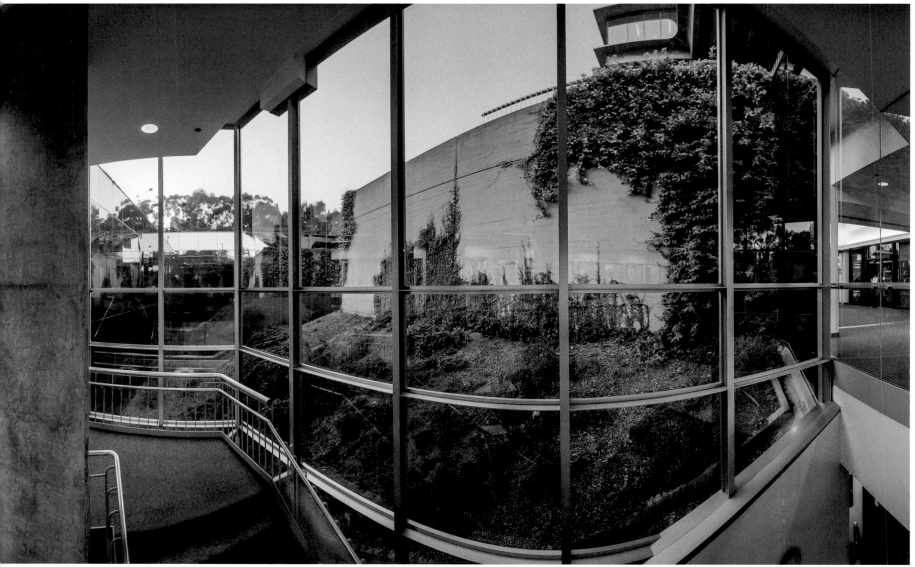

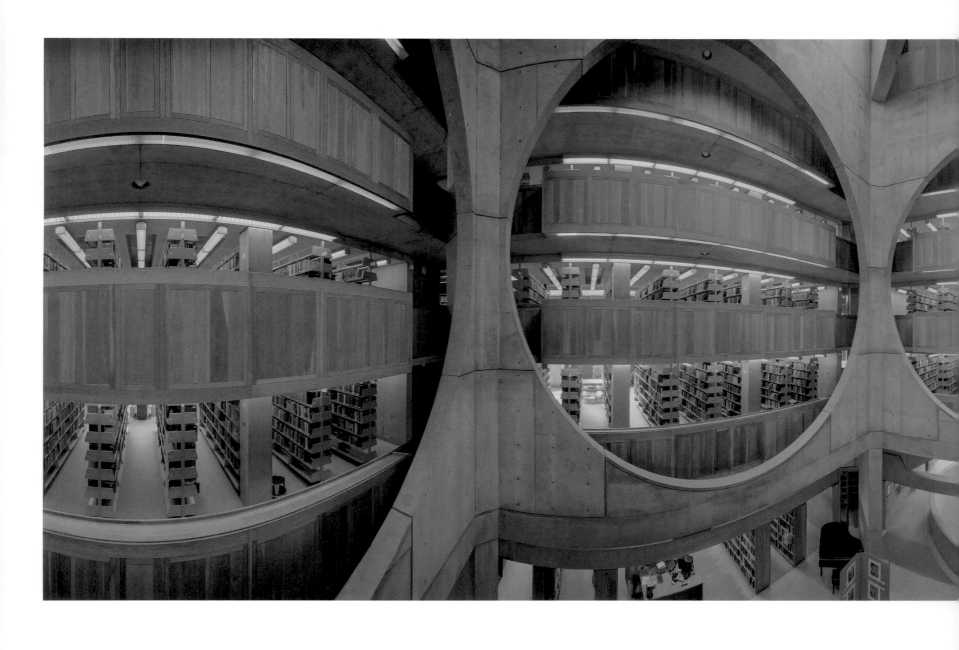

Phillips Exeter Academy Library, Exeter, New Hampshire
The library at Phillips Exeter Academy, the largest secondary-school library
in the world, was founded in 1905. Its current structure, completed in 1971
and designed by Louis I. Kahn, is considered one of the architect's best—
one where he used his own design principles to satisfy the school's specific
requests, which included using local Exeter brick. The library's Lamont Poetry
series, begun in 1983, invites two poets per year to give readings and attend
classes; the first to participate was Jorge Luis Borges.

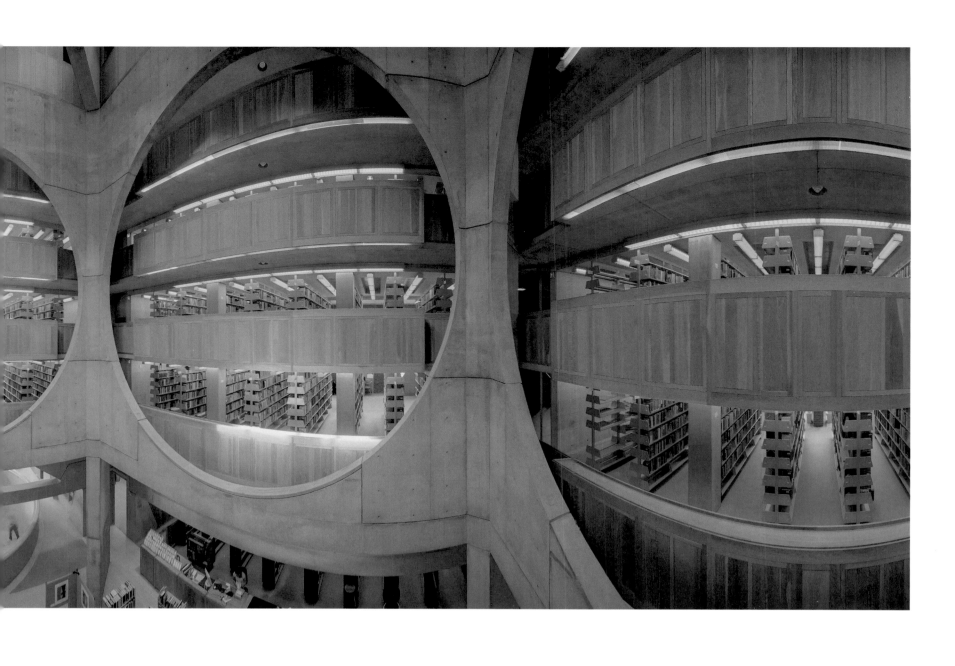

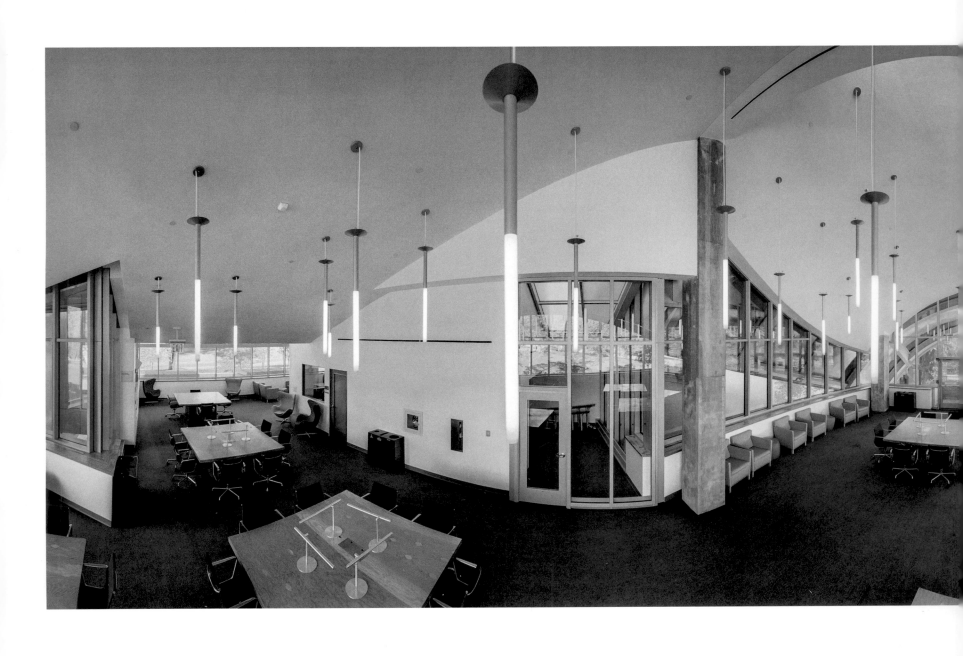

Lewis Science Library, Princeton University, New Jersey
Designed by architect Frank Gehry, the Lewis Library is located in the heart
of Princeton University's "science neighborhood," and offers collections
specialized in astrophysics, behavioral sciences, biology, chemistry, geosciences,
mathematics, physics, and maps. Inaugurated in 2008, the colorful building
is meant to mirror the character of the students who use it. "Scientists who
are focused on complex issues may find that the abstract landscape of the
building will stimulate their imagination and perhaps lead them to thinking
outside the box," said Gehry.

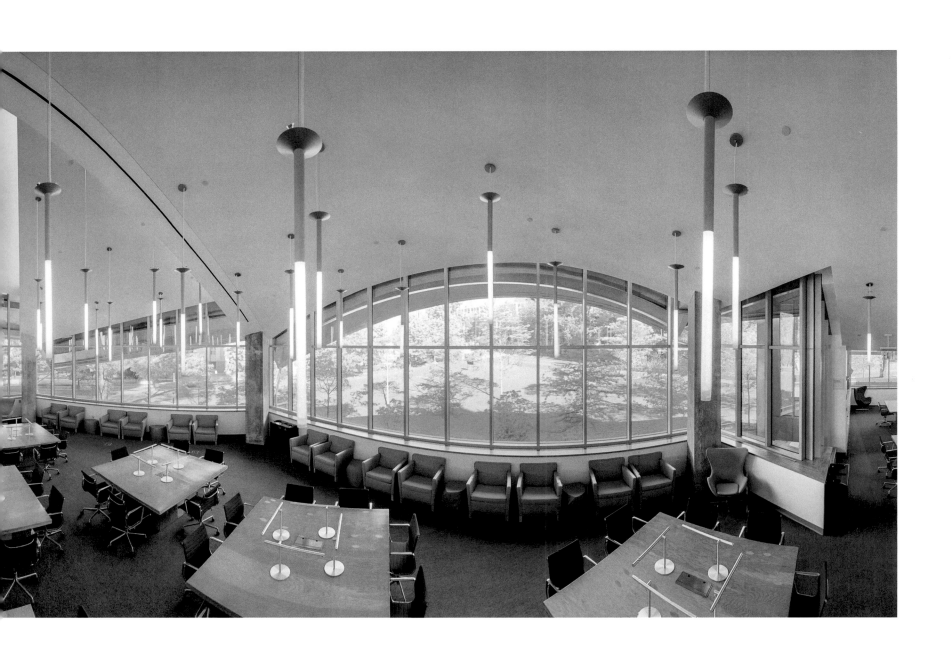

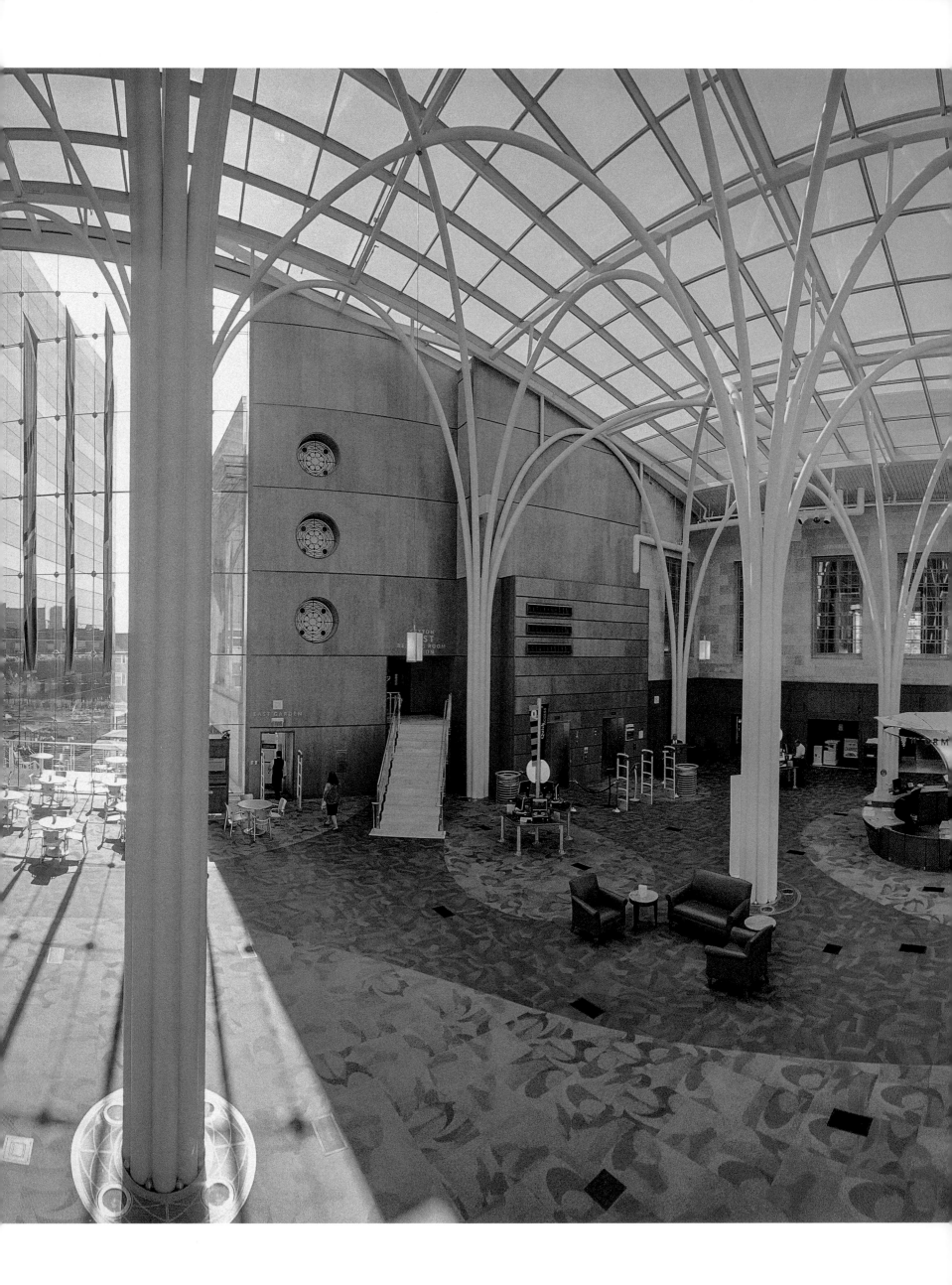

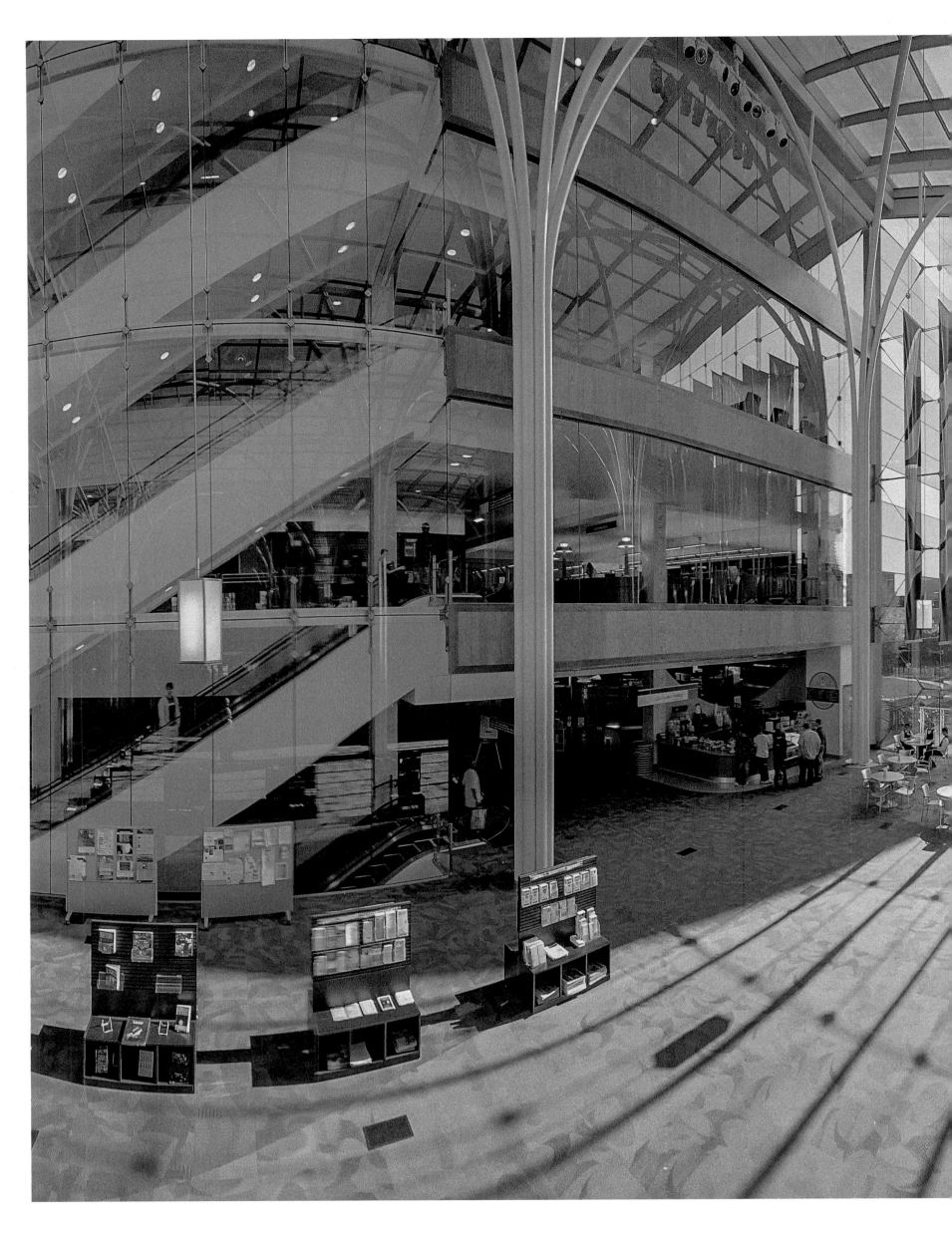

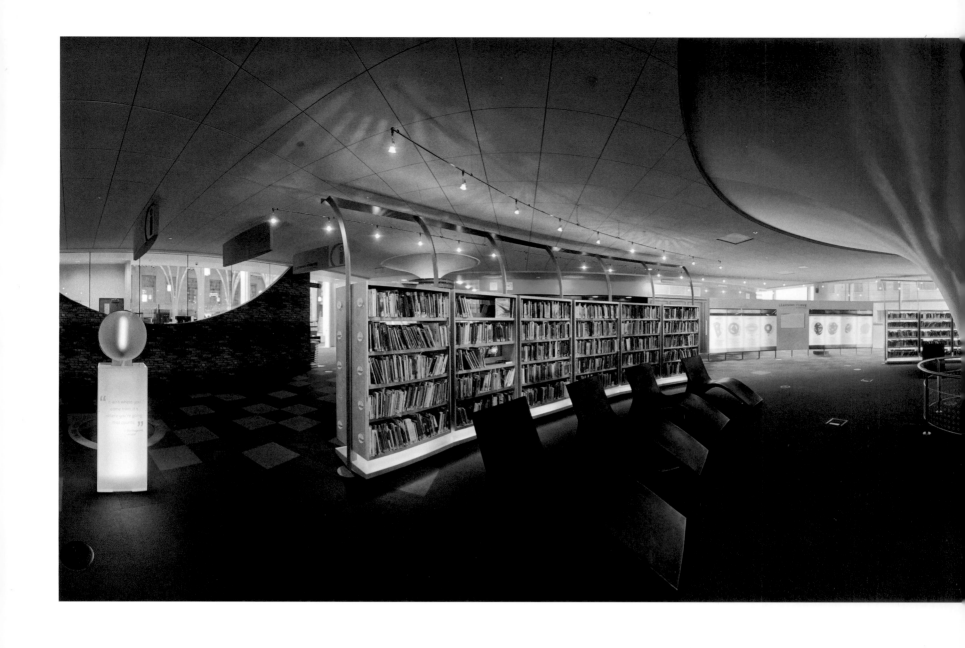

Above and gatefold

Indianapolis Public Central Library

Founded in 1873, the Indianapolis Public Library has since expanded to include a Central Library building, constructed downtown near the Indiana World War Memorial Plaza, and twenty-two county branches. The expansion of its central branch, originally built in a Greek-Doric style in 1917 following architect Paul Philippe Cret's design, was concluded in 2007. The library today offers extensive digital collections, attracts over four million visitors each year, and circulates nearly sixteen million items.

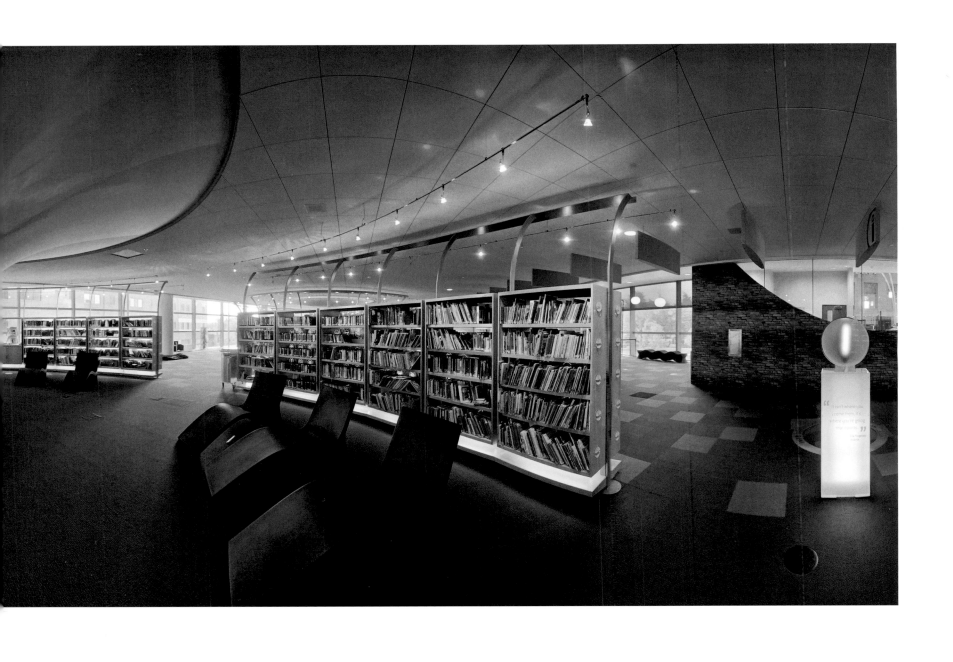

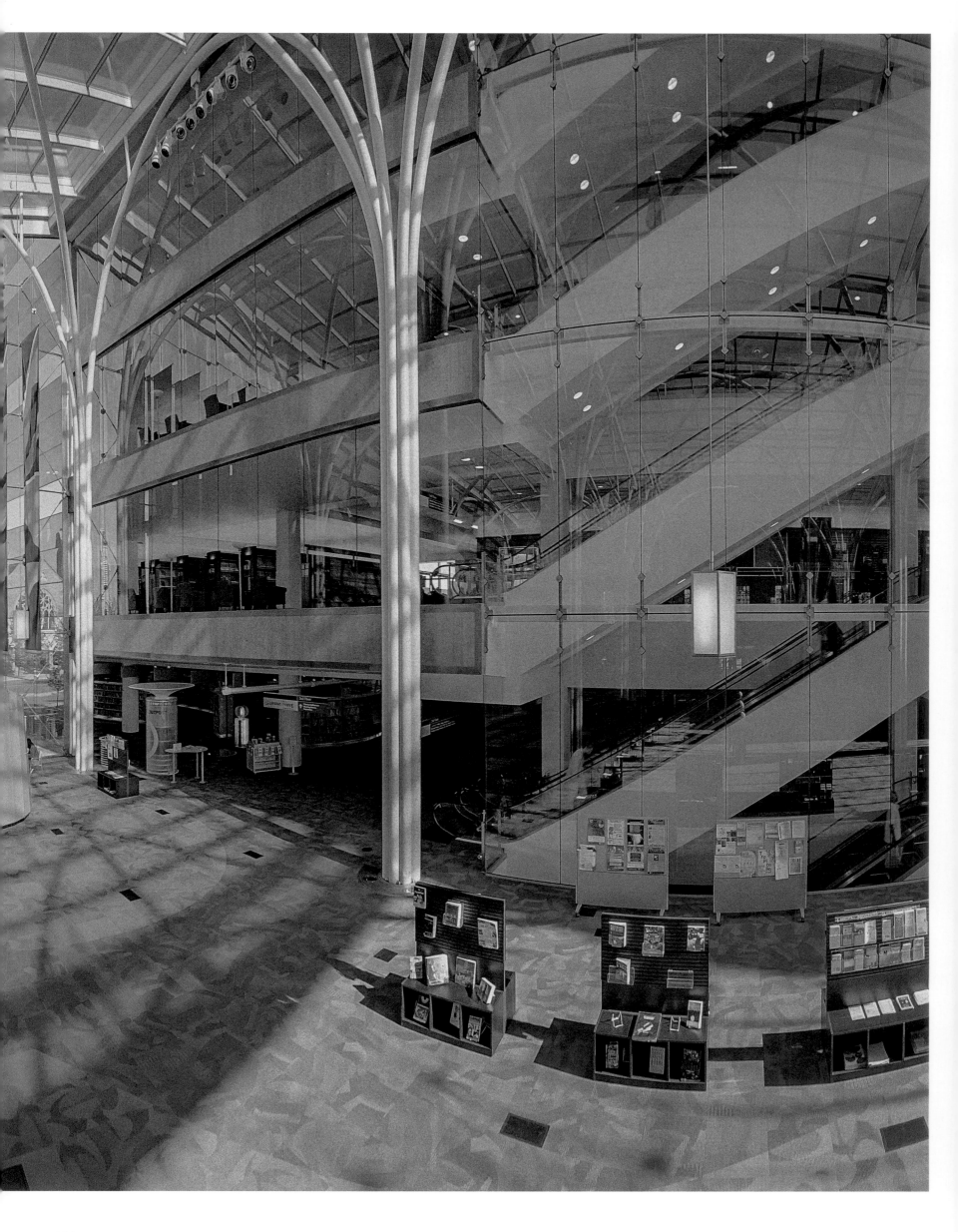

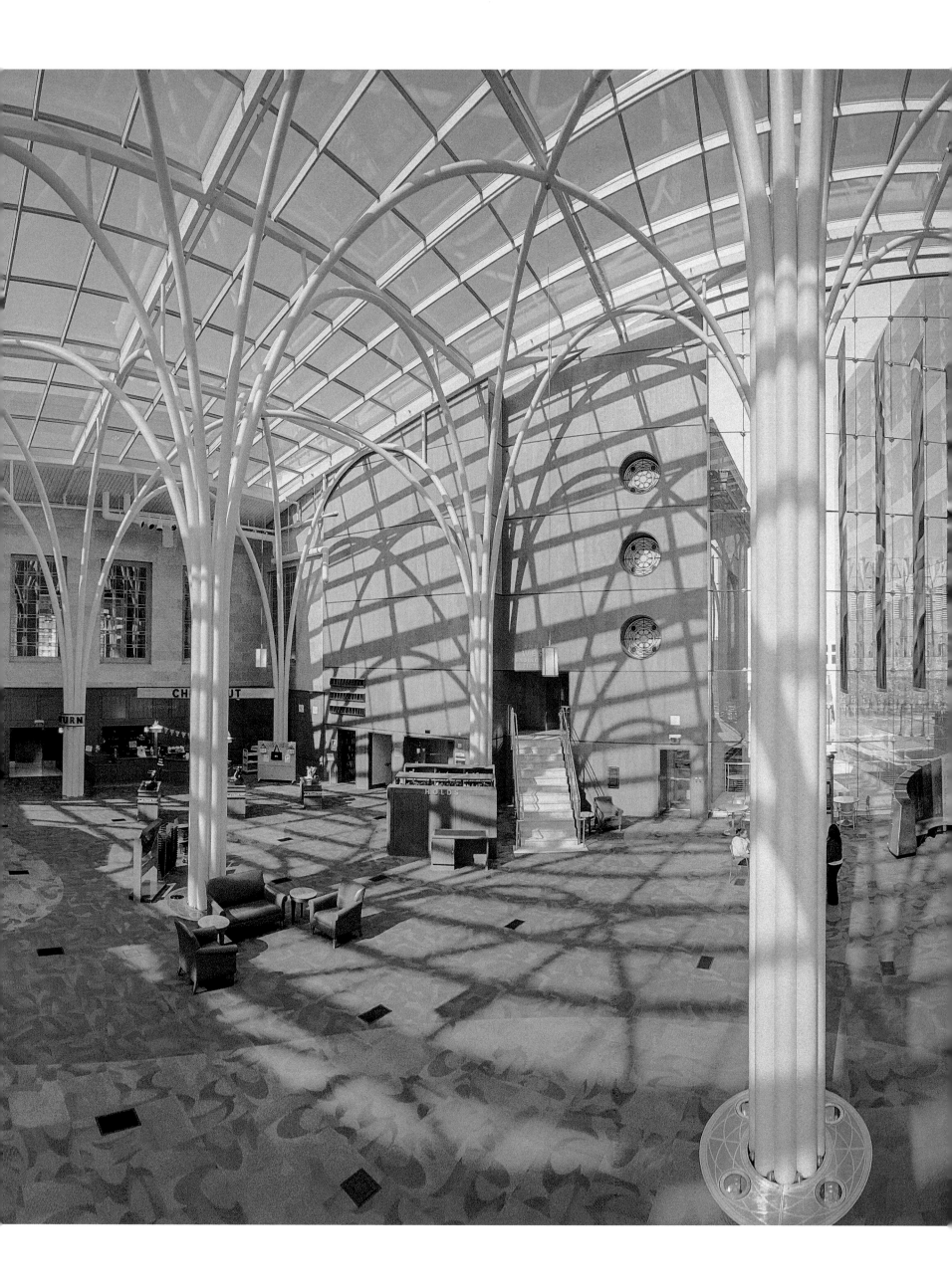

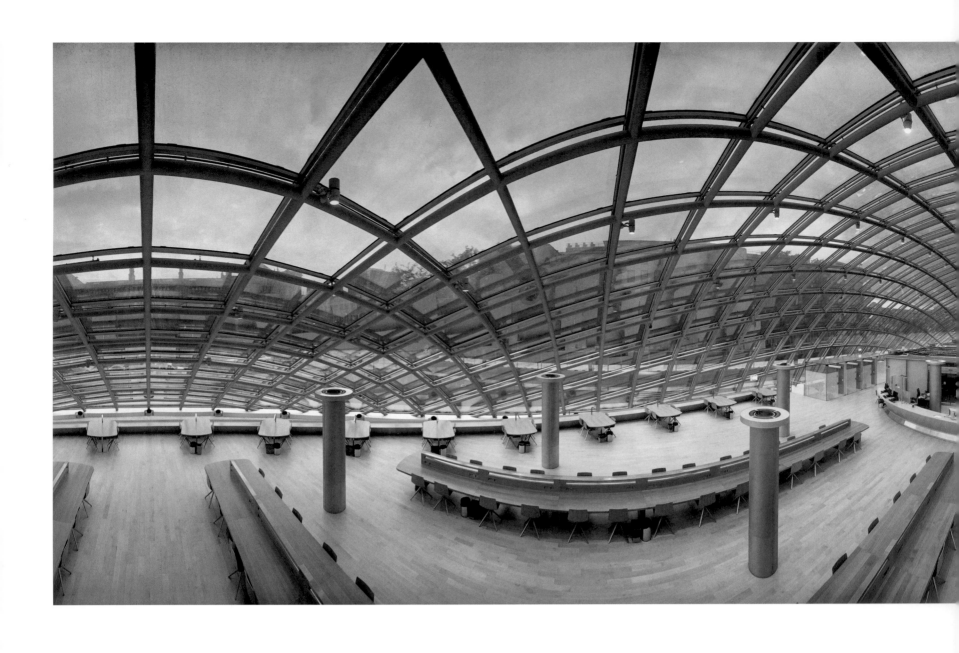

Joe and Rika Mansueto Library, University of Chicago
Open since 2011, the Mansueto Library features a distinctive elliptical glass
dome above its Grand Reading Room. In addition to high-tech conservation
and digitization facilities, the library features a below-ground automated
storage and retrieval system that can hold 3.5 million volumes. Designed by
German American architect Helmut Jahn, the building has earned important
recognitions, including a Distinguished Building Citation of Merit by the
American Institute of Architects' Chicago chapter and a Patron of the Year
Award by the Chicago Architecture Foundation.

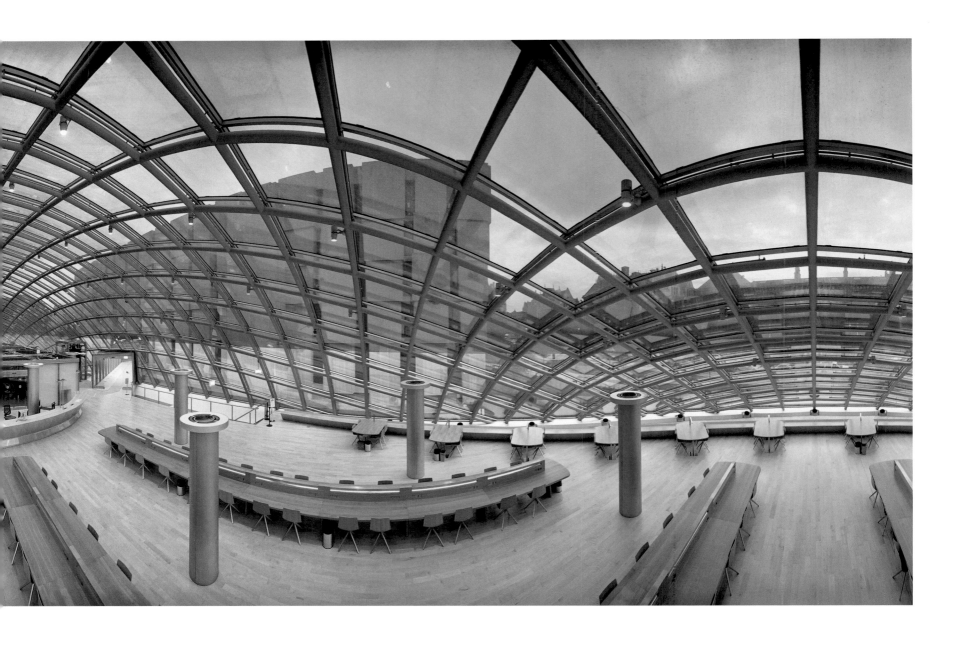

Following pages
Seattle Public Library
The Seattle Public Library is known today for its iconic eleven-story glass-and-steel building designed by Dutch architect Rem Koolhaas, inaugurated in 2004. The asymmetrical structure features multipurpose areas, a fifty-foot-tall reading room, and an innovative "book spiral" system that allows for volumes to be arranged in a continuous and thematically organic manner without interruption, following the Dewey decimal system. The building's lattice-like exterior structure creates a beautiful and dynamic play of light and shadow inside the library's different spaces.

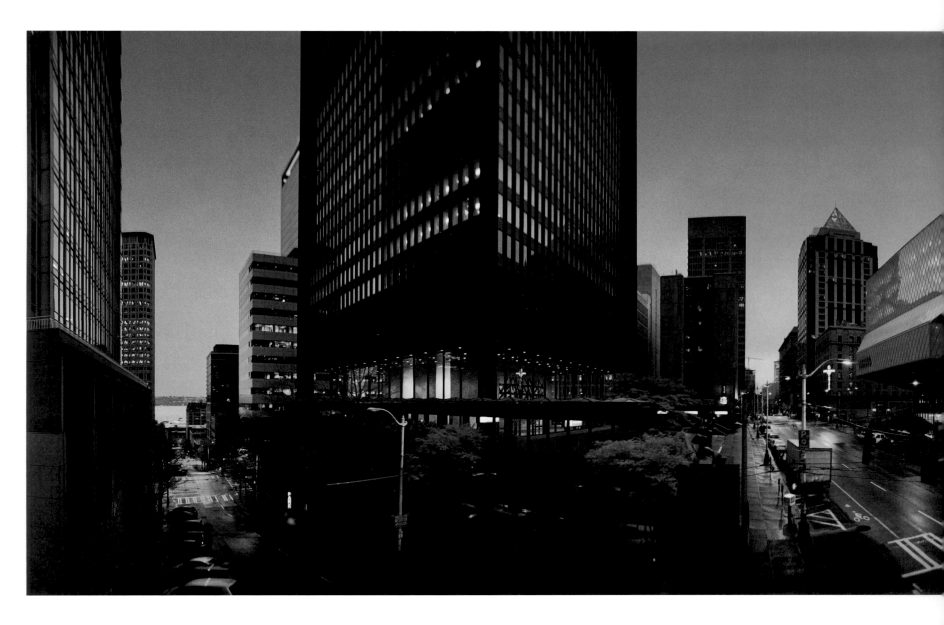

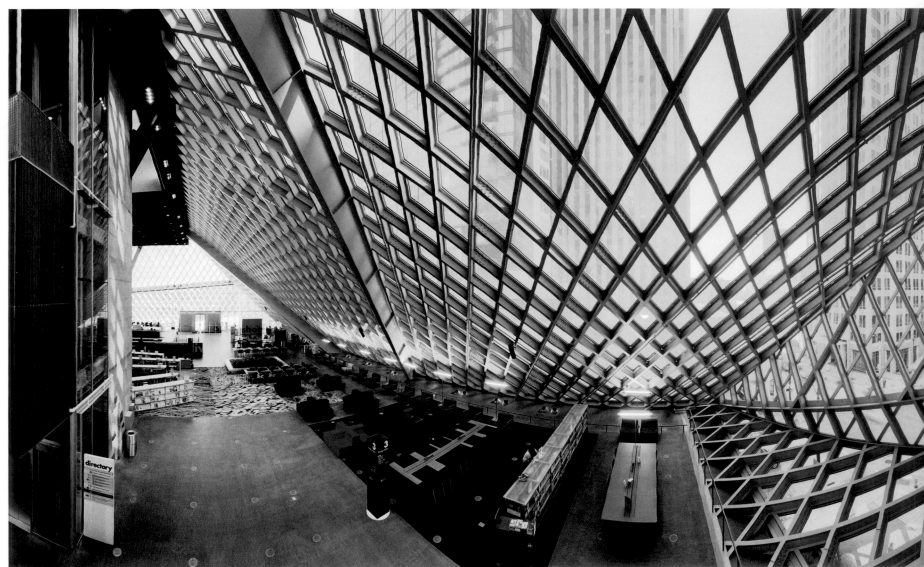

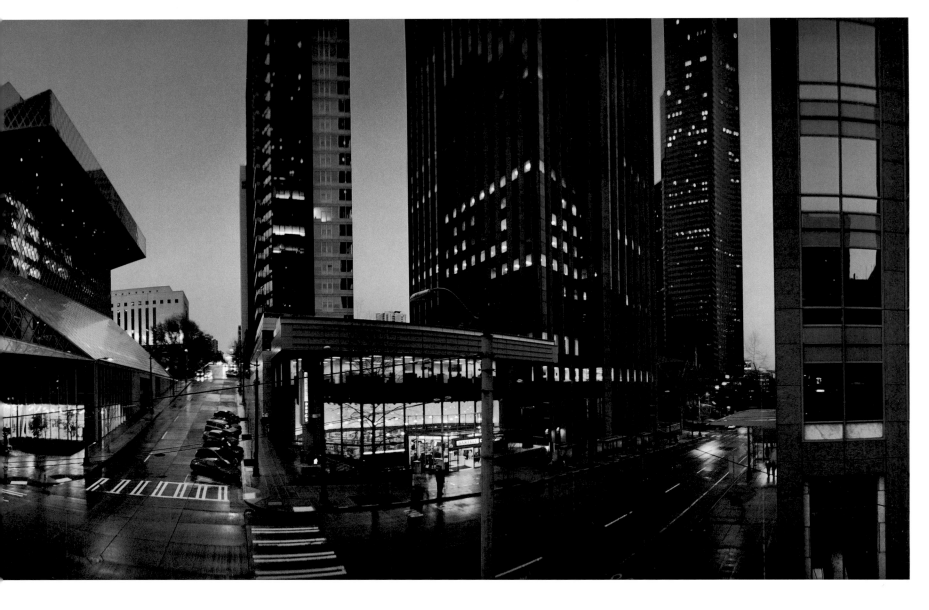

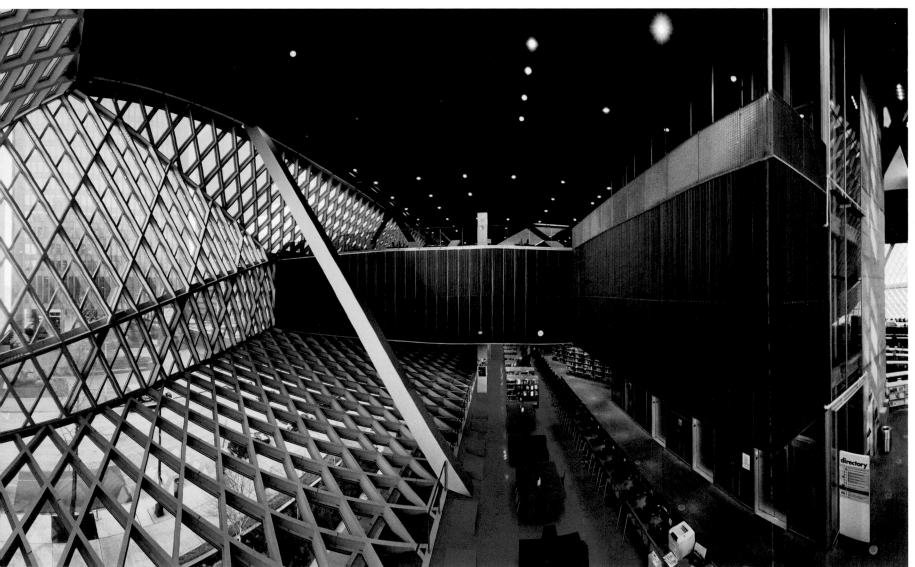

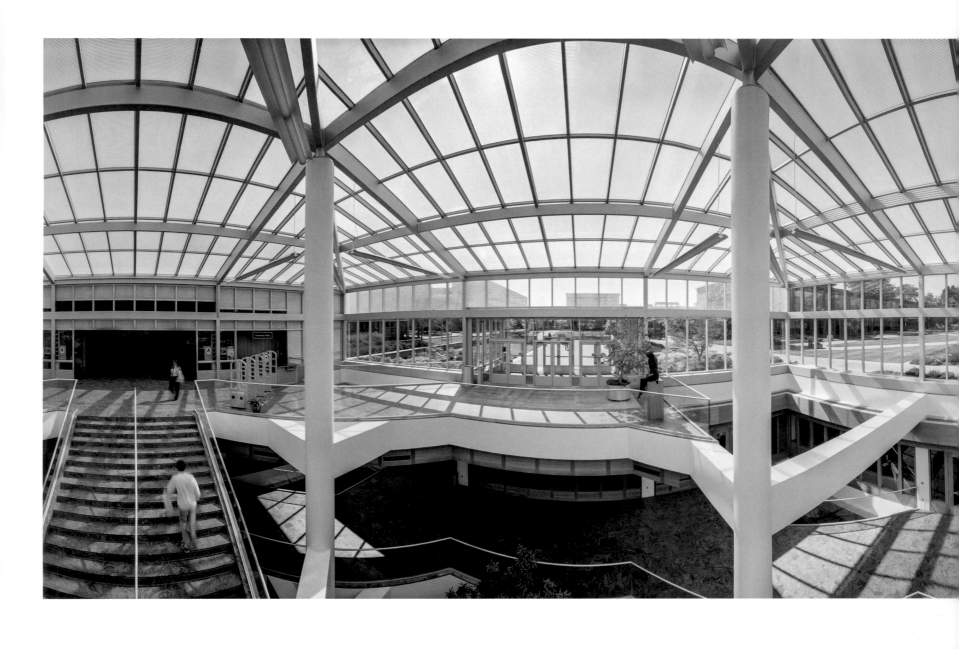

Harold B. Lee Library, Brigham Young University, Provo, Utah
The Harold B. Lee Library is the academic library of Brigham Young
University, the largest religious, private university in the United States.
Characterized by continuous growth, the library's most recent expansion
was completed in 2000. Its numerous special collections include manuscripts
from the nineteenth, twentieth, and twenty-first centuries focused on the
American West with an emphasis on Latter-Day Saints (Mormons), as well
as the Women's Manuscript Collection, which concentrates on the lives, roles,
and accomplishments of women in Utah, within Mormonism, and in the West.

Following pages
John Spoor Broome Library, CSU Channel Islands, Camarillo, California
Completed in 2008, the John Spoor Broome Library occupies an award-winning modern building by British architect Norman Foster. The new, contemporary glass structure incorporates some of the original buildings of the former Camarillo State mental hospital and stands out among the campus's colonial-style buildings. The library's special collections include the Robert J. Lagomarsino Collection, consisting of papers, photographs, and memorabilia relating to the political trajectory of the California Senate member and U.S. Congressman, and the Irene and Jorge Garcia Chicano/a Studies Collection, among others.

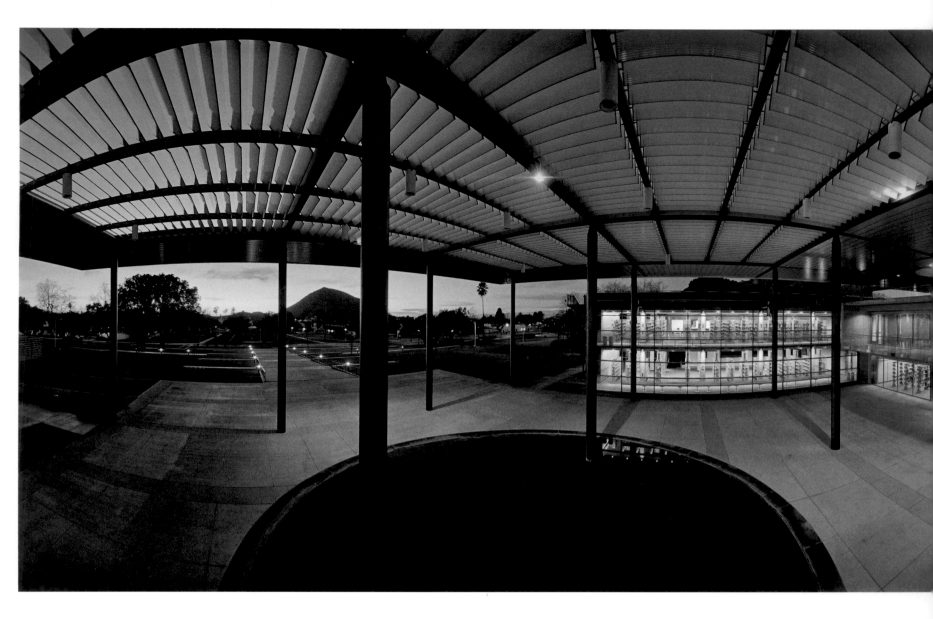

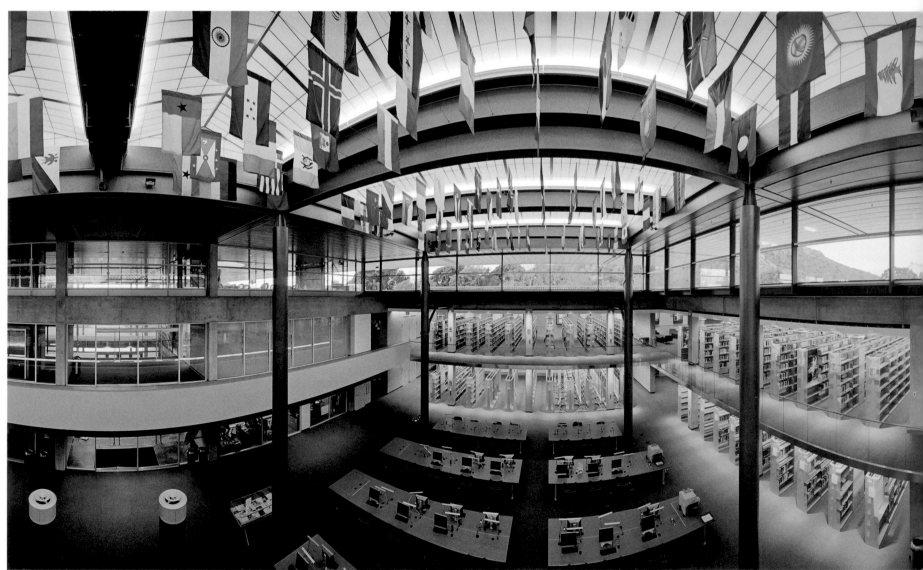

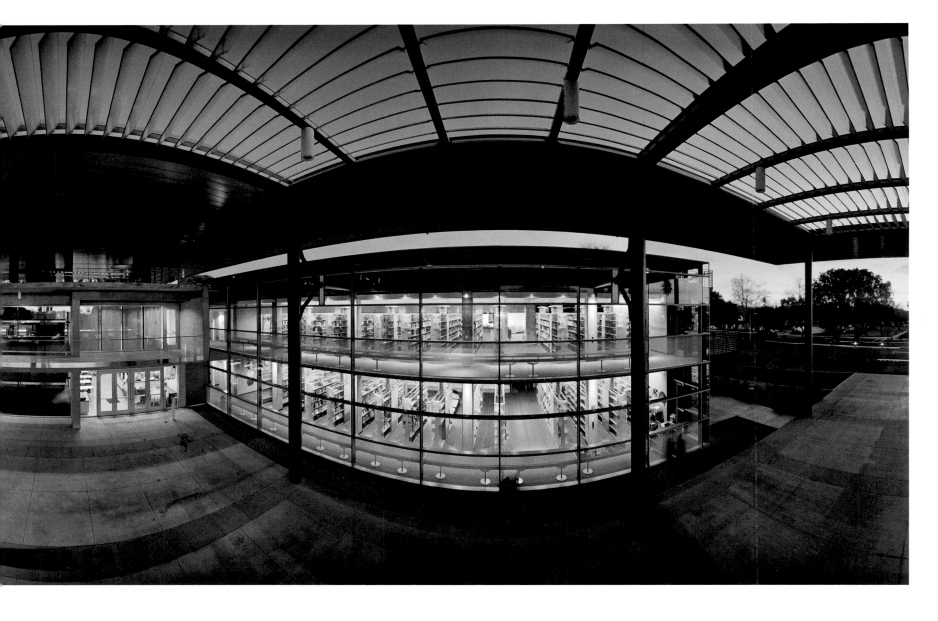

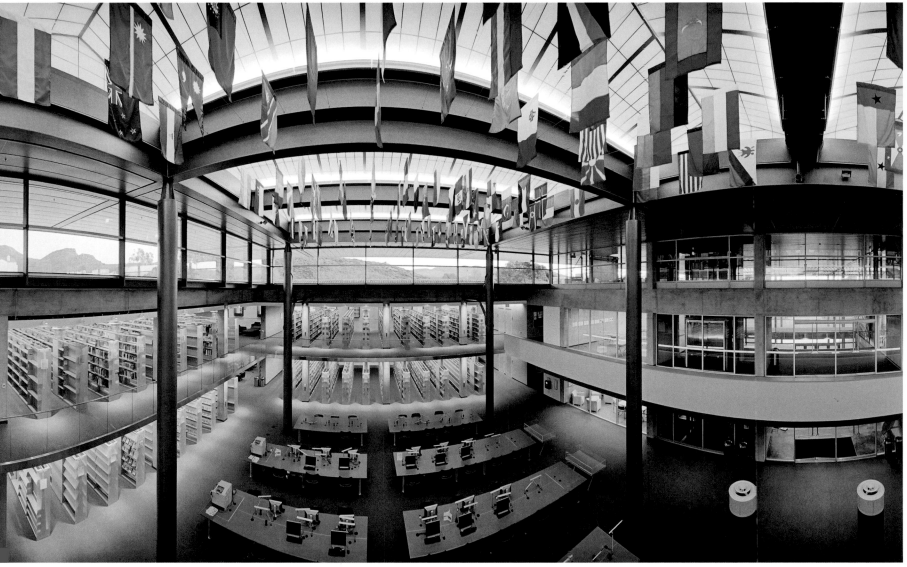

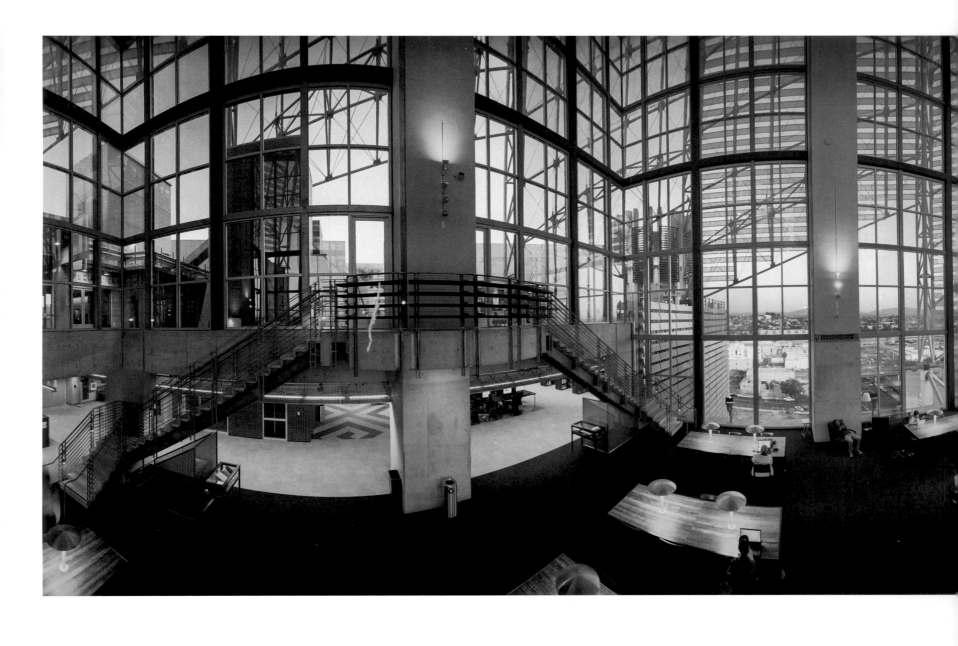

San Diego Public Library Reading Room
The Reading Room of the San Diego Public Library, dubbed "The People's Penthouse," is a three-story glass room with scenic views, part of a new state-of-the-art library building inaugurated in San Diego's East Village in 2013. The reading room includes a sixteen-foot chandelier made of copper cloth and resin panels, while its large tables, chairs, and repurposed furniture were designed by artist Roy McMakin. The room's light-filled interior harks back to the San Diego Carnegie Library, demolished in 1952, whose design called for abundant natural light.

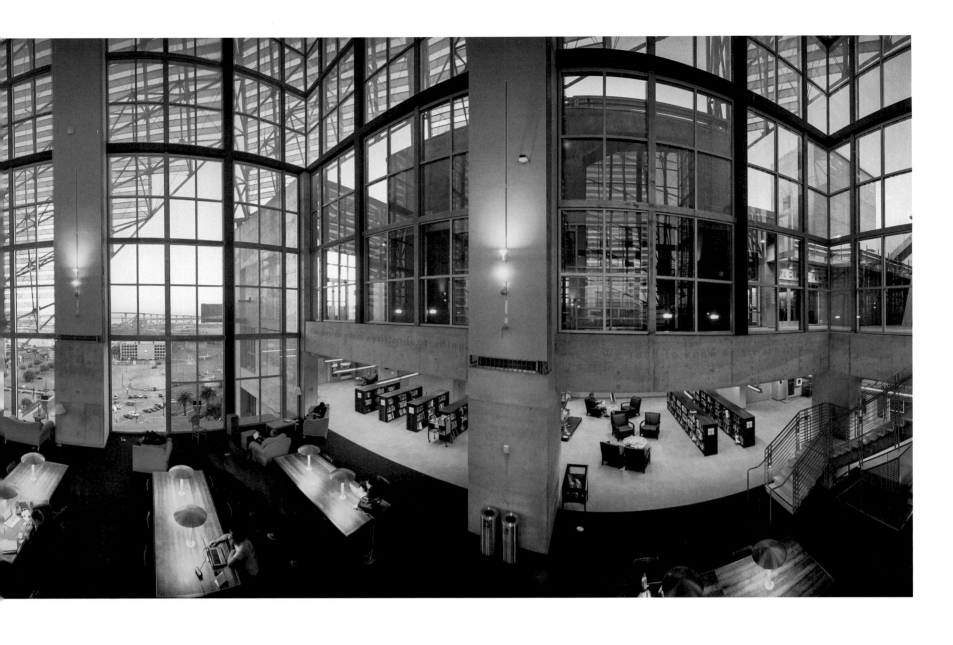

Following pages
Salt Lake City Public Library
The first Free Public Library of Salt Lake City opened in 1898. In 1998, marking the library's centennial, the city approved an $84 million bond for the construction of a new main library. Conceived by architect Moshe Safdie and others, the new six-story, triangular building includes a curving, ascending exterior wall that doubles as a ramp from the public plaza to a rooftop garden. The building has received many accolades, including the distinction of Library of the Year in 2006 from *Library Journal*.

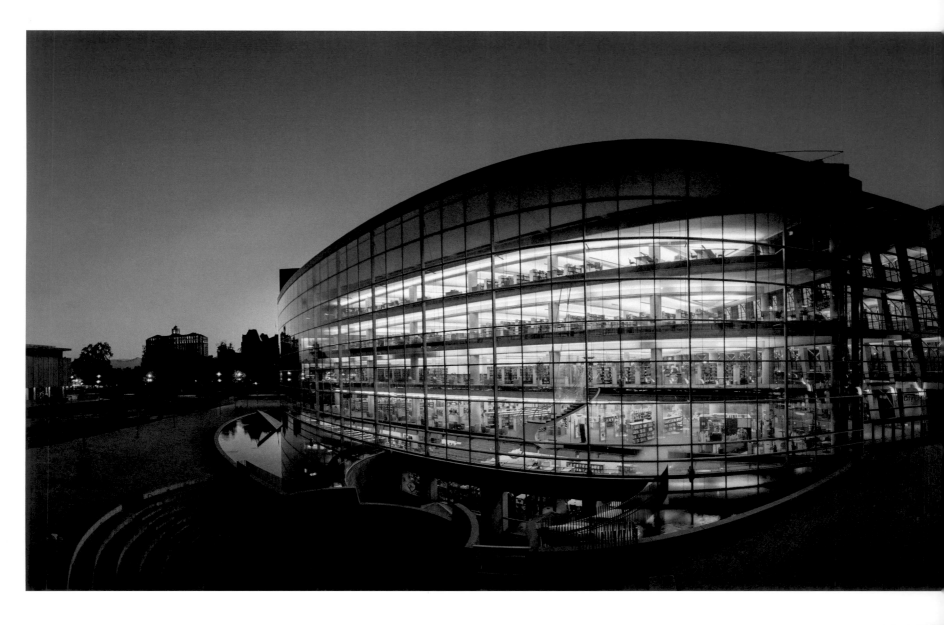

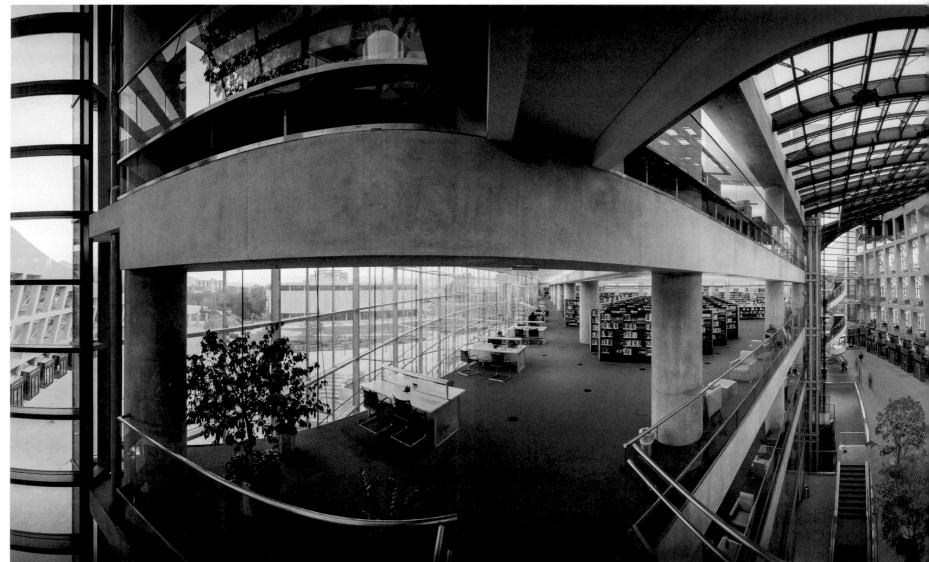

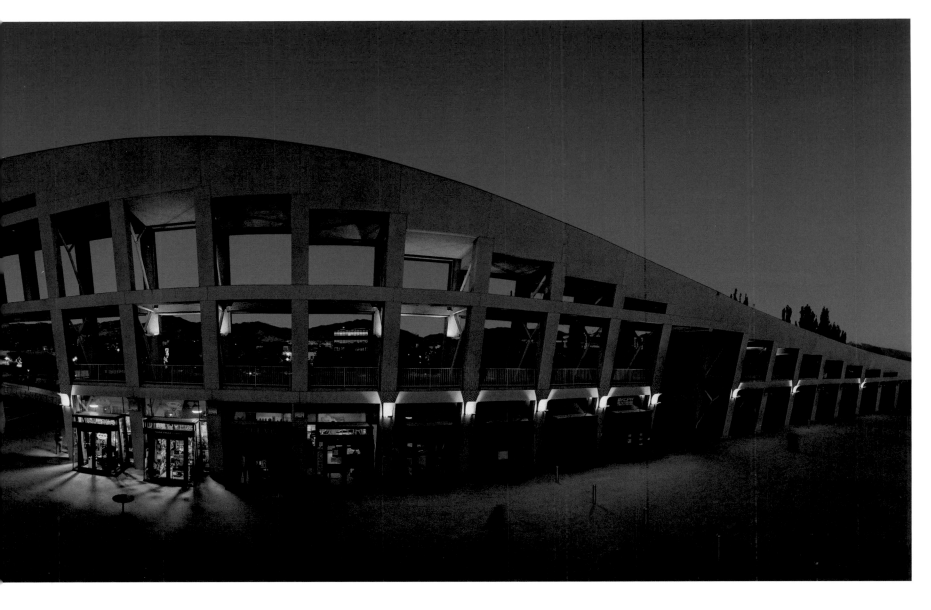

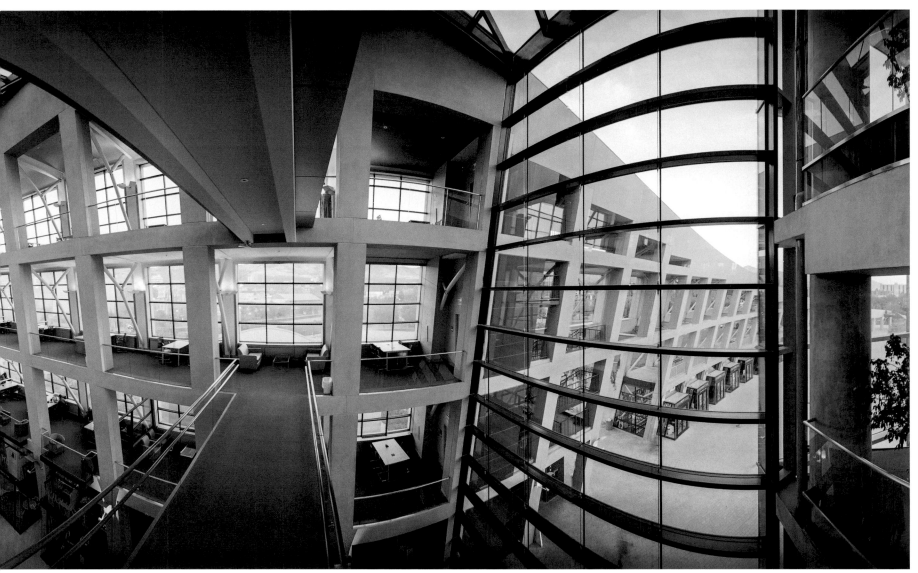

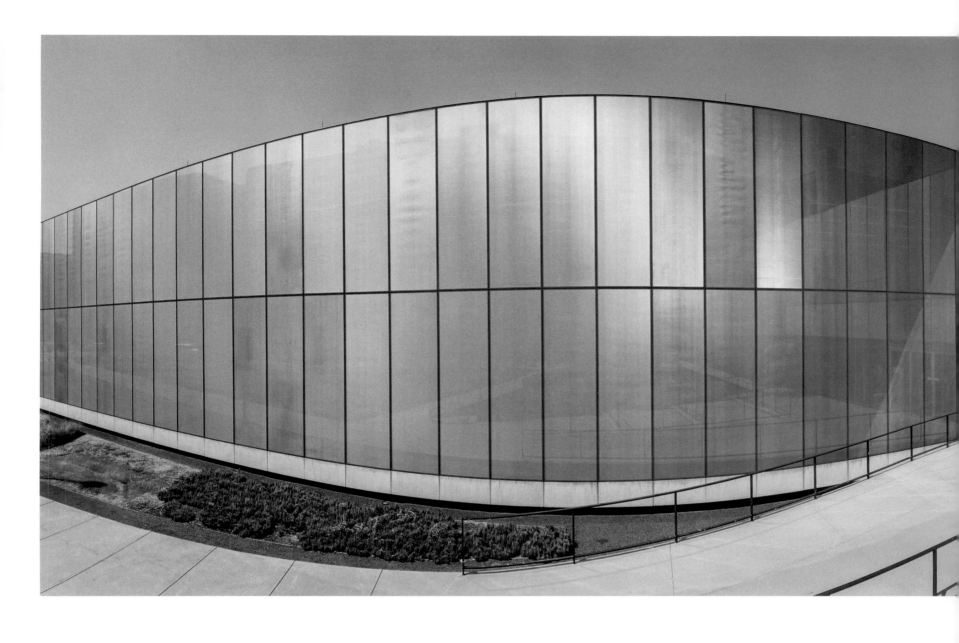

Des Moines Public Library, Iowa
The new Central Library in Des Moines, part of a large revitalization plan
of the city's downtown, was inaugurated in 2006 with an innovative design
by British architect David Chipperfield. Its exterior, furnished with panes of
copper mesh, offers patrons a view to the outside but no looking in during
daytime; at night, the effect is reversed, with the illuminated library interior
visible from without. The new structure, funded by donations large and small,
allowed for a significant expansion of the library's collection and services.

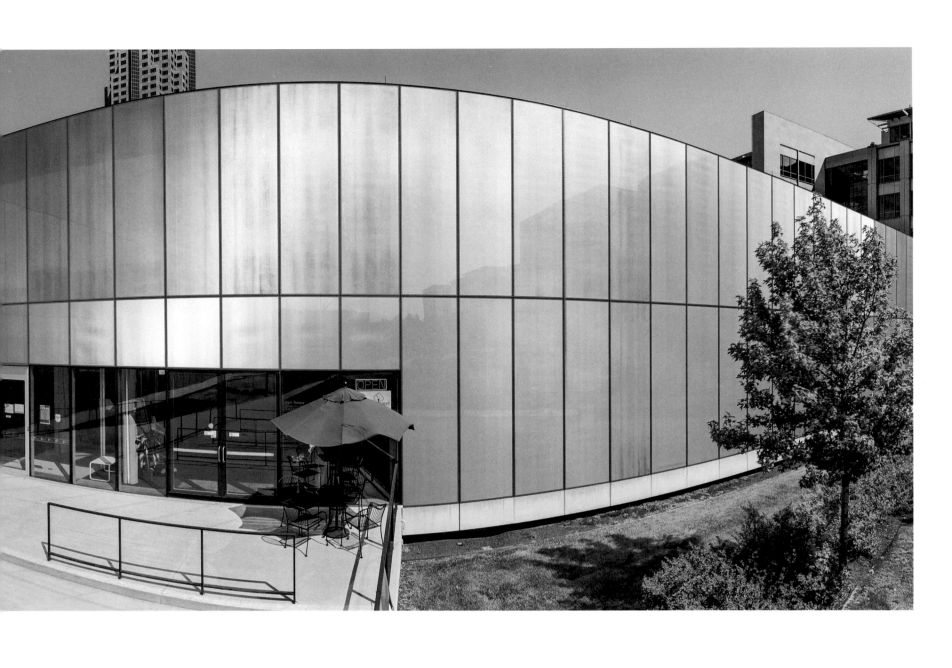

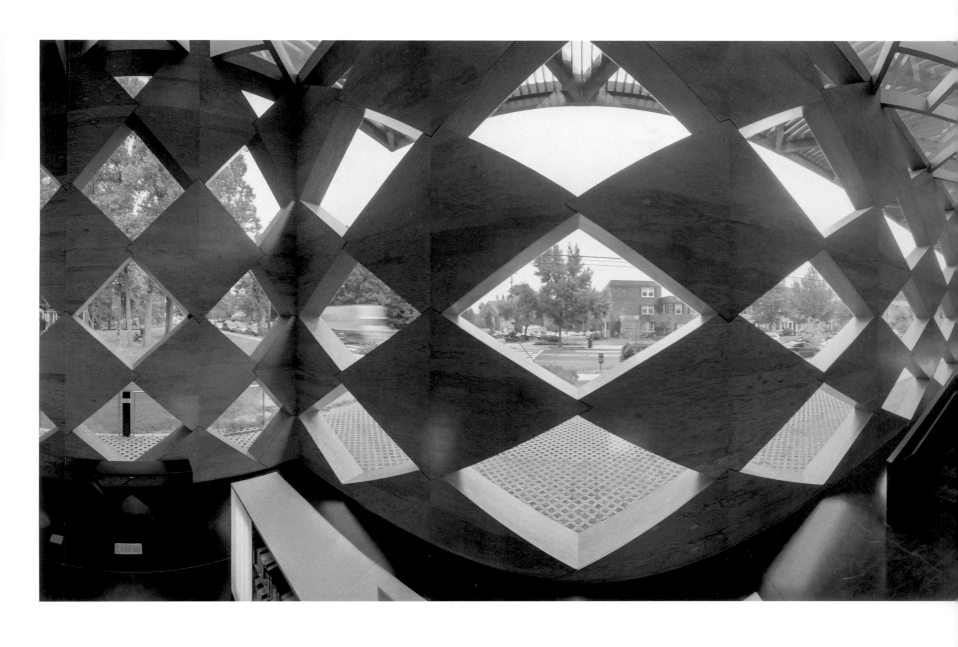

Francis A. Gregory Library, Washington, D.C.
The Francis A. Gregory Library, designed by renowned Ghanaian British
architect David Adjaye, opened to the public in 2012. Situated within
Fort Davis Park, the building's distinctive geometric facade reflects its
surrounding natural environment. The library has a collection of forty
thousand books, films, and other materials, and the ability to accommodate
a growing collection. The new building is highly environmentally friendly,
receiving silver LEED (Leadership in Energy and Environmental Design)
certification by the U.S. Green Building Council.

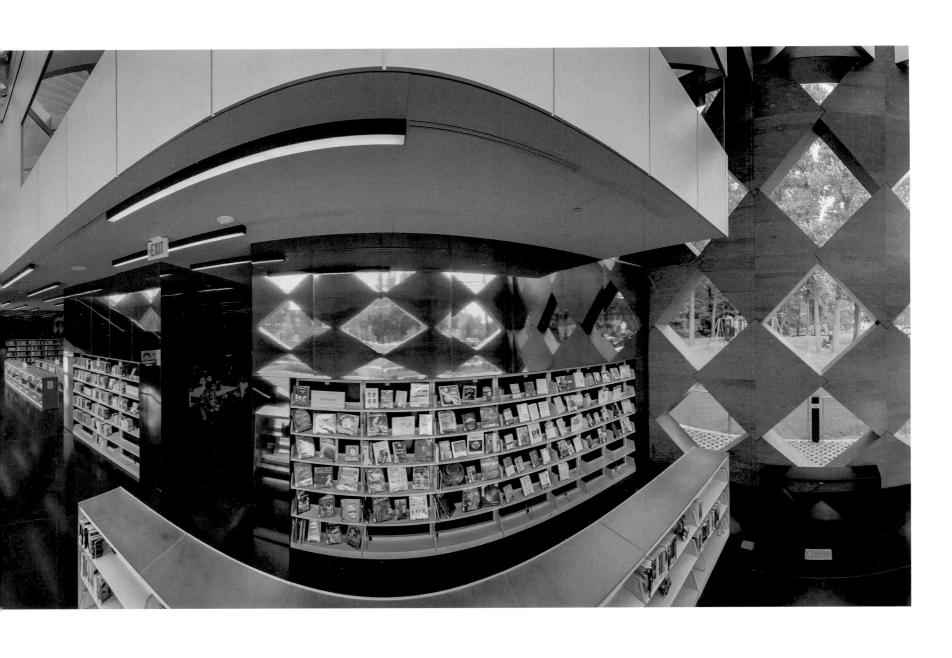

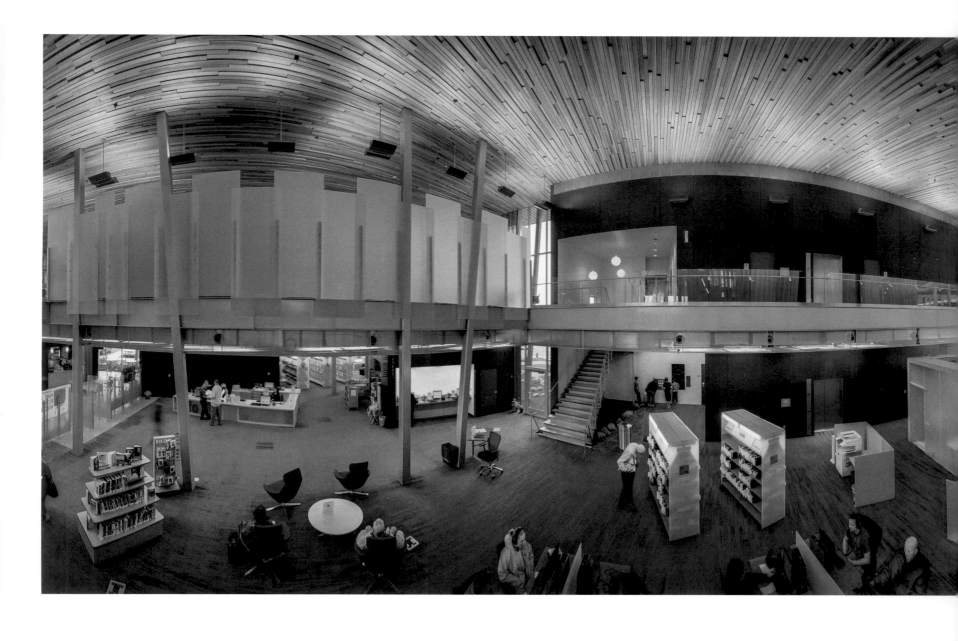

Prescott Valley Public Library, Arizona
The Prescott Valley Public Library is the town's first stand-alone library and
serves its fast-growing community in the high Arizona desert, which includes
Yavapai College. Completed in 2009, the unique building design was inspired
by Glassford Hill, the now-extinct volcano that formed the valley. Free lectures,
plus digital literacy and business courses, are available for local entrepreneurs
and members of the community in the building's new classrooms and
spacious amphitheater.

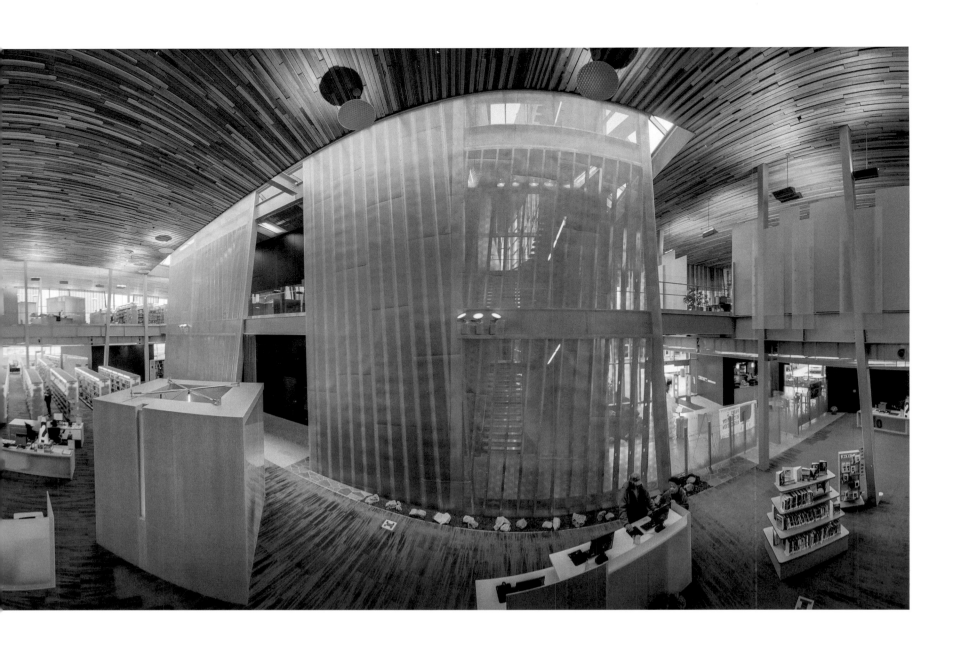

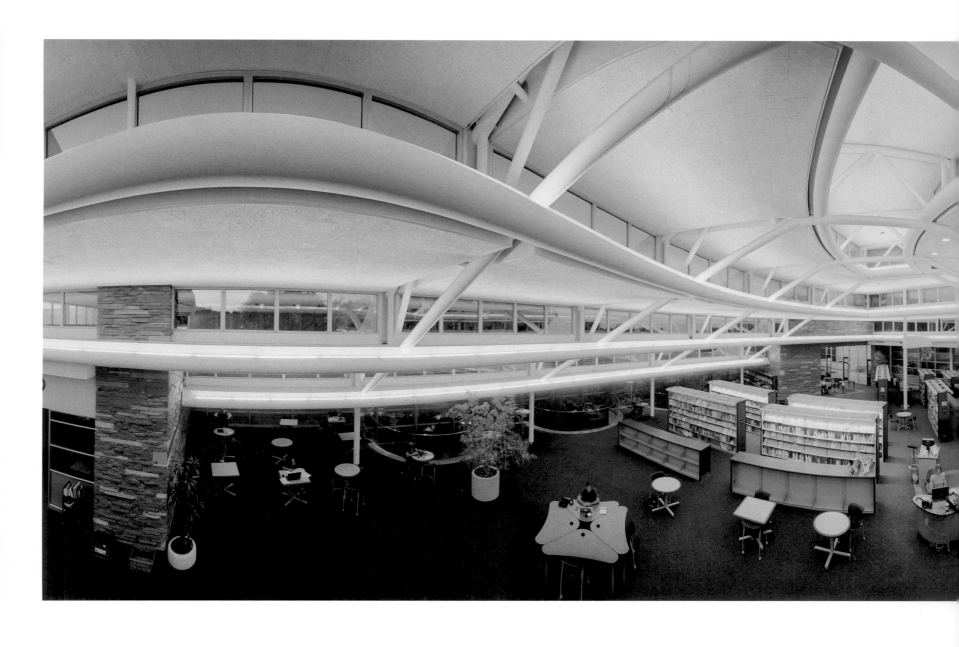

Boulder Public Library, Colorado
The Boulder Public Library features a broad book collection that serves the population of Boulder and beyond. Among the library's over 270,000 items, its holdings in early literacy, graphic novels, cooking, and history are particularly strong. The original two-story library building was completed in 1961, south of Boulder Creek in the city's downtown area. Several renovations and additions, in 1974, 1987, and 1992, made it possible to accommodate a children's room, media center, auditorium, art gallery, staff office, and local TV studio.

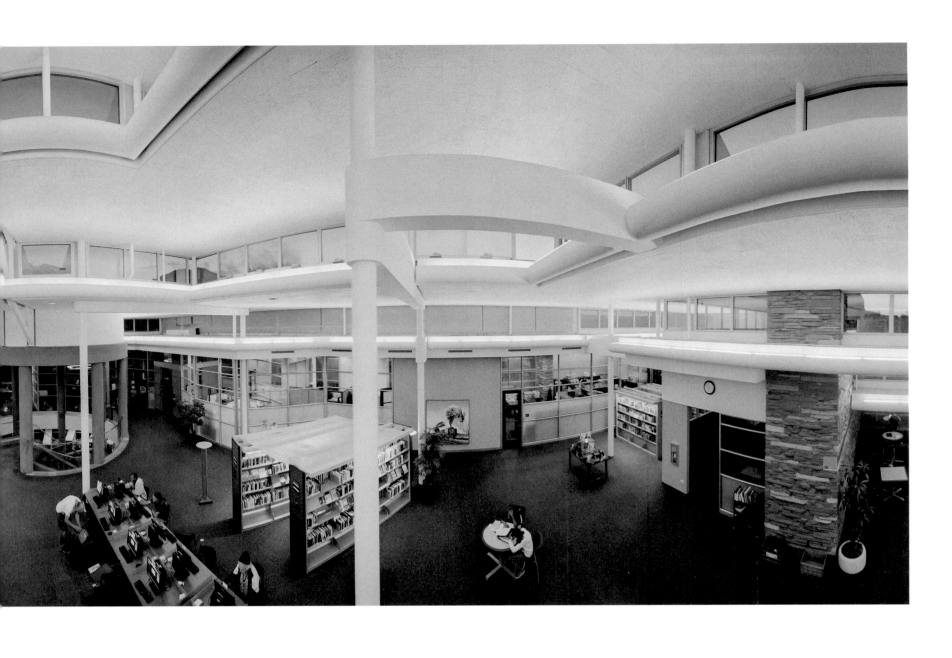

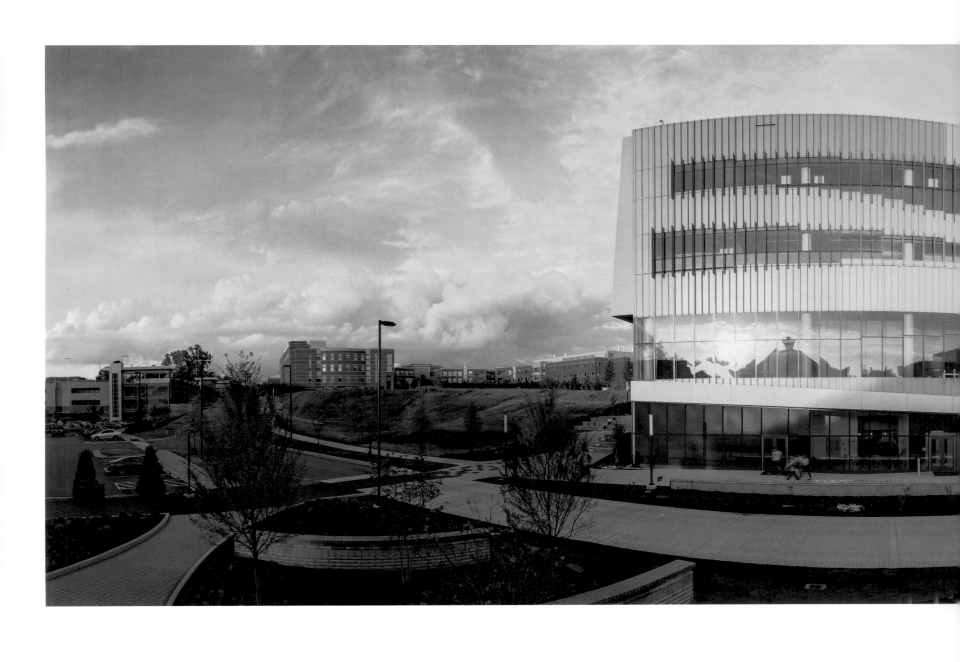

James B. Hunt Jr. Library, North Carolina State University, Raleigh
The Hunt Library is located in the university's Centennial Campus, named the nation's top research park in 2007. Its brand-new signature building, led by architecture and design studio Snøhetta, was dedicated in 2013. The structure privileges technologically sophisticated learning spaces and more room for its large student body through space-saving solutions like bookBot, an automated book-delivery system that holds up to two million volumes. The library is also home to the Institute for Emerging Issues, a think tank led by former North Carolina governor Jim Hunt.

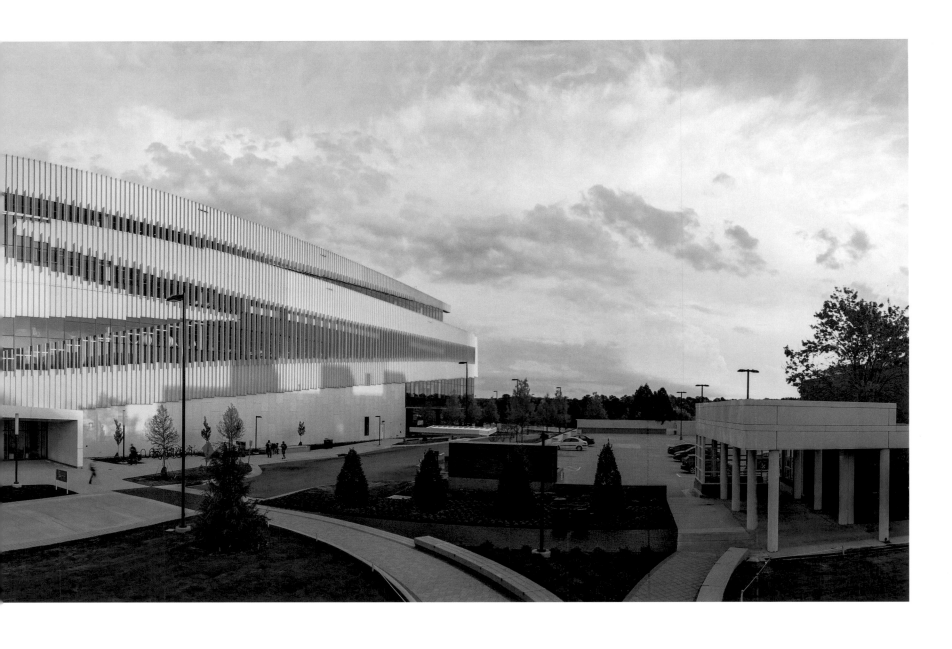

Following pages
Denver Public Library
The Denver Public Library was established in 1889 by renowned librarian
John Cotton Dana in a wing of a Denver high school. A new central library
building, designed by Michael Graves and the firm of Klipp Colussy
Jenks DuBois, opened in 1995 at the same time branch renovations were
completed. The library is known for its collections of Western history and
fine-art works—such as landscapes by Albert Bierstadt and Otto Kuhler
and a portrait of historian Caroline Bancroft—in addition to its collection
of Otto Perry's railroad photographs.

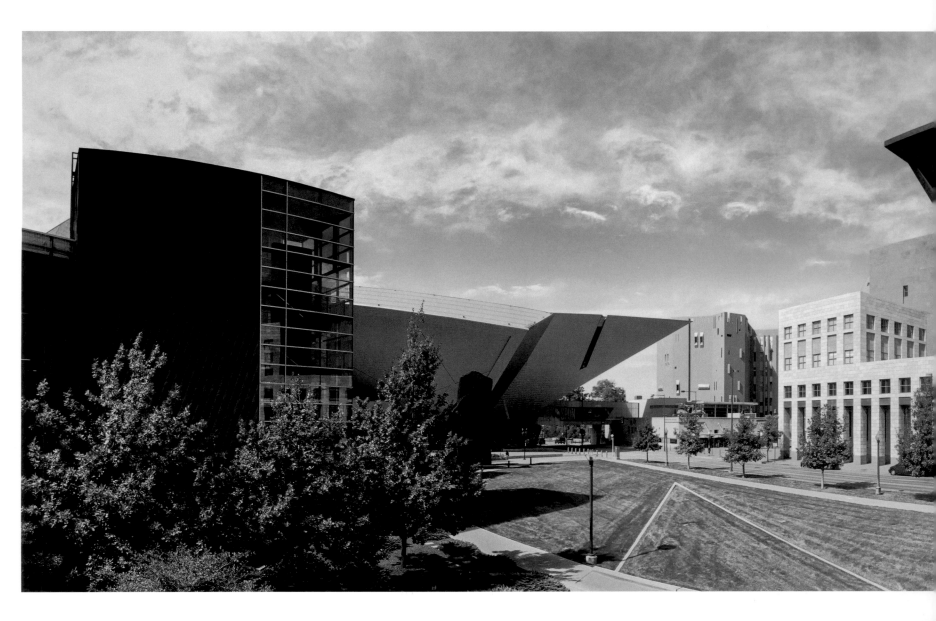

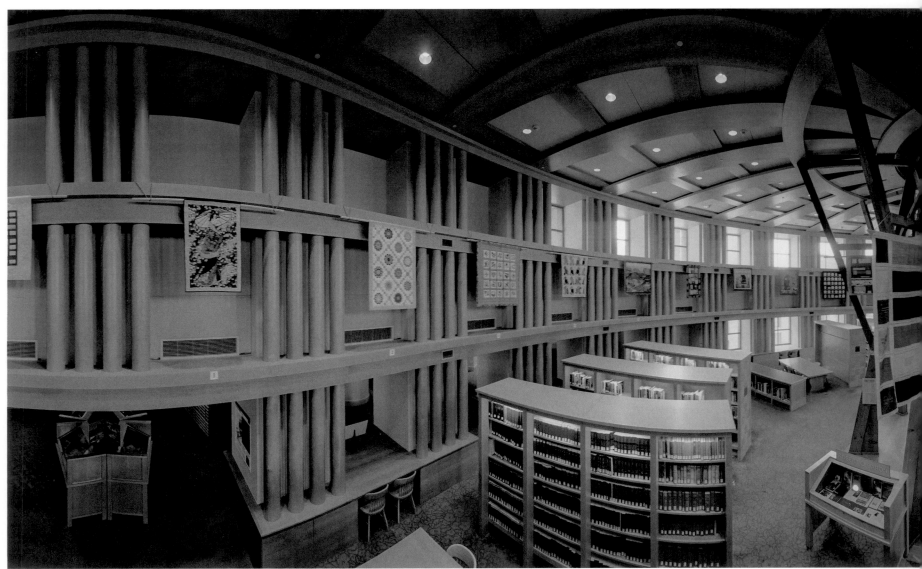

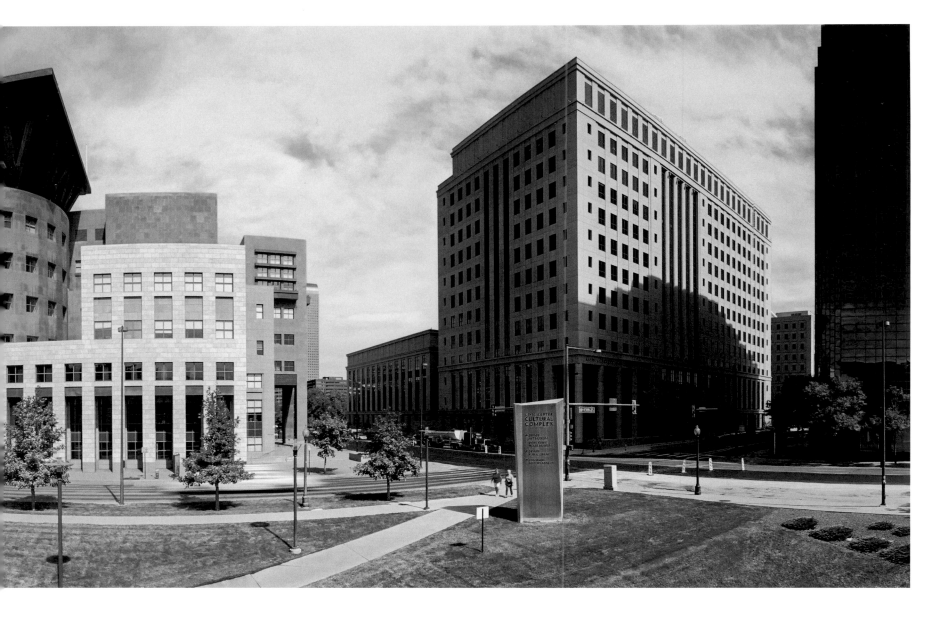

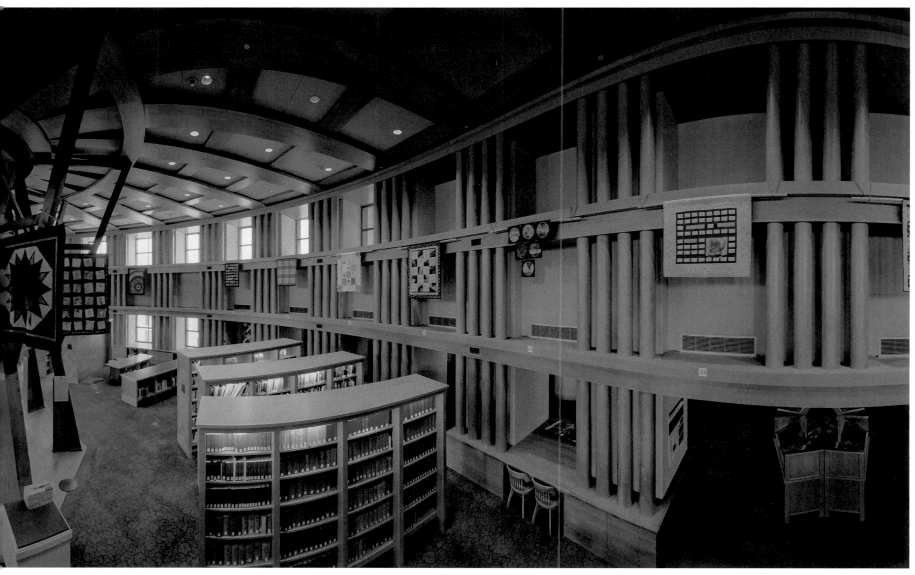

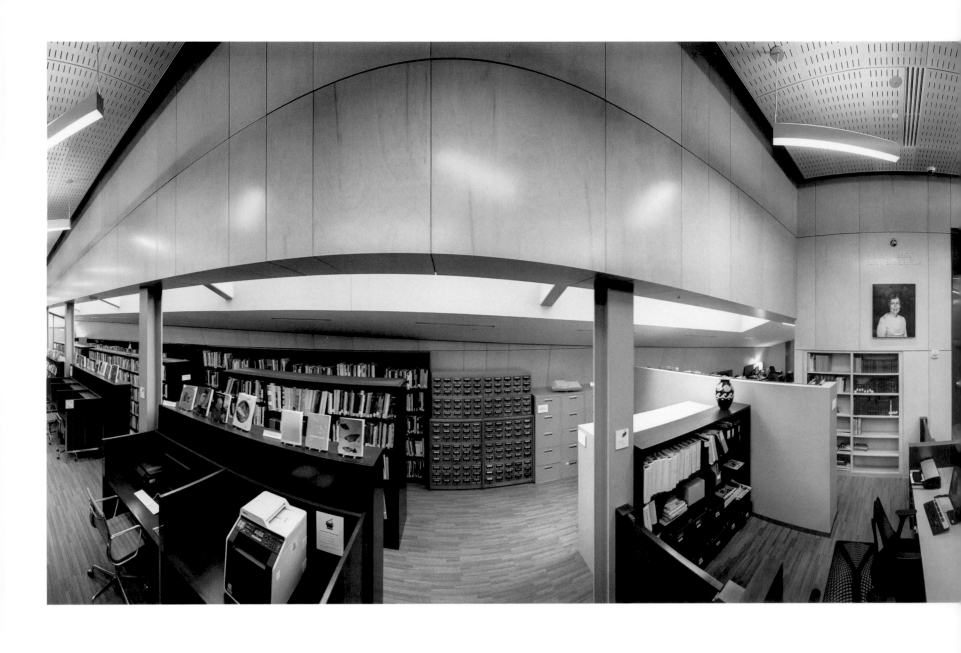

Mary R. Schiff Library and Archives, Cincinnati Art Museum
Located in the recently renovated and LEED-certified Longworth Wing of
the Cincinnati Art Museum, the Mary R. Schiff Library offers its patrons a
rich collection of over one hundred thousand art historical books, periodicals,
reference volumes, and multimedia works that span the decorative arts,
photography, and fashion. In addition to its specialized collection focused
on the Cincinnati art scene and its artists, the rooftop library also offers
its patrons a balcony and bookshop, and expansive views of the city. (The
portrait on display in the image above is of the library's namesake, and
mother of Thomas R. Schiff.)

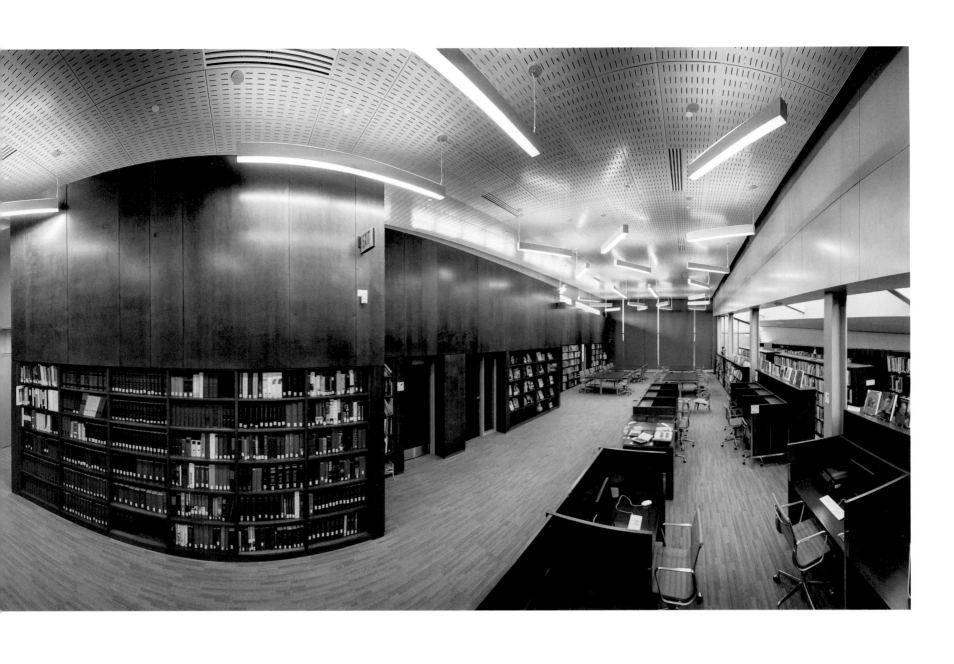

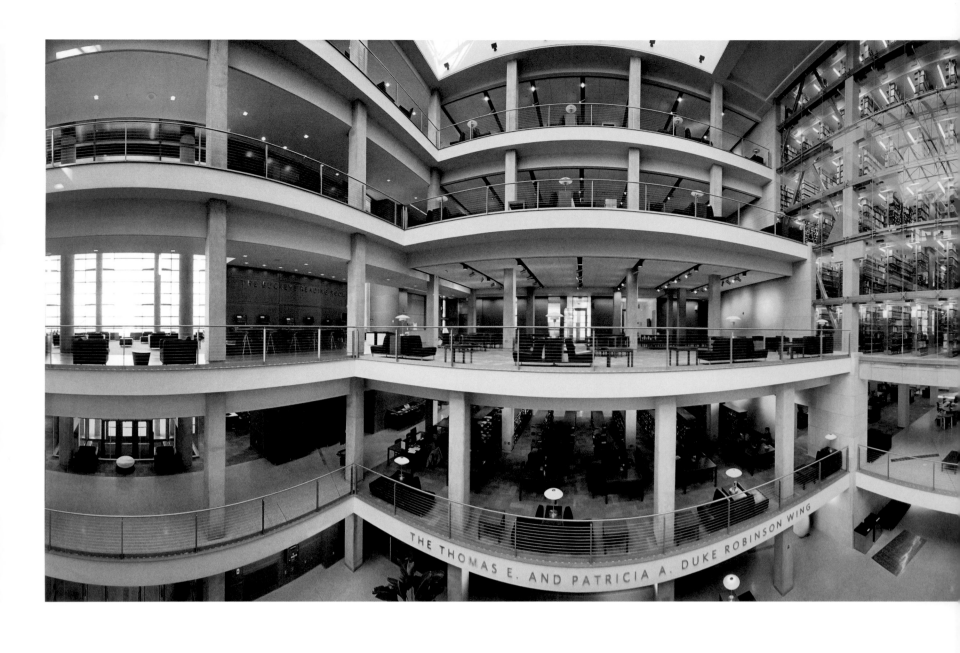

Thompson Library at Ohio State University, Columbus
Originally built in 1913, the Thompson Library completed its most recent
renovation in 2009, earning numerous architecture awards. The renovation
included the permanent installation of Ann Hamilton's public artwork *VERSE*
(2011), a text that interweaves three accounts of world history on the floor
of the library's Buckeye Reading Room. Previous additions were demolished
in order to enhance the view of the original Beaux Arts building, and balance
the transparency of the new facade.

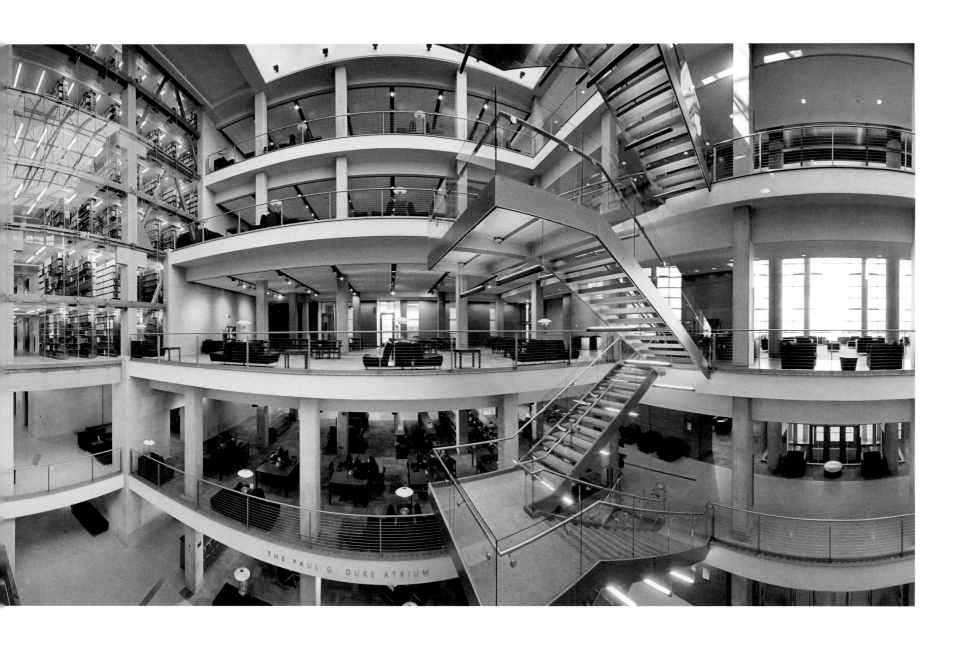

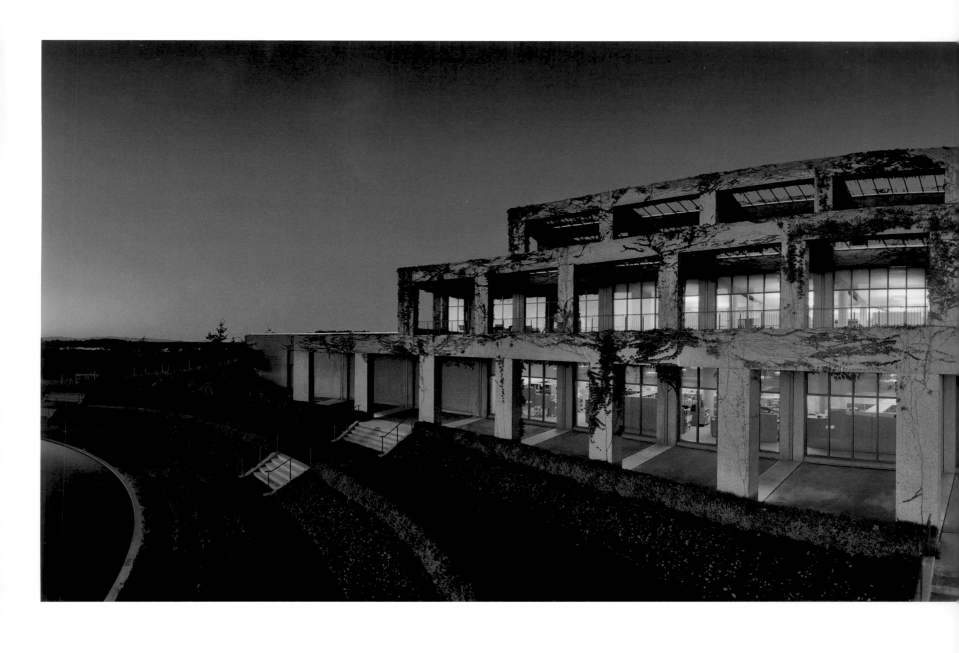

Library of Congress Packard Campus, Culpeper, Virginia
Opened in 1969 as a security storage facility for the Federal Reserve, the building was taken over for the National Audio-Visual Conservation Center and opened in 2007 as a base for the preservation of the world's largest assemblage of films, television programs, and radio recordings. The Packard Campus boasts over ninety miles of shelving, climate-controlled vaults for various materials, and specialized individual vaults for more flammable nitrate film. Primarily underground, the forty-five-acre campus is located near the Blue Ridge Mountains.

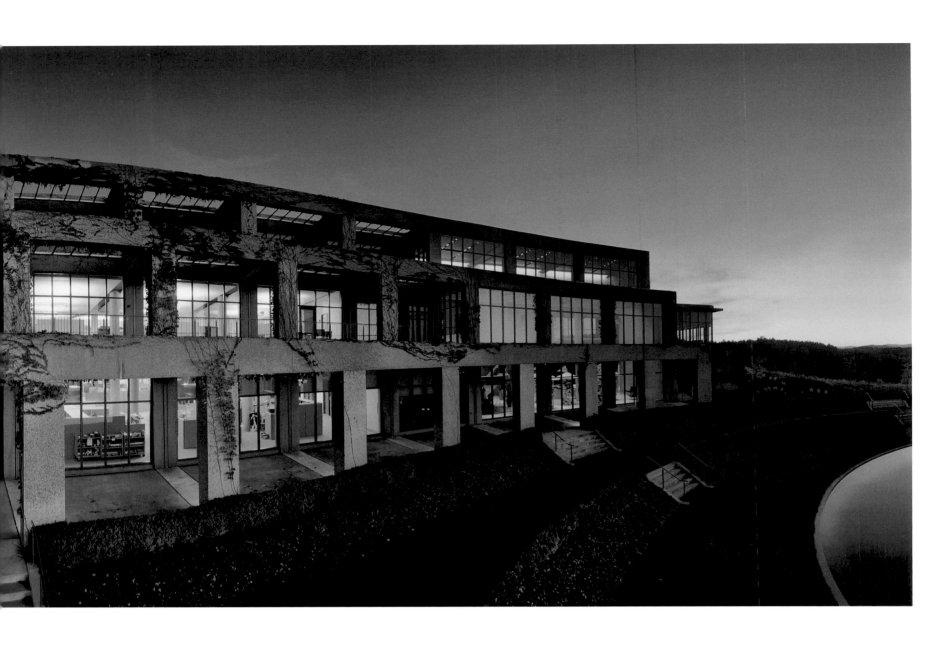

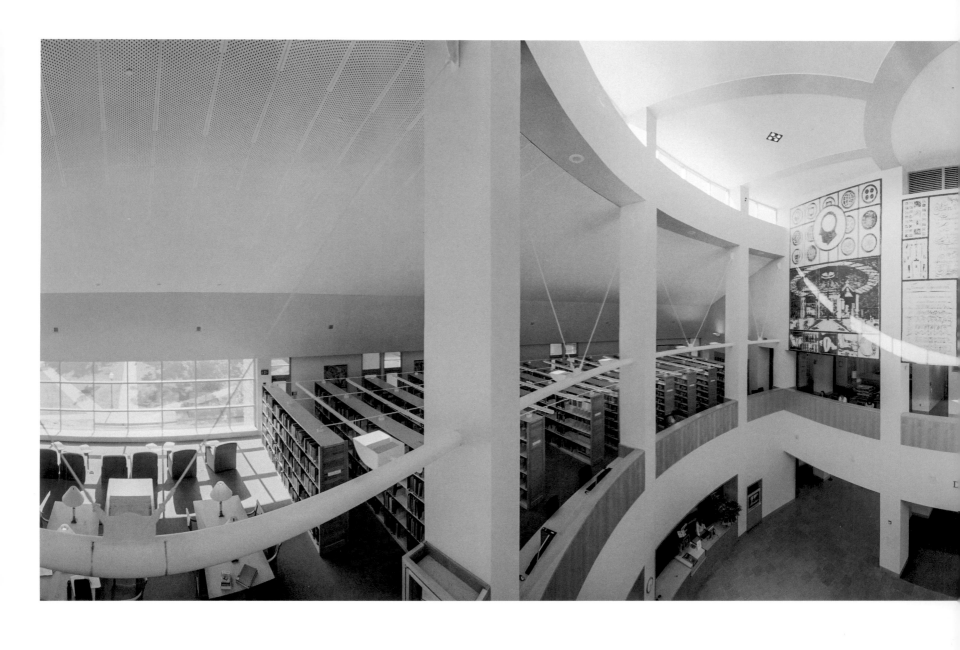

Davis Family Library, Middlebury College, Vermont
The Davis Family Library has been part of Middlebury College since 2004.
The new structure was environmentally designed, with bookcases and tables
built from certified lumber harvested from a nearby forest, linoleum rather
than plastic carrel and counter surfaces, and recycled-fiber carpets. In addition,
local firms and materials were used whenever possible. Its collection includes
treasures such as a sixteenth-century Book of Hours; Thoreau's personal,
annotated copy of *Walden*; and poet Robert Frost's personal effects.

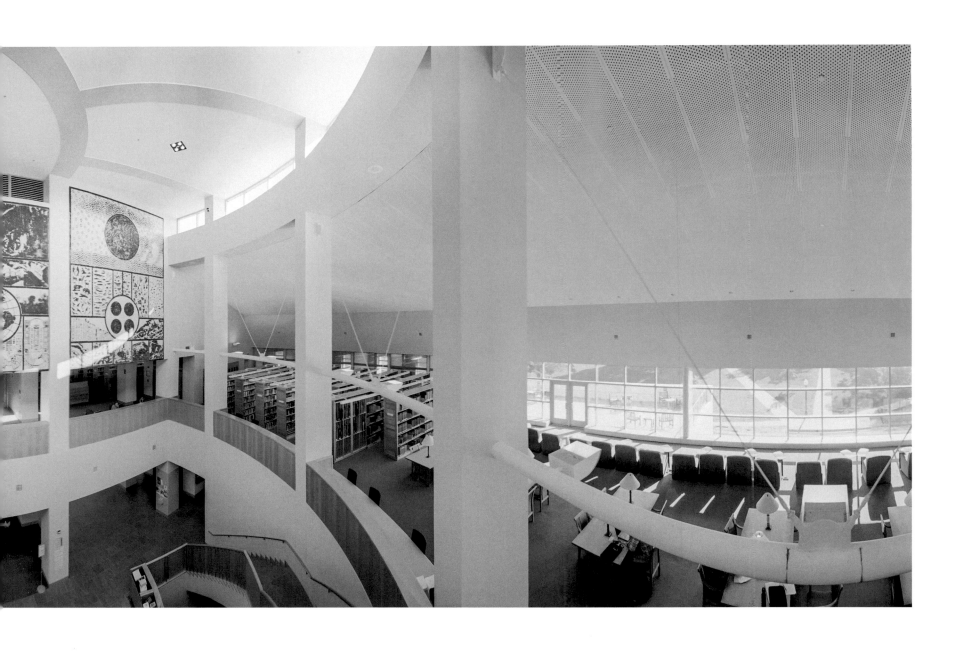

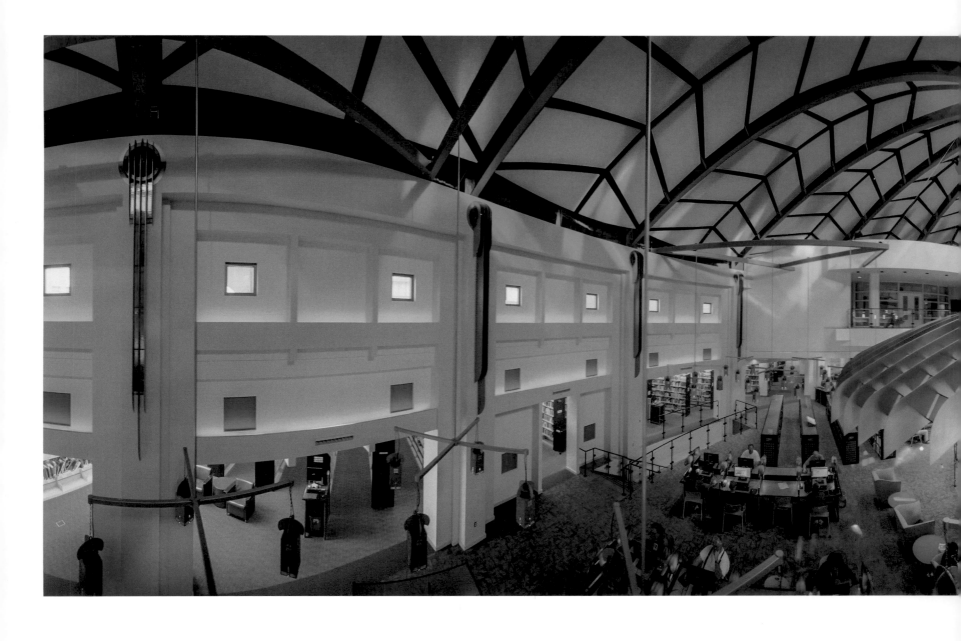

Kalamazoo Public Library, Michigan
The Kalamazoo Public Library grew out of 123 books, available to users for
a single hour per week, in 1860; it later was known for establishing one of
the first children's rooms, in 1896. Today, its iconic building—an amalgam
of a 1959 structure inspired by Le Corbusier's modernist Villa Savoye and
a 1998 expansion—complements its award-winning services. One of its
distinctive features is artist Michael Hayden's holographic collar at the
base of its skylight, which throws colorful bands of light onto the walls.

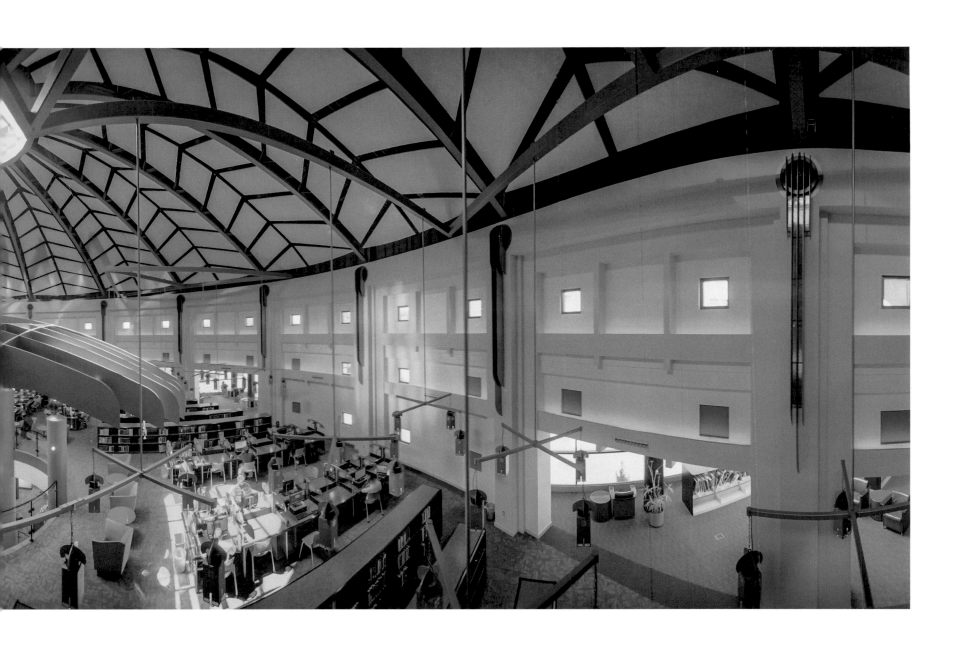

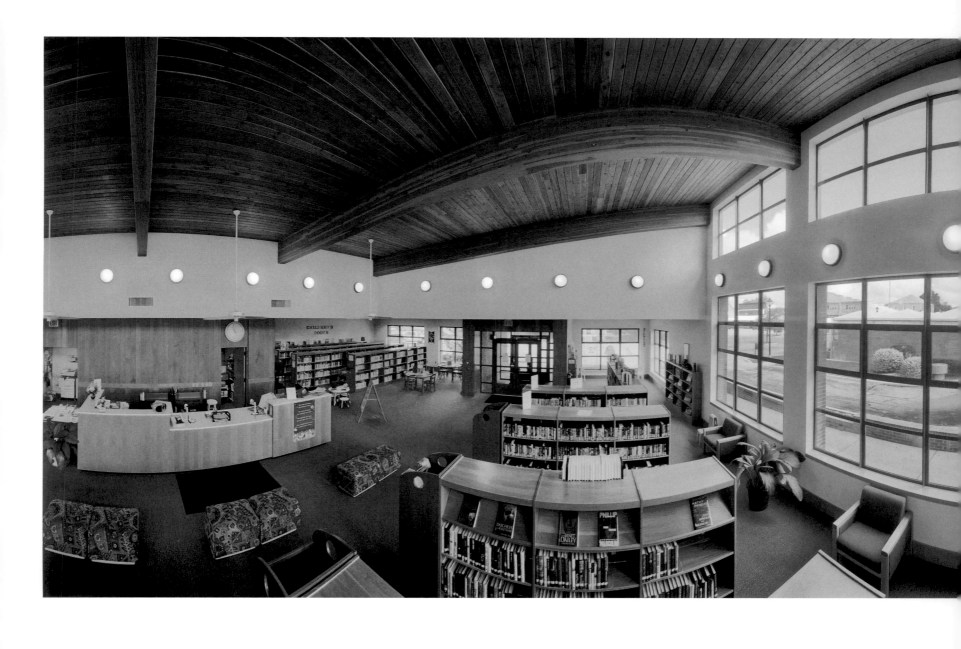

Bartholomew County Public Library, Hope, Indiana
The Hope Branch of the Bartholomew County Public Library was completed in 1998, following a design by New York architect and architecture professor Deborah Berke. The library's brick exterior and awnings were devised to fit in with the other buildings in the town square. The interior open floor plan is welcoming to visitors, who receive access to over two hundred thousand books, multimedia offerings, and magazines, as well as wireless Internet.

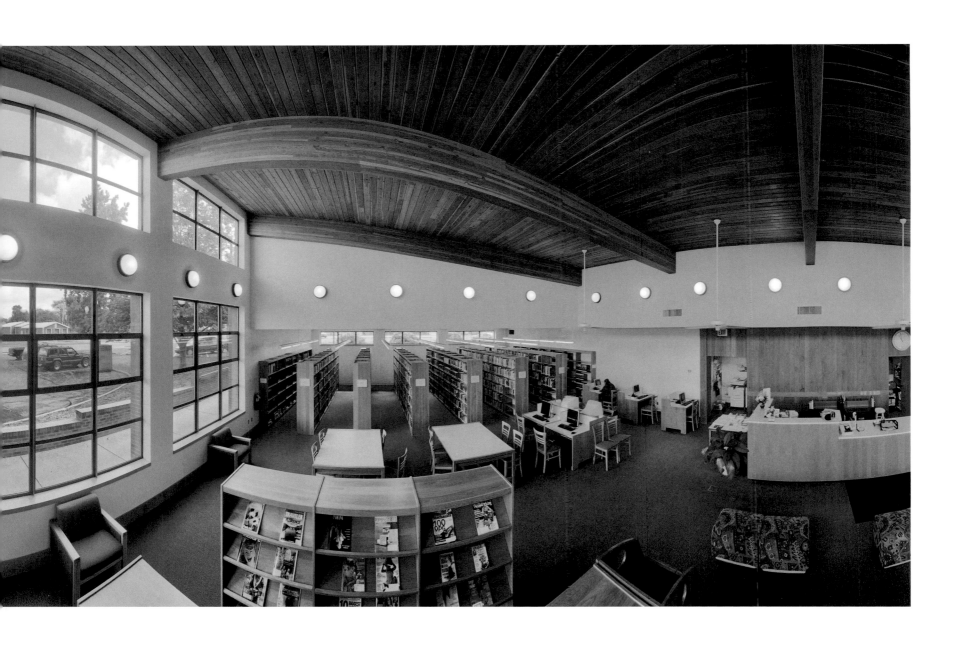

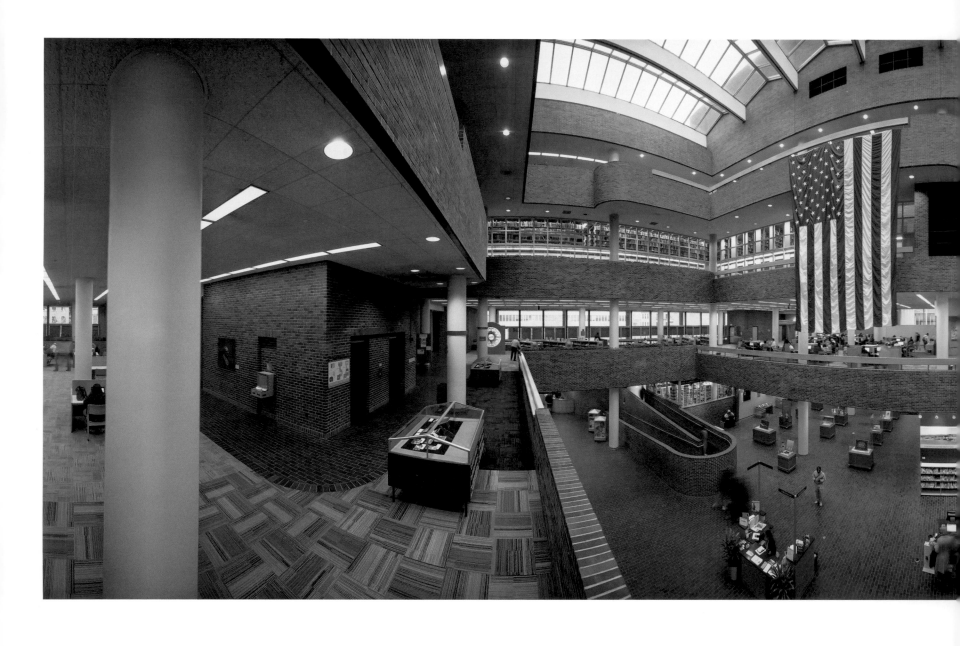

Public Library of Cincinnati and Hamilton County
The main library of the Public Library of Cincinnati and Hamilton County
system serves around one million users per year. In addition to its expansive
collection of books and databases, the library offers a comprehensive
community program that includes its William Hueneke Homework Center,
offering academic assistance to primary and secondary-education students
as well as adults. Since 2014, the library has hosted a writer-in-residence
program that provides local writers with a stipend and the opportunity to
share their work with the community through workshops and events.

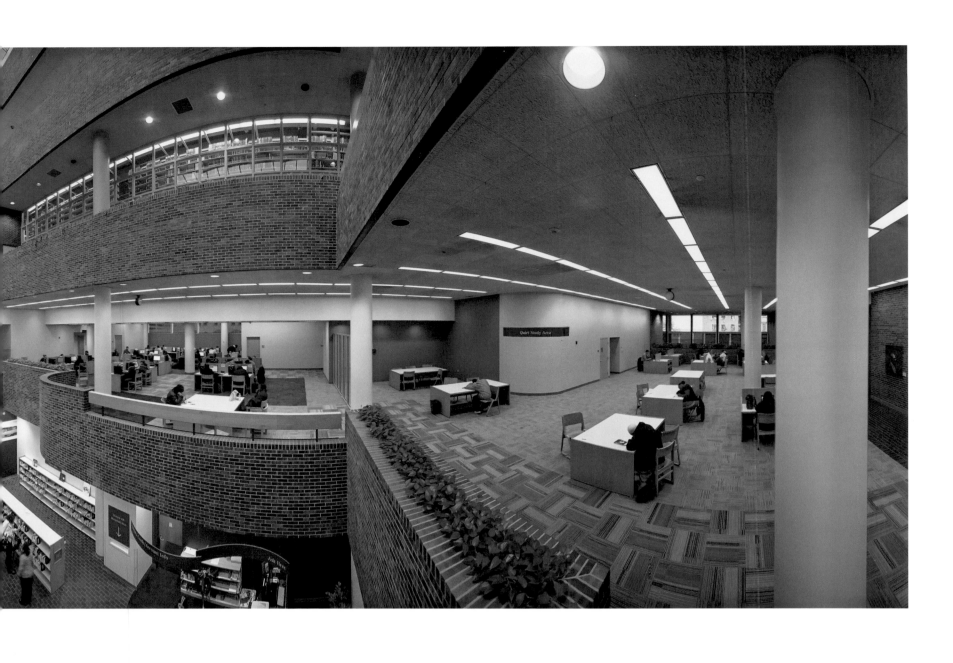

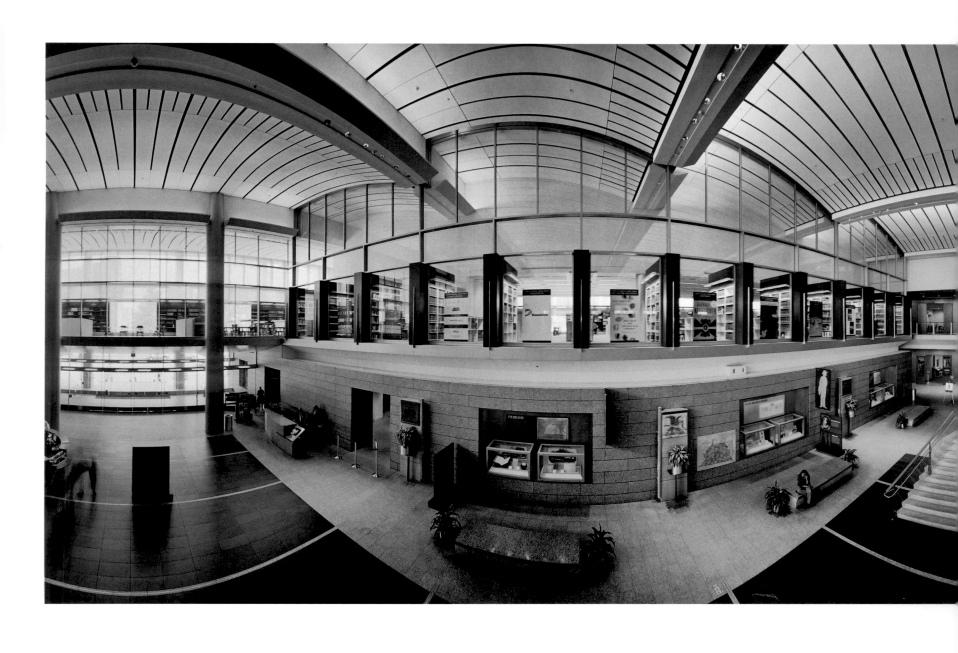

Library of Virginia, Richmond
Created in 1823, the Library of Virginia holds the most complete collection of books, maps, documents, and other materials illustrating the history, culture, and government of Virginia, including the colonial period. Its democratic holdings—which represent the voices of the country's founders as well as everyday people—draw researchers from around the world. Among its most prized historic works is a 1624 book by John Smith, *The Generall Historie of Virginia, New England, and the Summer Isles*, an early account of Virginia history.

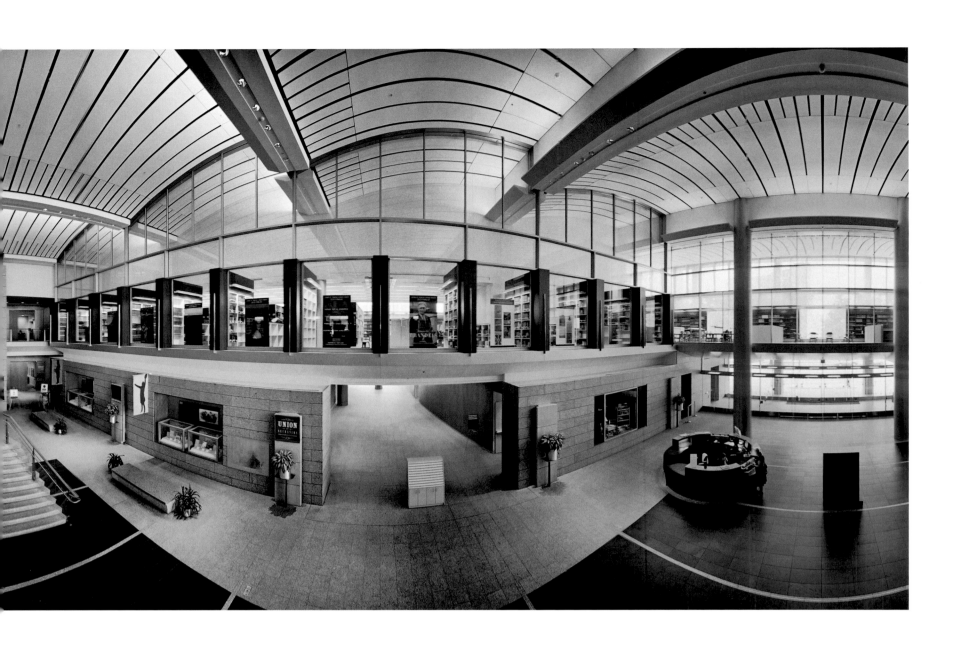

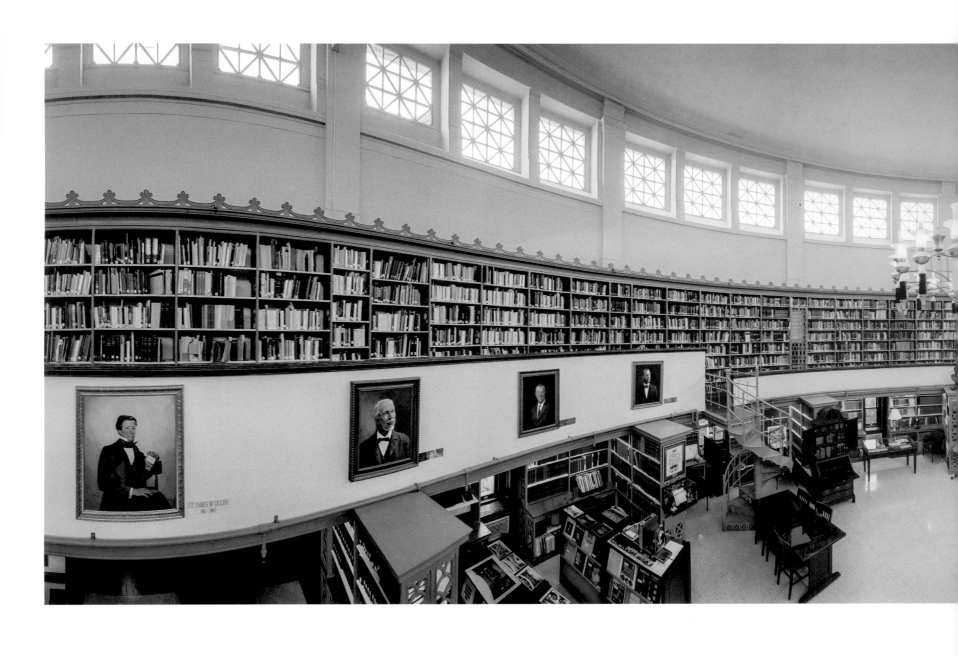

James M. Gilliss Library, U.S. Naval Observatory, Washington, D.C.
The Gilliss Library, situated on the grounds of the United States Naval
Observatory, is one of the leading scientific libraries in the country, serving
not just as a library, but also as the Observatory's social and ceremonial
center. "The library is an essential tool in the everyday working of the
Observatory," says Dr. Kenneth J. Johnston, its scientific director. "Its
contents are needed for the Observatory's mission: determining time both
atomic and astronomical and charting the positions of celestial objects."

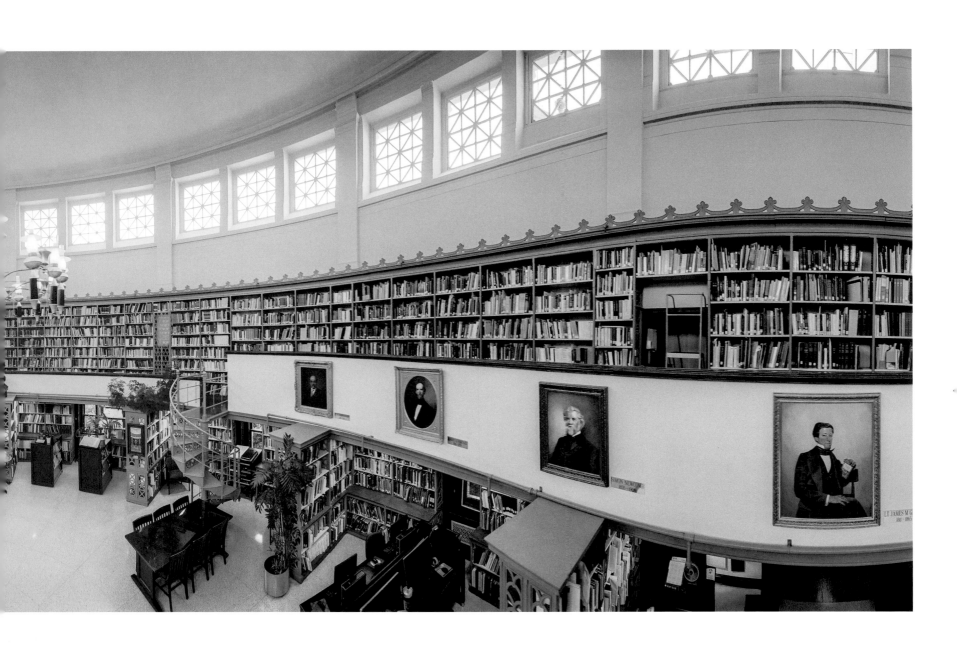

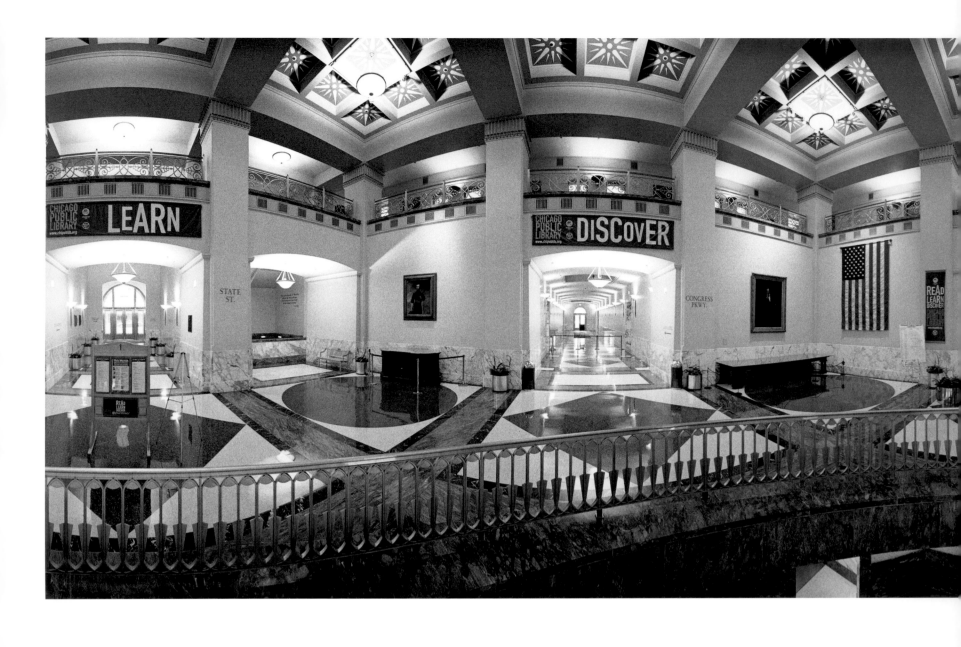

Harold Washington Library Center, Chicago
The Harold Washington Library Center is the main library of the Chicago
Public Library System, named after the city's first African American mayor.
Its building design, by local architect Thomas Beeby, was selected through
a 1987 competition, and remains one of Beeby's best-known but also most
controversial projects, its bold, postmodern style both revered and despised.
Upon completion in 1991, it was the largest library in America. Its special
collections include rare documents on Chicago and Civil War history.

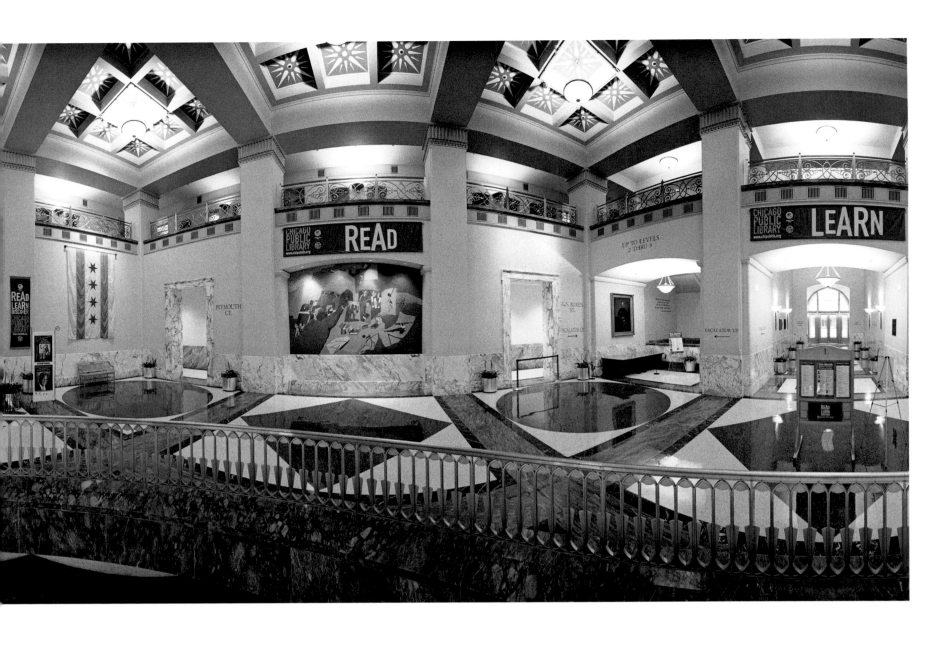

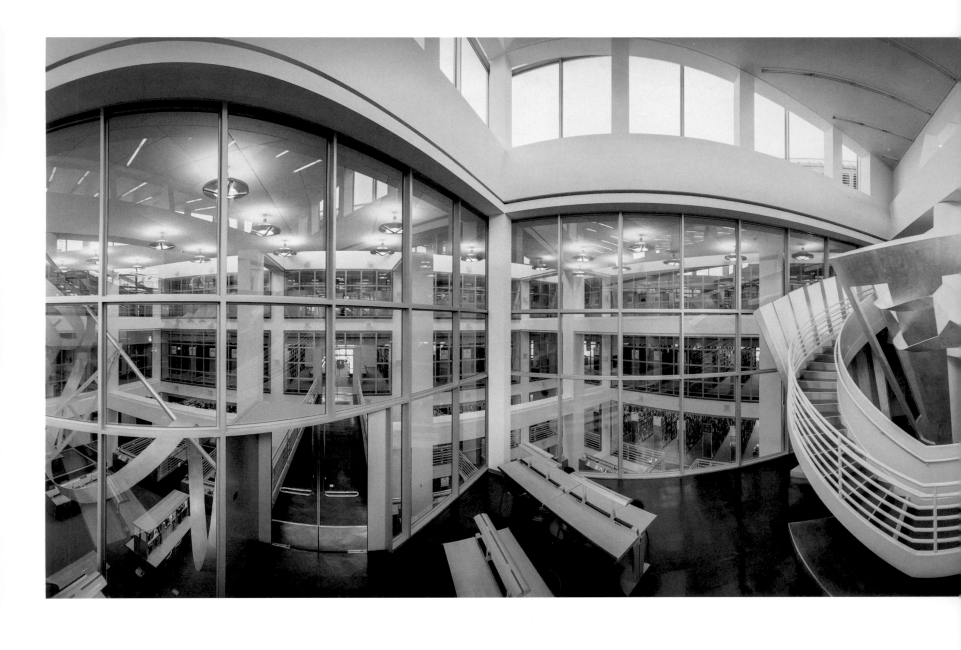

Herb Caen Magazines and Newspapers Center, San Francisco Public Library

The library's Magazines and Newspapers Center, named in honor of *San Francisco Chronicle* columnist Herb Caen, offers its patrons thousands of periodicals in addition to San Francisco city directories and U.S. and international telephone books. The center's reading room features *Functional and Fantasy Stair and Cyclone Fragment*, a work by U.S. sculptor and installation artist Alice Aycock. It consists of a suspended "cyclone fragment" sculpture and a winding staircase that wraps around an unraveling metallic cone—a metaphor, according to the library, of "knowledge unfolding."

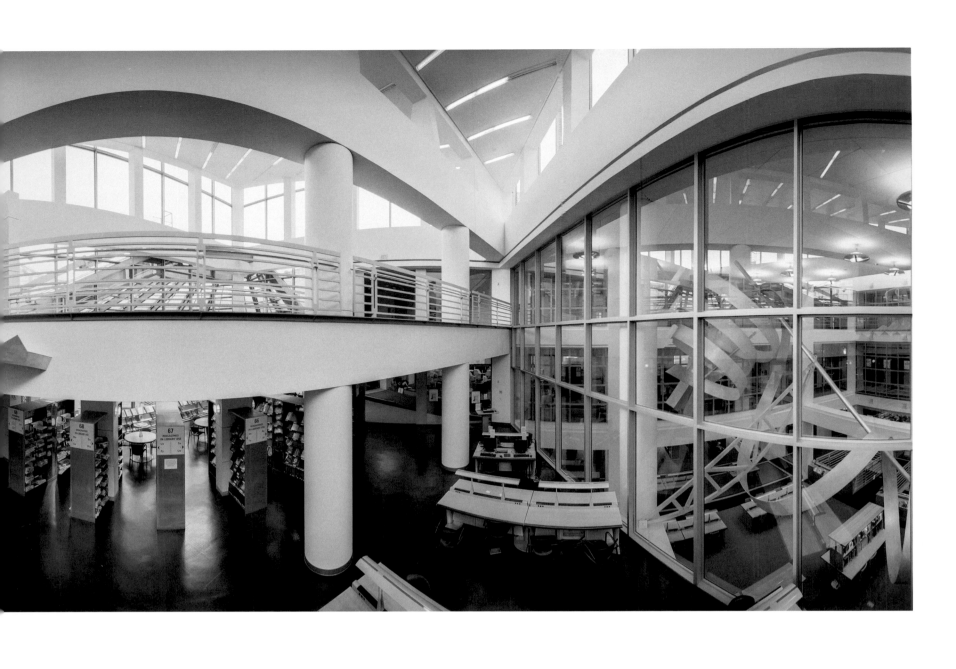

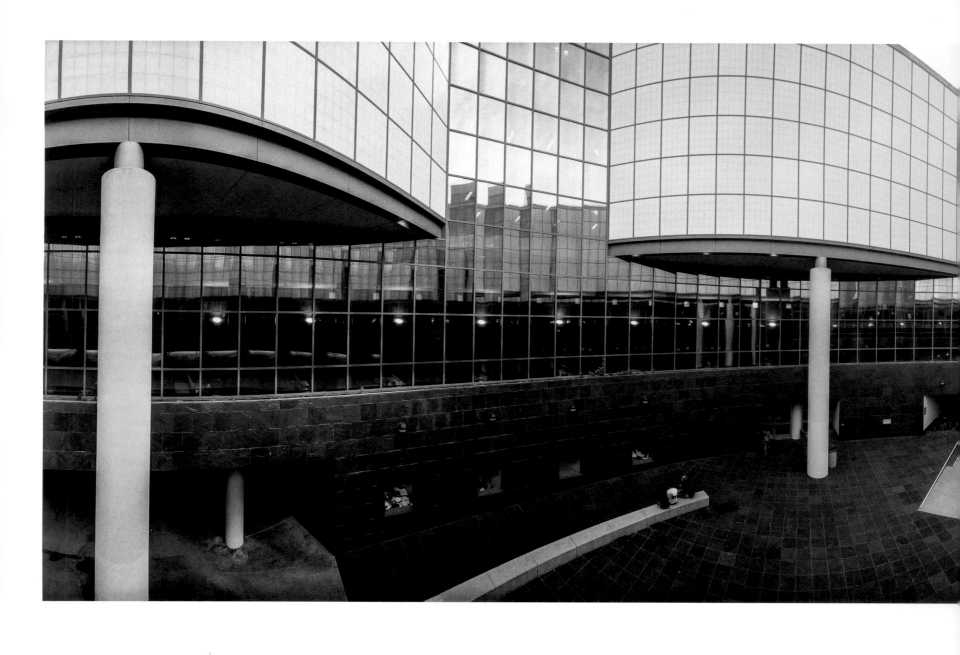

Francisco J. Ayala Science Library, University of California, Irvine
The Ayala Library is named after Francisco J. Ayala, a former Dominican
priest turned evolutionary biologist and philosopher. One of the largest
consolidated technology, science, and biomedical libraries in the United
States, it contains collections and services to support research and teaching
in the schools of biological sciences, engineering, information and computer
science, physical sciences, and medicine. The building, inaugurated in 1994
and designed by Sir James Stirling, can be said to resemble the USS
Enterprise from *Star Trek*.

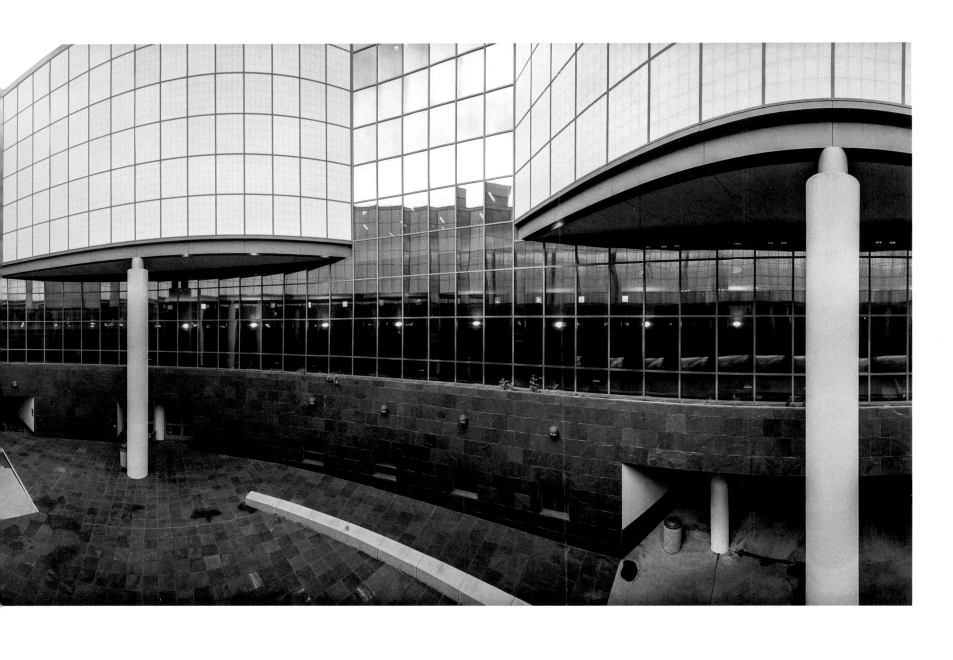

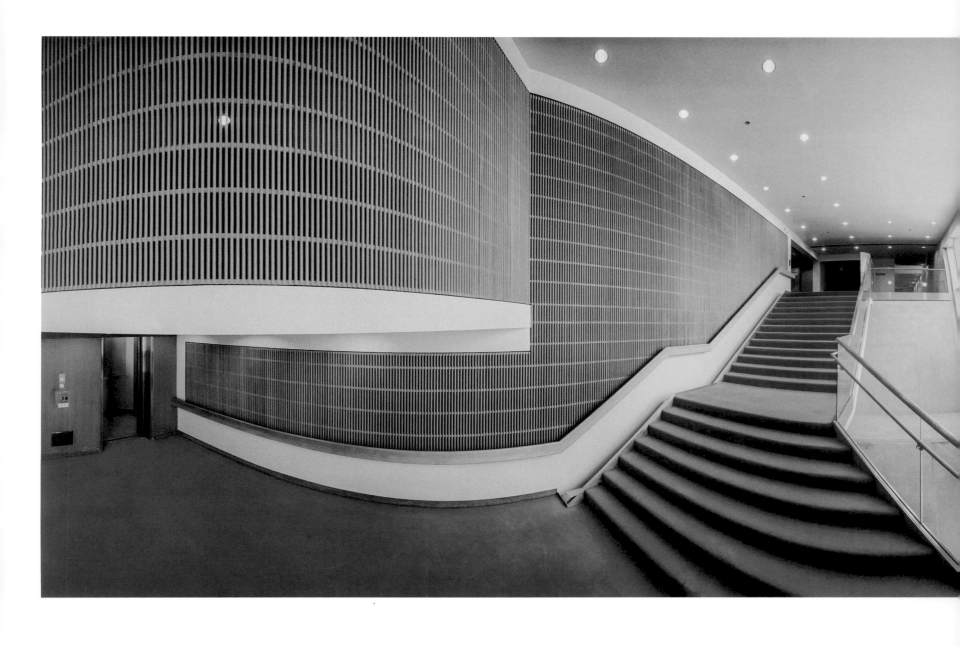

Allan and Alene Smith Law Library Addition, University of Michigan, Ann Arbor

The need for a larger law library at the University of Michigan was identified in the mid-1970s and the firm of Gunnar Bikerts, a Latvian architect who studied under Eero Saarinen, was chosen for the project due to their successful track record for adding to existing structures. After setbacks related to geological challenges, the building opened in 1981. Although wholly underground, the interior is light and airy thanks to the building's high ceilings, open structure, and "light wells" that funnel brightness into even the deepest of the three stories.

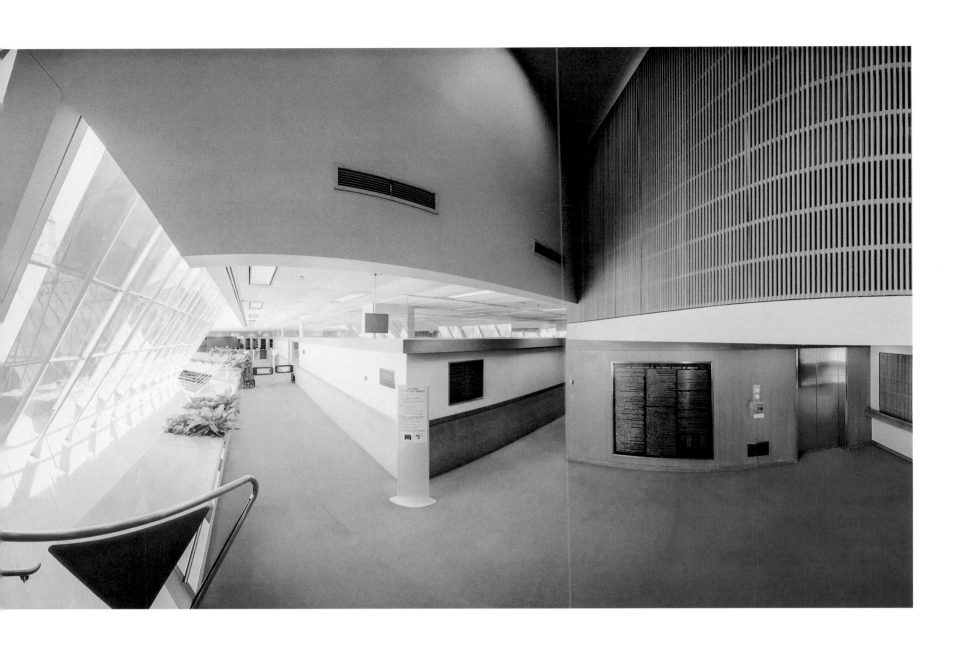

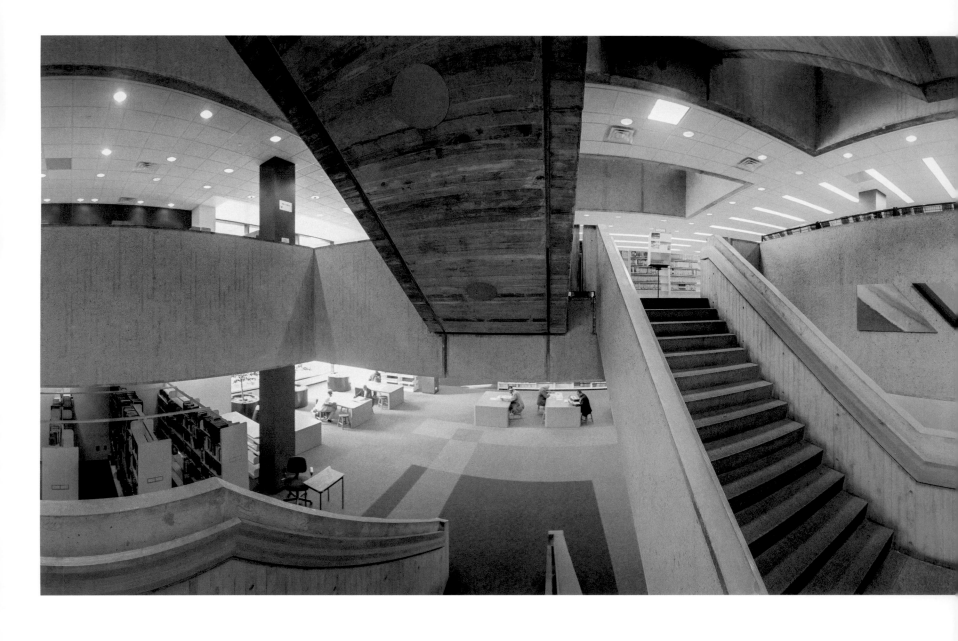

Atlanta Central Library
Atlanta's library system originated with the Young Men's Library Association, founded in 1867, and later was bolstered by several large donations from Andrew Carnegie in 1899. The central branch's modern structure—dedicated in 1980 under the leadership of Ella Gaines Yates, its first African American director—was designed by the Hungarian architect Marcel Breuer, famous for his involvement with the Bauhaus. The distinguished building capitalizes on natural light and was envisioned to be monumental, so its unique character would not be overshadowed by larger buildings.

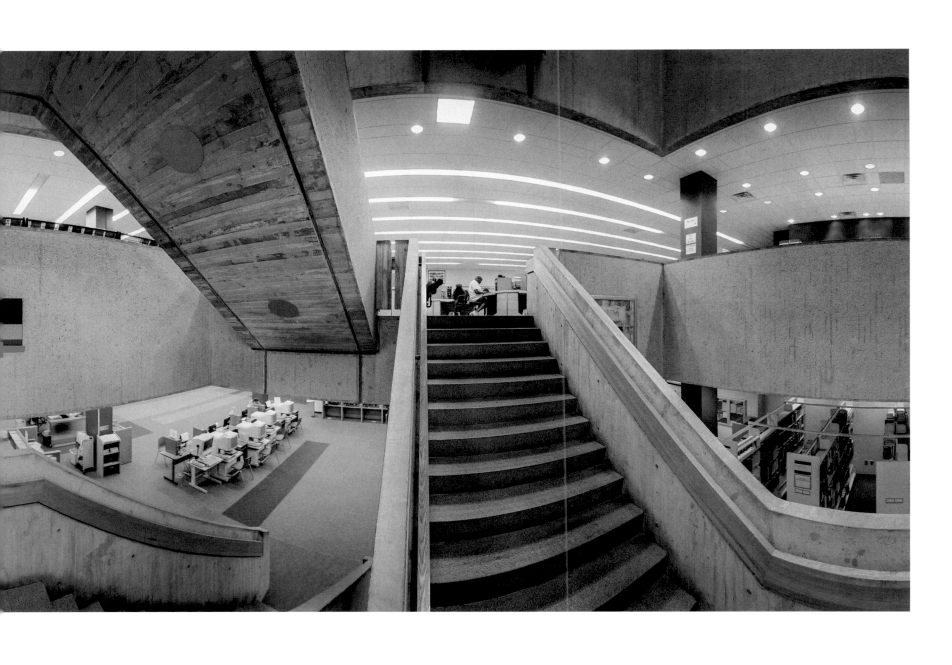

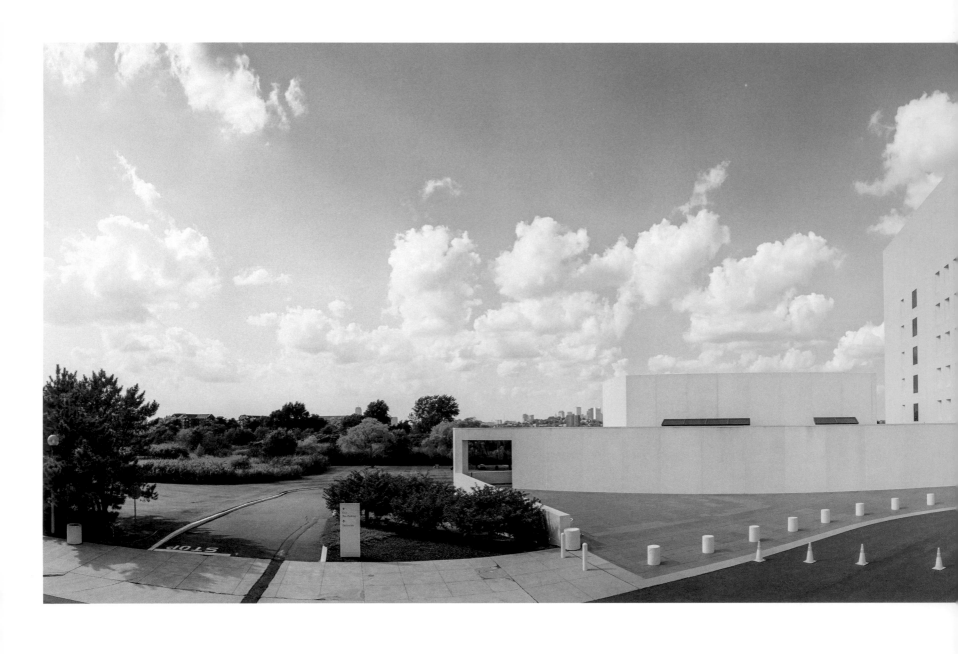

John F. Kennedy Presidential Library and Museum, Boston
Composed of a museum, archive, and educational institute, the Kennedy Library, designed by architect I. M. Pei and dedicated in 1979, occupies a ten-acre park and honors Kennedy's interest in linking the arenas of academia and public affairs. "People should leave the Library feeling that this was someone they would have liked to know, feeling sorry that they missed those years, and feeling that somewhere, somehow, the country will fulfill the promise that he strove for," said Patricia Kennedy Lawford, the former president's sister.

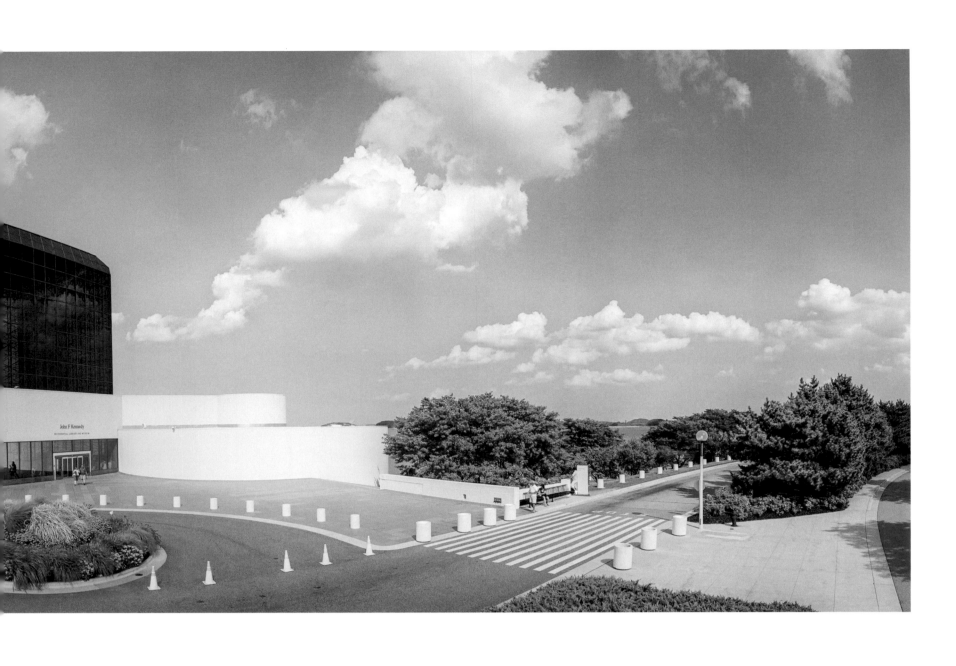

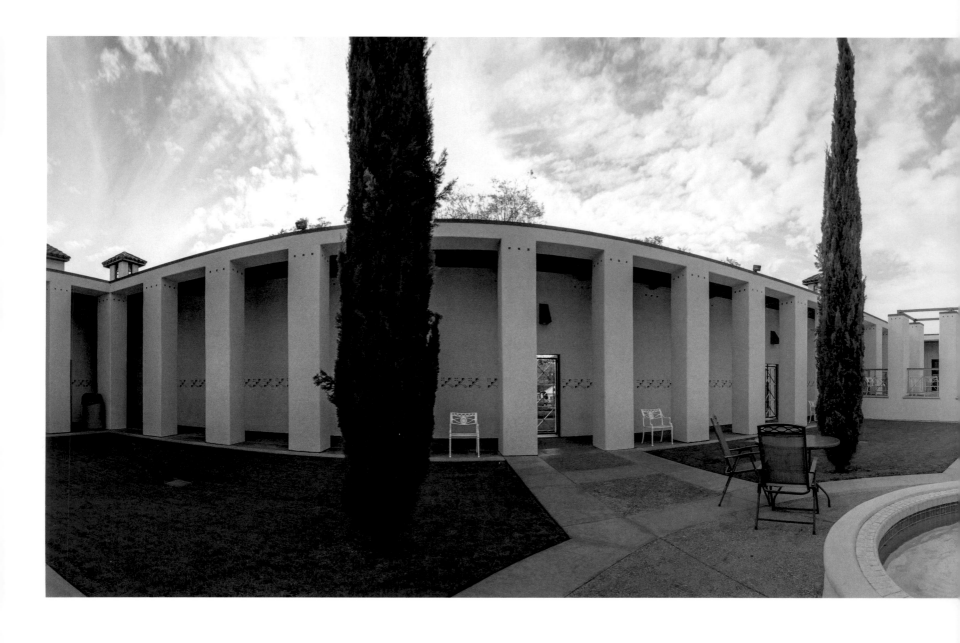

San Juan Capistrano Library, California
The San Juan Capistrano Library, which opened to the public in 1983, was the city's first public building. Designed by the American architect Michael Graves, the structure received an award from the American Institute of Architects and was touted "the first authentic postmodern masterpiece" by *Newsweek*. Its unique design caused controversy in the town when Graves's modernist interpretation of traditional Spanish colonial style was chosen over 140 others. Graves also designed the interior and all the library's furniture—including smaller tables and chairs for children.

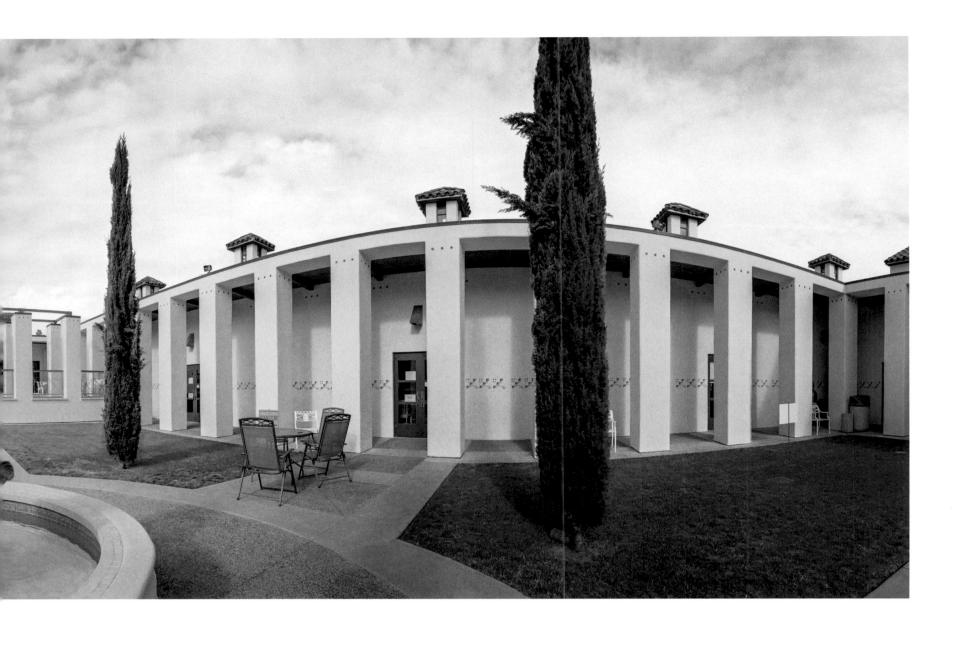

Following pages
Michigan City Public Library, Indiana
The Michigan City Public Library, first opened in 1897, today occupies an iconic building conceived by German American architect Helmut Jahn, easy to recognize thanks to its sawtooth-roof design. Inaugurated to great acclaim in 1977, the building's fiberglass exterior walls allow daylight to flow in during the day and emit a soft glow at night. The library also features a fifteen-foot sculpture commission from artist Tom Scarff: *Centura* (1997), an abstract female figure with a polished, stainless-steel book in her upraised arm.

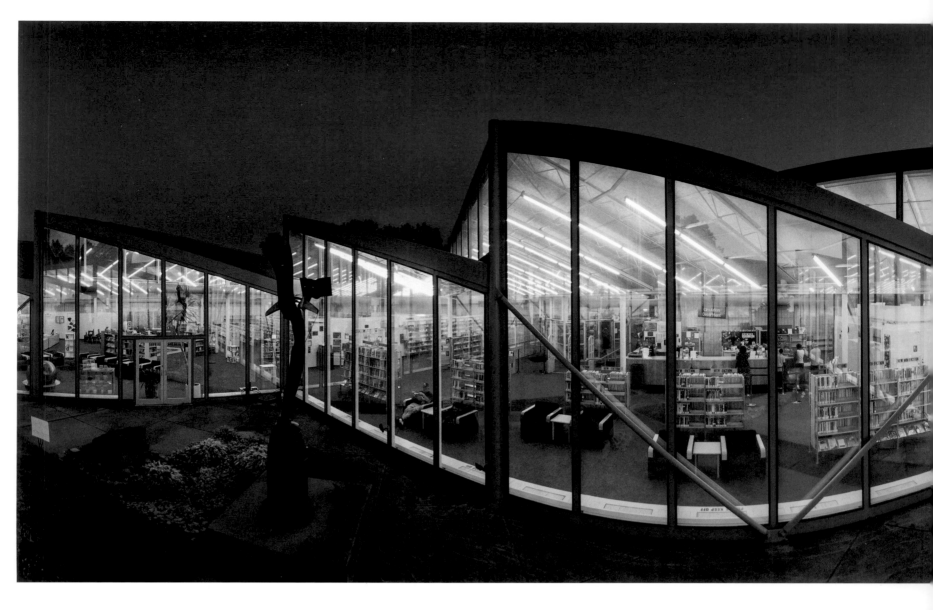

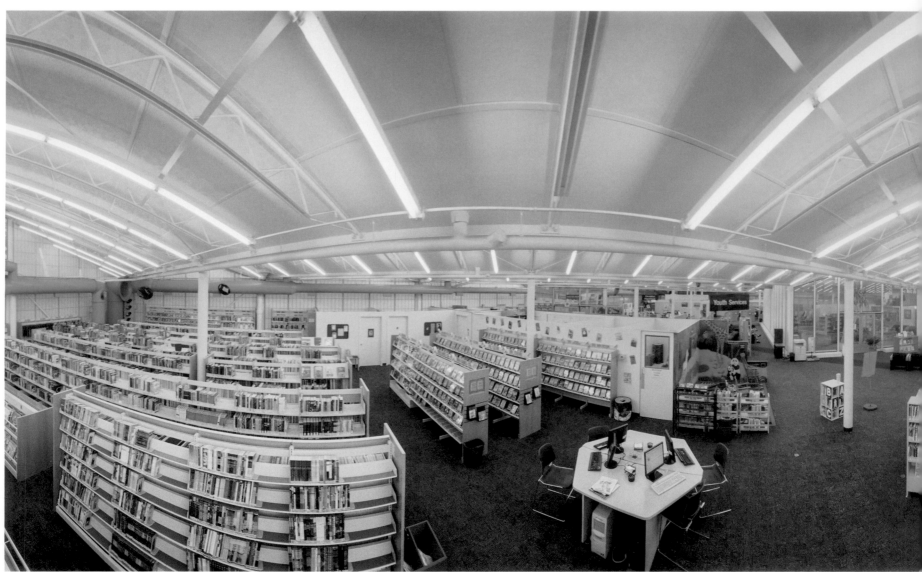

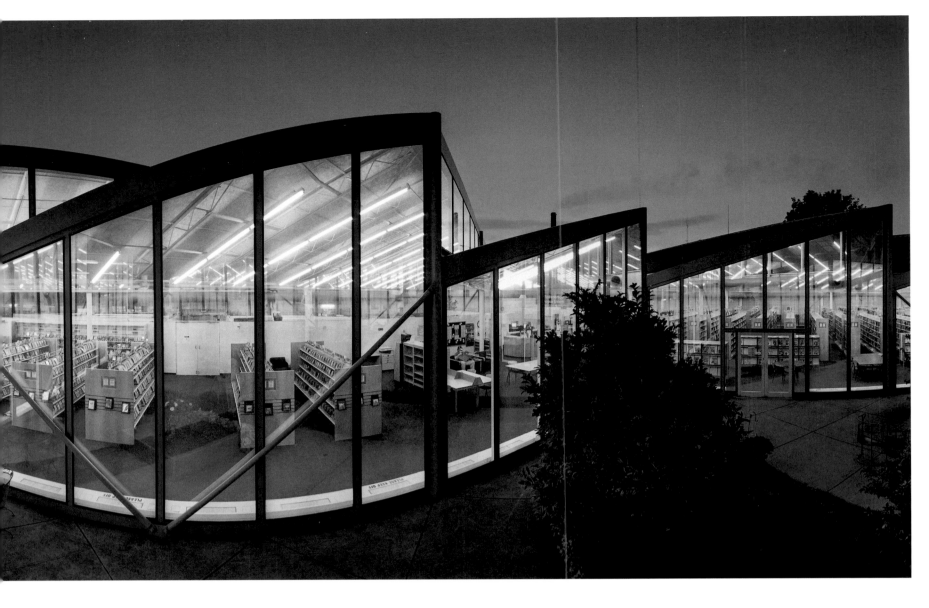

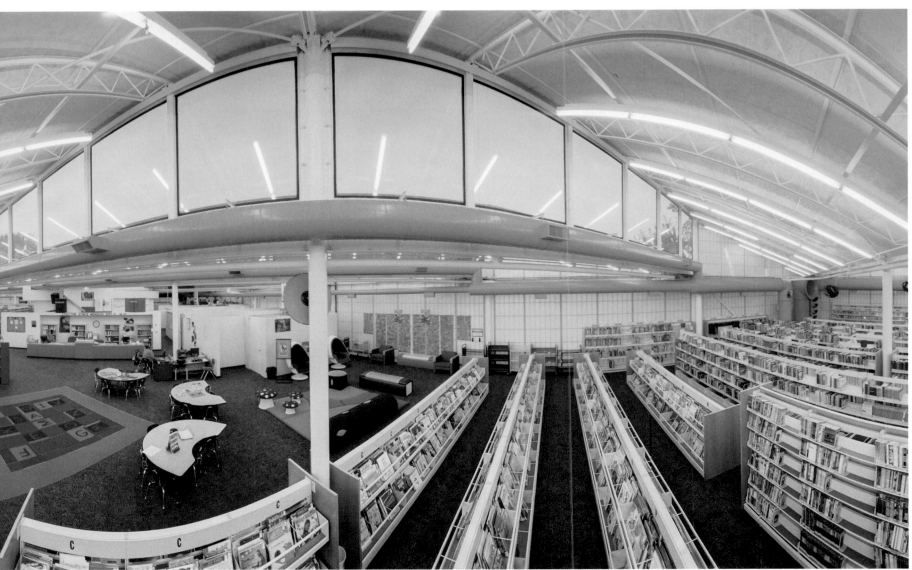

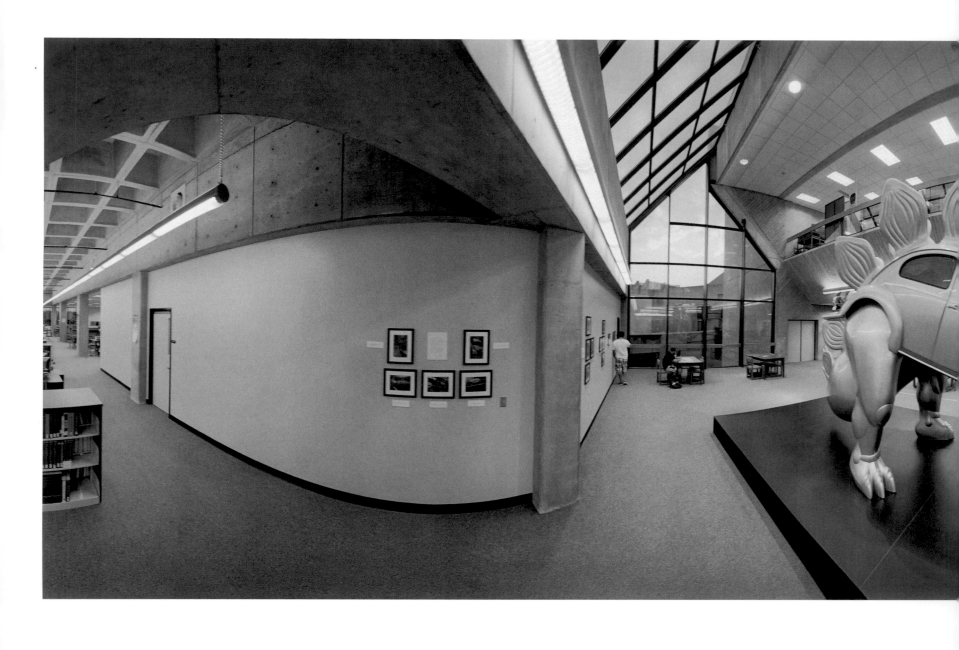

Steely Library, Northern Kentucky University, Highland Heights
Built in 1975, the Steely Library honors the memory of Dr. Will Frank Steely, the university's first president and cofounder. Its Eva G. Farris Special Collections and Schlachter University Archives preserve the history of the university and the Northern Kentucky–Greater Cincinnati area, emphasizing through its holdings the African American, military, and Appalachian histories of the region. Patricia A. Renick's sculpture *Stego*, a combination of a VW Beetle and a stegosaurus, is on long-term loan to the library.

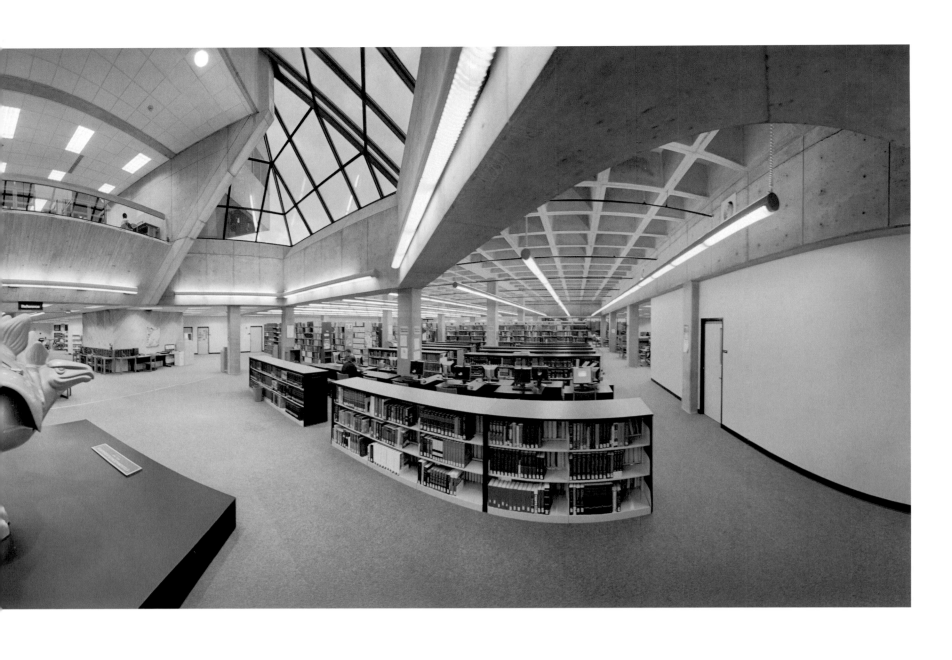

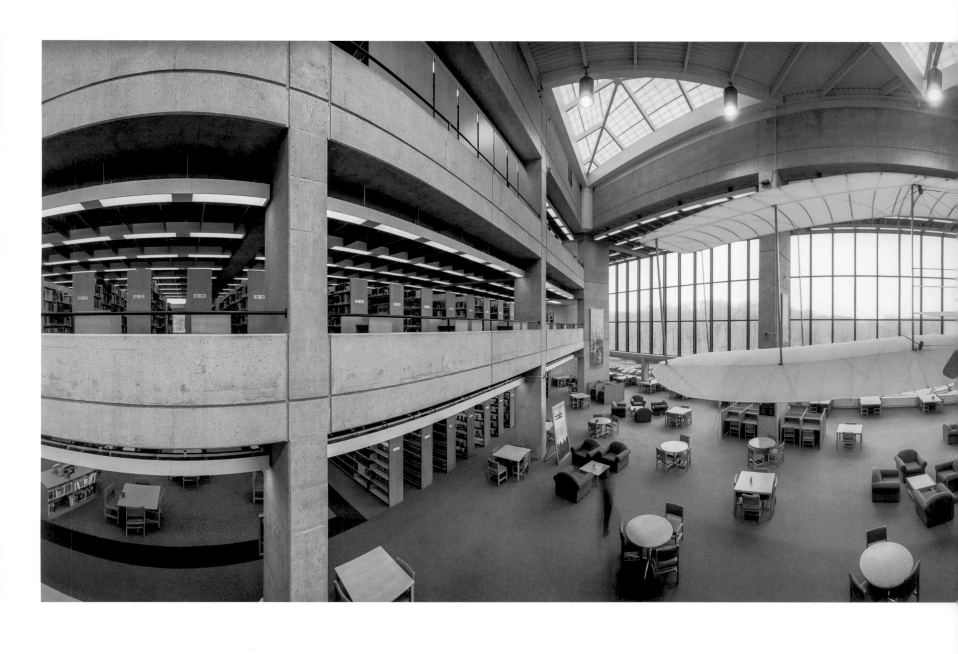

Paul Laurence Dunbar Library, Wright State University, Dayton, Ohio
The library at Wright State University, designed by renowned Japanese
American architect Don Hisaka and dedicated in 1973, honors Dayton-born
Paul Laurence Dunbar, an African American poet and novelist popular in the
late nineteenth and early twentieth centuries. The library takes pride in its
Dunbar collection, an inscribed, first-edition collection of the writer's books,
as well as in its Wright Brothers Collection, one of the most complete in the
world, which includes thousands of photographs documenting the Wrights'
invention of the airplane.

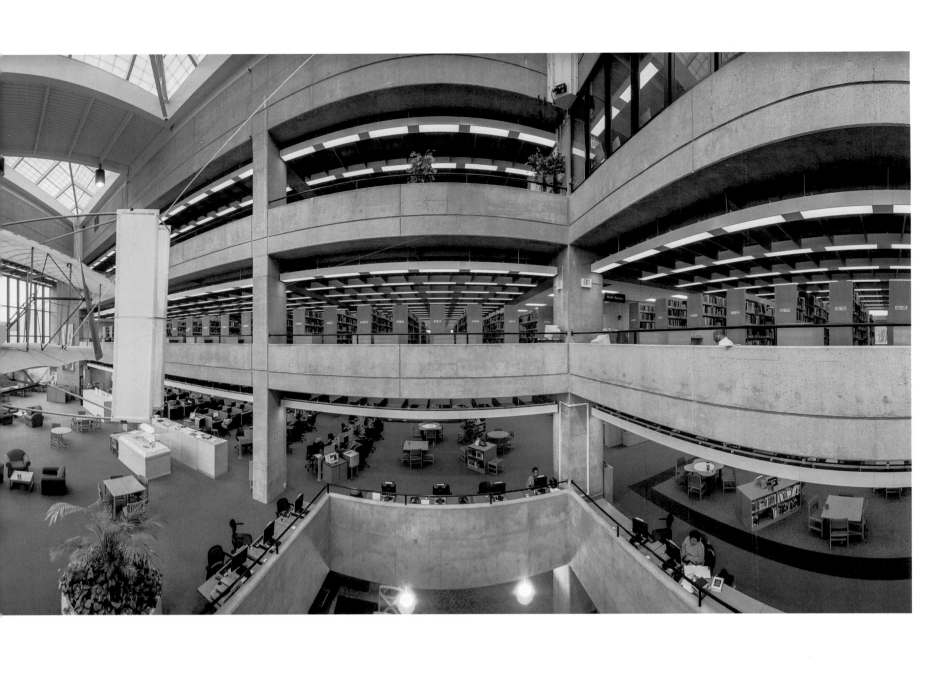

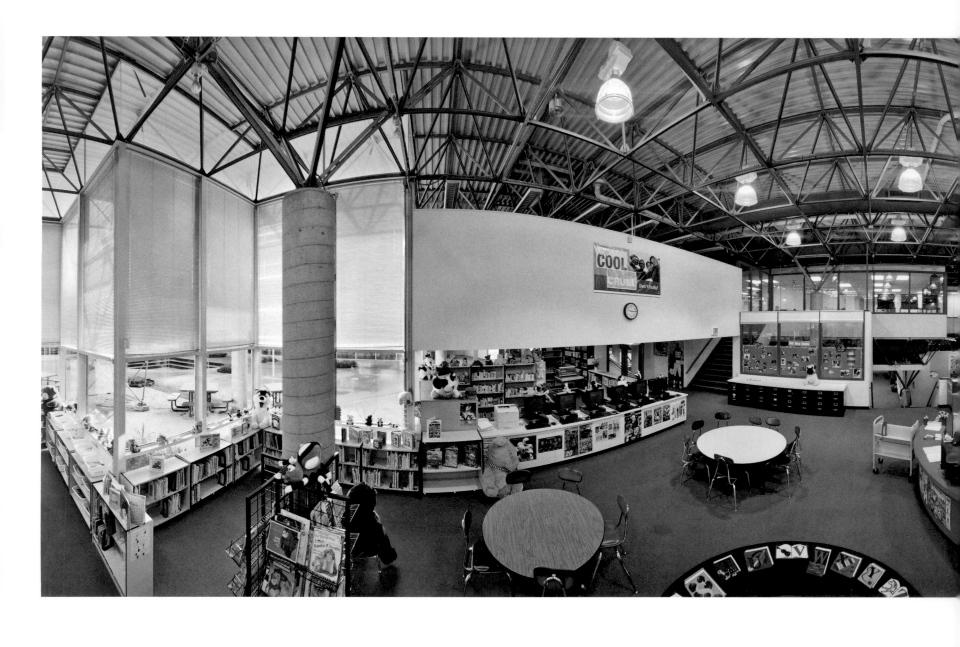

Columbus Signature Academy, Fodrea Campus, Indiana
The Fodrea Campus of Columbus Signature Academy was designed by
Louisiana-born architect Paul A. Kennon and opened to the public in 1973.
Today, the library's collection holds about nine thousand titles, which serve
the school's student body of four hundred students per school year. The
school is in the process of building a maker space within the library with
a strong emphasis on STEM (Science, Technology, Engineering, and Math)
areas. The library currently features a computer lab, a reading room, flexible
seating, and an interactive whiteboard.

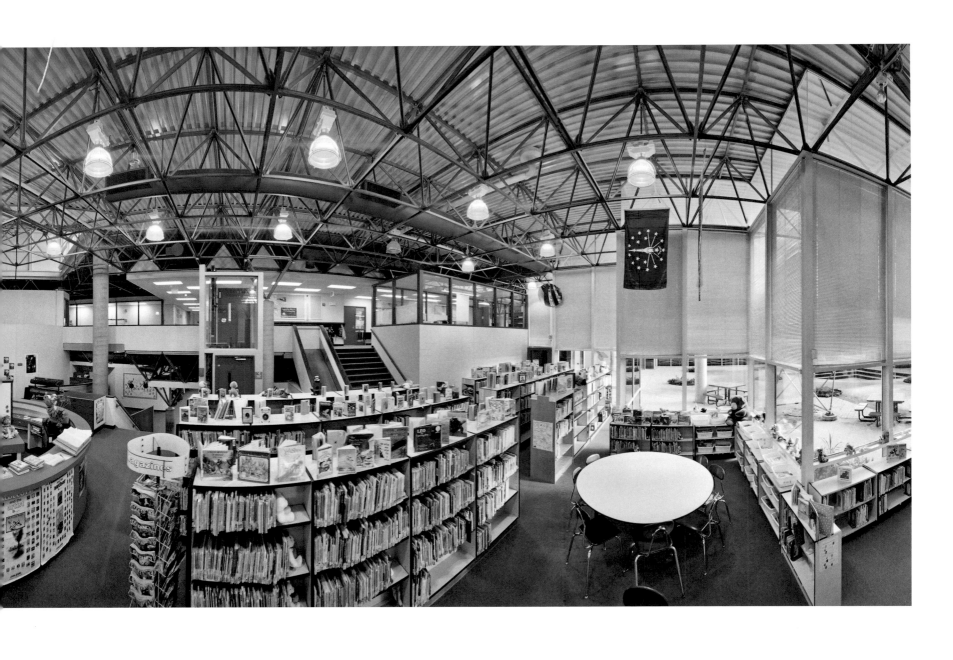

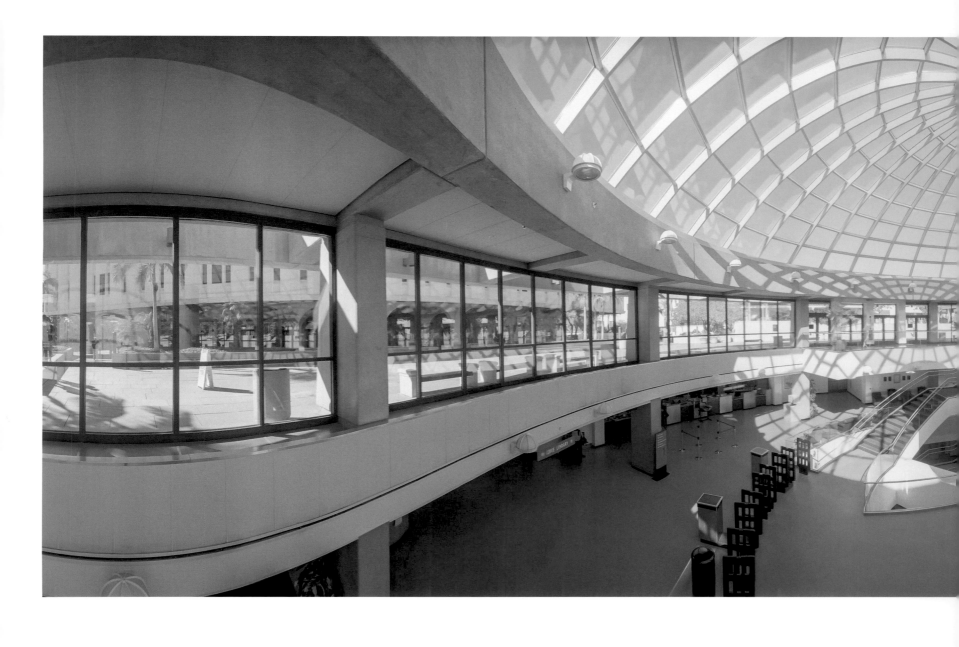

Love Library, San Diego State University
The Love Library at San Diego State University owes its name to Dr. Malcolm
A. Love, its fourth president, credited for overseeing its transformation from
college to university. The library's special collections focus on alternative
religious movements, surfing, and speculative fiction, while its archival
collections highlight Chicano/a history, San Diego history, and women's
studies. With extensive holdings of children's books as well as related history
and critical literature, the library supports the university's National Center for
the Study of Children's Literature.

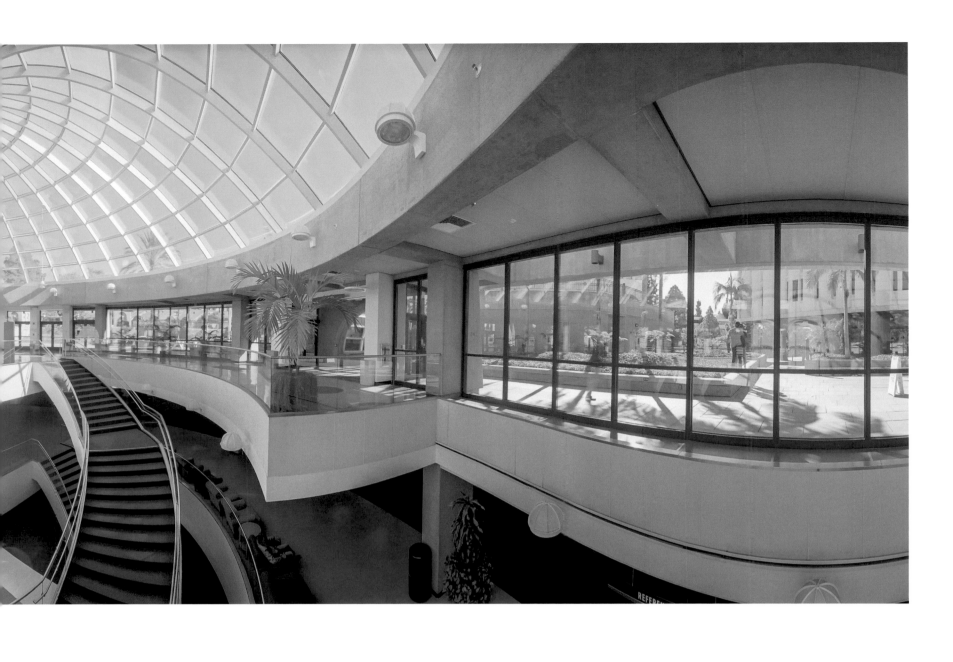

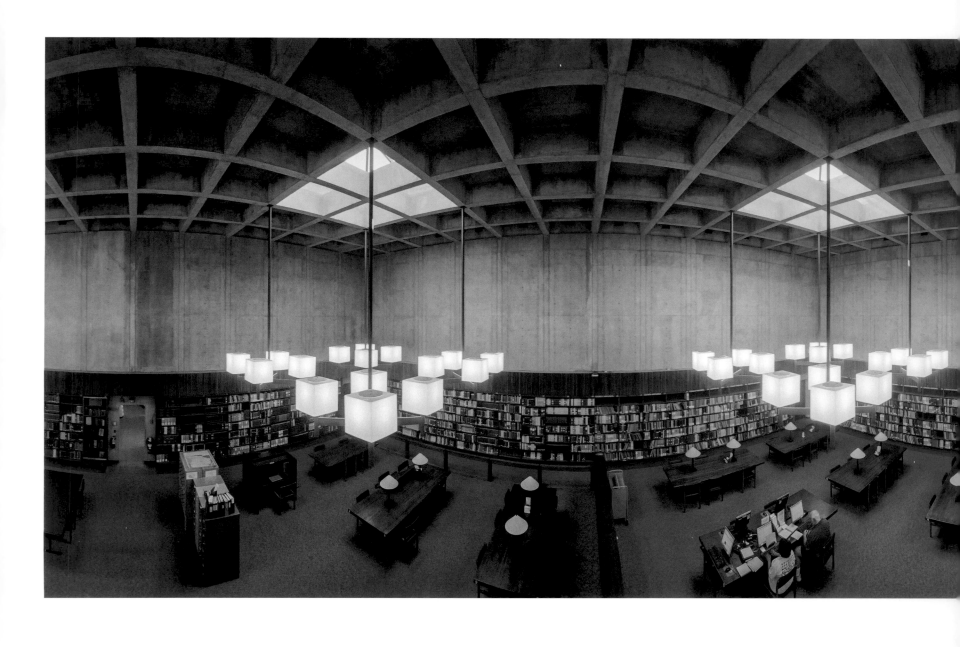

Ohio History Connection Library, Columbus
The Archives and Library within the Ohio History Connection hold and offer its patrons extensive information concerning the state's history. As the official state archives, the Ohio History Connection also serves as the delegated repository for historically valuable government records, including among its collections the papers of local politicians and civic organizations. While controversial to some, its building design, by Columbus firm W. Byron Ireland & Associates, is recognized by many architects as a paradigm of Brutalism in the United States.

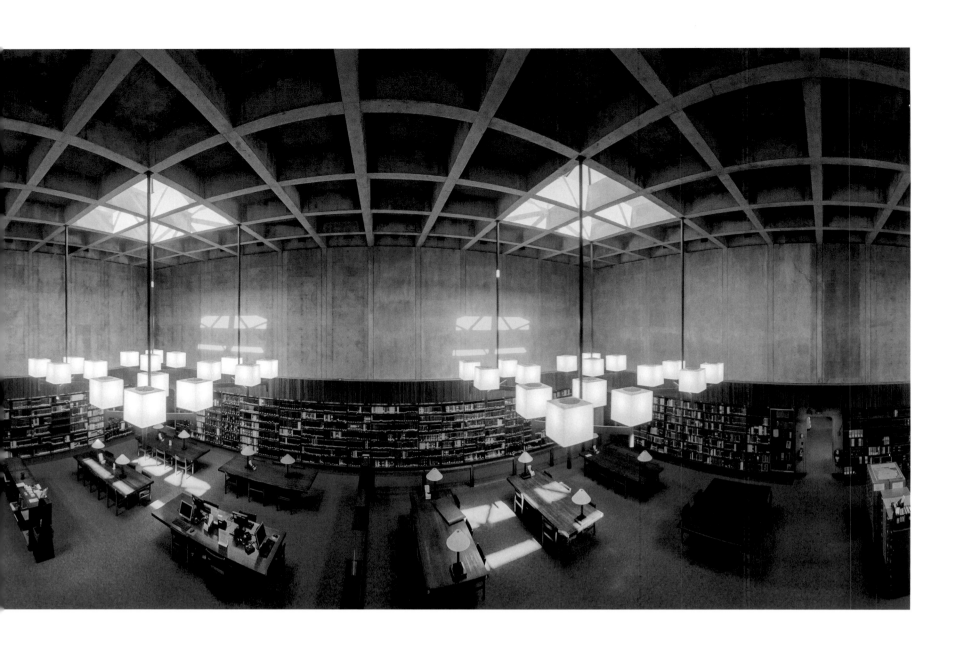

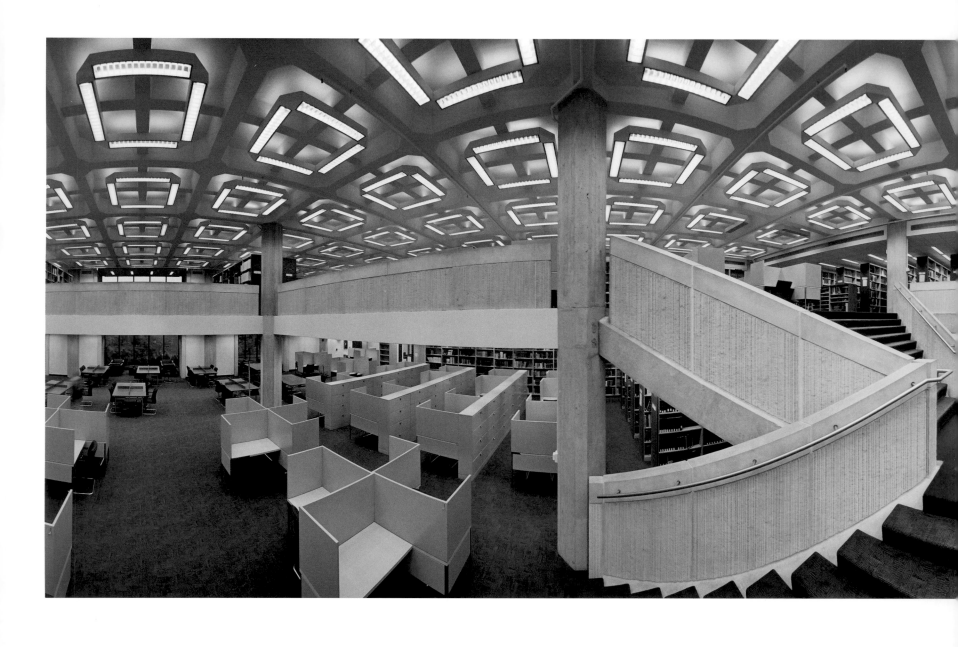

Joseph Regenstein Library, University of Chicago
Completed in 1970, the Regenstein Library honors the memory of industrialist
Joseph Regenstein, a fourth-generation Chicagoan recognized for his advances
in plastics, paper, and chemistry. Known for its distinctive Brutalist design
and outer wall of projecting and receding concrete bays, it is the largest
library on the UC campus. Henry Moore's bronze sculpture *Nuclear Energy*
(1967) flanks the library, memorializing the place where Enrico Fermi and
other scientists completed the first controlled, self-sustaining nuclear chain
reaction on December 2, 1942.

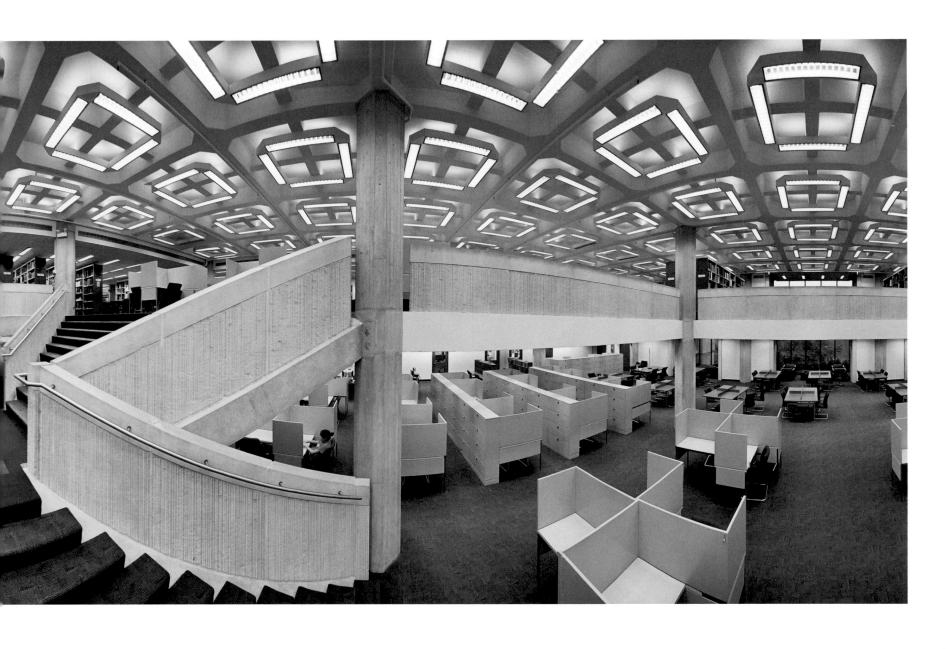

Following pages
Earl W. Brydges Building, Niagara Falls Public Library, New York
Library services in Niagara Falls were initiated in 1814 when a citizens'
association founded the "Grand Niagara Library" with forty volumes. After
decades of itinerancy, the library obtained a half-million-dollar grant from
Andrew Carnegie in 1901 and moved into a marble-floored building with
room for thirteen thousand books. The Earl W. Brydges building, designed
by Paul Rudolph, became its home in 1974. On the third floor, the library hosts
the Local History Department, which preserves the history of Niagara Falls
through books, photographs, and ephemera.

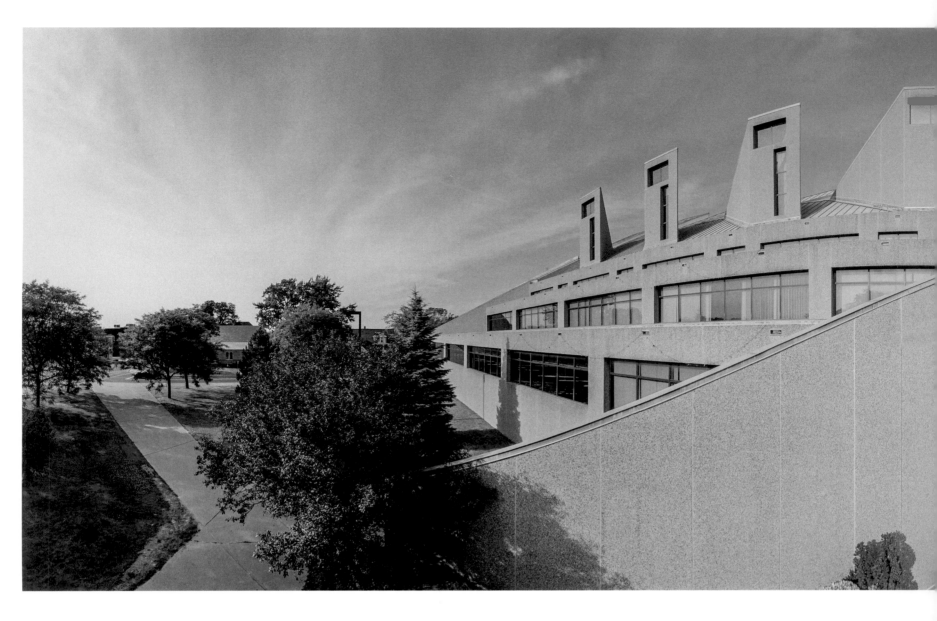

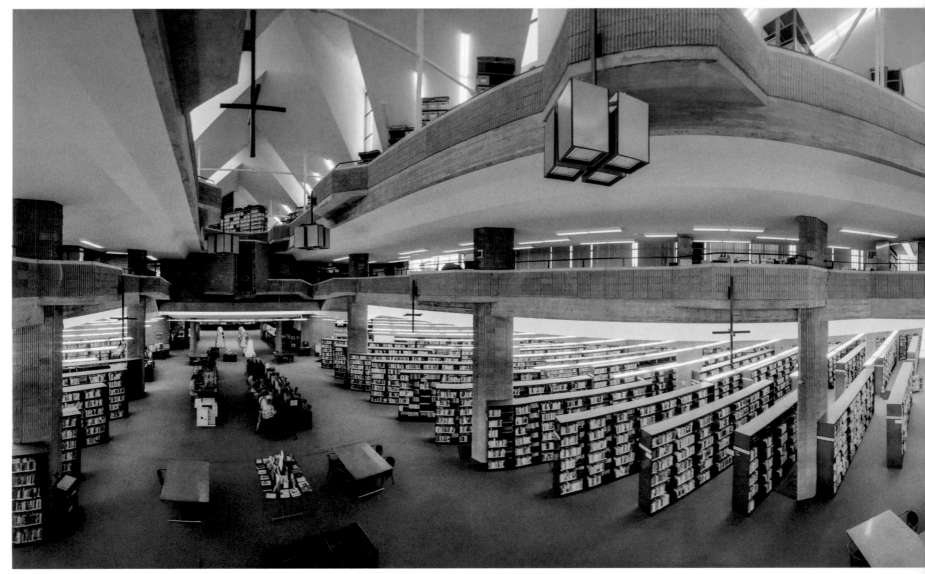

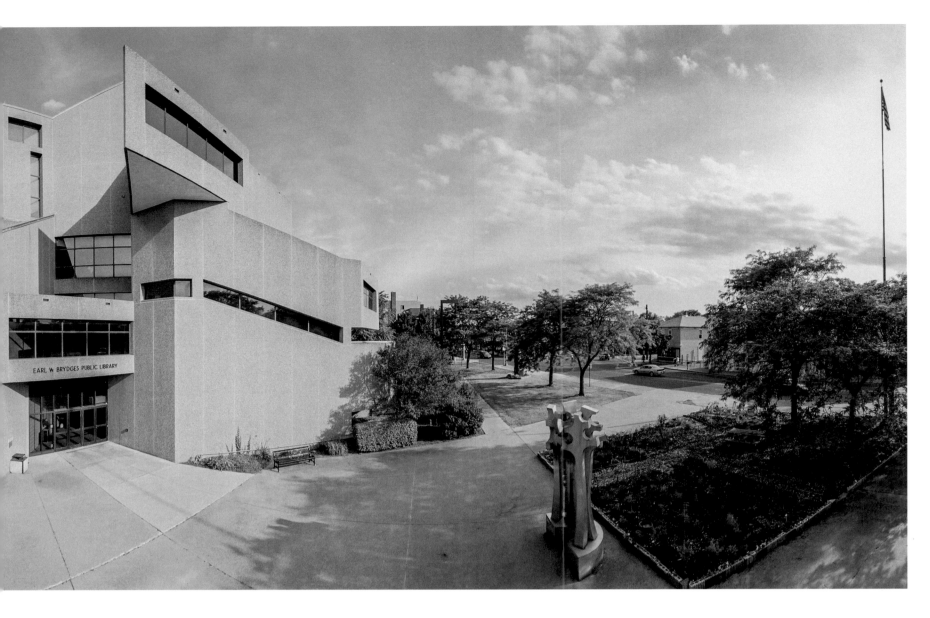

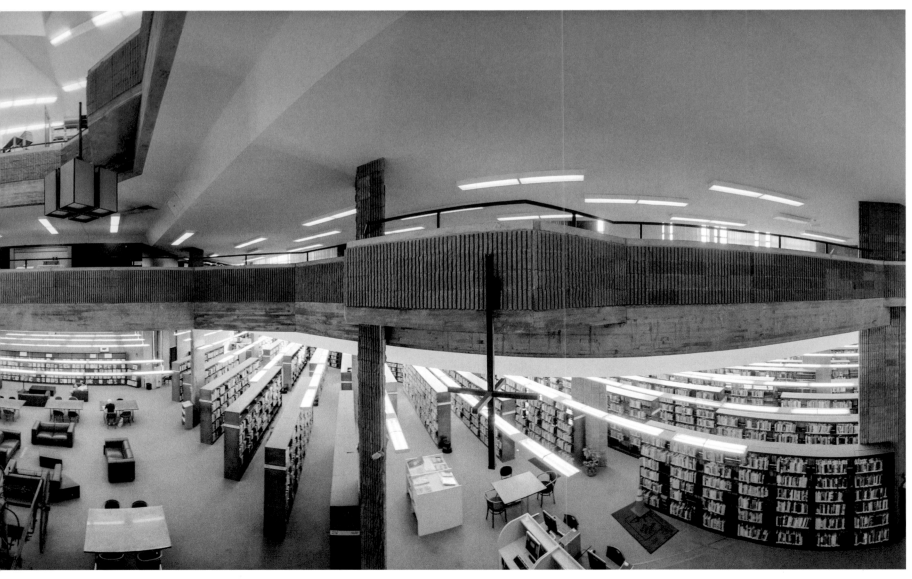

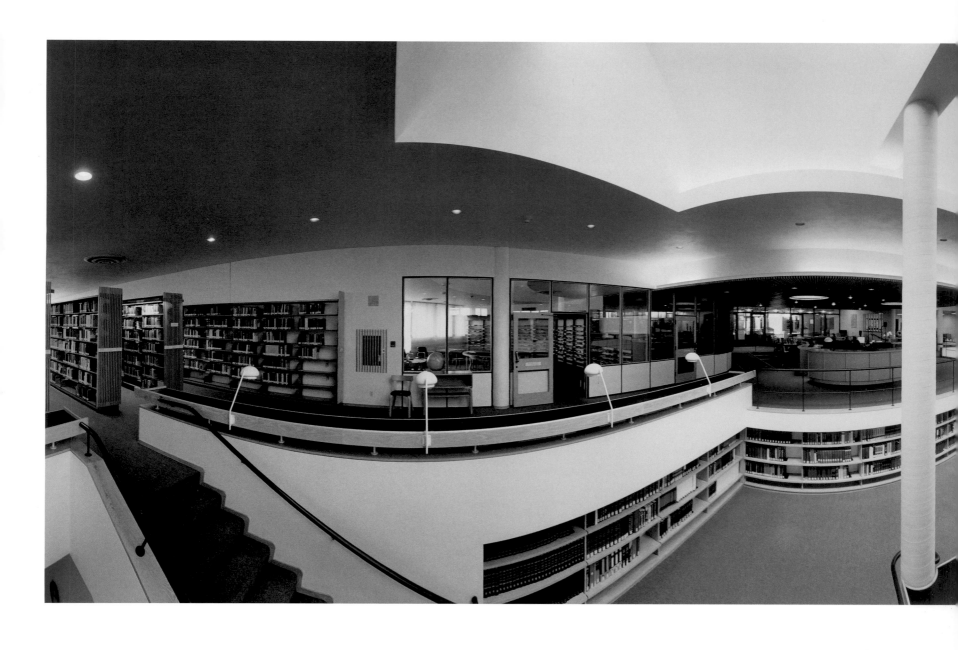

Mount Angel Abbey Library, Saint Benedict, Oregon
The Abbey Library's collection was built from the few volumes that survived
a catastrophic fire in 1926 and the purchase, in 1932, of the contents of a
used bookstore in Aachen, Germany. Its holdings in philosophy, patristics,
and Latin Christian studies were significantly expanded in the 1980s and
'90s. The library occupies a three-story building designed by Finnish architect
Alvar Aalto, and comprises one of the largest collections of Aalto furniture in
North America. It was dedicated in 1970 with a performance by Duke Ellington.

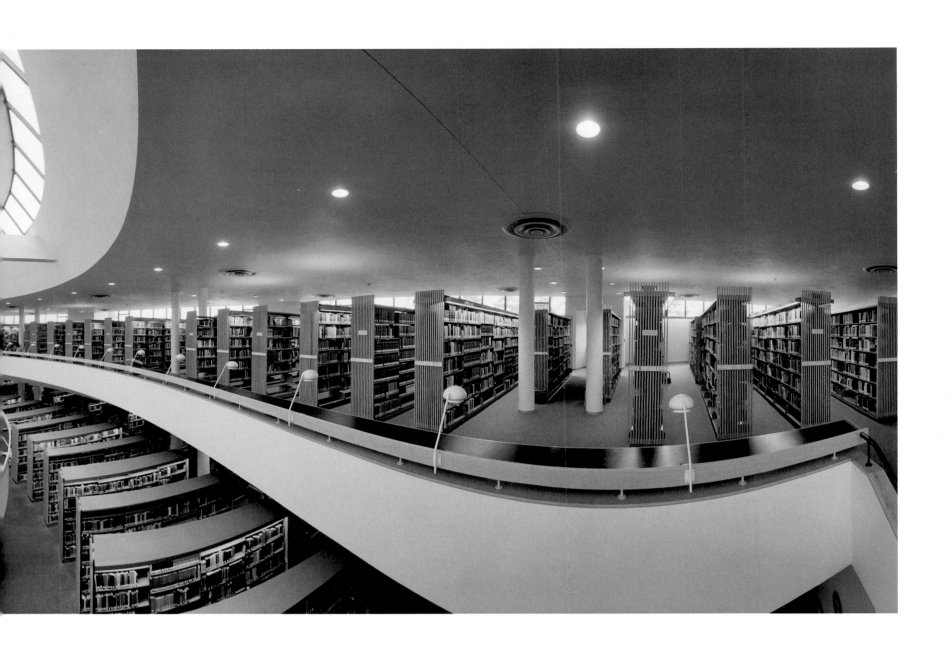

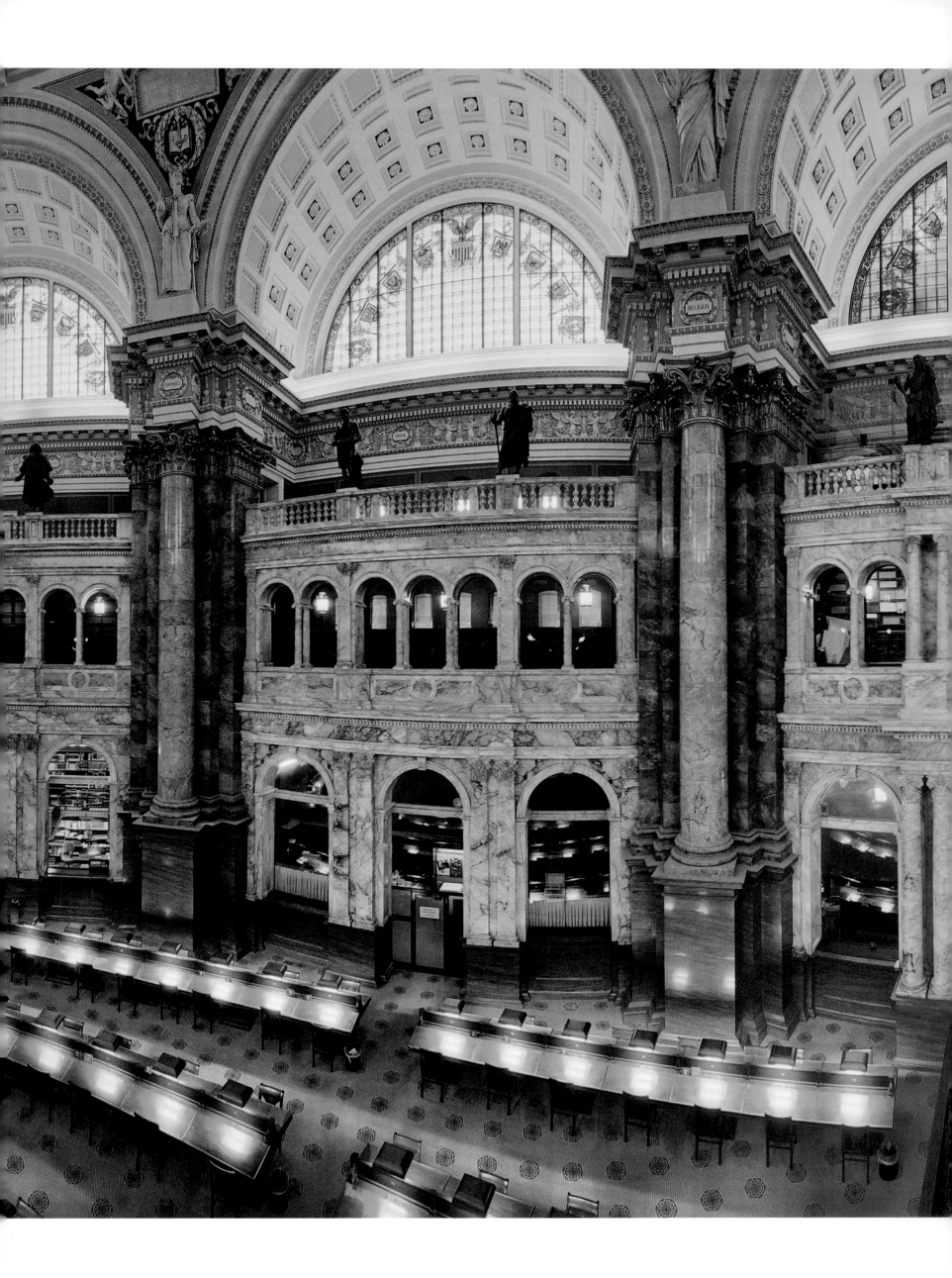

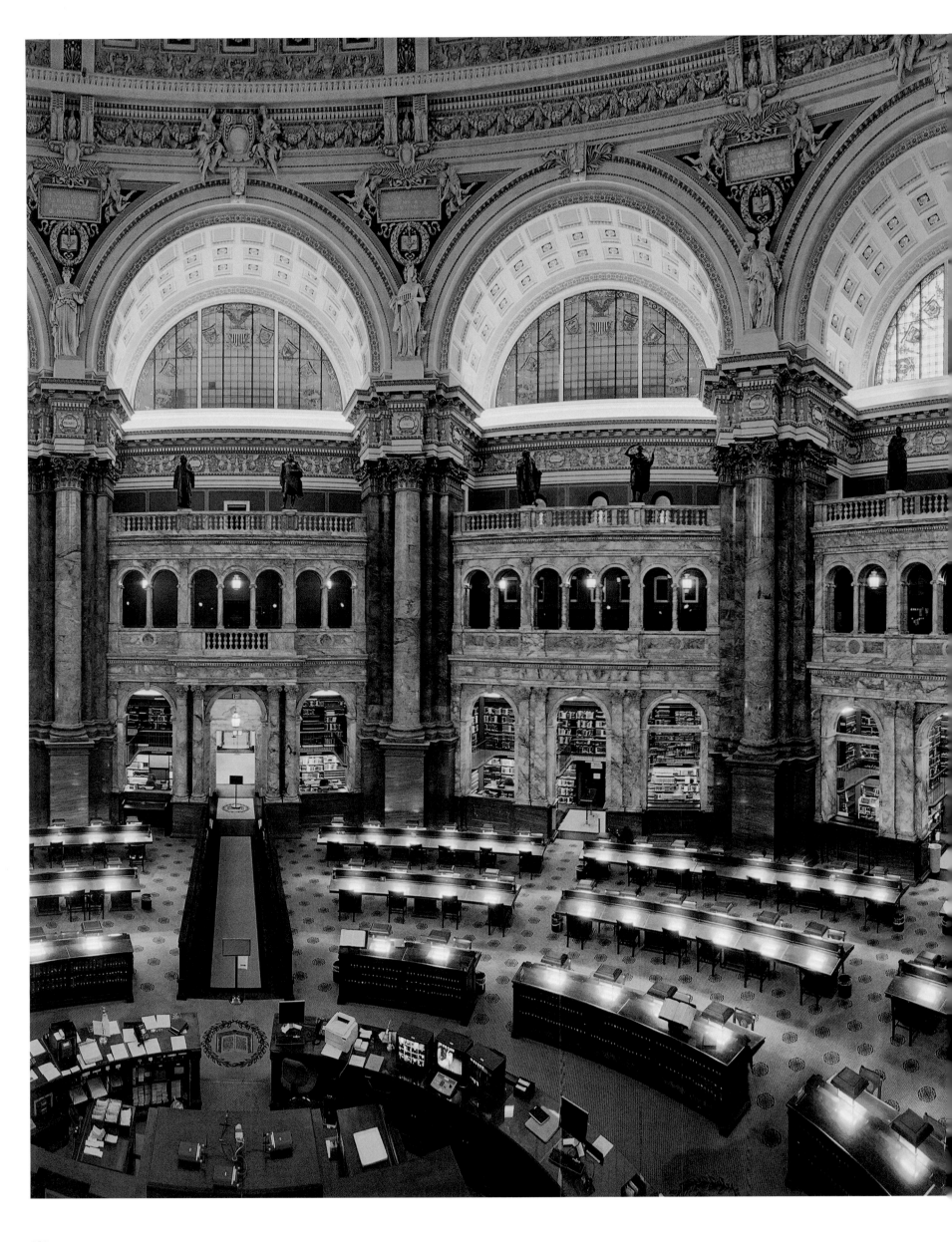

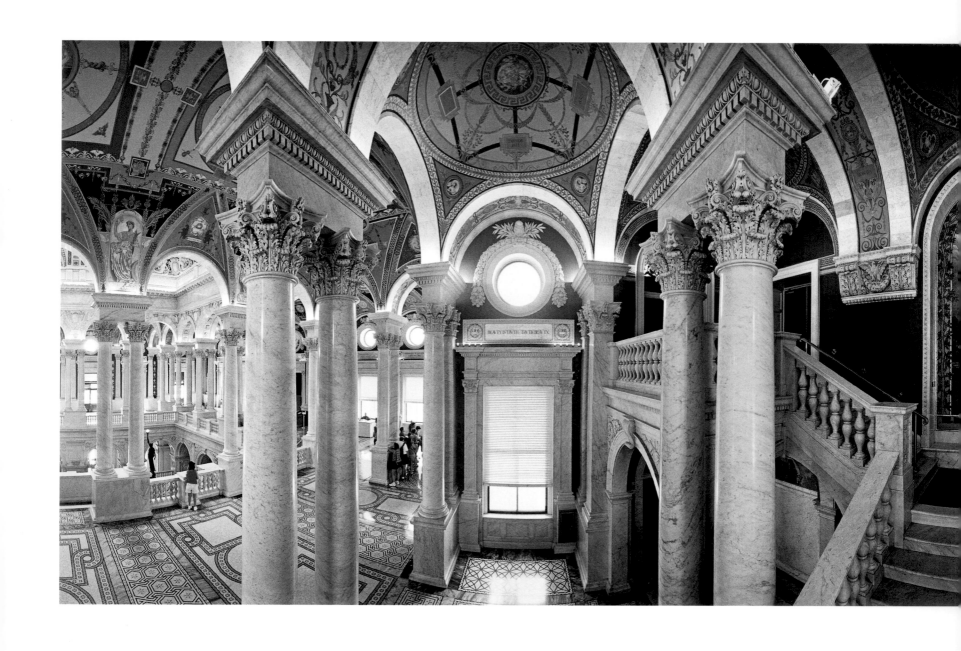

Above, gatefold, and following pages
Library of Congress, Washington, D.C.
John Adams created a reference library for Congress in 1800 when the
nation's capital moved from Philadelphia to Washington, D.C. Invading
British troops destroyed this original library in 1814; following the war,
Thomas Jefferson supplied his personal library to start the collection of
what is now the Library of Congress. Housed in a Renaissance-style building
designed by architects John L. Smithmeyer and Paul J. Pelz, the national
monument was opened to the public in 1897 and today features more
than 158 million unique and rare items.

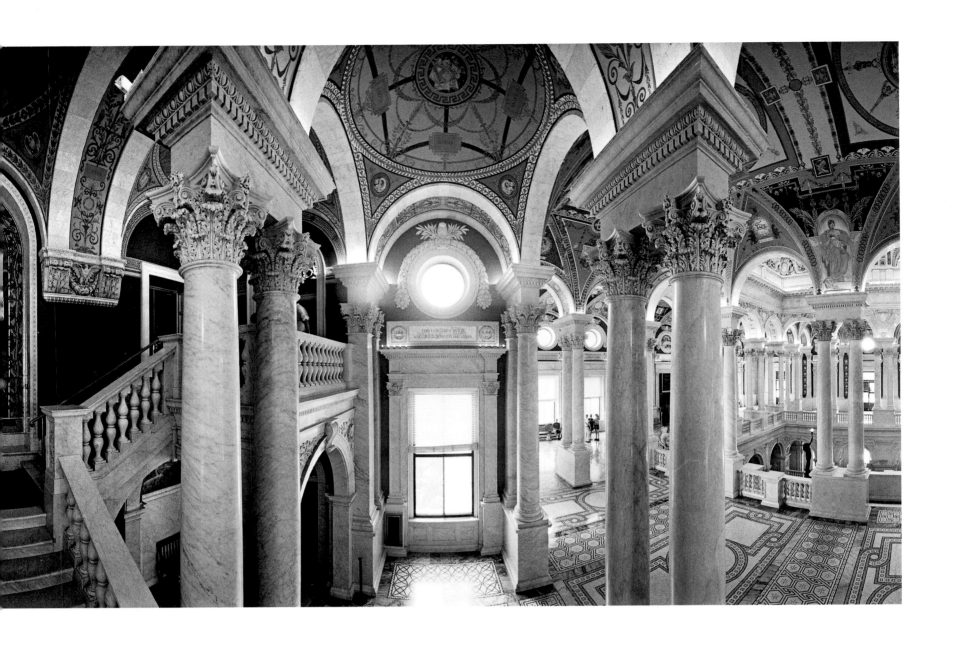

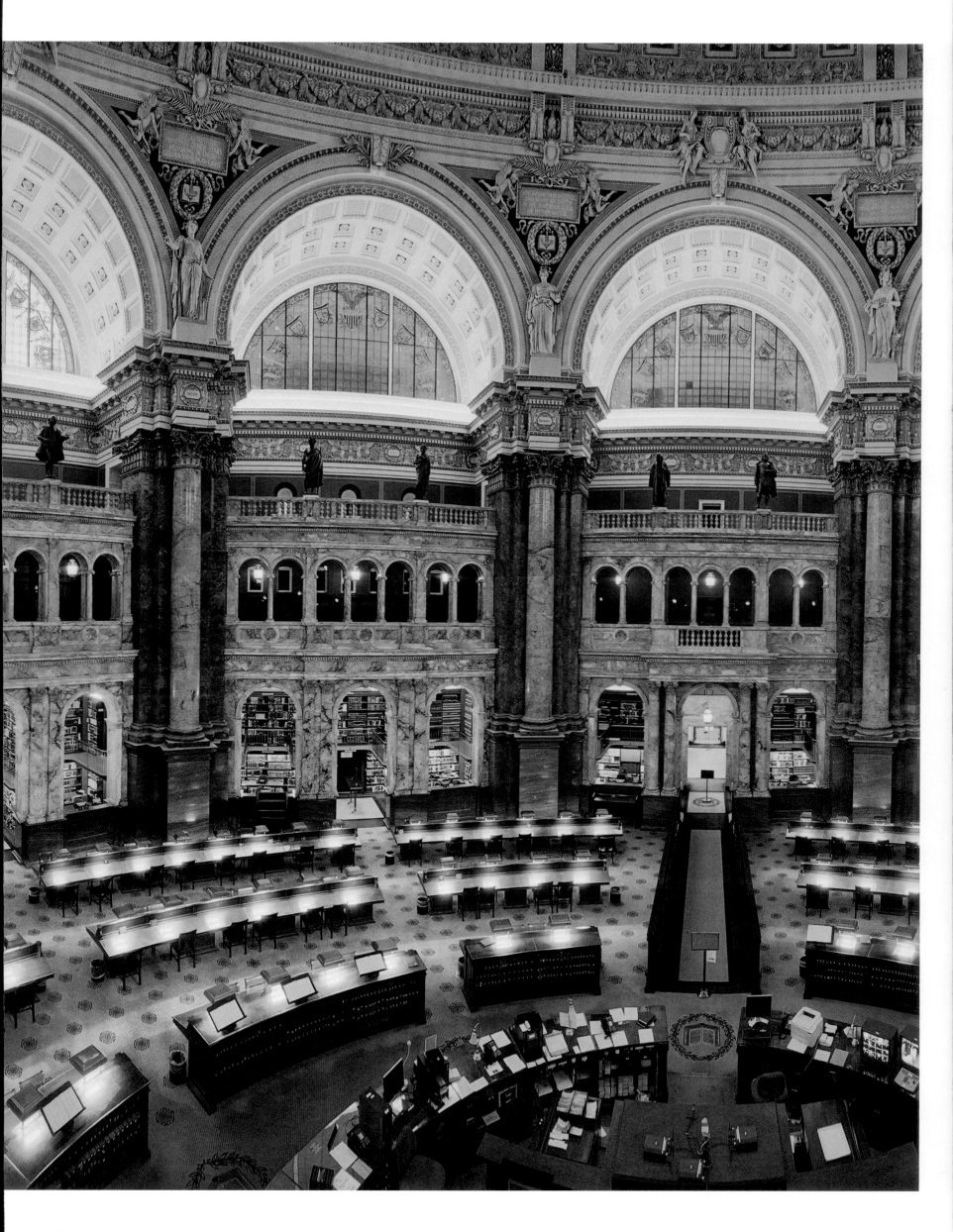

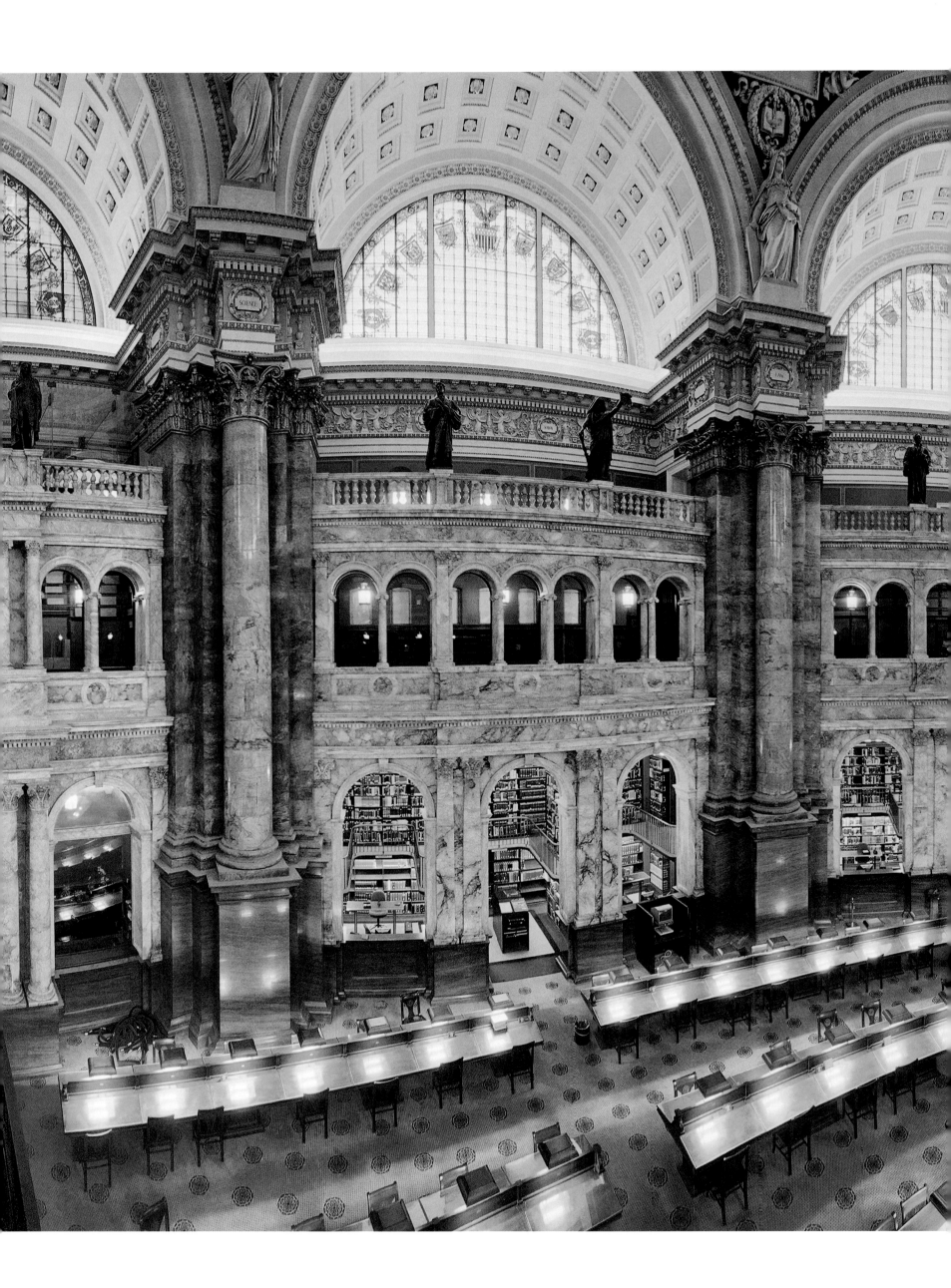

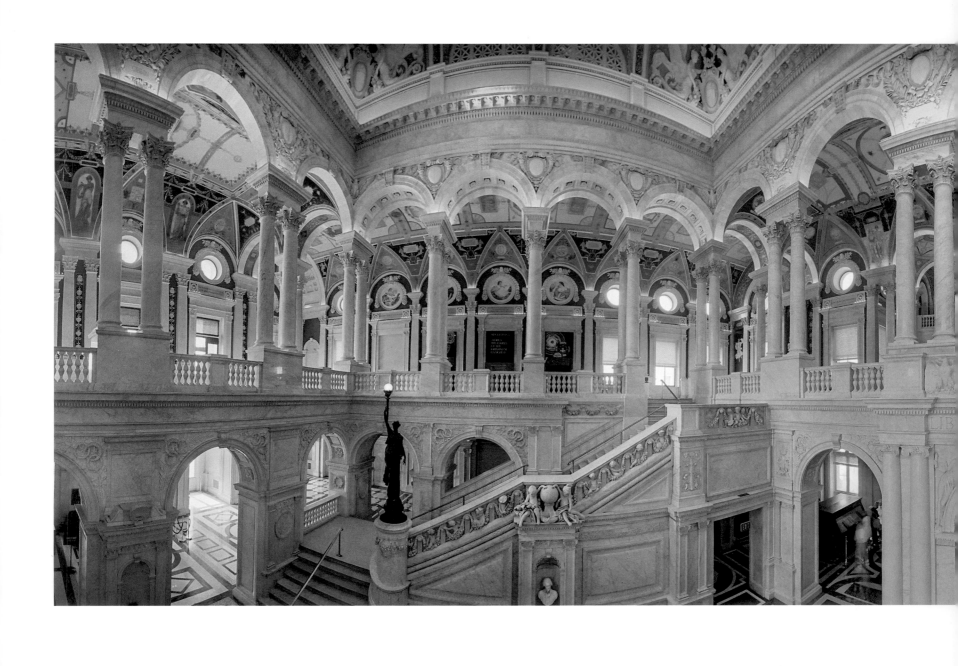

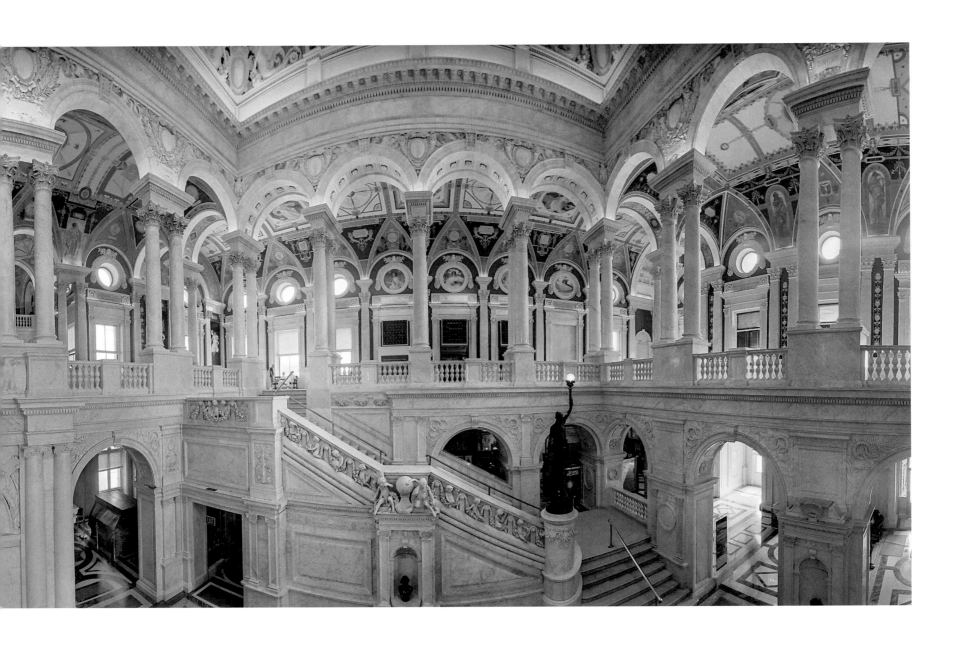

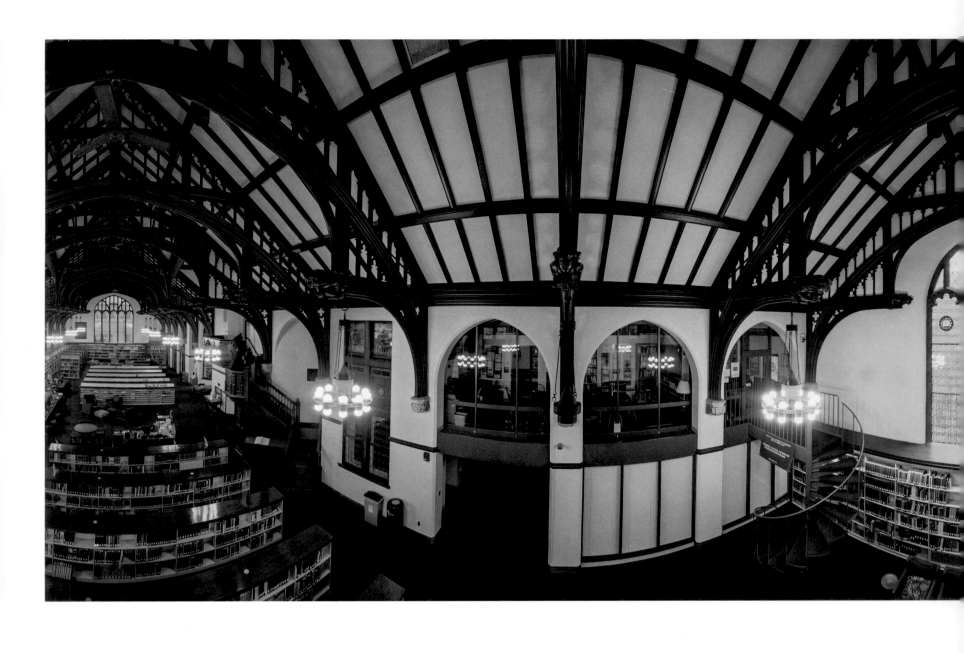

Williston Smith Library, Mount Holyoke College, South Hadley, Massachusetts

Named in part for A. Lyman Williston, a female trustee of the university, the Williston Smith Library was built in 1905. Several of its rooms were modeled after illustrious European spaces: its main reading room was designed to resemble Westminster Hall, the oldest part of Westminster Palace in London, while its atrium was modeled after the Medici Library in Florence. The court features a wellhead with the Latin inscription, "You who are thirsty, come and drink freely," which is also the library's motto.

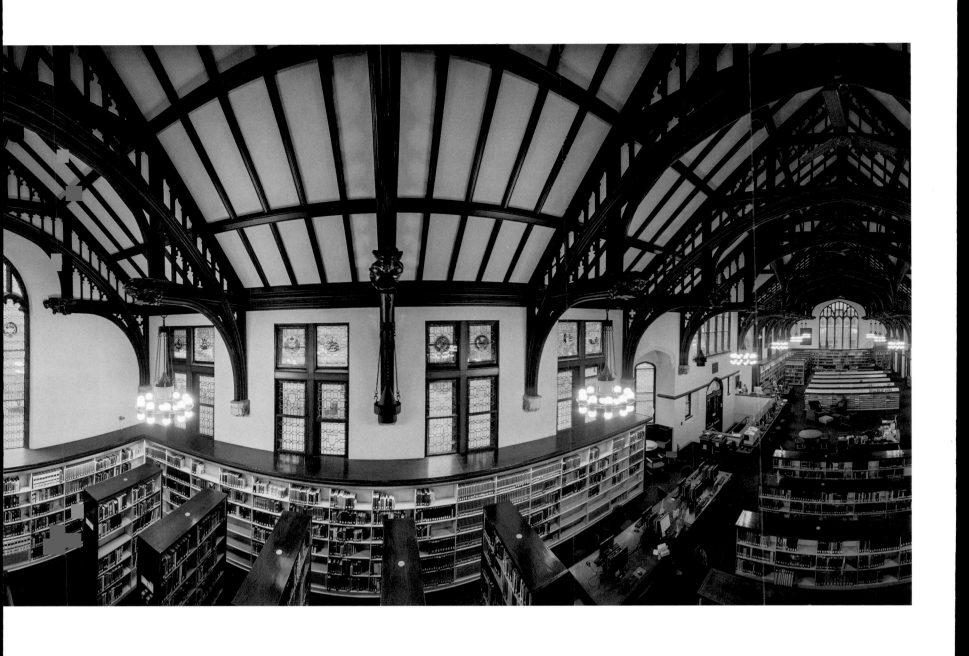

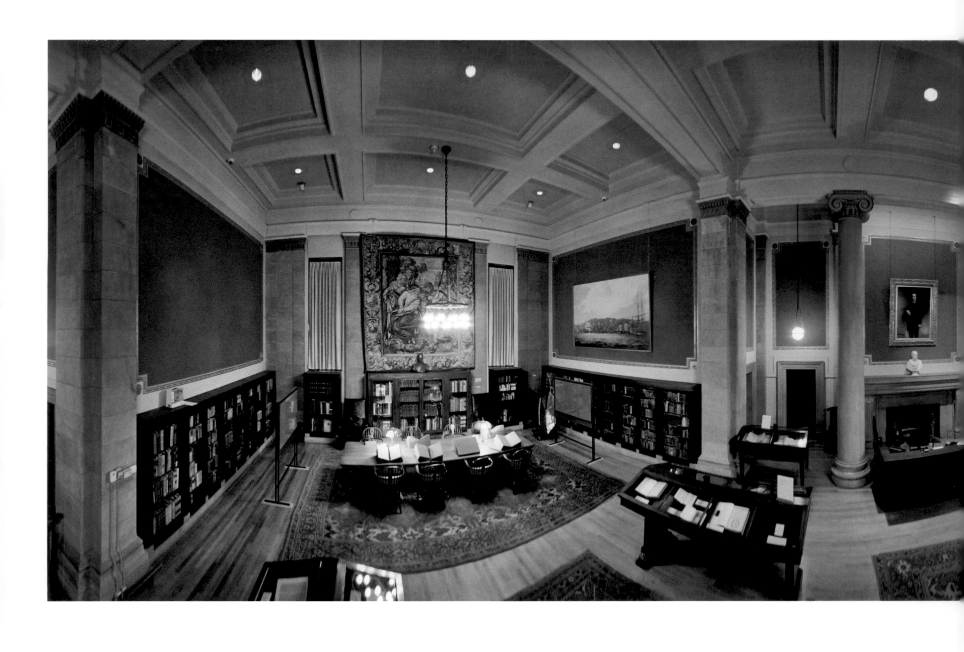

John Carter Brown Library, Brown University, Providence, Rhode Island
The John Carter Brown Library began as the private collection of John Carter
Brown, a businessman and book collector enthusiastic about the discovery
of the New World. Located at Brown University since 1901, the library owns
fifteenth-century editions of Columbus's letter to the Spanish court announcing
his discoveries, the world's most complete collection of Spanish American
works printed before 1820, and a large collection of political pamphlets
produced at the time of the American Revolution, among many other
remarkable materials.

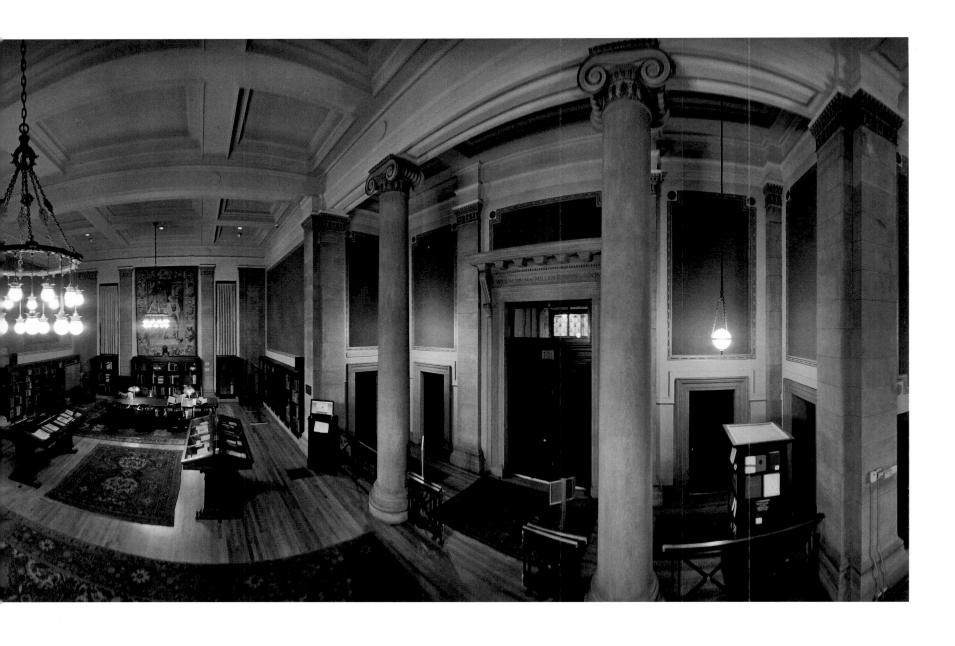

Following pages
St. Louis Public Library
The St. Louis Public Library originated as a subscription library in 1865, and began serving the general public in 1874. The monumental Central Library building, designed by architect Cass Gilbert, who also designed the Woolworth Building in New York and the U.S. Supreme Court, was inaugurated in 1912 and made possible thanks to a gift from Andrew Carnegie. When the building was restored in 2011, granite was quarried from Mt. Waldo, Maine, the same source of the building's original material.

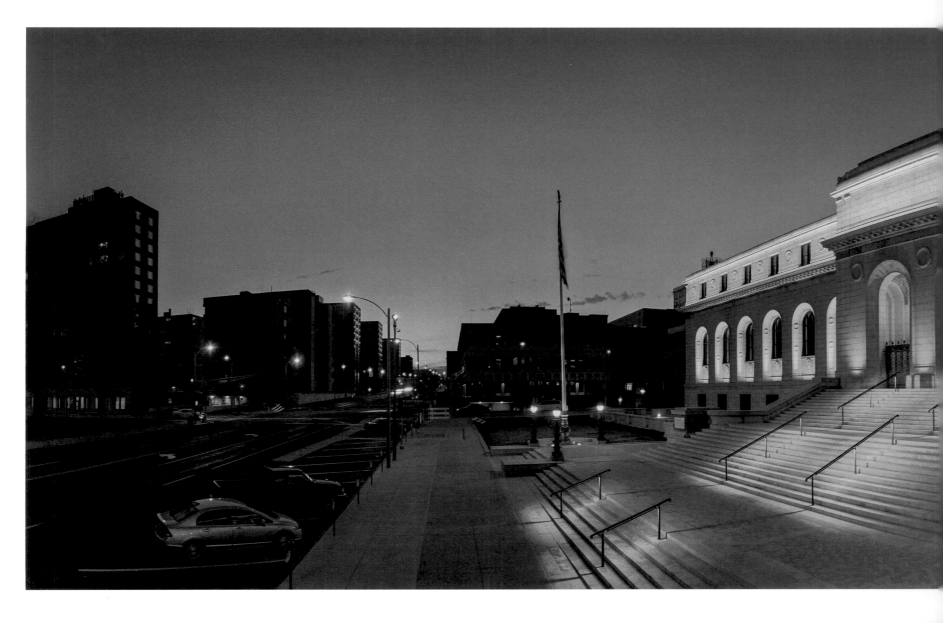

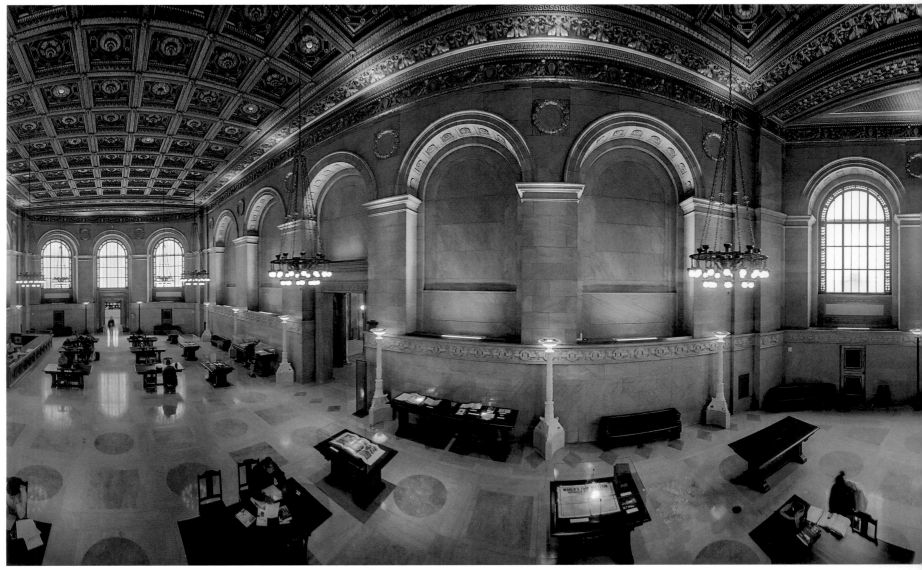

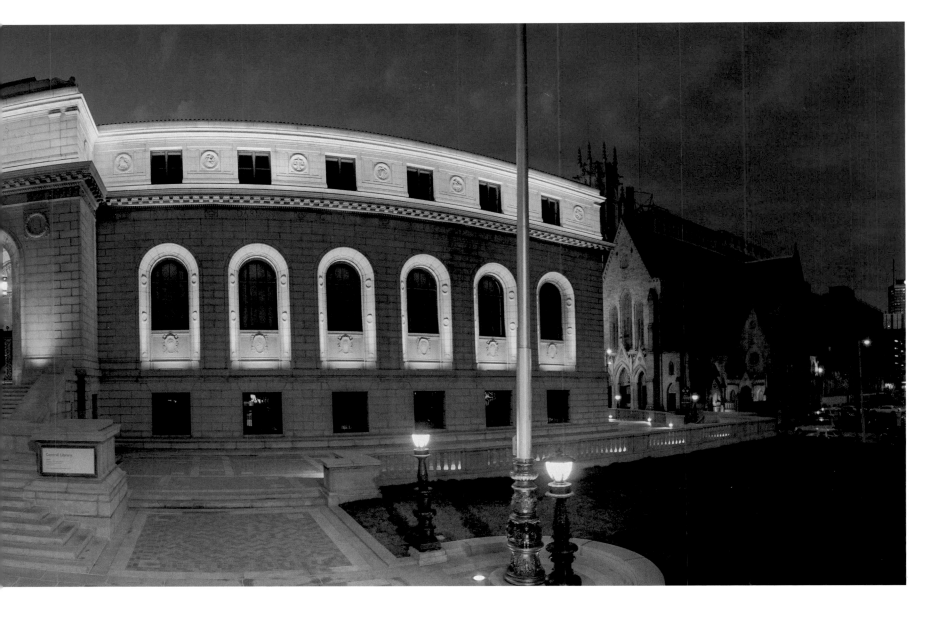

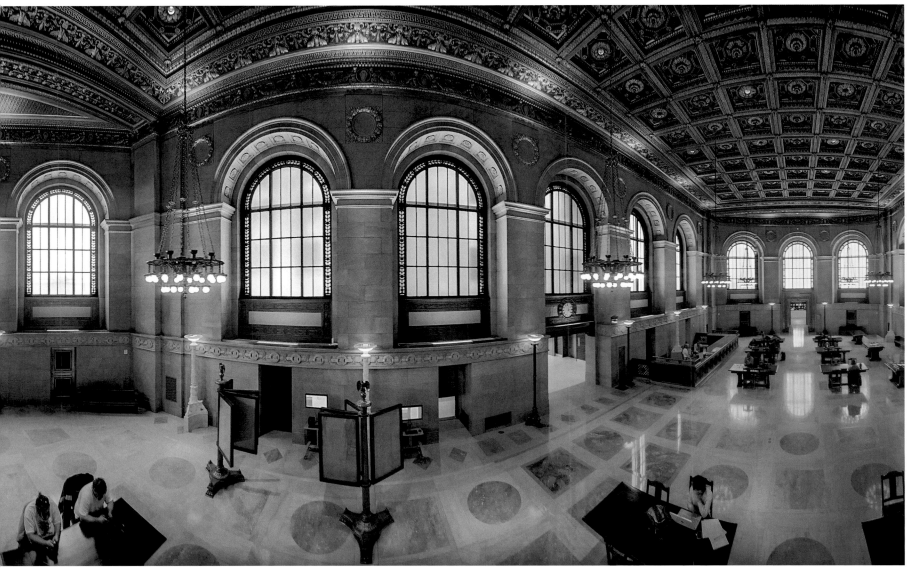

Carnegie Library of Pittsburgh
The Carnegie Library of Pittsburgh was founded with a one-million-dollar donation from Andrew Carnegie, whose philanthropic spirit helped fund not only the main library but also five regional branches. Located in the Oakland neighborhood of Pittsburgh, the library's collection includes over 2.5 million items. Its Oliver Special Collections Room specializes in the preservation of rare books, manuscripts, and photographs, with some items dating back to 1477, while the Children's Archives hold materials from the library's history as the first U.S. school for children's librarians.

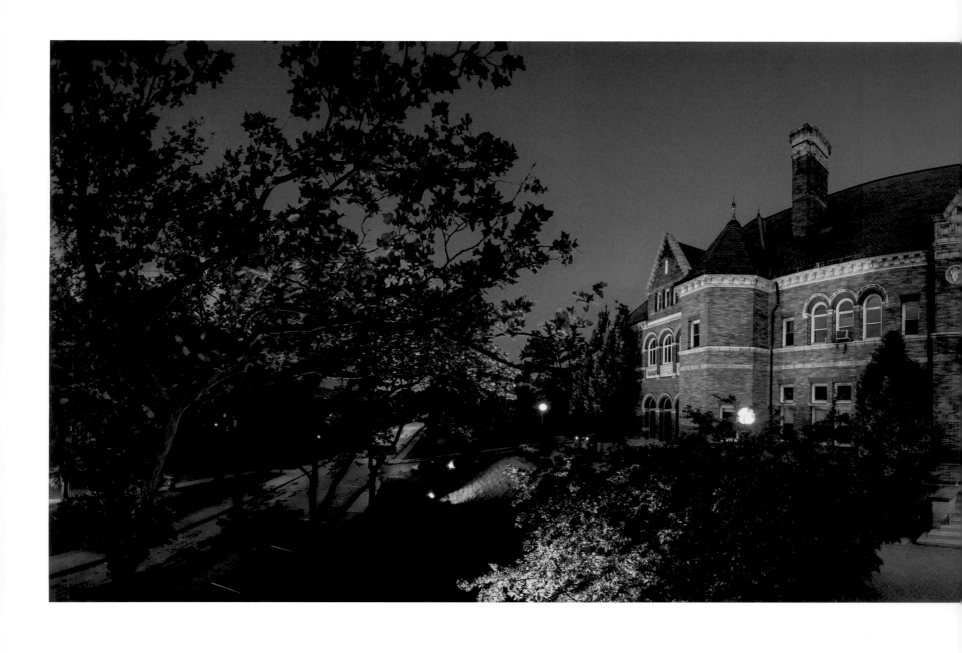

Carnegie Library of Homestead, Munhall, Pennsylvania
The Carnegie Library of Homestead is a public library founded by Andrew
Carnegie, the seventh of the nearly 1,700 U.S. libraries he commissioned.
Completed in 1898, it is the third oldest Carnegie library in continuous
operation in its original structure in the United States, and also one of the
few that didn't require public funds to subsidize its operations, given original
funding by Carnegie's local steel plant and subsequent endowment. The
Homestead today houses nearly thirty-five thousand volumes, and includes
a music hall and athletic club in the same building.

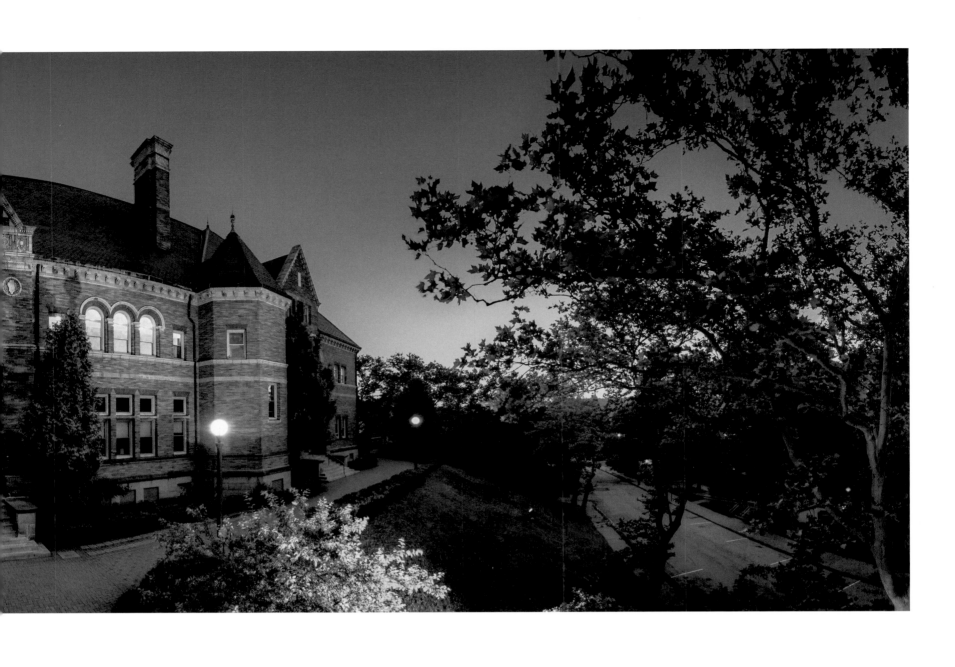

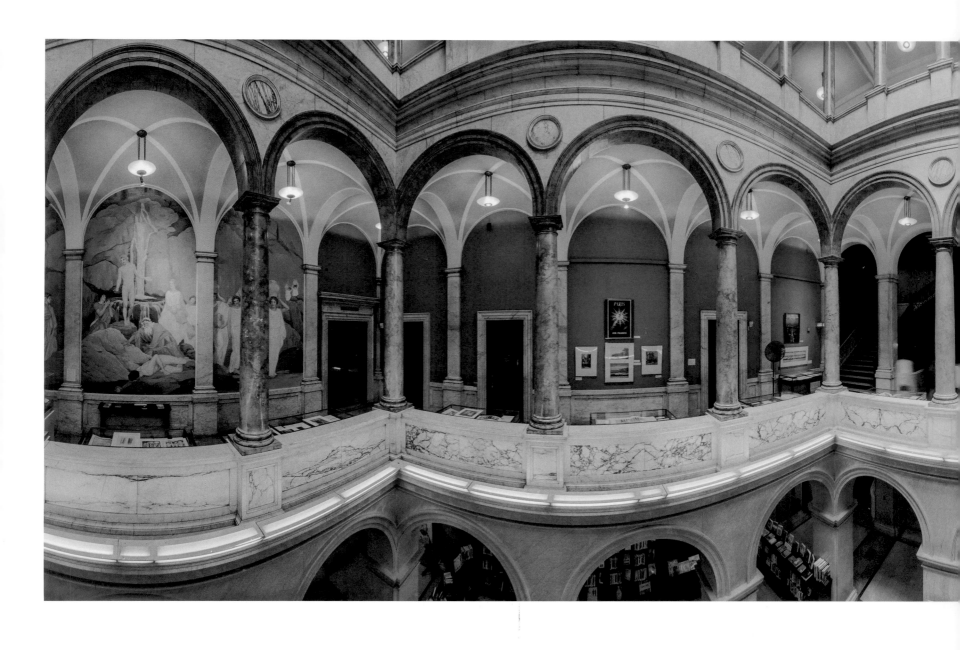

Newark Public Library, New Jersey

When the Newark Public library opened its doors in the late 1880s, it featured over ten thousand books in open stacks, an innovative offering for its day. The current four-story building, based on a fifteenth-century Florentine palace, was designed by Beaux-Arts architecture firm Rankin and Kellogg and completed in 1901. Under the leadership of director John Cotton Dana, from 1902 until 1929, the library established a foreign-language collection for immigrants and one of the first business collections in the nation.

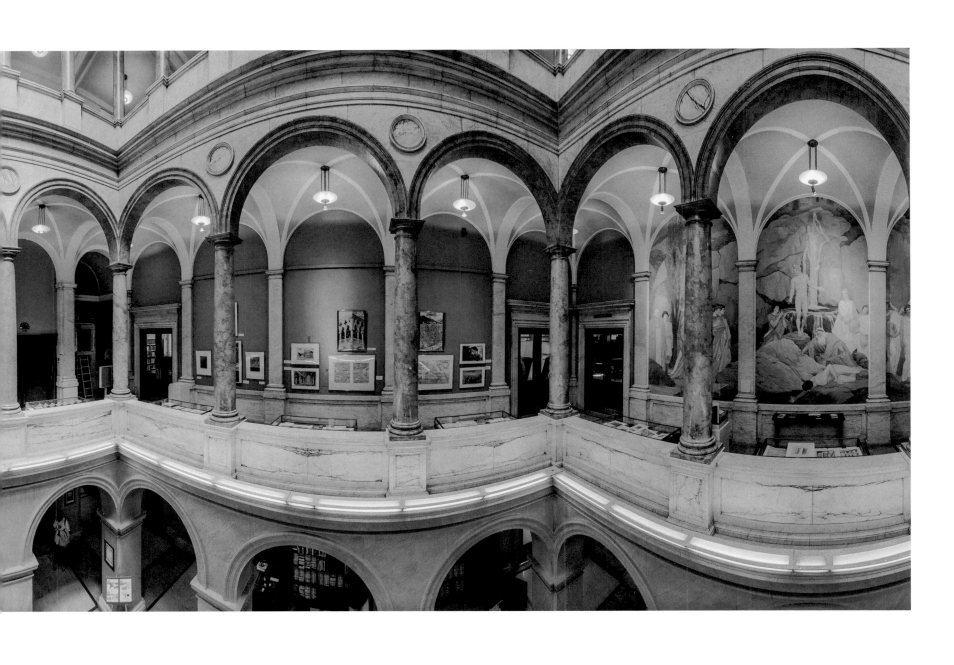

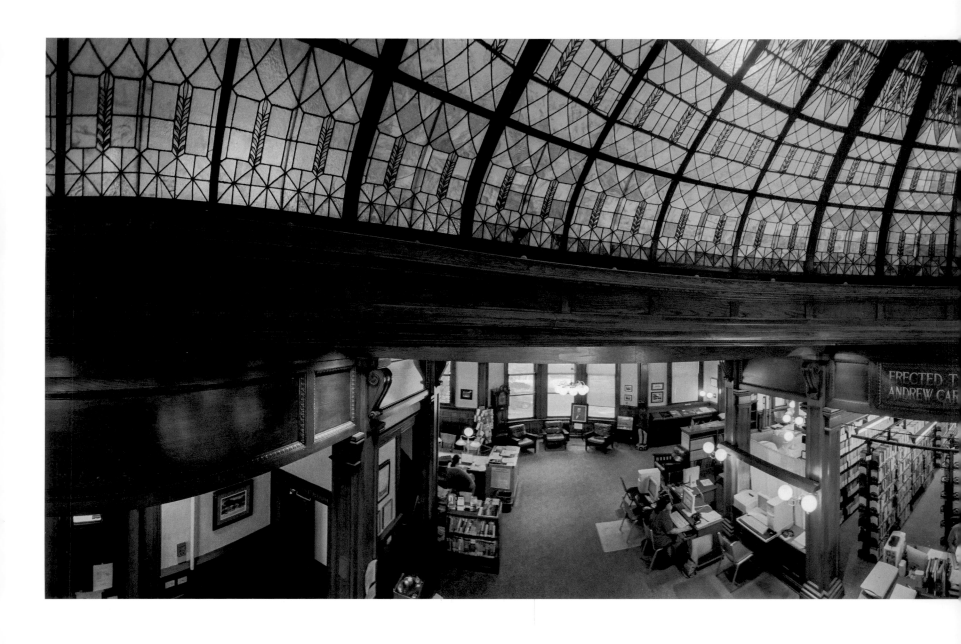

Lincoln Public Library, Illinois
The Lincoln Public Library is part of a group of around 1,700 libraries
established by Andrew Carnegie in the United States between the late
1800s and the early 1900s. Founded with a grant obtained in 1901 and gifts
by Stephen Foley, the Lincoln Public Library embodies the ideals that fostered
the free-library movement and its objective of a more cultured America. In
1980 the library was included in the National Register of Historic Places.

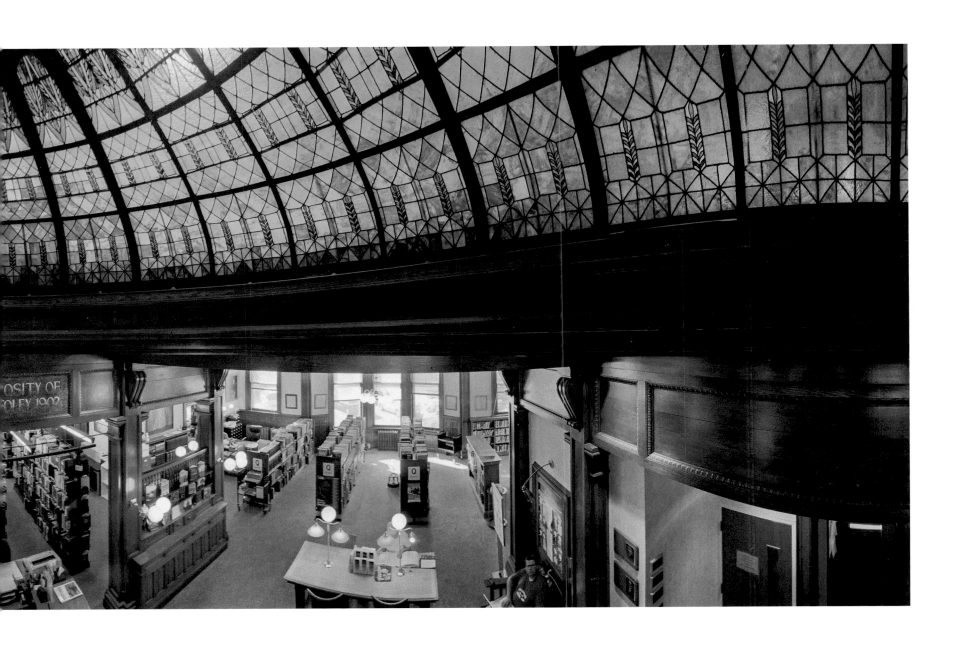

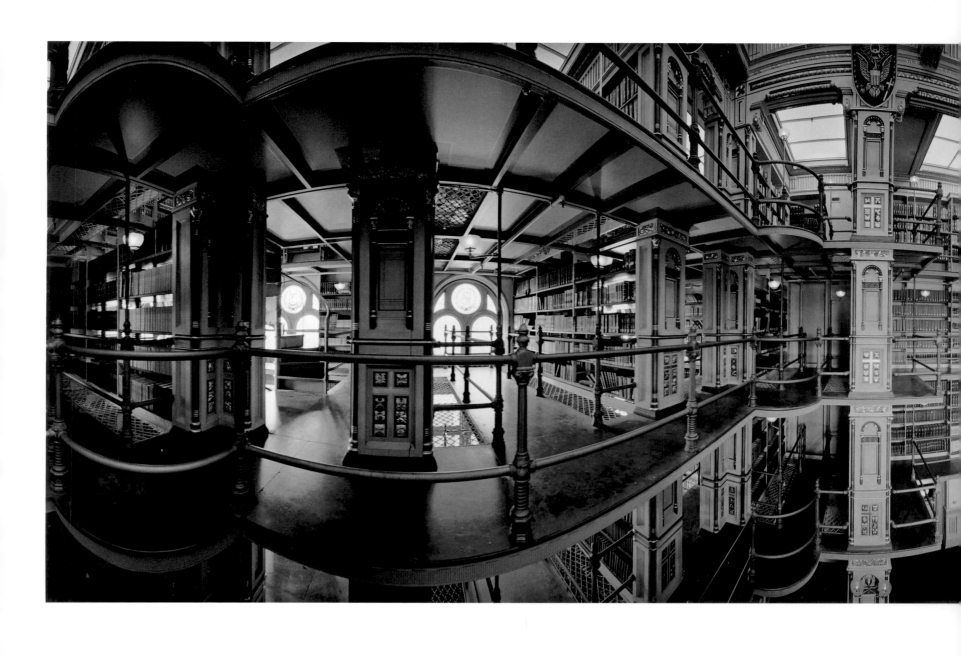

Riggs Library, Georgetown University, Washington, D.C.
The Riggs Library is housed within the Healy building, one of Georgetown's main historic structures, built in a Flemish Romanesque style. The building and the library within were designed by architects Paul J. Pelz and John L. Smithmeyer, the team also responsible for the Library of Congress. One of the rare extant cast-iron libraries in the United States, Riggs served as the main library on campus from 1891 until 1970, when Lauinger Library was completed.

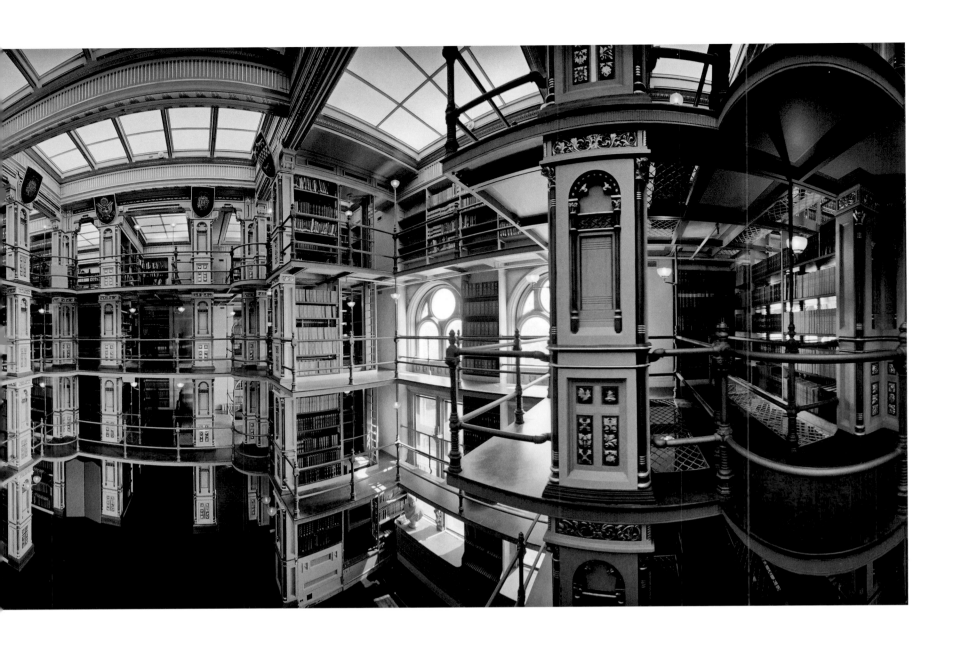

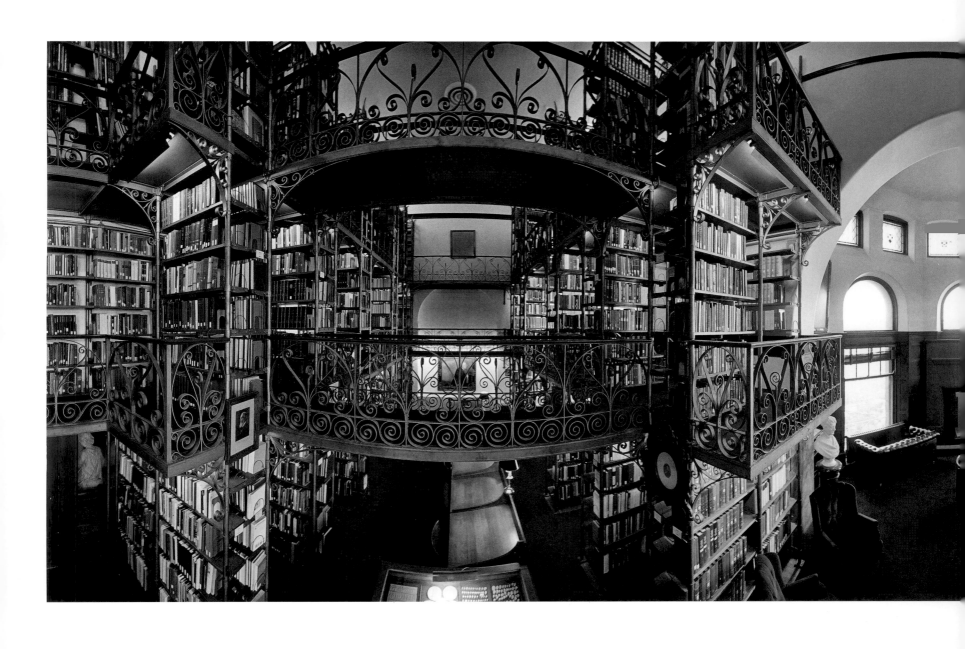

Uris Library, Cornell University, Ithaca, New York
The Uris Library was Cornell's original university library, designed by its first architecture student, William Henry Miller, and inaugurated in 1891. Built in Richardsonian Romanesque style, the cross-shaped building features a central "nave" reading room illuminated by long rows of windows. The three-story White Library housed within features intricate wrought-iron stacks and elevated corridors, ornate chandeliers, and dark-red carpeting. It was originally built for the collection of university cofounder Andrew Dickson White, and also contains furniture and artifacts from White's diplomatic career in Germany and Russia.

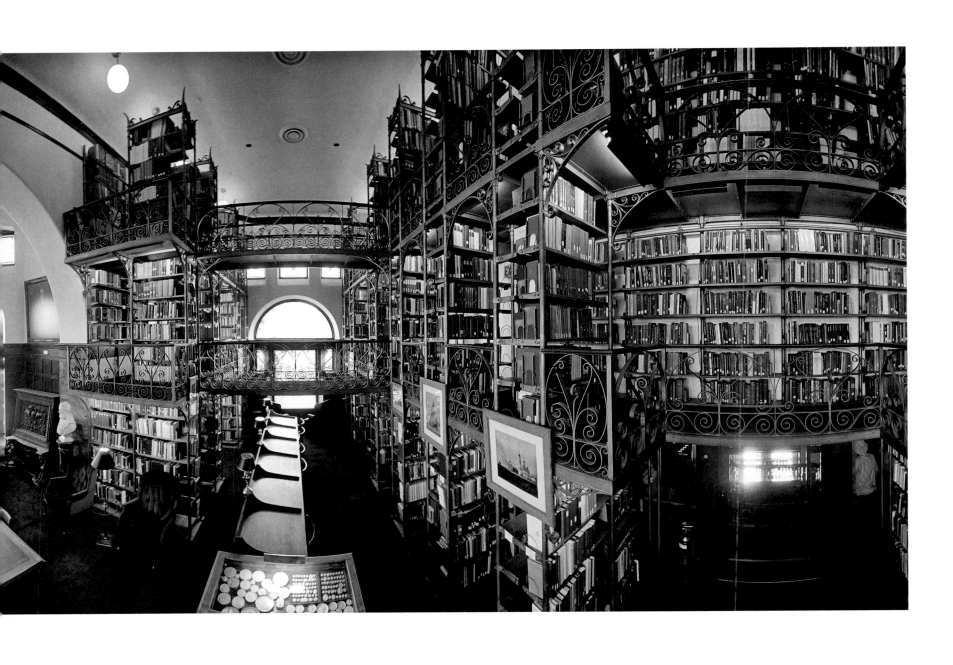

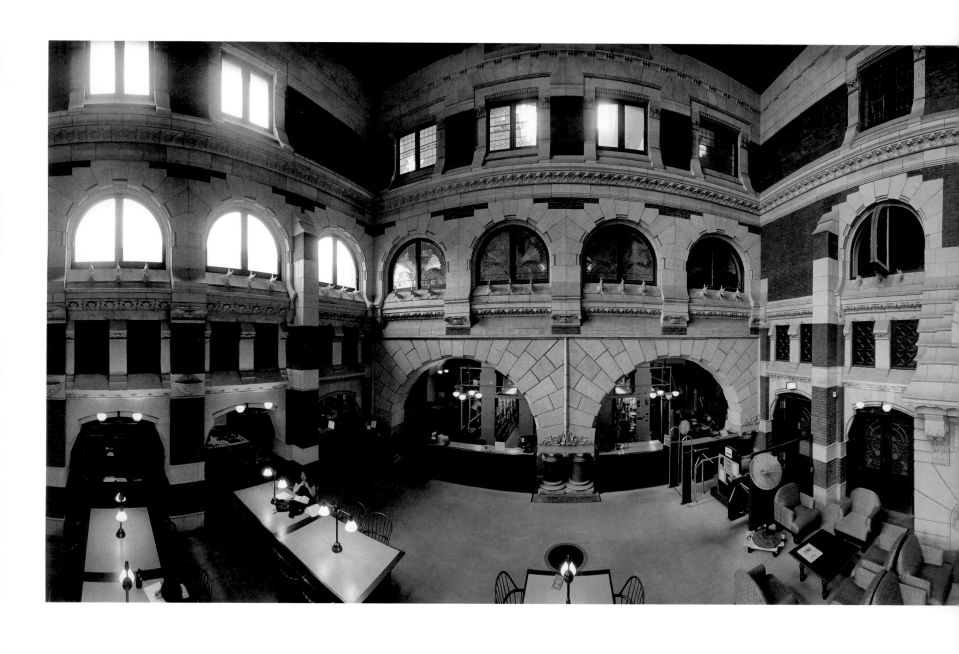

Fisher Fine Arts Library, University of Pennsylvania, Philadelphia
The Fisher Library, also known as Furness Library in honor of its architect, Frank Furness, is distinctive for its red sandstone, brick, and terracotta Venetian Gothic design, its inspiration drawn from Philadelphia factories in the late nineteenth century. Inaugurated in 1891, Furness's distinctive but unfashionable design was not fully appreciated until the mid-twentieth century. In 1957, Frank Lloyd Wright visited the library and announced, "It is the work of an artist."

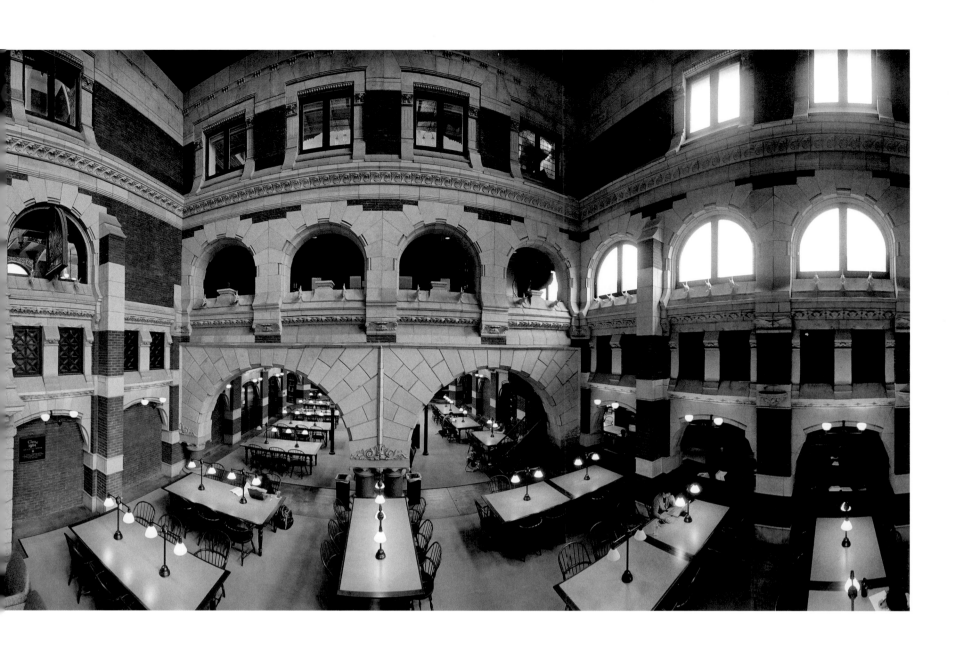

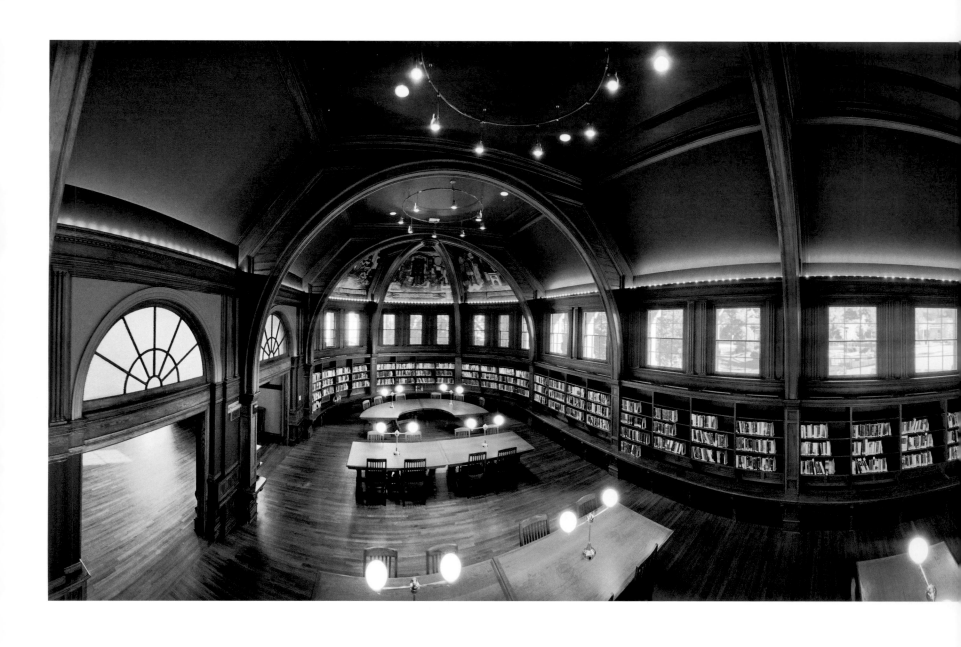

Cambridge Public Library, Massachusetts
The main building of the Cambridge Public Library is a historic 1889
structure built in the Richardsonian Romanesque design, conceived by
architects Van Brunt and Howe. The library's collection includes historic
Cambridge newspapers and directories, as well as a rich collection of
photographs. Its Cambridge Room in particular houses many research
history materials related to the city, including resources such as obituary
and marriage announcements and genealogy reference books. Today, the
old building is flanked by a state-of-the-art structure completed in 2009.

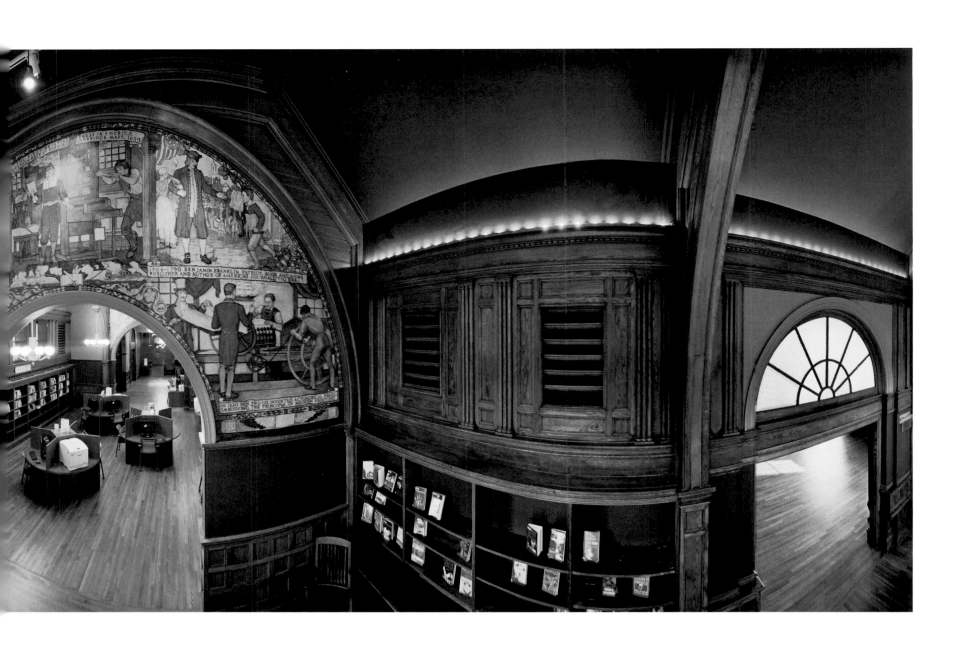

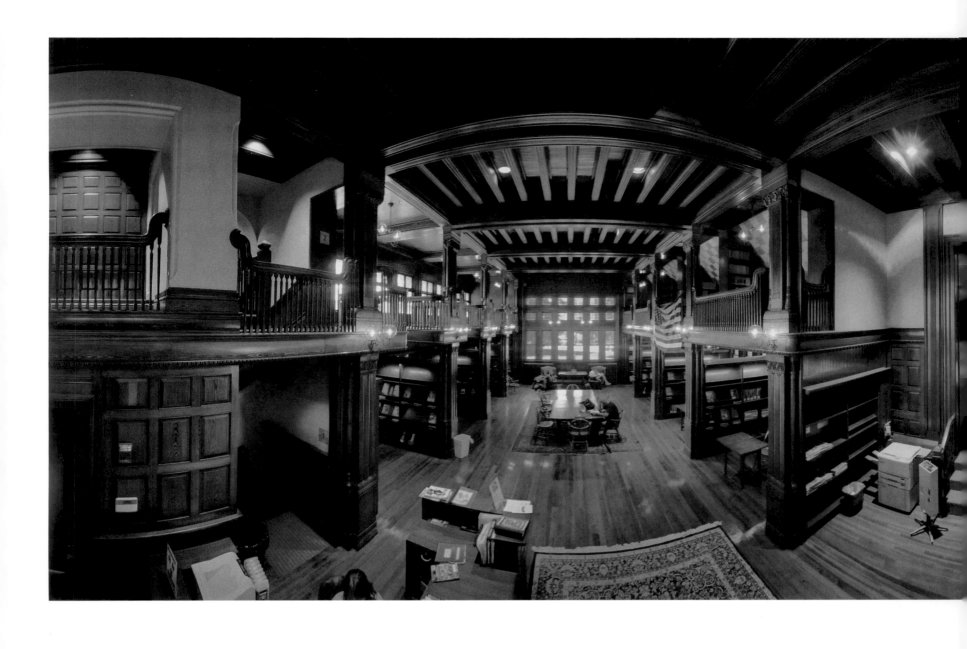

Thomas Crane Public Library, Quincy, Massachusetts
Dedicated in 1882, the Thomas Crane Public Library is also known as
the Richardson building after its architect, Henry Hobson Richardson.
Considered one of the architect's best mature works, the building features
a foundation of Quincy granite, clerestory windows, and a Romanesque-
style arch at its entrance, and woodwork inside made from North Carolina
pine. Its stained-glass window, dubbed the "Old Philosopher," is considered
a masterpiece and was made in honor of Thomas Crane, whose family
provided generous funding for the library's construction.

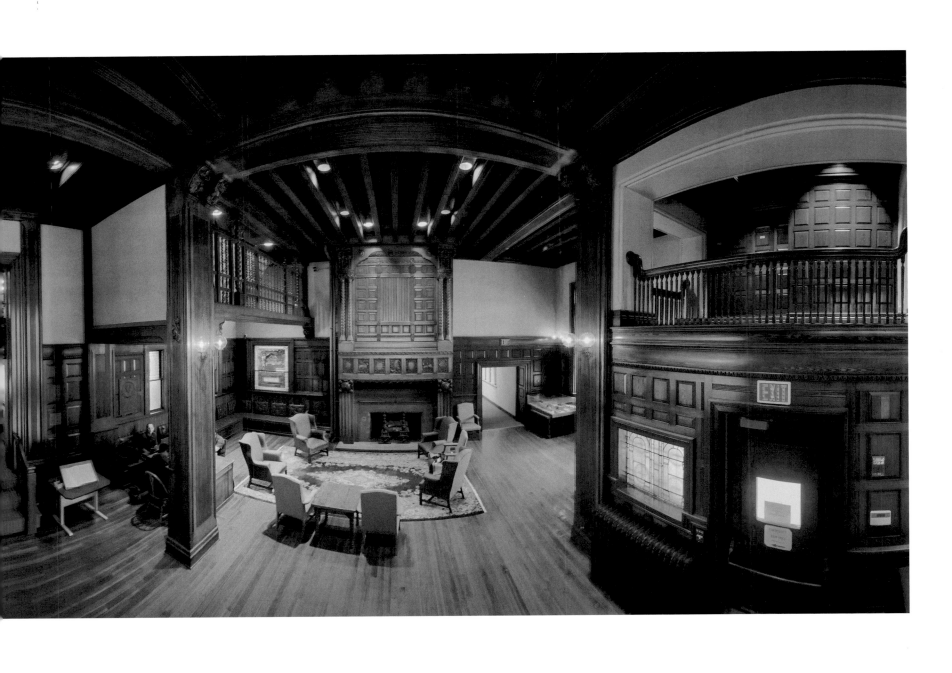

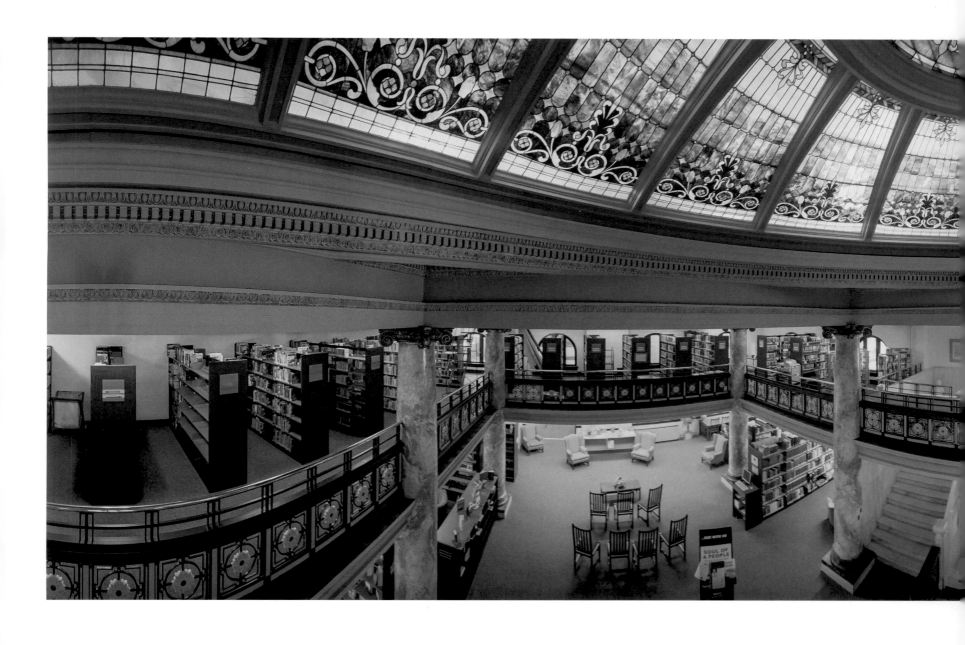

Portsmouth Public Library, Ohio
The public library in downtown Portsmouth has served the city since 1879, following the donation of a structure by the local City Schools Board of Education. A fifty-thousand-dollar donation from Andrew Carnegie permitted the construction of a new building, inaugurated in 1906. The library features *Portsmouth Daily Times* microfilm and other regional papers, plus a bookmobile service dating to 1938 and a local history department. Its hundredth anniversary was celebrated with a reenactment of the opening ceremony, which involved early-1900s apparel.

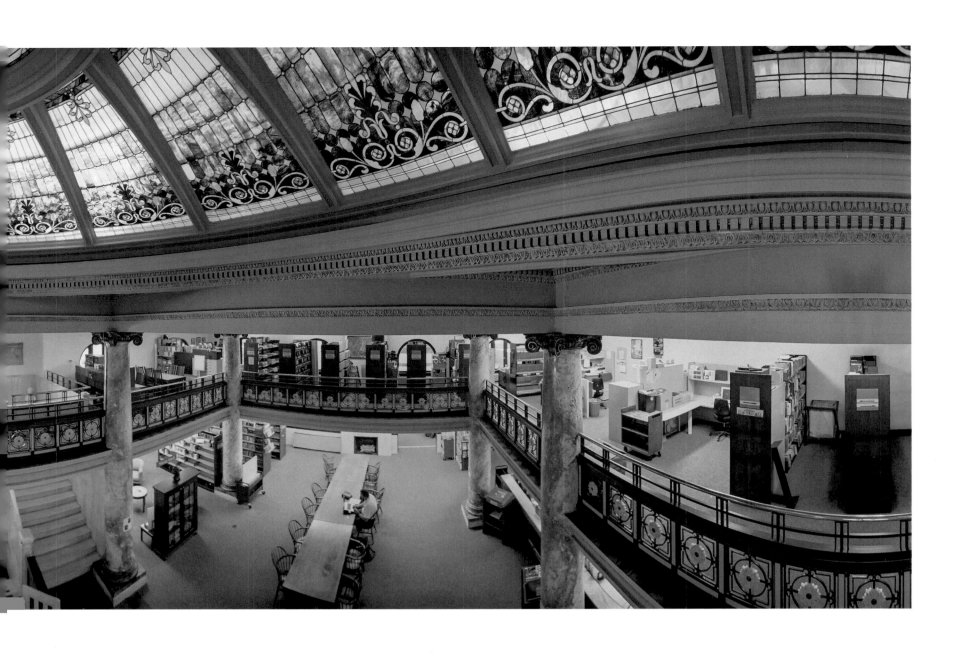

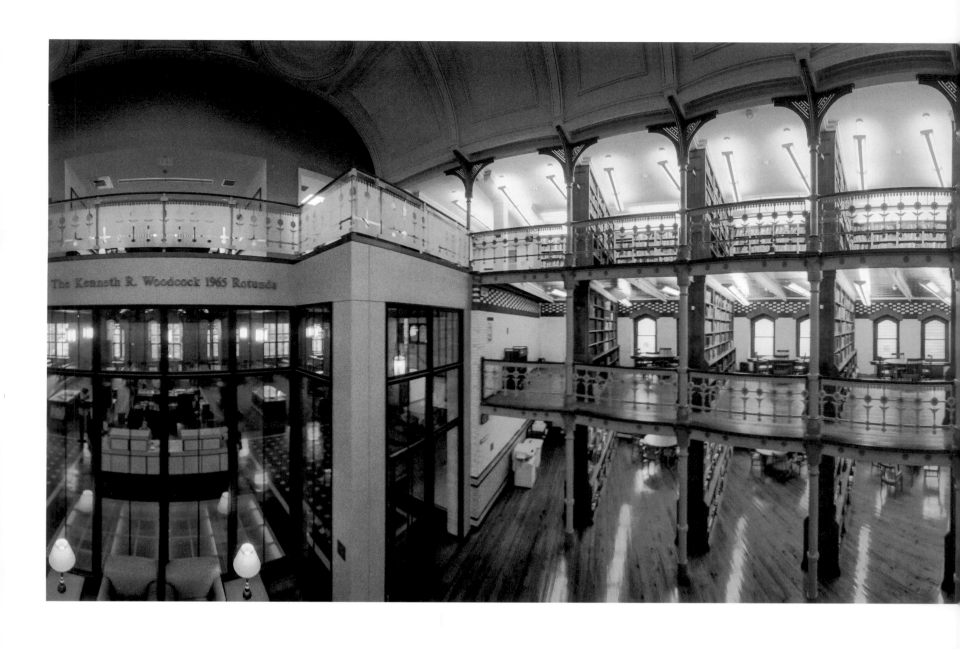

Linderman Library, Lehigh University, Bethlehem, Pennsylvania
The Linderman Library opened in 1878, featuring a stunning Victorian
rotunda and wrought-iron ornaments; the rotunda, as well as the elegant
grand reading room from 1929, have been preserved throughout several
renovations. It is rumored that its architect, Addison Hutton, modeled the
building design after London's British Museum. The library prides itself on
its rare books collection, which includes a copy of *On the Origin of Species*
by Charles Darwin, and a four-volume oversize edition of *Birds of America*
by John James Audubon.

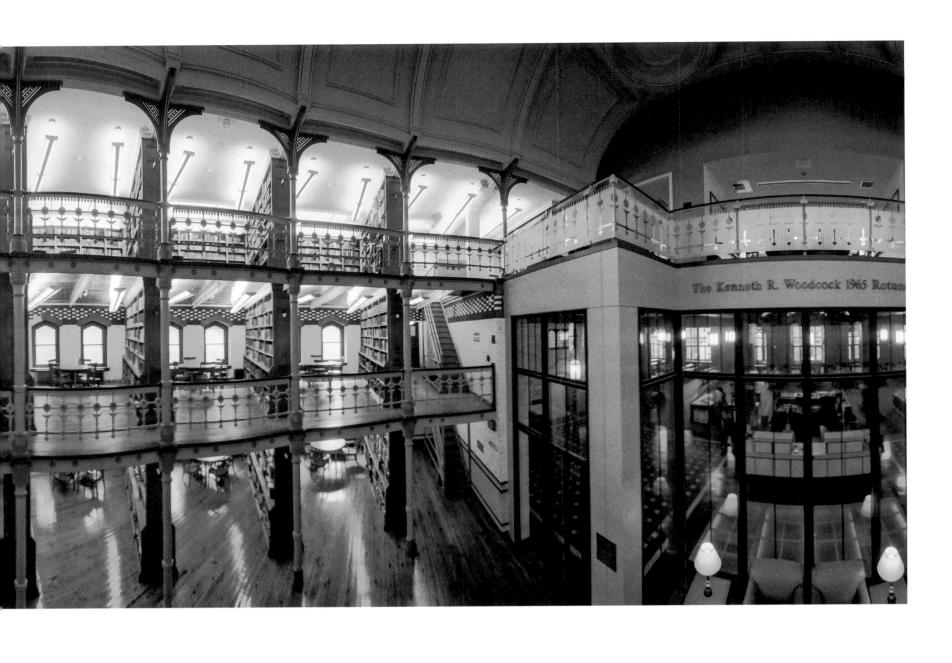

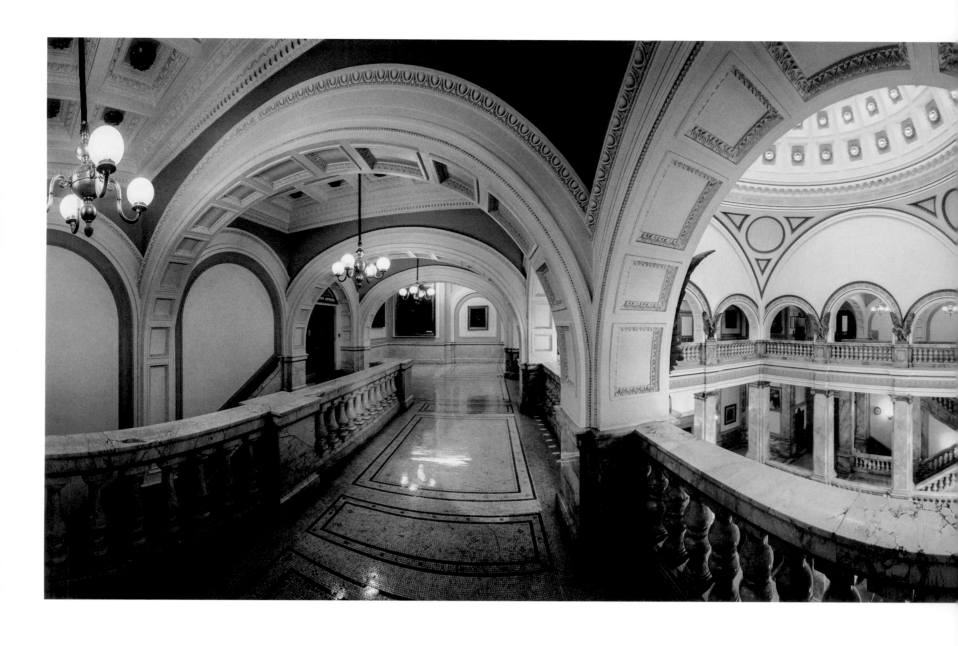

Milwaukee Public Library
Established in 1878, the Milwaukee Public Library grew out of the Young Men's Association's collection of ten thousand volumes, many of which were in German. In the 1890s, a competition was held for a new building design— and even garnered a submission by Frank Lloyd Wright. Local firm Ferry and Clas won, with a U-shaped design offering a single entrance but separate facilities for the library and museum. The museum eventually moved out, making way for a growing library that today includes twelve branches.

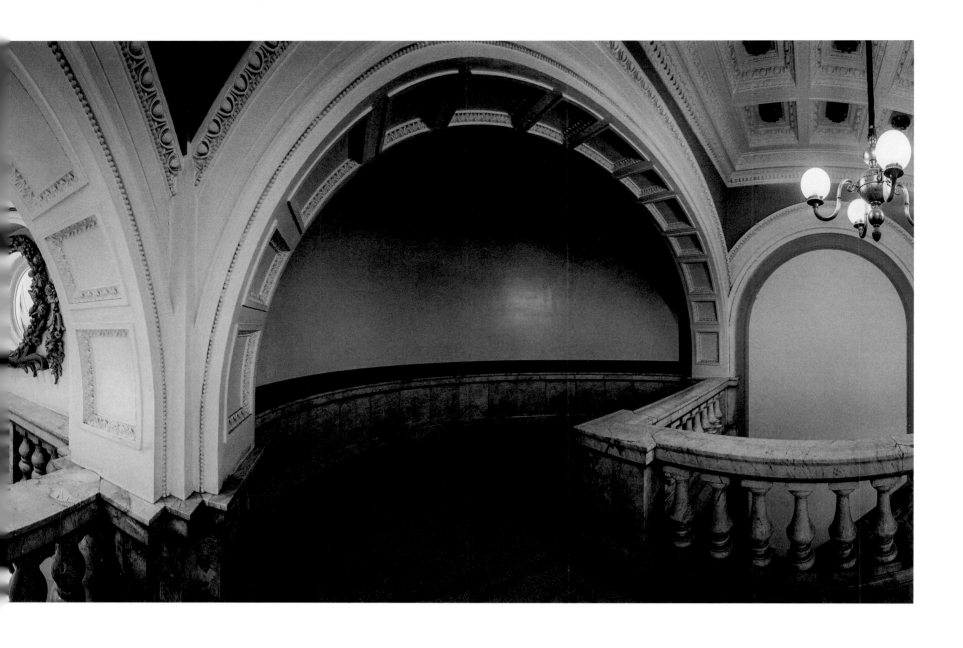

Following pages
Bates Hall Reading Room, Boston Public Library
The majestic Bates Hall is named after banker Joshua Bates, whose love
of literature led to a fifty-thousand-dollar donation in 1852 with the stipulation
that the building be "an ornament to the City, that there shall be a room for
one hundred to one hundred and fifty persons to sit at reading tables, and
that it be perfectly free to all." His vision was fulfilled in the Reading Room;
with its barrel-vaulted ceiling and fifteen arched and grilled windows, it remains
an important historic landmark.

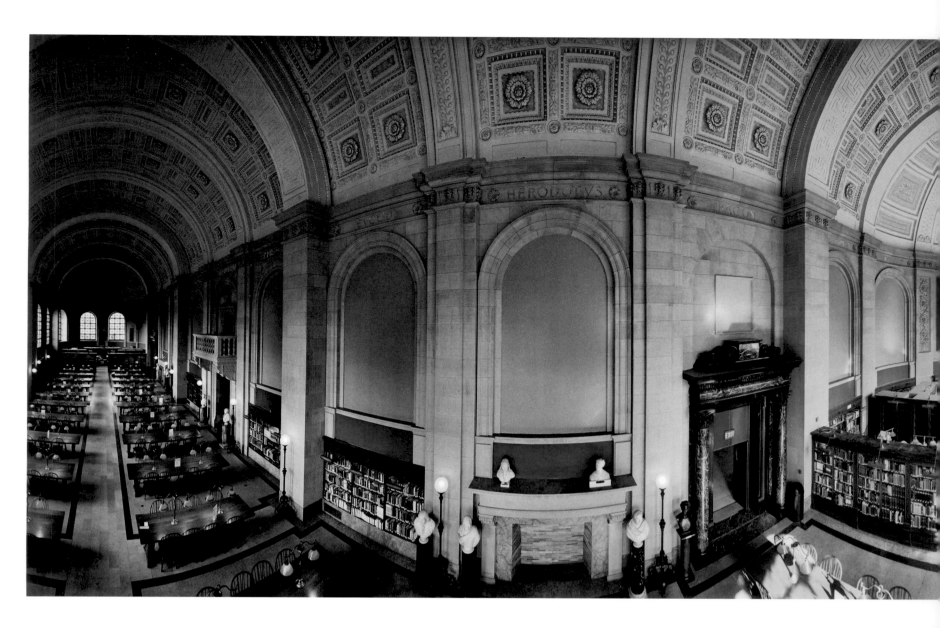

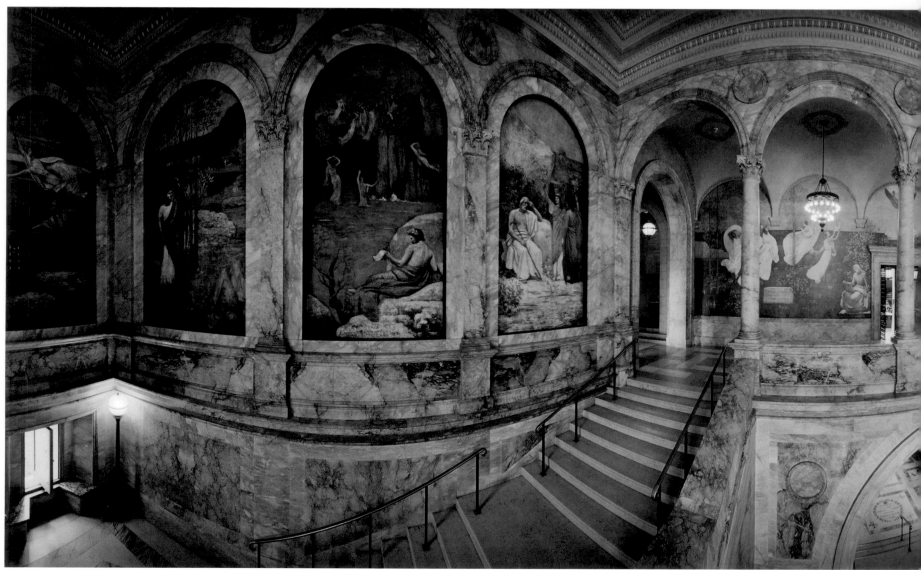

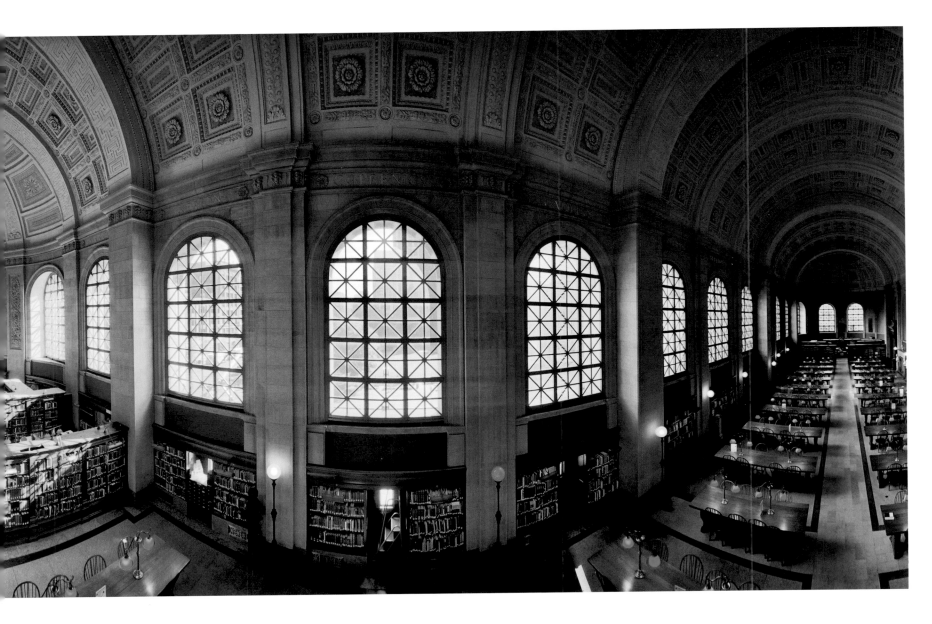

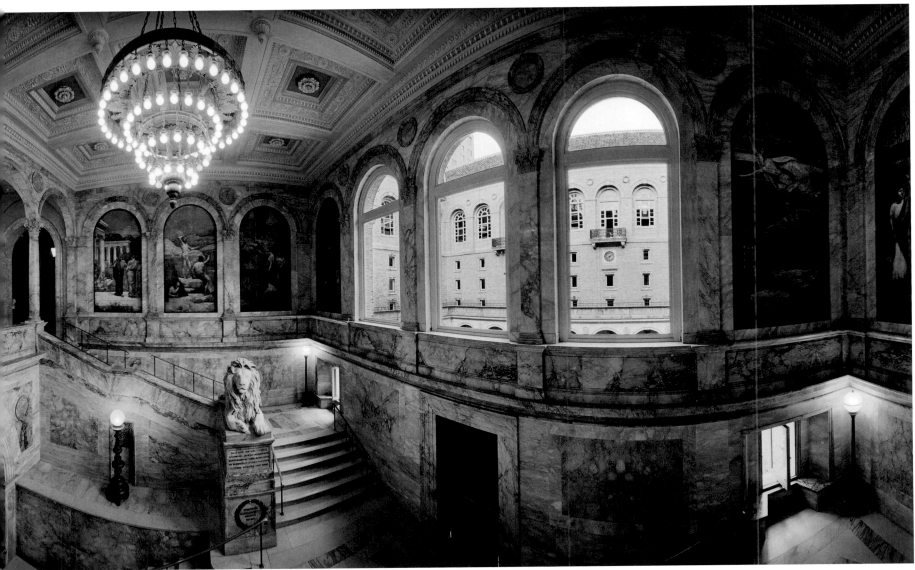

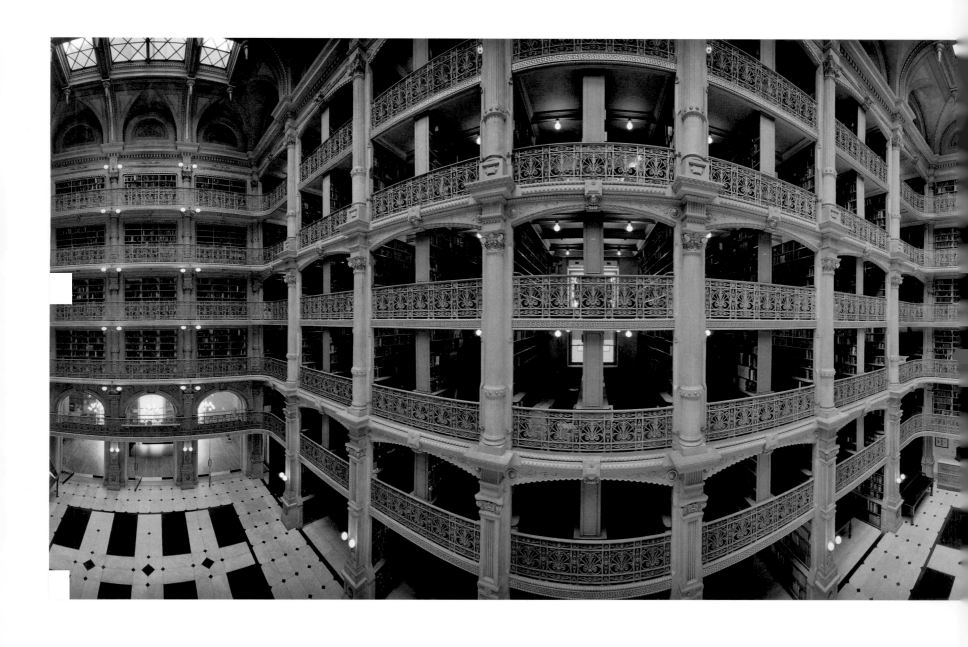

George Peabody Library, Baltimore
Conceived as a part of the Peabody Institute in 1857 by philanthropist George Peabody, the library opened its doors in 1878 to the citizens of Baltimore. With five tiers of dramatic cast-iron balconies reaching sixty-one feet up to the skylight, this venue has become a favorite for locals to host weddings surrounded by the more than three hundred thousand volumes. Now a Johns Hopkins research library, it remains true to Mr. Peabody's original wishes and is open to the public.

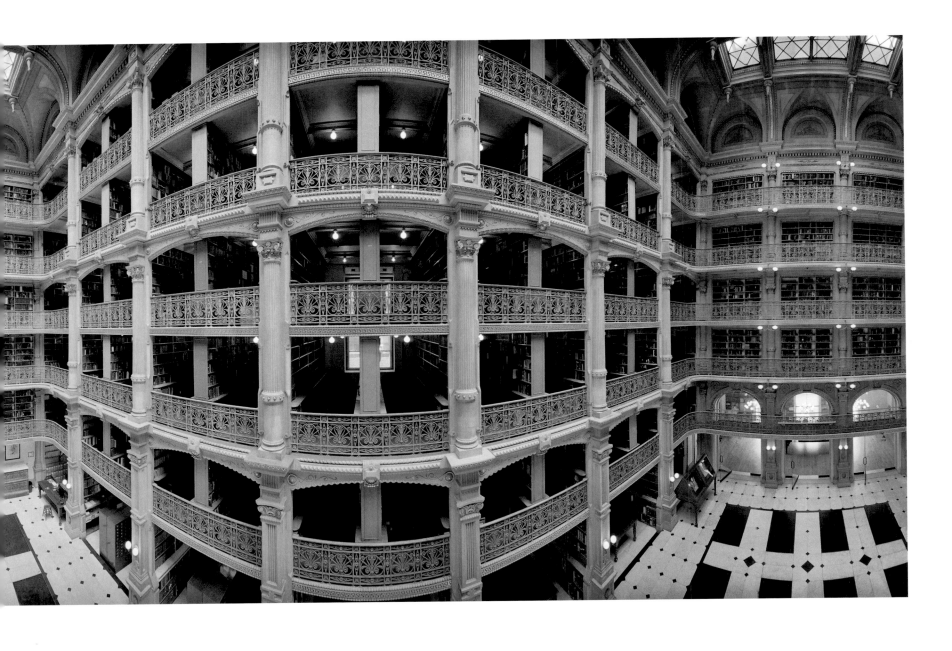

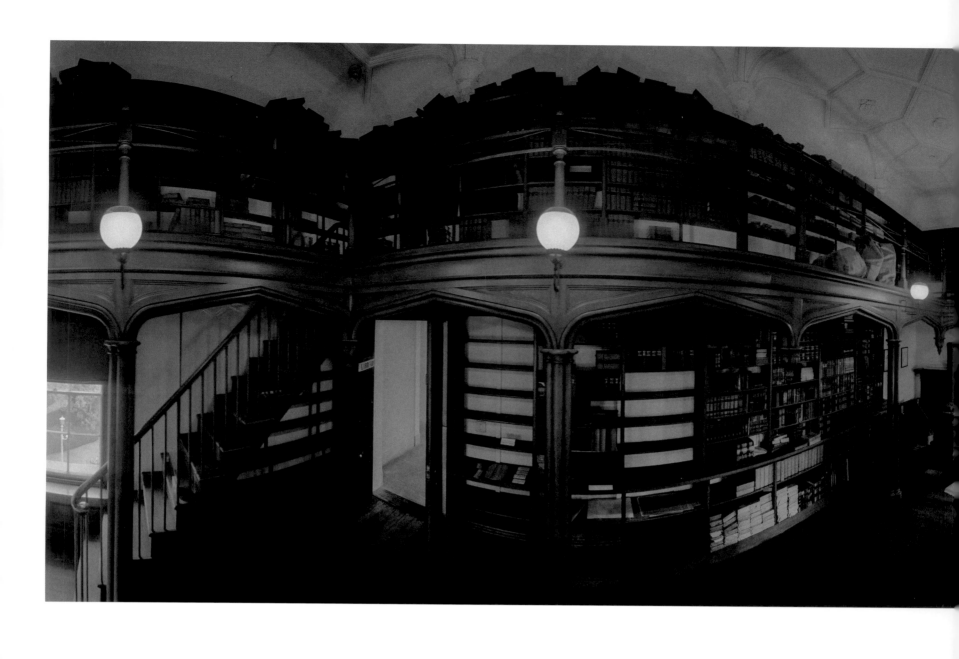

State Library Room, North Carolina State Capitol Building, Raleigh
The library in the North Carolina State Capitol was finished in 1842, after shelves, a gallery, and a staircase were added to support the expanding collection. It served its purpose until 1888, when its materials outgrew the room; the collection is now located in the Archives and History/State Library Building. The original library was opened to the public in 1845; its current appearance today, recreating the 1856–57 period, is based on information from records in the state archives.

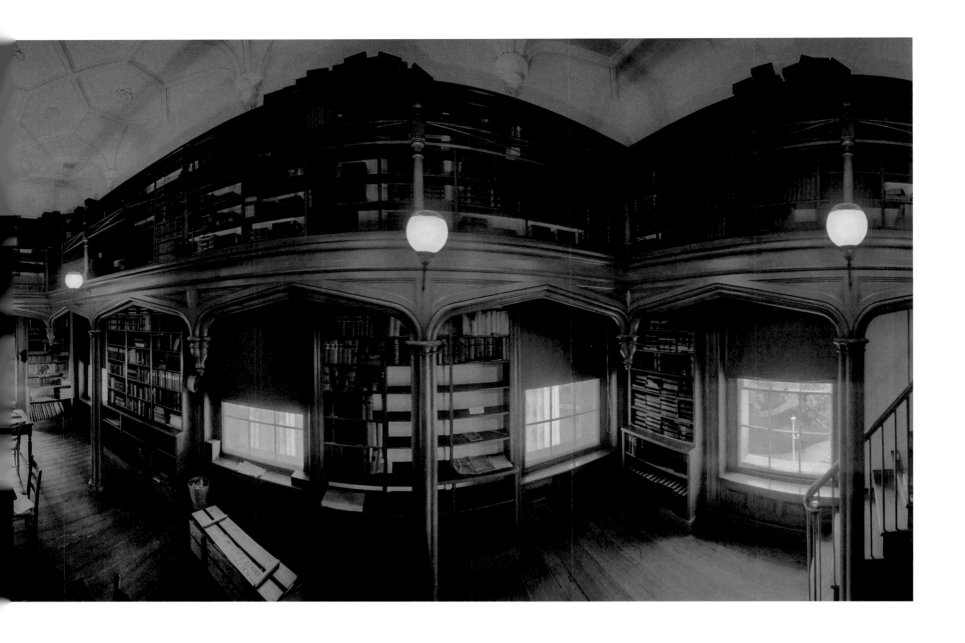

Following pages
Athenaeum of Philadelphia
The Athenaeum of Philadelphia, an independent library and museum, was founded in 1814 and occupies an 1845 building designed by local architect John Notman. The building's simple exterior belies its sumptuous, twenty-four-foot-ceiling rooms, which offer visitors a museum-level collection of decorative arts from the early nineteenth century. Its library collection, which presents materials "connected with the history and antiquities of America, and the useful arts, and generally to disseminate useful knowledge," is focused on architecture and interior design from 1800 to 1945.

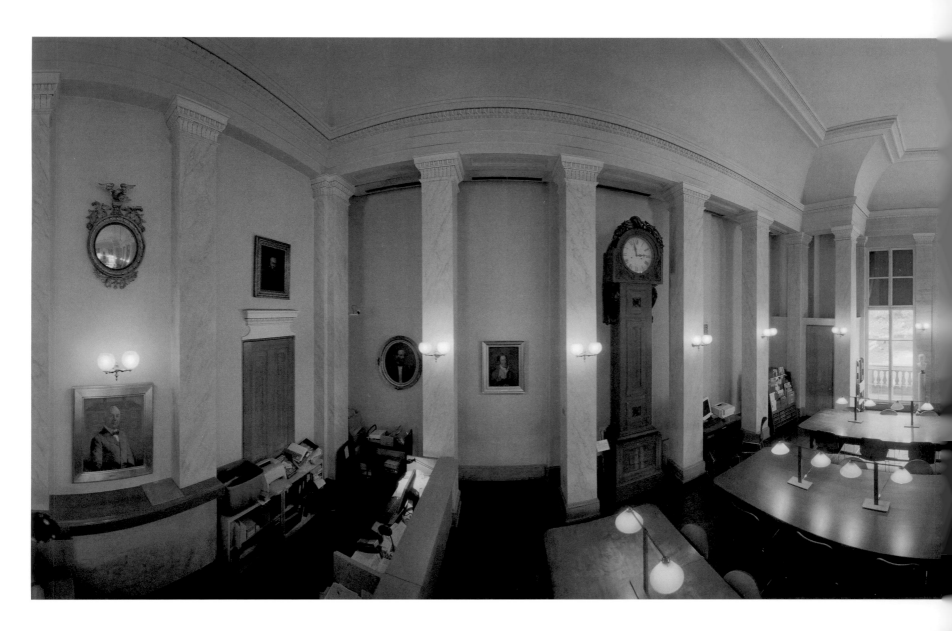

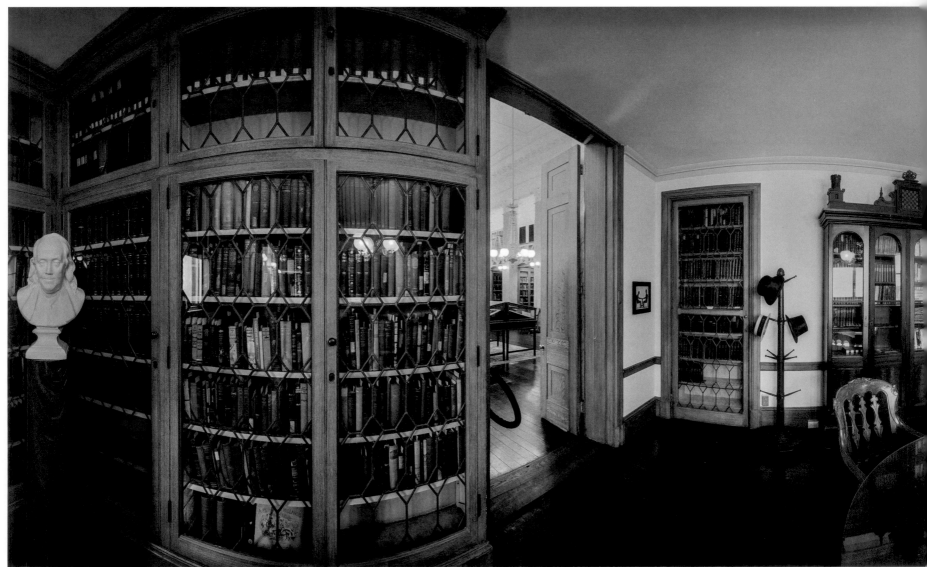

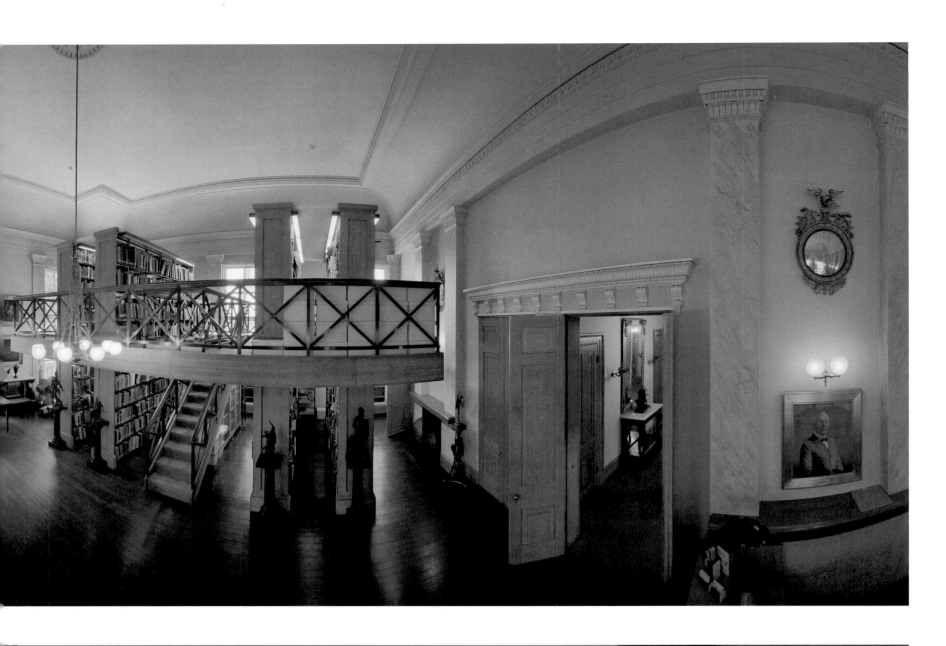

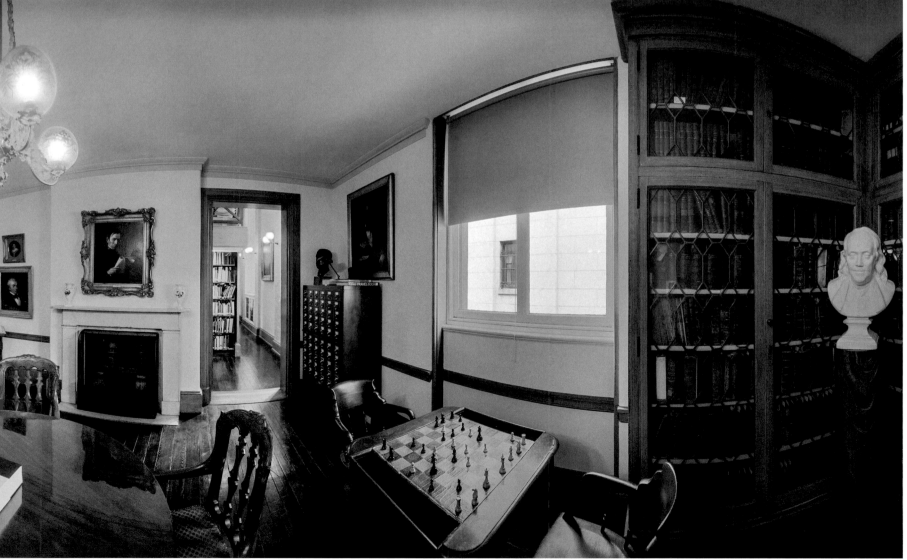

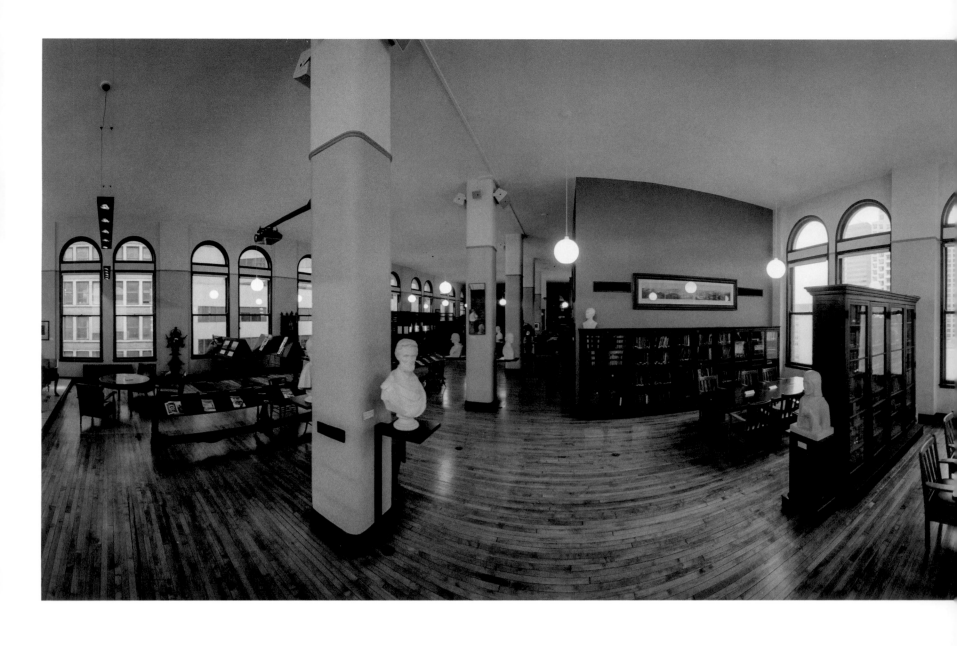

Mercantile Library, Cincinnati
Founded in 1835, the Mercantile Library in Cincinnati owes its name to its founding group of merchants and clerks. The membership-based library maintains an expanding collection of books and prides itself on a rich cultural program that dates back to the 1840s, when prominent writers and thinkers like Ralph Waldo Emerson, Herman Melville, and Harriet Beecher Stowe were invited to speak. In recent years, the library has hosted writers such as Ann Patchett, Salman Rushdie, and Robert Caro, among many others.

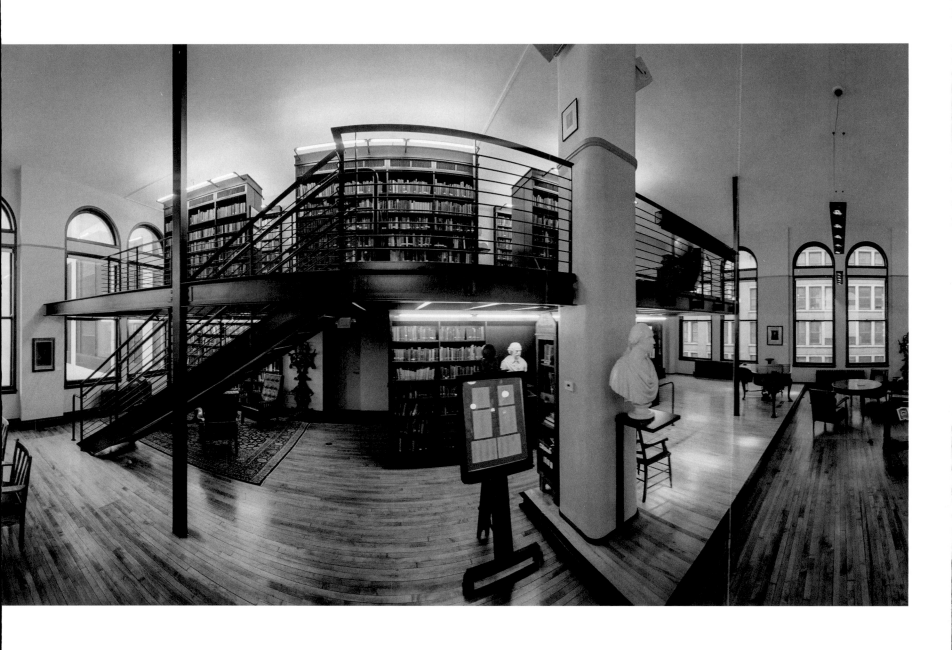

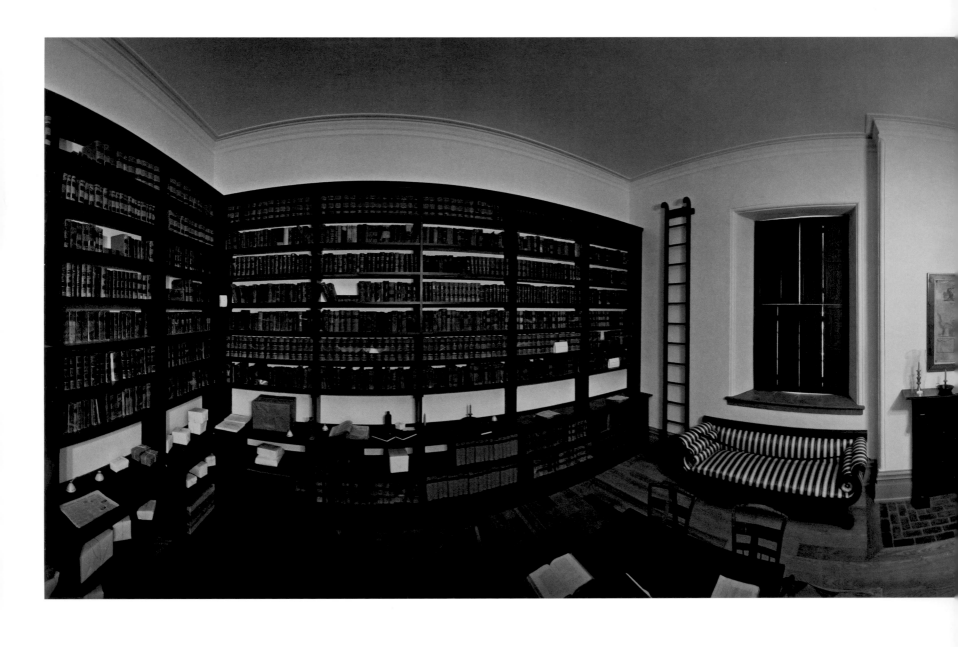

Old State Capitol Library, Frankfort, Kentucky
Kentucky's Old State Capitol was the third location of the state's government seat from 1830 to 1910. Its Greek Revival design was conceived by Gideon Shryock, one of the first professional architects in Kentucky, and included polished marble sourced from quarries on the Kentucky River banks, not far from Frankfort. In the 1990s, the building was restored to its original 1850s appearance. Managed by the Kentucky Historical Society, it welcomes visitors for historic tours.

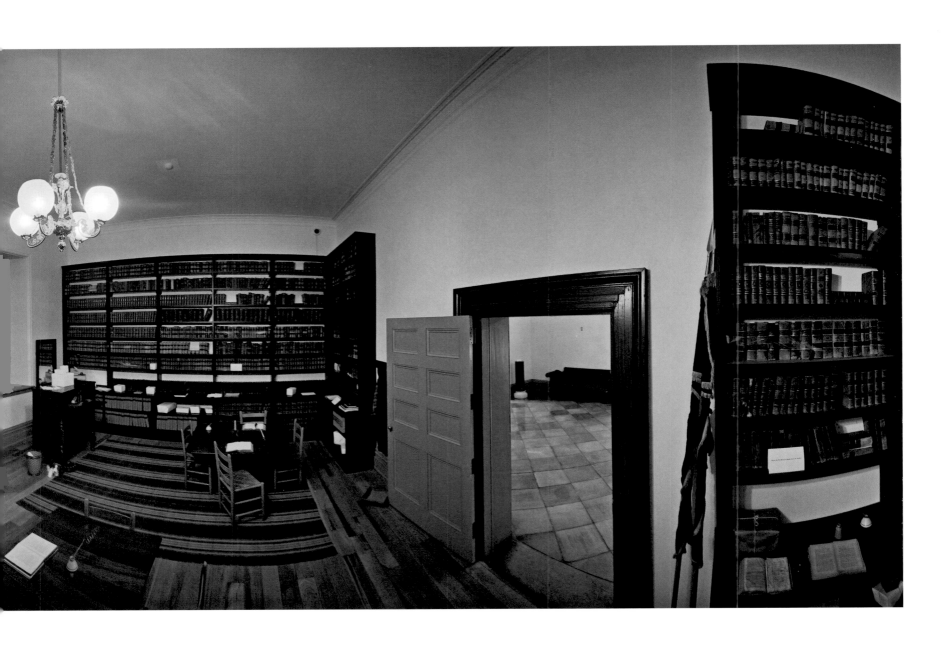

Afterword
Thomas R. Schiff

My interest in the library began maybe two decades ago, when I became drawn to both architecture and the panoramic photograph. I became fascinated by how the history of the United States is reflected in our civic buildings; how the great old libraries on the East Coast, of two centuries ago, evolved into dynamic, contemporary public spaces like the Seattle Public Library, or the Salt Lake City library. The interest for me is in the arc of history.

I have a library of my own at home that's mostly photography books, and I've always loved books; as a child my mother would take me to a branch of the Cincinnati public library where I would spend many evenings looking through books on aviation, science fiction, and photography. I first photographed a library—Cleveland library—in about 1995, and the idea of photographing libraries grew on me steadily, as I traveled around, thinking about architecture and public spaces. Before libraries, I had started a series of panoramic photographs of Frank Lloyd Wright houses. And as I would travel to different cities, photographing Frank Lloyd Wright buildings, I'd also scout out interesting public buildings. I just gradually started to photograph libraries—alongside old movie theaters, art museums, courthouses, state houses, and city halls. Over a twenty-year period, these subjects became my photographic life, and I've now built a collection of photographs of each of them. Often when I visit a city—especially if I'm unlikely to get the chance to revisit it again in the foreseeable future—I'll try to photograph all the buildings that I'm interested in while I'm there.

In this process, I came to appreciate the library as an important expression of our civilization; to appreciate how important access to education and learning is for the well-being of people in America. The library is also an expression of America's great tradition of philanthropy. Of course, the library is often associated with the name of Andrew Carnegie, America's most successful industrialist, who built nearly 1,700 public libraries in the U.S. in the late nineteenth and early twentieth centuries. Often, when I talk to people about the project, they'll ask, "Are you going to photograph all the Carnegie libraries?" Which I can't, because there are too many, and I don't want to, because many of them are so similar. I'm really looking for variety in styles and different types of architecture, and how the form of the library expresses different ideals at different points in time.

The Internet, as the ultimate source of information, clearly challenges the idea of the library in the twenty-first century, but doesn't seem to have stopped its progress or changed the value we place on libraries as centers of our communities. They're important not just because of the books available to read there, and the books they preserve, but as places anyone can go for quiet, or to study, or for contemplation. They have other social benefits; many city libraries today are used by homeless people for shelter, for instance. Meanwhile, nobody really knows how to archive digital images yet, with technology moving so fast, but you never have to worry about the technology of a book becoming obsolete. Books have been around for hundreds of years and they'll be around in hundreds of years to come.

It's an interesting question as to whether the civic statements some of these buildings make are more important than the books they have on their shelves. A library is invariably a statement: a realization of the prevailing or forward-looking civic ideals, by the architect, the philanthropist, the community. Libraries are also about improving people. They argue how a refined, methodical, and regulated path might improve us, and improve life in America. Libraries are places of rules and codes and systems. They advertise that you may free yourself and better yourself by honoring a set of codes and observances.

While I don't find one particular time period more important, or appealing, than any other, I am attracted to libraries that are places of great vision and planning and care—the quality of the architecture, and how well it's looked after subsequently. The great Louis Kahn libraries—there are not so many of them—are extraordinary places, exquisite in their detail, and extremely interesting. He's one of the architects of libraries I most admire, as well as Frank Lloyd Wright, who also built relatively few libraries, but which are all exceptional. When I photograph libraries I try to experience them and depict them in a way that values the original vision of the architect and the designers, presenting the space as they might like to see it presented.

It's one of the great characteristics of a lot of the historic libraries, that their custodians work really hard to preserve and maintain the original vision of their founders and architects. There are a few libraries in this book where an interior has been re-created at a later date, but most of them are original spaces, studiously preserved as such. I haven't chosen a single library to photograph where the original lighting system has been replaced by fluorescent tubes.

I'm rarely able to enjoy libraries the way they are intended or the way that I would ideally like to. The Boston Athenaeum is an incredible place, but when I'm there, as with any other library, I'm preoccupied with making the photographs, thinking about the camera and the film and the exposure, and the tripod and so on. I don't take the time to sit down and read a book or experience just being there. Though the Boston Athenaeum is just about the most perfect place to read a book!

I usually get to photograph for an hour before the public comes in. The librarians want to preserve the privacy of library patrons, which suits me because I want to picture the library as a space without people. And they're very easy to work with. They're usually welcoming and very cooperative, and enthusiastic to support your interest in their library. And of course librarians are very helpful people, that's their nature. Their job is to help you become educated in whatever area you want to become educated. I hope the viewer gets a sense of the qualities of the librarians from these pictures, because although for the most part you don't see them at work, I would like to communicate how much goes into looking after these spaces, maintaining them to the standards you see in the pictures. I find I have an affinity with the librarian. They're always cordial, and helpful,

nd humble. And I admire how much they believe in their mission. enjoy the time I spend interacting with them. The same can't be aid about working in art galleries, where people's attitudes toward heir patrons and visitors are often very different.

A lot of planning ahead of time goes into making these pictures. Often when you try to contact people, you don't hear back. And then fter a couple weeks of trying to get through to a particular person, ou find out that they can't help you with what you need. They'll say, Call so-and-so in a different department," and then you start again. So you really have to plan several months ahead of each shoot. This roject has taken a lot of persistence and planning.

I have chosen to work with a panoramic film camera, which adds omplexity to the business of making the pictures, but I really like he format. It offers a different way to look at a building. When the amera swings around in a circle, it takes out all the straight lines, f the floor and the ceiling, so that lines you typically see as straight n a conventional photograph—and which are often straightened by professional architectural photographers—appear curved. I use hose curves as part of the composition. In fact, your eye doesn't ee straight lines; it actually sees in arcs—try tracing a straight line ou see ahead of you with your finger and you'll usually find you have raced an arc—but your brain corrects this impression so you think ou see straight lines. In this sense, the panoramic photo is really a representation of how your eye actually works.

I find it enthralling how you can see the entire contents of a room n a 360-degree view, flattened out into two dimensions. Panoramic photography became popular one hundred years ago with the nvention of the Cirkut camera, used to photograph large groups of people, with film that was ten inches high by several feet long, with prints made as contact prints. The subjects were organized at an equal distance to the camera—in a semi-circle usually—and ence appear in a straight line on the print. I use a modern equivalent, called a Hulcherama, that's more compact and easier to operate. It ses 2¼-inch roll film, and works on the same principle: the motor otates the entire camera, which doesn't have a shutter but rather a vertical slit where the film is exposed, in a 360-degree arc. The peed of the film moving past the slit determines the equivalent shutter speed. Unless I have the camera on top of an elevated tripod, have to walk around the camera while the lens is rotating to avoid appearing in the photograph myself.

I do have a digital panoramic camera, but because there isn't much demand for them, the technology isn't very developed. They've been superseded in any case by software programs that automatically stitch together multiple frames, taken on a regular digital camera. But that's not how I make panoramic pictures. I've been using a film camera for so long, I don't want to change. I like the look of the image you get with film. I'm comfortable with the technology, and the photographs that I shot twenty years ago are consistent with those I shoot today.

Every library has a fascinating story, which this book hints at but can't begin to do justice to. I love the story of Elihu Yale, and how, before there was a college building at Yale, there was a collection of great books, and he built a library to house them, that the university was in turn built around. Yale's Sterling Memorial library is wonderful. It has a dramatic central space dedicated to its card catalogues, which are very extensive. A lot of attention was paid to the ordering system when the building was designed.

Another library at Yale, the Beinecke, is one of the most spectacular of libraries. Designed by Gordon Bunshaft of Skidmore, Owings, and Merrill, it looks like an alien spacecraft, with daylight kept away from vulnerable rare books with the use of panels of translucent marble, rather than windows. The sunlight filtering through the marble gives everything a muted yellow hue. The books are stacked in a six-story tower in the middle of the space, surrounded by these translucent marble walls. The design is breathtaking.

The Lillian C. Schmitt Elementary School Library in Columbus, Indiana, is one of my favorites, and, like so many, it has a great story.

Columbus is the home of Cummins Engines, which was led in the 1940s and '50s by Irwin Miller, an architecture enthusiast. He had discriminating taste—he hired Eero Saarinen to design his house— and he made an offer to the city: "Here is a list of the top architects in the country, and if you hire any of these people to build a school or library, the Cummins Foundation will pay the architect's fees." So they did that, and their school library is a modernist landmark of the great architect Harry Weese.

And the Amelia Givin free library in Mount Holly Springs, Pennsylvania, is fascinating to me. Mount Holly Springs is a small town that people might drive through and think "this is a typical American small town; nothing special" and take no notice of it. But if they stopped to visit the library, they'd experience a unique Romanesque building, with the most elaborate Moorish fretwork of any building in the country. It's extraordinary and beautiful. It was the first free public library in the county, funded and built by a woman who ran a local paper company—someone in the community who was motivated to make her community a better place. After she retired she reputedly would go round to the library in her carriage, every week, give the librarian the day off and the use of her carriage, and take on the role of the librarian herself.

When we think of philanthropists, we usually think of people like Andrew Carnegie, or J. P. Morgan, one of the richest men of his time, who gave up his grand town house to become the Morgan Library. A brilliant and dazzling gift to New York, no doubt, but one that may eclipse the endeavors of so many more modest philanthropists, devoted to improving life for people in their communities.

I come from a successful family of businesspeople, and my father was always involved in several civic projects at any one time, and nonprofit endeavors. He knew that if you want to have a good community, you have to do more than just run your business. He wasn't schooled in art, but he became chairman of the board of the Cincinnati Art Museum, and helped make it one of the country's great museums. He was doing what he thought was right. But it concerned him that he didn't know very much about art. So he would track down art experts in town, and pull them aside to ask them about an artwork: "Tell me about this. I'm going to be running the board, tell me what it means."

He taught me by example. And though he never came to know much about art, he encouraged me to pursue my passion for photography. One aspect of my work on libraries, and art museums, and great civic buildings, is to show my respect to people like him.

From an interview with Chris Boot, Cincinnati, October 2016

The Library Book
Photographs and afterword by Thomas R. Schiff
Introduction by Alberto Manguel

Jacket photo: George Peabody Library, Baltimore, 2010

Editor: Chris Boot
Design: SMITH
Production Director: Nicole Moulaison
Production Manager: Nelson Chan
Project Editor: Nicole Maturo
Senior Text Editor: Susan Ciccotti
Proofreader/Copy Editor: Sally Knapp
Extended Captions: Paula Kupfer
Technical Support: Jacob Drabik, Ryan Elliot,
and Brian Emch
Work Scholar: Jasphy Zheng

Additional staff of the Aperture book program
includes:
Sarah McNear, Deputy Director; Lesley A. Martin,
Creative Director; Amelia Lang, Managing Editor;
Kellie McLaughlin, Director of Sales and Marketing;
Richard Gregg, Sales Director, Books; Taia Kwinter,
Assistant to the Managing Editor

The author offers special thanks to Mary Ellen Goeke.

First edition, 2017
Printed by Artron in China
10 9 8 7 6 5 4 3 2 1

Library of Congress Control Number: 2016957042
ISBN 978-1-59711-374-8

To order Aperture books, contact:
+1 212.946.7154
orders@aperture.org

For information about Aperture trade distribution
worldwide, visit:
www.aperture.org/distribution

aperture
Aperture Foundation
547 West 27th Street, 4th Floor
New York, N.Y. 10001
www.aperture.org

Aperture, a not-for-profit foundation, connects the
photo community and its audiences with the most
inspiring work, the sharpest ideas, and with each
other—in print, in person, and online.